European and American Paintings and Sculpture

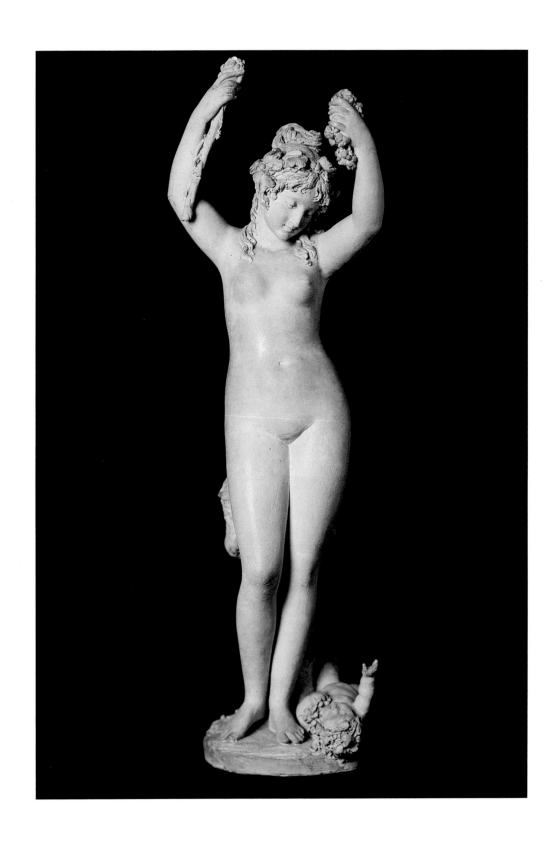

European and American Paintings and Sculpture
Selected Works

Nancy M. Huth and Alain G. Joyaux
Essay by Ned H. Griner

Ball State University Museum of Art
1994

for Georges Jules and George William

[Son art est] le symbole sensible de la Nature, de cette
grande Nature vague, qui gaspille le pollen et produit
brusquement l'envol de mille papillons et dont on ne sait
jamais si elle est l'enchaînement aveugle des causes et des
effects ou le développement timide, sans cesse retardé,
dérangé, traversé, d'une Idée.

Jean-Paul Sartre, 1946

Cover:
Sultane sur une ottomane, circa 1772–1776
Jean-Honoré Fragonard
see text, page 99

Frontispiece:
Bacchante avec un enfant, 1817
Joseph-Charles Marin
Gift of the Ball State University Foundation in honor of the
Ball family on the occasion of the seventy-fifth anniversary
of Ball State University
see text, page 107

Contents

Acknowledgments, 7

Introduction, 9
Alain G. Joyaux

The Founding of the Collection, 17
Ned H. Griner

List of Color Plates, 27

Notes to the Reader, 39

Catalogue of Paintings and Sculpture, 43
Nancy M. Huth and Alain G. Joyaux

Index of Artists, 191

Acknowledgments

Over the past twelve months, countless persons have contributed immeasurably to this publication. On behalf of both the Ball State University Museum of Art and the university, it is a pleasure to express our sincere appreciation to all of them.

The current project had its beginnings in late 1992. To Richard Burkhardt, we owe the original conception of a publication that might honor the university's seventy-fifth anniversary and serve to acknowledge but one component of the Ball family's commitment to the Muncie area community and to Ball State University. To Oliver Bumb, chairman, and to the members of the Ball State University Seventy-Fifth Anniversary Committee, we express our gratitude for their assistance in securing the funds necessary to bring this publication to fruition. Research travel was graciously supported by Margaret Merrion, Dean, College of Fine Arts and by Warren Vander Hill, Provost and Vice President for Academic Affairs.

To the following persons and institutions who, over the past twelve months, have contributed to the realization of this publication by making available resources, providing pertinent information, offering encouragement, and answering last-minute inquiries, we should like to express our sincere appreciation: Patricia Lang, Associate Professor, Department of Chemistry; Eugene McCane, Instructor, Department of History; Herbert Saxon, Manager, Biology Field Areas; Gil Smith, Associate Professor, Department of Architecture; and Janet Amos, Graduate Assistant; the Archives of American Art, Smithsonian Institution, and Richard Wattenmaker, Director; Martin Krause, Curator of Prints and Drawings, Indianapolis Museum of Art; the Intermuseum Conservation Association; and the Michigan State University Libraries.

Special mention must be made of the staff and exceptional resources of the Frick Art Reference Library, New York; the invaluable assistance of the interlibrary loan staff, Alexander M. Bracken Library, Ball State University; the authors of the Internet Access Software, Sonoma State University, for making possible access to on-line library catalogues world-wide; Jane Joyaux for so patiently tracking down the minutia upon request over the past ten years; and David T. Owsley, mentor and friend.

Important research on Thomas Cole and other American nineteenth-century works was undertaken during academic year 1989-1990 by Laurie Handley under the auspices of the Ball State University Undergraduate Fellows program. To Amanda Laudig, we express our appreciation for her work on editing entries from earlier publications and researching literary sources. Special acknowledgment is also due Shelly Couvrette, the museum's assistant registrar, for translating and reformatting handwritten notes into legible object records over the past four years and to her assistant Sharon Selvey. The typescript was expertly produced by Lisa Carmichael, Melissa Baird and Julie Mains.

To John Huffer, Ronald Partain, and Edgar Self, we express our appreciation for the black and white photographs and color transparencies reproduced in the following pages. No publication is complete without the firm hand of an editor. For her generous cooperation and invaluable assistance our thanks go to Patricia Martin Gibby, Director, University Publication Services. For production of the catalogue, from typescript and photographs to a printed and bound volume, we acknowledge Bang Printing, Elkhart, Indiana.

Museum publications inevitably make substantial demands on many persons, and none can be realized without the cooperative efforts of the museum's employees. Highest recognition is due to Lisa Carmichael, Office Manager and Assistant to the Director, and Terrence McIntee, Preparator, and the many student employees of the Ball State University Museum of Art for their willingness to participate in the project regardless of the pressing demands of the museum's day-to-day operations.

Special thanks are due to Ned Griner for once again sharing his expertise and insights into the history of the visual arts in Muncie and for his continuing commitment to building the Ball State University Museum of Art collection. His influence as a member of the faculty for more than thirty years and his substantial efforts over the past two years have altered the very nature of the collection.

Finally, we are grateful for the privilege of expressing our deepest appreciation to those who are responsible for the resources housed in the Ball State University Museum of Art. The works of art elucidated in these pages are but an overview of a lasting legacy, one that was firmly established in 1918 through the foresight and generosity of Frank C. Ball and built upon over the past seventy-five years by the Ball brothers and their families, the Muncie area community, and the university's alumni and friends. We have just reason to be proud of the scope and quality of the works included herein and are delighted to share them with the reader.

Alain G. Joyaux
Director
Ball State University Museum of Art

Nancy M. Huth
Assistant Director and Curator of Education
Ball State University Museum of Art

Introduction

The 1993-1994 academic year marks the diamond anniversary of Ball State University. In celebration of seventy-five years as a state-assisted academic institution of higher education, Ball State University is proud of its emergence as a premier teaching university emphasizing scholarship, creativity, and diversity to undergraduate and graduate students with faculty that, in addition to their teaching, are encouraged to perform service and engage in scholarly inquiry. This year-long commemoration affords opportunities to reflect on Ball State University's evolution as a major teaching university and, more important, to look ahead to the university's future as a major force internationally in improving the quality of life.

—Mission, Seventy-Fifth Anniversary Year

As we look forward to the year two thousand and the dawn of a new millennium, we take this opportunity to review our past and to honor those who made today possible—those whose example we must embrace as we look ahead to the future.

In late 1992, the seventy-fifth anniversary committee first suggested a publication that might commemorate this landmark year for Ball State University and recognize but one aspect of the Ball family's leadership. Since then, just over twelve months have elapsed: a moment, if we consider the research challenges presented by an important collection, but sufficient time, we hope, to compile an overview of this manifestation of the Ball family's lifelong philanthropic commitment to the university and to the Muncie area community.

To a museum visitor the essential place of the Ball family and foundations throughout the history of the Ball State University Museum of Art is immediately apparent. Seventy percent of the works on view in the permanent collection galleries either were donated by a member of the family or are on loan to the university from the Ball Brothers Foundation, the George and Frances Ball Foundation, or David T. Owsley. Without their generosity, the museum's educational mission within the university and the larger community, its very ability to enrich the quality of life of its many constituents, would be seriously jeopardized.

Members of the Muncie area community and the alumni and friends of the university have also donated indispensable portions of the collection. In doing so, they responded to the efforts of those whose vision and continued support created a community collection. Among their ranks we discover an ever-expanding association of patrons who confirm the importance of the collection to the university and the greater community.

The Muncie arts movement, so eloquently recorded in Ned Griner's *Side by Side with Coarser Plants: The Muncie Arts Movement, 1885-1985*, has today lasted one hundred and eight years. In his book, Dr. Griner notes that the creation of a permanent collection of art intended to enrich the Muncie area community was proposed in the fall of 1905. Just four months later, the collection was founded when the Muncie Art Association purchased its first painting. During an April 17, 1907, meeting, members of the association discussed a plan to construct a permanent exhibition space.

Through their 1917 purchase of the property and buildings of the bankrupt Muncie Normal Institute, giving the institution new life as Indiana State Normal School, Eastern Division in 1918, the Ball brothers assured the Muncie community ready access to higher education.[1] Intended from its inception to give Muncie-area residents access to works of art of high quality, the community's collection was an appropriate component of an institution dedicated to a strong liberal education.

To house the community's expanding collection, a modest art gallery was included in the school's 1927 library building, today known as North Quadrangle. By 1931, school officials were planning the construction of an arts building that would include a museum space. On May 1, 1936, Ball State Teachers College and the larger arts community celebrated the dedication of the new arts building. For the first time the visual and performing arts and the Ball State Teachers College Art Gallery were united under one roof. Forty-seven years later, in 1983, the Department of Art, the Department of Theater and Dance Performance, the School of Music, and the Ball State University Art Gallery joined together as the College of Fine Arts to better serve the university and the community. Acknowledging a half-century of maturation, the university trustees approved changing the name of the gallery to the Ball State University Museum of Art in 1991.

Initiated by a few far-sighted persons dedicated to improving the quality of life in the Muncie area community, the Ball State University Museum of Art today houses an educational resource of more than nine thousand works of art displayed on a rotating basis in more than sixteen thousand square feet of exhibition space. Permanent and loan collections include works of art created during the past five thousand years by cultures throughout the world. The museum houses important collections of American nineteenth- and early twentieth-century paintings, European eighteenth- and nineteenth-century paintings, and select works from the thirteenth through seventeenth centuries. Its collection of prints and drawings, representative of the last five centuries, is particularly strong in contemporary work. The museum also boasts an important collection of decorative arts, the Ball/Kraft Collection of Ancient Glass, and substantial ethnographic and Asian collections.

In recent years, the concept of quality of life—a specific community's, our nation's, the world's—has been a prominent topic of discussion. We consider improvements in the quality of life desirable and record our achievements proudly. Such ideas are not the exclusive purview of contemporary society. The American psyche has consistently embraced as fundamental to society a vision of the world as it might be—a vision expressed more than a century ago by Judge Orlando J. Lotz in his May 2, 1889, address to those attending the opening of the second annual exhibition of the Muncie Art School:

> But few persons realize the debt of gratitude that we owe the artist. We are not aware of how much he contributes to our happiness. We never see a building whose proportions and symmetry please and excite our wonder and admiration but that its design was formed in the brain and penciled out by the hand of the artist. We never see a fine illustration or engraving in a book or painting on the wall that was not first born of the imagination and skill of the painter.
>
> Many years ago Washington Irving wrote "In America literature and the elegant arts must grow up side by side with the coarser plants of daily necessity." Although we have labored under difficulties America is not unknown in the republic of letters and the realms of fine arts. In poetry we have produced a Pain and Longfellow; in the drama a Forrest and Booth, in sculpture, a Powers and a Story, in oratory a Webster and an Ingersoll; in painting a Stewart [Stuart] and a Whistler.[2]

In America, the resources and institutions that enable people to live rich and rewarding lives have indeed grown up "side by side with the coarser plants of daily necessity." Unique to this country is that private beneficence has taken the leadership role. It is this American tradition of philanthropy—this obligation felt and embraced by those who created our nation's museums, parks, and libraries, and encouraged our artists, poets, and musicians—that we celebrate through this publication. It is this history that we must build upon as we look to the future.

Frank C. Ball and the Ball Family

On January 14, 1918, Frank C. Ball purchased fifteen paintings from the American Art Association auction of the James Buchanan Brady collection. Six weeks later, he purchased fifty-four paintings from the February 25-March 4, 1918, American Art Association auction of the George A. Hearn collection. We can well imagine his growing enthusiasm at the evening sessions of the Hearn sale. On February 26, he purchased a single work. The next day he acquired six paintings. On the twenty-eighth, he purchased nine paintings. On March first, he acquired thirty-five paintings.

Frank C. Ball never intended these works to grace his Minnetrista Boulevard home. In the spring of 1918, having no suitable public exhibition space in Muncie, Mr. Ball loaned the collection to the John Herron Art Institute (Indianapolis Museum of Art), where it might benefit the citizens of Indiana. A decade later, with the dream of a permanent art gallery in Muncie realized, in February, Frank C. Ball's collection was installed in the recently constructed library art gallery at Ball Teachers College. With the move to the new arts building in 1936, Frank C. Ball added his collection of ivories and cuneiform tablets to the paintings in the recently constructed museum.

In 1936, the museum's two-story atrium space, sculpture court, was largely barren. Early the next year, an exhibition from the Grand Central Art Galleries of paintings and sculpture by leading American artists filled sculpture court with late nineteenth- and early twentieth-century bronzes and the temporary galleries with contemporary paintings. At the close of the exhibition, sixteen bronzes and ten paintings remained in the galleries, joining the Frank C. Ball collection. In late 1937, Frank C. Ball's collection of contemporary Indiana paintings and a number of important works purchased in 1935 came to the university.

Broadly inclusive but not encyclopedic in scope, the Frank C. Ball collection provided a nucleus on which to build for the future. Embracing this tradition of beneficence, other members of the Ball family further enriched the quality of life in the Muncie-area community and advanced the university's strong liberal education curriculum by placing their personal collections in the care of the museum.

E. Arthur Ball's art interests centered on Renaissance works and French paintings of the eighteenth century that he purchased in the 1930s and early 1940s. When his collection was transferred to the museum in 1951, the event was celebrated with a special exhibition of the paintings.

George A. Ball's lifelong interest in history and intimate knowledge of glass were to find new expression through his acquisition in the early 1930s of a substantial collection of ancient glass. In 1952, Edmund F. Ball acquired the James Lewis Kraft collection of ancient glass. Late that same year, the Ball/Kraft Collection of Ancient Glass, together totaling one hundred and seventy-six pieces, came to the university.

In 1954 Margaret Ball Petty gave six paintings to the museum from a collection she and her late husband, Fredrick J. Petty, had acquired. More than thirty years later, in 1985, the Margaret Ball Petty Foundation, the Ball Brothers Foundation, and the Petty family created the Margaret Ball Petty Endowment Fund and the Edmund F. Petty Memorial Lecture Fund. These financial resources will continue to enhance the collection and further the museum's educational programs in future years.

In memory of his grandparents, Frank C. and Elizabeth Brady Ball, David T. Owsley gave seven Pre Columbian works to the museum in 1963. Thirty years have passed since this first contribution and not a moment was wasted. To date, David T. Owsley has donated more than nine-hundred works of art to the museum and has placed many additional works on

extended loan. In such diverse areas as old master prints and drawings, Eastern and Western decorative arts, contemporary painting and sculpture, ethnographic art, and old master paintings, his gifts and loans have altered forever the very nature of the collection.

In 1971, Bertha Crosley Ball (Mrs. Edmund Burke Ball) donated a small collection of early twentieth-century works on paper. After her death, her surviving children, Edmund F. Ball, Janice Ball Fisher, and Adelia Ball Morris, donated additional portions of her collection to the museum. In 1975, they gave her collection of decorative arts, five years later a second group of objects, and a final group of objects and paintings in 1985.

Founded with an initial collection of more than two-hundred pieces and named for its primary donor, the museum's David T. Owsley Ethnographic Gallery was dedicated in 1978. Edmund F. and Virginia Ball contributed a number of oceanic works to the ethnographic collection one year later and additional pieces in 1987. Soon after the opening of the gallery, Lucy Ball Owsley (Mrs. Alvin M. Owsley), and the Edmund F. Petty family also made important contributions to the ethnographic collection.

During the early years of the century, George A. and Frances Woodworth Ball formed an important collection of American paintings. Their interest and knowledge and over time their collection were passed to their daughter Elisabeth. Aided and encouraged by her parents, Elisabeth expanded the American paintings collection considerably and formed important collections of works on paper, decorative arts, and children's books. Gifts to the university from Elisabeth Ball were first recorded in the mid 1940s. By bequeathing her collections to the George and Frances Ball Foundation, she assured that they would be shared with the Muncie community.

Between 1983 and 1990, the George and Frances Ball Foundation added to the museum more than one thousand works of fine and decorative arts from the George and Frances Ball collection and the Elisabeth Ball collection. Funding from the George and Frances Ball Foundation also enabled the museum to construct a decorative arts gallery, dedicated on October 28, 1989. There for the first time, the museum could exhibit a comprehensive overview of its decorative arts collection. Coinciding with the opening of the new decorative arts gallery, important additional gifts and promised gifts were made by Lucina Ball Moxley and more recently by Judith Cummings, her daughter.

The Community and the Alumni and Friends of the University

Soon after the Frank C. Ball collection was installed in the new library art gallery in 1928, members of the Muncie area community and the alumni and friends of the university began contributing to the collection. In 1931, Reverend C.I. Kiern's significant collection of Japanese decorative arts was given in his memory by his daughter Anna M. Kiern. Six years later, Muncie native Daniel Jarrett Hathaway contributed an important collection of Chinese

porcelain. In 1940, Mr. and Mrs. William H. Thompson donated their collection of Italian old master paintings to the museum.

Through the generosity of Mrs. Grace Jennings and Mrs. William N. Johnston, an important group of Native American ceramics entered the collection in 1947. During her tenure as an art professor, Susan Trane compiled a collection of early twentieth-century works on paper. In 1961, Stella Trane Jackson presented this collection to the museum. In 1979, the Althea Stoekel bequest added to the museum's collection of late nineteenth- and early twentieth-century decorative arts. Two years later, Robert Thomas honored the memory of his parents, Mr. and Mrs. Ray M. Thomas, through the donation of their collection of Japanese decorative arts.

In 1944, a loosely formed group of supporters joined together to further enhance the collection by initiating community-funded purchases. United by an interest in strengthening the museum and enhancing its collections, in 1973 this association of persons was formalized as the Friends of the Ball State University Art Gallery. Friends Fund monies today provide a primary means to address specific needs in collections development.

To stimulate public interest and participation in the collections, exhibitions, and programs of the museum, the Ball State University Art Gallery Alliance, a committee of the friends, was formed in 1981. Monthly alliance lectures assure that its members are informed spokespersons for the museum, and alliance members host many of the museum's special events. In recent years, alliance contributions have provided an additional means to address collections development.

Completed in November 1992, the Wings for the Future Campaign for Ball State University raised $44.1 million dollars over five years to further the educational mission of the university. As a component of this campaign, the Ball State University Museum of Art Endowment was initiated with a $500,000 challenge grant from the Ball Brothers Foundation. Income from the endowment is earmarked for collections development and conservation. Established as a component of the museum endowment in 1991 through the leadership of Richard M. Ringoen, the Lucy Ball Owsley Memorial Fund will provide income to support the museum's acquisitions, conservation, and education goals.

A University and Community Resource

The Ball State University Museum of Art offers the university and community direct experiences with significant works of art representative of major world cultures. More than a feast for the eyes or an accumulation of objects reflecting the diverse tastes and interests of its donors, a museum collection is a group of unified works arranged in a particular order. Only where we successfully establish order through selected acquisitions do we encourage visitors to consider the evolution of ideas represented by the individual works. Building a cohesive survey of Western art and allocating space to exhibit a balanced overview from the Medieval

14

era to the present remains a primary goal. We are fortunate that in recent years it has become possible to think in terms of achievement and refinement.

The museum also remains committed to a continuing schedule of temporary exhibitions. Emphasis is placed on exhibitions drawn from the collection, those which further illuminate the collection, and those that enable the museum to remain actively engaged with contemporary art. Through such exhibitions the museum seeks to reflect the diversity of the world in which we live while remaining responsive to the educational mission of the university and the aspirations of the community.

Interwoven with permanent and temporary exhibitions are educational programs that will further faculty, staff, student, and public appreciation and understanding of the collection. Forming a link between the exhibited works and the viewer, educational programs addressing the needs of a wide range of disciplines ideally strive to make the viewer self-sufficient in interacting with the object that he or she confronts.

Since February 1992, written materials developed for permanent and temporary exhibitions have been incorporated into a public-use education database called ART (an acronym for Art Reference Terminal). Through simple, user-friendly technology and language, ART database terminals in the galleries give visitors access to the museum's collections management database files on all objects housed in the museum. Unique among museum interactive devices, ART incorporates both the museum's extensive curatorial files—sixty distinct categories of information—and information on subject matter, artist, and style or culture written for general audiences.

The Catalogue

This first published overview afforded an important opportunity to undertake considerable new research on a broad cross section of the collection. Early in the process, we faced the realization that the time allotted necessitated limiting the scope of the project. We chose to focus on painting and sculpture, selecting objects carefully to provide a broad overview of the history of Western art from the Medieval era to the present. In doing so, we attempted to balance our interest in including many of the finest pieces with a desire to demonstrate the wealth of this teaching resource.

The catalogue includes ninety-seven works—sixty-nine paintings and twenty-eight sculptures. To make the collection readily accessible to the museum's general audience and provide a point of departure from which to enhance their understanding of the individual works, essays accompany many of the catalogue entries. These essays are not intended to expand the body of scholarship on the artist or the work discussed. Documentation accompanying each work includes complete inscriptions and labels, notes on condition, detailed histories of ownership, extensive exhibition histories, published and unpublished references, and

occasional remarks. The documentation is provided to make possible the accurate placement of the works within the broader context of each artist's oeuvre and to provide a firm basis for further inquiry.

Because of their importance in our overview of western art, we have chosen to include some works that have resisted our best investigative efforts and are thus presented with little documentation. Others are extensively documented yet pose problems of attribution and point to the importance of continued research. Regrettably, we have also found it necessary to omit a number of works whose condition or the present state of our research has not enabled us to determine quality and/or authenticity.

Finally, the reader will note that many of the works of art included here are on permanent or extended loan from the Ball Brothers Foundation, the George and Frances Ball Foundation, and David T. Owsley. Unmindfull of the success or failure of the normal school founded in 1918, the founders of the collection shared the dream of a public collection of works of art representative of the diversity of the world in which we live that would benefit the Muncie area community in perpetuity. Seventy-five years have elapsed and Indiana State Normal School, Eastern Division, has today become a major university. It is perhaps too easy to forget that there was substantial risk in tying the future of the community's collection to the fate of an institution that had started and folded three times between 1899 and 1917.

We have inherited a philanthropic tradition that intended permanent benefit. The future will present new opportunities and unforeseen constraints. The challenge we face is to further this tradition of beneficence that has today endured for three-quarters of a century. Should we accept the challenge, this publication will indeed honor the seventy-fifth anniversary of Ball State University and the family that has played such a decisive role in its history—not as a record of the present, but as a foundation for the future.

Alain G. Joyaux

Notes

[1] Indiana State Normal School, Eastern Division, became Ball Teachers College in 1922, Ball State Teachers College in 1929, and Ball State University in 1965.

[2] The full text of Judge Lotz's address appears in Griner, Ned H. *Side by Side with Coarser Plants: The Muncie Arts Movement, 1885-1985*. Muncie: Ball State University, 1985, pages 15-17.

The Founding of the Collection

As Ball State University celebrates its seventy-fifth anniversary, it is time to pause and reflect on how a small normal school of 1917 has managed to become a university of national stature. Success and greatness simply do not just happen, they are the result of the industry, dedication, devotion, and material support of many individuals and agencies. Ball State is fortunate to have had this kind of support during the past seventy-five years. Among its many supporters, the Ball family is most notable. It has been through the example of this exceptional family that important leadership, moral guidance, and generous beneficence has done so much to foster the growth and excellence of the institution. The Balls have not only contributed to the university, but also recognized the need to support other elements of life in health, religion, history, various social agencies, and the arts. The Ball family has recognized the social complexities of a community, understanding that a high quality of life was necessary to maintain a viable cultural and social environment. Their example has stimulated others to join them in their quest for civic responsibility resulting in a culturally rich and economically diversified community.

When Frank C. Ball, a twenty-nine-year-old industrialist, came to Muncie in 1886 to investigate natural gas with an eye to relocating his business from Buffalo, New York, he most certainly had no idea of the impact that he and his brothers would have on the community in the years to come. Muncie had little to offer other than the promise of inexpensive natural gas. The streets were not paved and everything looked dusty and very dirty to him. Later, he reported in his *Memoirs* that "there was nothing about the town that particularly appealed to me. But the men were all courteous, kind, and businesslike." Beneath this rather unpromising exterior, he did see the potential for the future. After returning to Buffalo, he reported his findings to his brothers, Edmund B., William C., George A., and Lucius L., and the decision was made to move the family business to Muncie. Frank C. Ball was the first of the brothers to settle in Muncie with the task of building a glass plant; on March 1, 1888, the first glassware was produced. The other brothers were soon to follow, and the family was soon to become firmly established as prominent civic leaders.

The business made rapid growth in the next few years; by 1893 employed a thousand men. New buildings and facilities were constructed, and the company became one of the largest green-glass container plants in the West. During the next few years, the Balls began to amass a fortune from the growth of the business. They felt an obligation to their adopted community and soon began to share some of their profits. It was a family with a sense of

obligation and desire to help Muncie and the state of Indiana achieve a higher level of culture and well being—it was a company with a soul.

The Ball family recognized that acquiring wealth also meant responsibility in the sharing of their good fortune through philanthropy. Philanthropy was not new to them but with the death of Edmund B. Ball in 1925, they felt it important to institute the Ball Brothers Foundation. The first major beneficence of this foundation was the establishment of Ball Memorial Hospital in Muncie, a dream of the late Edmund B. Ball, who felt that a more modern hospital was needed in the community. Edmund F. Ball, the son of Edmund B., wrote in 1985, the occasion of the foundation's sixtieth anniversary, that the foundation initially established a series of objectives. The first "among these objectives were broadening the extent of philanthropic interests and increasing the Foundation's holding. Another goal was to begin acquiring works of art and literature, of which Ball State University would become the principal beneficiary."

The beneficence of the foundation was generous and widespread, embracing a variety of institutions representing many objectives and interests. More often than not the benefactions were not publicized, and some received little notice. However, some were of such importance that they could not escape attention. Other than the hospital, examples of their foundation's better known philanthropies in Muncie have been the Y.M.C.A. and Y.W.C.A. buildings, the Masonic Temple, and most recently the Minnetrista Cultural Center.

Before the foundation was created, the single greatest contribution to Muncie and Indiana was the Ball brothers' foresight in rescuing the defunct normal school that later became Ball State University. George N. Higman had the idea of creating a normal school in 1895. One year later an executive committee consisting of seven businessmen was organized. The process of creating a normal school was complicated, and after considerable difficulty with financing, the building was constructed and opened in the fall of 1899 under the name of Eastern Indiana Normal University. Once open, the school required further funds to guarantee continuing operations, and a number of local businessmen pledged their support, among them the Ball Glass Manufacturing Company. Notwithstanding the financial guarantors, insufficient enrollment ensued, and the normal school closed in August 1901. Efforts to salvage the operation also failed.

The next year heroic efforts were again mounted to resurrect the university. In 1902, a plan was advanced to reopen the facility, and Francis Asbury Palmer was persuaded to contribute $100,000 in the hope that the Christian Church of North America would match his donation. A number of Muncie citizens also contributed money and volunteer work to refurbishing the building, which had fallen into neglect. The Christian Church of North America was busy raising $100,000 to match Palmer's pledge and the Ball brothers had agreed to contribute $10,000. When the funding campaign fell short of its goal, Frank C. Ball agreed to contribute the amount needed to make the $100,000 quota. The necessary money seemed to be in hand. Then fate made a turn. Mr. Palmer died, his heirs contested his will, and the financial campaign failed. The prospect of Muncie having a university again came to an end.

Three years later, another attempt was mounted to resurrect the beleaguered school. An effort was made to introduce a bill in the Indiana General Assembly to have the state take over the facility and establish another normal school. The bill failed. The publicity resulting from this legislative action caught the attention of two Indianapolis men. They proposed that the University Association allow them to form a corporation as a private facility financed through the sale of stock. Stock was sold and the school was reopened in 1905 as the Indiana Normal School and College of Applied Science. The school soon developed severe problems, and the president resigned. Frank C. Ball and others attempted to save it and persuaded Lemuel A. Pittenger to become the chief administrator. It was obvious that additional support would be needed; attempts were made to entice Taylor University, a Methodist college in Upland, Indiana, to transfer its operations to the Muncie normal school. Taylor declined the offer and in 1907 the Indiana Normal School and College of Applied Science closed.

The concept of a normal school seemed to be lost forever, and the grounds and the buildings deteriorated, not to mention the fact that the real estate value of the neighboring area was on a rapid decline. Then in 1912, the school was once again resurrected, this time as the Muncie Normal Institute with Frank C. Ball as a member of the board of trustees. As the enrollment increased to 2,000 students, it appeared that maybe the worst was over and that Muncie would have a stable school. Again, financial problems haunted the school, this time complicated by a philosophical rift between the board of trustees and president Michael Kelly. Furthermore, World War I was in progress and perhaps the Normal School did not seem very important. On January 17, 1917, the creditors asked for foreclosure, and the court ordered the assets of the institution sold.

The Normal Institute assets were appraised at an estimated value of more than $409,000. Since there were no offers to purchase the property, six months later the court ordered that it be sold at public auction. The bidding began at $25,000. After spirited bidding, the Ball brothers purchased the 64.62 acre property with its two buildings for $35,100. Legislation was passed in 1917 permitting state educational institutions to accept private gifts enabling the Ball brothers to give their purchase to the state to be used as an institution of higher education. After a shaky beginning with a history of four attempted starts, Muncie was now the home of the Eastern Division of the Indiana State Normal School in Terre Haute.

From its inception in 1895 until its closure in 1917, the normal school was in trouble financially. Regardless, the Ball brothers had faith in the enterprise and, along with others, had supported it all those years. To them an institution of higher education was essential to Muncie—they regarded it as their civic obligation to see that it succeeded. The normal school was now on more secure ground than ever before. When school opened again in 1918, there were 380 students registered.

Frank C. Ball was appointed a member of the board of trustees, and the brothers were soon to provide funds to erect a new gymnasium, Lucina Hall, Elliott Hall, and a substantial portion of the cost of a new arts building. A new era had begun.

The construction of a new arts building in 1936 was important to what by then was known as Ball State Teachers College. The Ball family had always been interested in the arts beginning in the early Muncie years. They saw the arts as an important part of the learning process. Frank C. Ball in his *Memoirs* noted that music "ennobles the character, purifies the mind, and I believe makes it easier for the scholars to learn their lessons." He also noted that more "than any other profession, the arts do demonstrate to us all the uniqueness of the human species and the potential divinity and beauty of the creative act." These were not hollow words; the Ball brothers were collectors of art, readers of literature, and appreciators of good music. They understood the value of the arts, and early in their Muncie years, the brothers and their wives were active in promoting the arts in their community.

The story of their involvement in art began rather inauspiciously late in the nineteenth century; it can be said that it was their wives who first cultivated the interest of their husbands. The Muncie art movement began in March 1892, when a group of women who studied painting under the tutelage of J. Ottis Adams, a Muncie portrait and landscape painter, formed an organization that became known as the Art Students' League. Originally, its purpose was to maintain Adams's studio, which had been closed, in an attempt to continue their painting classes. League membership was limited to invitation. During the League's first ten years of existence, they not only studied painting, but also presented several exhibitions to the public.

Recognizing that the League was an exclusive organization, the women decided that Muncie needed another art organization with a broader base of community membership. In the fall of 1905, they appointed an executive committee to attempt to organize an art association. The committee drafted their proposed objectives, two of which were defined as, first, sponsoring "a yearly exhibit of pictures of the best American and European artists, and incorporated with this, an exhibition of the latest arts and crafts of the country—said exhibition to be FREE to the public," and, second, purchasing "one of these pictures each year, as the beginning of a permanent collection to be located in some public building accessible to all members at any time, for study." In other words, this is the beginning of the concept of an art museum in Muncie with its own permanent collection, which would be of benefit to the college and community in the years to come.

To carry out the association's objectives, several committees were authorized: membership, finance, exhibits, art museum, civic art, and art education. The committees consisted of a wide range of Muncie's citizens, numbering 144 members. A board of directors was organized with George F. McCulloch functioning in an ad hoc capacity as chairman and with Frank C. Ball as a member. Ball shortly replaced McCulloch as the first president. He served faithfully in that capacity until 1936, when the Ball State Teachers College Art Gallery was constructed.

Under the leadership of president Ball, the association made great strides and attracted a large membership of Muncie citizens. Still in its infancy, just four months old, the association

organized an exhibit and voted to spend one hundred dollars from its treasury, a donation from the Art Students' League, to purchase a painting for its permanent collection. The members were eager to make good on their promise to sponsor exhibitions and begin a permanent collection. Arrangements were made with the J.W. Young Gallery of Chicago to loan oil paintings and watercolors, a total of about ninety items. To make the exhibit profitable for Mr. Young, he stipulated that one or more pictures must be purchased. The exhibition was held in May—the first of a series of annual spring exhibitions sponsored by the association. Four paintings were sold.

It was a formidable task for such a young organization to undertake the sponsorship of an annual exhibition that would require financial reserves, work, and coordination of the part of the membership.

From this exhibition, the association, using the one hundred dollars from the Art Students' League, purchased *The Sand Pit*, a painting by Carl Wiggins. The exhibition was a public success. Precise attendance figures are not available, but visitors purchased 1,268 catalogues at five cents each. In spite of the large attendance, the event was not a financial success, and the association had to borrow $350 from the bank to meet expenses. However, it was a beginning; Muncie had a respectable art exhibit and was able to purchase one of the paintings for its permanent collection.

In spite of what appeared to be a substantial membership of thirteen hundred, the association launched a new membership drive, creating a committee with the intention of increasing the membership by seven hundred to make it possible to raise enough funds to retire the loan from the bank.

As the art movement gained strength, the issue of an art gallery for Muncie kept coming up. One of the stated objectives of the association had been to "establish, equip and maintain a permanent art gallery." On April 17, 1907, the board met in the assembly hall of the public library to discuss finances and membership. A report was also received from the Committee on a Permanent Art Gallery chaired by Mr. Edmund B. Ball. He reported that

> this committee together with the Mayor, Mr. L.A. Gutherie and president of
> the Public Library board Mr. T.F. Rose had planned for an extension to our
> present library building and thus make room for an art museum. At present
> this was not possible for lack of funds but may yet be realized.

This is the first documented discussion of plans for an art gallery in Muncie; as might have been expected, the major drawback would be the lack of funds. The association must have understood that an art gallery was perhaps permanently beyond its means—the subject was mentioned very little in subsequent years. But the seed of the concept of an art gallery had been planted, and after several years had passed, it would germinate, not so much through the association but through the efforts of certain persons associated with the organization.

With little prospect for success in establishing an art gallery, the association moved ahead with plans for more exhibitions. The May exhibition became an annual affair, and other exhibits were planned for other months. With no exhibition space available to the association, the Commercial Club became the primary venue.

Experience had shown the association in 1906 that mounting an exhibition was a task almost beyond the ability and resources of a neophyte organization. The assistance of a more experienced organization was needed if they were to continue with effective exhibits.

At this time, Richmond, Indiana, had a more mature and experienced art association (founded in 1898) that was organizing its own exhibits. The Richmond association had been successful in sponsoring exhibits; it had in fact been able to establish a permanent art gallery as part of the Richmond High School so that art might be an integral part of the educational environment of students and at the same time be available to the adults of the community.

To accomplish their objective, the Richmond association held annual exhibitions that included the work of many prominent artists from Indiana as well as from the East. Since the expense of such important exhibitions was rather high for the Richmond association to bear alone, they invited the Muncie association to participate, with an agreement to pay a share of the expenses. The Muncie Art Association accepted, establishing a working relationship with its counterpart in Richmond.

The spring exhibit of 1907 had among its paintings a Childe Hassam, *Entrance to the Siren's Grotto*. The infant Muncie Art Association, already in financial difficulty, coveted the Hassam. To complicate matters, the asking price for the painting exceeded the association's self-imposed $100 limit. At an association meeting, Mrs. Frank C. Ball reported that Mr. Hassam had wired that he would discount his painting to $400—still $300 over the limit. Mr. Frank C. Ball and Mr. George McCulloch organized a subscription drive, seventeen persons contributed from $10 to $40 each for a total of $570, and the association became the proud owner of a Childe Hassam.

In the following years, the association continued its working relationship with the Richmond Art Association and made purchases as often as financial conditions permitted. The collection grew to include works by J. Ottis Adams, Palmer, Bessire, Breverman, and Francis F. Brown—to name a few from a 1960 inventory list of twenty-two.

Three years after Edmund B. Ball reported to the association board that because of a lack of funds a new wing would not be added to the library for exhibition purposes, he again reported to the board that the "museum [was] probably forthcoming, when the city was ready for same." Not a very optimistic report, but it does show that the idea was still in the minds of the association; the topic did not formally come up again for several years. During this time, the association's exhibit program continued in spite of a dwindling membership.

In 1914, the association received a serious blow when the Commercial Club informed them that the exhibition space they had been using was needed for other purposes and would henceforth no longer be available. As a result of this setback, the exhibitions were discontinued until 1922, when Flora Bilby, chairperson of the Central High School art department, urged the association to sponsor several small exhibits in the hallway of the high school throughout the year. During the course of the year, they sponsored five exhibitions, featuring local painters and photographers as well as exhibitions received from other organizations outside Muncie. At this time the association decided to move its permanent collection from the Muncie library to Central High School on permanent loan.

But the financial condition of the association worsened, and a year later it went inactive for a period of five years, leaving the collection (including the Hassam) hanging in the hallway of the school. In 1925, the Muncie Art Students' League assumed responsibility for the paintings, moving them back to the Muncie library for safekeeping and exhibition.

By 1923, Ball State Teachers College had a small art department with a modest curriculum. It was headed by Susan Trane. Because it was important to her for students to see original art by others, she initiated a fundraising campaign among the students to purchase paintings by Indiana artists to hang in the art room and various building hallways. Francis F. Brown, who joined the faculty in 1925, also became active in arranging exhibitions on campus anywhere he could find wall space. These exhibits attracted the attention of students and faculty alike and were well received.

In 1926, the college began plans to construct a new library and auditorium complex—the building that today is known as North Quad. Since the need for a permanent exhibition area had become apparent, it was decided to incorporate one in the new building. The plans called for a room approximately sixty by twenty feet in size with oak doors and woodwork and at each end an archway, the one over the entrance to resemble a Greek temple entrance. The walls of the gallery were to be white, with a molding from which pictures could be hung. There was to be a skylight, but also electric lights so that the gallery could be illuminated at night. The exhibition area would begin in the entrance hallway and continue to the second floor where the gallery was.

In June of 1927, the building was ready and an exhibition was installed consisting of the work of Indiana artists, of which several paintings were by Francis F. Brown.

Muncie now had its first art gallery, a space specifically planned for the exhibition of art. The formal opening was held February 1, 1928, and the school paper, the *Easterner*, reported that "more than six hundred persons attended from Muncie and other cities." Frank C. Ball had been a collector of art with the intention of making it available to Muncie; since there was nowhere in Muncie to hang his paintings, they had been on display at the John Herron Art Institute of Indianapolis since 1918. With the new facility on the Ball State campus, he now moved this collection to the new gallery. The Balls had always believed that it was

important for students and the community to have the opportunity of viewing and studying original art, and now that the new gallery had been constructed, this vision had become a reality.

The Muncie Art Association was reorganized and began to sponsor exhibits in the new gallery.

In 1931, plans were initiated on the Ball Sate campus to begin a new art building, scheduled to be finished by September 1, 1933. It was to consist of a classroom building that would house classes in art, music, English, foreign languages, and the social sciences. One of its features was to be a main lobby with a two-branched staircase rising at the rear and leading to the mezzanine floor, where there would be art galleries. The lobby was thought of as a place where campus social activities would be held. The second outstanding feature of the building was to be a small auditorium, Recital Hall, seating about two hundred people, and designed to accommodate recitals, lectures, debates, and small dramatic productions. The seating was to be removable, allowing the hall to be used also for dances and social affairs. The gallery/recital hall complex in the center of the building would unite the cultural activities of the campus and also serve as a community arts center.

The proposed arts building was looked upon by the *Easterner* as "another step forward in the field of art and music on the campus in Muncie and the state of Indiana." The college and the Muncie Art Association were looking forward to their continuing relationship and expected to work together to sustain an active art program in Muncie for the benefit of the campus and the community.

But economic events of 1932 caused by the Great Depression created difficulties for the new arts building. The budget of Ball State Teachers College was slashed by $62,000, a 16-percent cut mandated by the Indiana State Teachers College Board. As a result, it was necessary to table plans for the new building.

In spite of the economic difficulties of the times, efforts were continued to construct the arts building. In January of 1934, the prospects became brighter when an official announcement of a federal grant from the Public Works Administration in the amount of $95,000 was received. Bids for the project were scheduled to be opened on March 6, 1934, with the expectation that work would begin in about two weeks. The total cost was now estimated at $370,000, with $95,000 coming from the PWA grant; the balance of $275,000 had already been raised through the state education fund levy.

When the bids were opened by the State Teachers College Board the first week of March 1934, they were rejected—they did not come within the available budget. New bids to be opened April 9 were advertised.

Alternative plans were being studied. Among the cost-cutting measures considered (and rejected) was the elimination of the auditorium. In an effort to preserve the original plan of the building and to maintain the elegance of the gallery and auditorium, the Ball Brothers

Company offered, through the leadership of Frank C. Ball, to provide additional funds not to exceed $59,117.55 if the local officials of the college would apply for additional funds for the construction.

The application of the PWA bore more fruit than was asked for. Less than one month later, on April 6, 1934, the *Easterner* reported that the PWA had made an additional grant of $33,000. "This latest sum added to the original $95,000 raised the aid received from the PWA to $128,000, or 30 percent of the total estimated cost of $420,000. Of the 70 percent of the construction costs to be borne by the state, Ball State will furnish $259,000, and the difference will be a gift of the Ball Brothers Company." The funds for the new building and the art gallery were in hand.

The cornerstone was laid July 10; sixteen months later the construction was finished. The building was opened to the public November 24, 1935. The paintings in the library gallery were moved to the new gallery. Among the permanent exhibits to have gallery space were the Frank C. Ball collection of old masters, the Muncie Art Association collection, the Ball collection of Indiana artists, and a group of pictures by Muncie artists. The opening was a significant event for Muncie and during the first two weeks the gallery was open more than three thousand people visited the building.

Five months later, a formal opening ceremony occurred. On April 30, 1936, the eve of the formal opening, a reception was held in Recital Hall and the art gallery. This event was attended by more than four hundred persons, including school officials, critics, teachers, ministerial groups, civic clubs, city officials, and other organizations. The *pièce de résistance* of the occasion was a collection of French paintings of the eighteenth century that was brought to the gallery through arrangements made by E. Arthur Ball from the well-known dealer Wildenstein and Company in New York. The grand opening was held the next day with fifteen hundred students and guests in attendance.

As the years passed, the gallery grew, developing its permanent collection and programs. In 1991, the name was changed from *gallery* to *museum*. Today, it stands as a major cultural asset providing excellence in art to the campus and community. Without the years of effort from the Art Students' League, the Muncie Art Association, Ball State University, the Ball family, and many citizens of Muncie, the museum would not have been possible. It was a cooperative effort, all working together to promote a cultural and educational institution for the betterment of the community. There is no way that the early members of the Art Students' League or the Muncie Art Association could have visualized such a magnificent facility. It became what it is because the Ball family had the vision to support the creation of the Normal School that later became Ball State Teachers College and Ball State University. Muncie has been fortunate to have such a family as the Balls, who had the resources, leadership ability, and foresight to recognize the value of an art museum in the community and as a teaching tool on a college campus.

Ned H. Griner

List of Color Plates

I. *Saint Wolfgang*, circa 1480-1510
 Unidentified maker, circle of Anton Pilgrim
 see text, page 50

II. *Madonna and Child*, circa 1494
 School of Lorenzo di Credi
 see text, page 55

III. *Il miracolo della manna*, circa 1635
 Ottavio Vannini
 see text, page 68

IV. *The Blue Boy*, June 1873
 Winslow Homer
 see text, page 130

V. *The Rapids, Sister Island, Niagara*, 1878
 William Morris Hunt
 see text, page 132

VI. *Entrance to the Siren's Grotto, Isle of Shoals*, 1902
 Childe Hassam
 see text, page 151

VII. *Sous-Bois I*, 1906
 André Lhote
 see text, page 155

VIII. *Canto Guerriero* (diptych), 1981
 Mimmo Paladino
 see text, page 186

Plate I, *Saint Wolfgang*

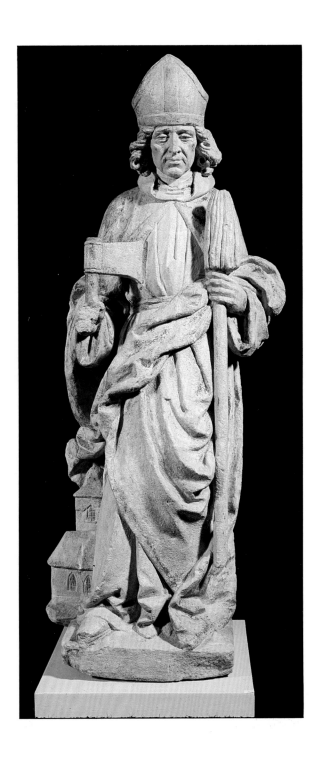

Plate II, *Madonna and Child*

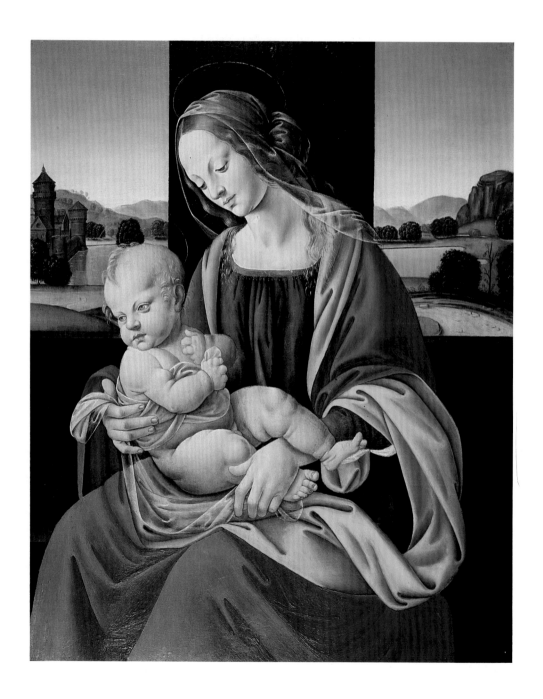

Plate III, *Il miracolo della manna*

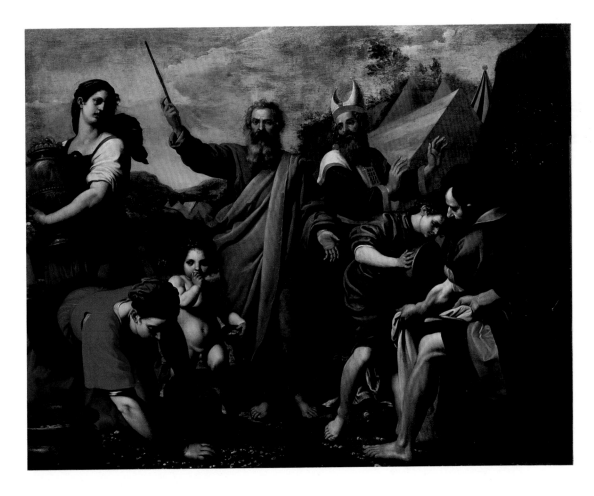

Plate IV, *The Blue Boy*

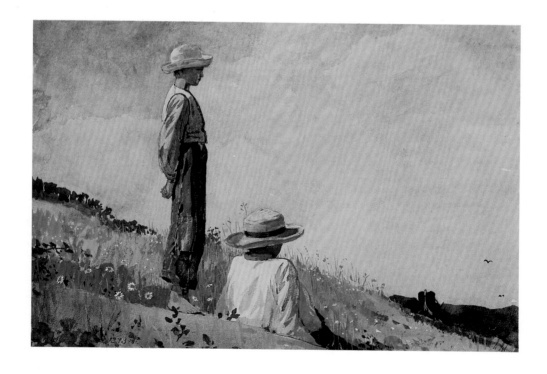

Plate V, *The Rapids, Sister Island, Niagara*

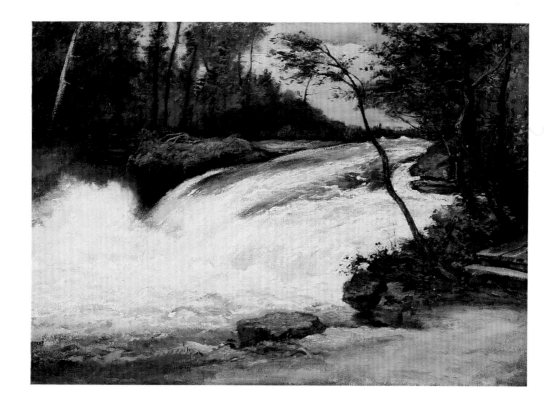

Plate VI, *Entrance to the Siren's Grotto, Isle of Shoals*

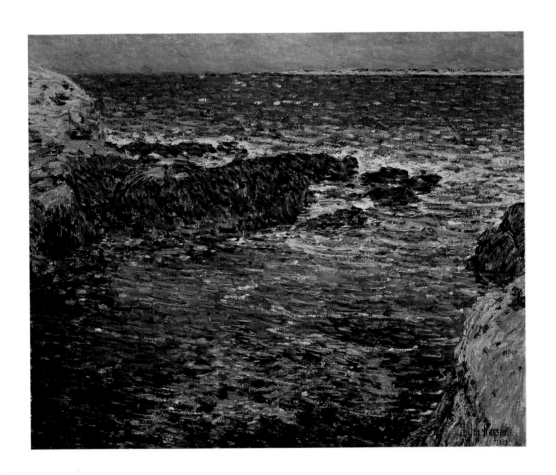

Plate VII, *Sous-Bois I*

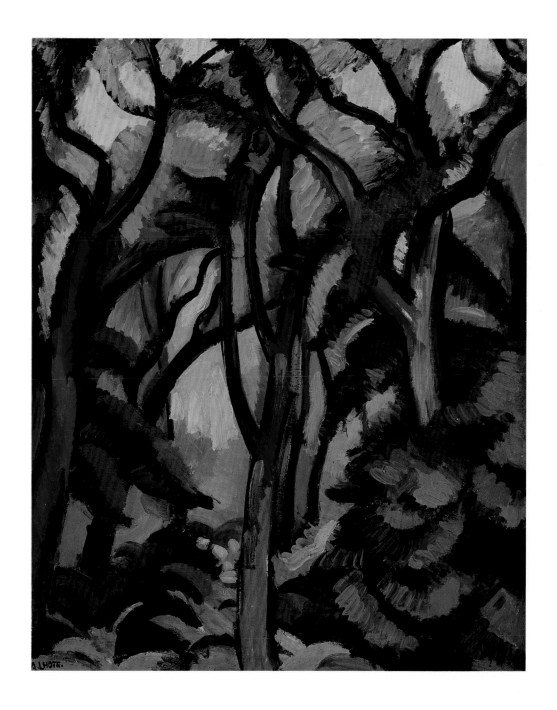

Plate VIII, *Canto Guerriero* (diptych)

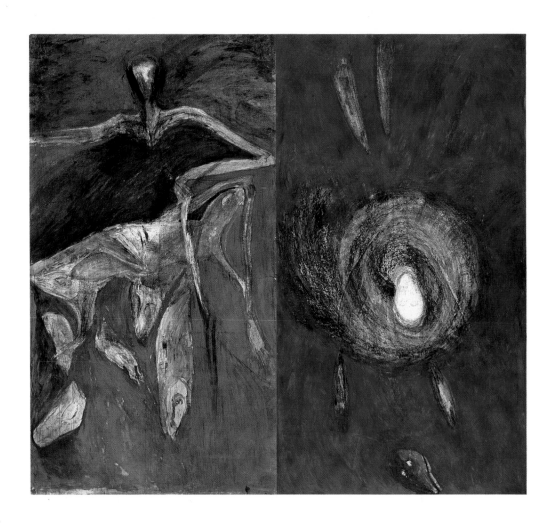

Notes to the Reader

This catalogue presents a necessarily highly selective overview of the Ball State University Museum of Art's resources in Western paintings and sculpture. Entries are arranged chronologically by date of execution; works without known dates are placed within approximate chronological sequence. Black and white illustrations accompany each entry with selected works illustrated in color immediately after Ned Griner's essay on the founding of the collection.

As this overview catalogue went to press, the Ball State University Museum of Art housed 9,127 works of art. Fewer than one hundred are included herein. Access to the museum's records for all 9,127 works and those that will enter the collection in future years is provided by the museum's Art Reference Terminal, currently installed in three places in the galleries. This on-line catalogue may also be accessed from remote sites world-wide through Internet. Persons interested in remote access to the museum's on-line catalogue should consult the museum staff for further information.

Following is a list of the typical categories of information included within the individual entries and their interpretation.

Artist's Name and Dates:

The name by which the artist is usually known is used in preference to abbreviated or alternative names. The date and place of the artist's birth and death are provided where known. Inevitably, dates and places are not always known. If a work is assigned to the school or studio of a specific artist, the master's date and place of birth and death are listed. Approximate dates and places are provided if the maker is unidentified.

Title:

The work bears its original title whenever it can be determined. Otherwise, preference is given to the title under which the work was first published. Additional titles by which the work has been known or published appear in parentheses below the title proper.

Date:

A single date indicates it was recorded by the artist on the work itself or is otherwise firmly documented. A date preceded by *circa* is one that has been established as accurately as is possible through circumstantial evidence. Whenever possible, bronzes are listed with both the date of execution of the model and the date of the bronze cast.

Medium and Support:

Unless noted otherwise, oils on canvas are stretched. Descriptions of supports include supplementary backings and linings added by restorers only when they have a noticeable effect on the present condition of the image.

Dimensions:

Measurements are given in centimeters followed by inches, height preceding width, which precedes depth. Sculpture is measured from the front or preferred viewing angle. Stretchers and panels are rectangular unless noted otherwise. Sculpture bases and frames are not included unless they are integral to the design of the work.

Donor or Fund and Accession Number:

If a donor financed the purchase of a work for the collection but did not own the work, the work will be listed as a gift of the donor but the donor's name will not appear within the work's provenance (see below). The first two numerical characters of the work's accession number indicate the year the work was acquired by or lent to the museum.

Essay and Sources:

Essays are intended to elucidate the work for the general reader through discussions focusing on subject matter, elements of the artist's biography, historical style, or a combination of these. The sources given immediately after the essay are the primary sources of the factual information contained therein and may serve as a guide for further reading on the artist. If a source also appears as a reference (see below), it is indicated with only the author's last name and the date of publication. The typographic ornament ❦ is used to separate the sources.

Inscriptions:

Signatures and inscriptions are transcribed as found on the work. Unless otherwise noted, there is no reason to believe that they are by the artist. Inscriptions and labels indicative of current ownership are not listed unless they include pertinent information. Within reason, monograms, ciphers, and idiosyncracies are noted. The use of a single virgule indicates a second line within the same inscription. The typographic ornament ❦ is used to separate the inscriptions.

Condition and Technique:

When the condition of a work has markedly affected its present appearance, a brief explanation has been supplied. When appropriate, additional notes on materials and technique are provided.

Provenance:

Each work's provenance lists its owners chronologically, with the years of acquisition when known. Probable but unsubstantiated owners are listed as such, and if appropriate an explanation is given. The earliest owner is listed first. The typographic ornament ❦ is used to separate the listed owners.

Exhibitions:

Exhibition histories refer specifically to the museum's piece and are as complete as possible. If a particular exhibition traveled, the additional venues are listed. Page and catalogue numbers are listed when they could be verified. If no catalogue was produced, this fact is noted. Exhibitions are listed chronologically. Though many institutions have changed their names over the years, preference has been given to the name of the institution at the time of the exhibition. The typographic ornament ❦ is used to separate the listed exhibitions.

References:

References are restricted to material of scholarly interest and are listed only when they specifically mention and/or reproduce the work. Exhibition catalogues are included only when they provide information beyond simple label copy for the work. Unpublished materials are listed as such. Spelling and usage errors in titles and quotations are transcribed as found and are not noted. References are listed chronologically. The typographic ornament ❦ is used to separate the listed references.

Selections from the Ball State University Museum of Art collection have appeared in two previously published checklists. These checklists are abbreviated in the references as follows:

Ball State, 1936 (Ball State Teachers College. *Catalogue of Paintings and Objects of Art from the Collection of Frank C. Ball*. Muncie: Ball State Teachers College, n.d., 1936.)

Ball State, 1947 (Ball State Teachers College. "Catalogue of Paintings, Sculpture, and Other Art Objects at Ball State Teachers College, Muncie, Indiana." *Ball State Teachers College Bulletin*, volume XXIII, number 1, September, 1947.)

Related Works:

Related works include studies for the specific work, versions of the work, and when appropriate, other pieces considered important to an understanding of the work. The list is not intended to be comprehensive, and no attempt has been made to list all such examples. Often the authors have not seen the works and have relied on published sources. The typographic ornament ❦ is used to separate the listed related works.

Remarks:

Where it seemed important to an understanding of the work and the documentation provided under provenance, exhibitions, references, and/or related works, the authors have included remarks to be considered in conjunction with the documentation. Although many of the questions that inevitably surfaced as research proceeded on the works included here were resolved, some resisted our best efforts. In such cases, the remarks provide a point of departure for further inquiry.

Catalogue of Paintings and Sculpture

Unidentified Maker

French (13th century)
active northeastern France, 13th century

Christ (?), circa 1225-1235

stone (limestone)
23.0 × 19.0 × 19.0 cm; 9¹⁄₁₆ × 7½ × 7½ inches

Anonymous gift in honor of David T. Owsley
93.024

Beneath a wrinkled brow, whose furrows are echoed in the channels of the hair and beard, eyes stare intently forward above prominent cheekbones and a slightly opened mouth. Having once topped a full-length figure, this stone head is a fragment from one of the many sculptures that decorated the entrance to a French Gothic cathedral. Thirteenth-century worshippers entering the cathedral passed beneath stone figures on either side of and above the doors. Gazing up, one could look into the faces of local saints, apostles, Old Testament kings, Christ, and the Virgin Mary. Lined faces with emphatically curling and waving hair, and piercing gazes—features like that of Muncie's head—met the stares of the faithful.

In the thirteenth century the role of large-scale sculpture was almost exclusively limited to that of embellishing the cathedral, the focus of town life. Inside, the structure was relatively austere, but outside, the façades and entrances became the site of rich decoration, most of it figurative. Flanking each door, wide jambs splayed out, forming walls that projected at an angle from the opening. These wide openings were decorated with rows of figures standing side by side. In the middle of the portal, the support between the two doors (the *trumeau*) also often bore a figure. This head may have once capped a figure from a portal, trumeau, or other portion of the cathedral in the destroyed town of Thérouanne.

In the thirteenth century, masons working in the Northeastern French town of Thérouanne were busy with the sculptural decoration for its cathedral. Three hundred years later, in June, 1553, Emperor Charles the Fifth of Austria, because of its French military post, bombarded the town and ordered demolition workers to dismantle the cathedral and all other buildings in the town stone by stone.

Members of the clergy in the nearby town of Saint-Omer requested that they be allowed to take some of Thérouanne's cathedral sculpture to decorate their church. Later that summer the transfer was made and today in the church at Saint-Omer figures of Christ, the Virgin Mary, and John the Evangelist from Thérouanne are still displayed inside the church. The head of the Thérouanne/Saint-Omer figure of Christ bears a striking resemblance to Muncie's head, suggesting a shared origin.

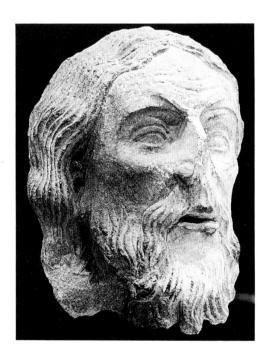

For the faithful, the elaborate sculptural embellishments of the cathedral entrances provided theological education. Together, the sculptures on either side of the door, above the door, and in the galleries on the upper stories of the façade formed a complicated symbolic program dictated by the resident theologians. Today, scholars believe that the sculptures of the doorways usually referred to Old Testament characters and events that prefigured persons and events from the New Testament. (Thus the story of the prophet Jonah's three days in the belly of the whale prefigured the three days between Christ's entombment and resurrection.) Above the main door these Old Testament precursors and prefigurations usually ended with the image of Christ, and the Virgin Mary typically figured prominently in one of the adjacent entryways.

SOURCES

Davezac, Bertrand, "Monumental Head from Thérouanne Cathedral." *The Bulletin of the Museum of Fine Arts, Houston* n.s. 8, number 2, Winter, 1983, pages 11-23. ❦ Duby, Georges, Xavier Barral i Altet, and Sophie Guillot de Duduiraut. *Sculpture: The Great Art of the Middle Ages from the Fifth to the Fifteenth Century*. Trans. Michael Heron. Geneva: Skira, 1990; New York: Rizzoli, 1990. ❦ Sauerlander, Willibald. *Gothic Sculpture in France 1140-1270*. Trans. Janet Sondheimer. New York: Abrams, 1972. ❦ Wixom, William. "Eleven Additions to the Sculpture Collection," *The Bulletin of the Cleveland Museum of Art*, number 66, March-April, 1979, pages 96-100, 145-146.

CONDITION and TECHNIQUE

The nose is broken and was once reconstructed. There are small losses and abrasions overall. Before cleaning, there were black accretions on the highlights and other areas. Conserved, 1993, Intermuseum Conservation Association, Oberlin, Ohio.

PROVENANCE

Probably Cathédrale de Thérouanne, Thérouanne, France; ❦ probably Saint-Omer, France, 1553; ❦ Dikran Kahn Kelekian, New York, New York; ❦ Paul F. Grigaut, Detroit, Michigan; ❦ J. Karel Weist, Detroit, Michigan, 1962; ❦ private collection, 1981.

RELATED WORKS

Unidentified maker. *Christ as Judge with Mary and Saint John*, circa 1230-1235, limestone, larger than life size, originally Cathédrale de Thérouanne, Thérouanne, France, removed in 1553 to Saint-Omer, France.

Unidentified maker. *Christ (Beau Dieu)*, *trumeau* figure, circa 1220-1225, limestone, larger-than-life-size, Amiens Cathedral, Amiens, France.

Unidentified maker. *Monumental Heads* (five ranging from 35 to 45cm high), circa 1235, limestone, said to be originally from Cathédrale de Thérouanne but doubtful. Today in the Museum of Fine Arts, Houston, Texas; Cleveland Museum of Art, Cleveland, Ohio, (two); Victoria and Albert Museum, London, England; private collection on loan to the Metropolitan Museum of Art, New York, New York.

Unidentified maker. *Roi de Juda* (head number 21), circa 1220-1230, limestone, larger-than-life-size, originally Gallery of Kings, Notre Dame de Paris, today Musée Cluny, Paris, France.

Unidentified Maker

Spanish (13th century)
active Catalan, Northern Spain, 13th century

Christ, circa 1225-1250

wood (linden or limewood), paint (tempera, oil?), metal (iron, gilt)
174.0 × 191.7 × 39.3 cm; 68 ½ × 75 ½ × 15 ½ inches

Given in loving memory of Lucy Ball Owsley by her son David T. Owsley
91.005

Prominent ribs, gory rivulets of blood, and a drooping lifeless head characterize this sculpture of Christ and emphasize his physical suffering during the crucifixion. Dating to the thirteenth century, this work comes from a time when the faithful participated in devotions that centered on visualizing the death of Christ during their meditations. Images like this would no doubt

have enhanced the practice of vividly calling to mind Christ's suffering.

Although works emphasizing Christ's suffering appeared as early as the tenth century, before the twelfth century sculptors also made images of the crucifixion that showed Christ in majesty, wearing a regal crown, his eyes open, often seeming to stand or hover before the cross. By the thirteenth century, when this figure was carved, sculptures emphasizing Christ's suffering became the norm. In this work, a crown of thorns once encircled the head (the small holes in the figure's hair are evidence of the crown), his eyes are shut, and his legs bend stiffly and awkwardly—all typical characteristics of sculpture of the thirteenth century.

As the collection's only large-scale sculpture from the middle ages, this work occupies a prominent place. Representative of the Romanesque period (named in the nineteenth century for the "Roman-like" appearance of the round arches that characterize the era's architecture), this sculpture dates to the very end of the era. During the Romanesque period, full-scale sculpture in the round appeared in Europe for the first time since the fall of the Roman empire.

The Romanesque era, roughly A.D. 1000 to 1200, witnessed a florescence of church building as the faithful grew in numbers and travelled widely, visiting sites with the most important saints' relics. With the rise in church building, sculptors were put to work carving stone and wood to adorn exteriors and interiors of the new, grandiose cathedrals.

Made of wood, yet nearly intact, with the exception of the missing toes and index fingers, this work must have come from inside a church. Figures of the crucified Christ were often accompanied by additional figures, such as the Virgin Mary and John the Evangelist, and crowned the large rood screens that separated the part of the church for the laity from the part for the clergy. Some churches in Spain (this figure's country of origin) also featured above the main altar life-size sculptural groups depicting the deposition of Christ. To judge from the good condition of its relatively fragile material, this sculpture probably came from an interior rood-screen or high altar group.

The gory drops of blood exuding from the wounds on Christ's torso, arms, and knees are not original. Conservators believe the painted blood, as well as the blue and white decoration of the loincloth, date to the nineteenth century. Above the figure's right knee, remnants of reddish pigment, the underlayer for gold leaf, may be from the original paint layer. The torso and legs were carved of a single piece of wood, and the arms and head were originally attached with large, hand-wrought nails.

SOURCES
Porter, Arthur Kingsley. *Spanish Romanesque Sculpture*. New York: Hacker Art Books, 1969. ❦ Schiller, Gertrud. *Iconography of Christian Art*. volume 2, *The Passion of Jesus Christ*. Trans. Janet Seligman. Greenwich, Connecticut: New York Graphic Society Ltd., 1972.

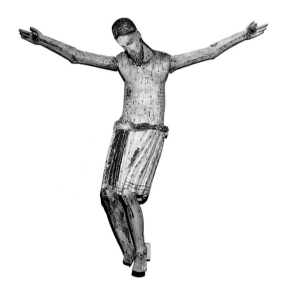

CONDITION and TECHNIQUE
The wood is in a remarkably good state of preservation. Losses are limited to the fingers, toes, beard, and drapery fold. Original paint is preserved below the later visible paint layers, and some original paint is exposed on the loincloth. The body is carved from one piece of timber, and the back is crudely hollowed out. The neck and head are attached with two large wrought-iron nails and appear to be the original means of attachment. The two arms, originally attached with nails, have been drilled and are attached with wooden dowels. The original wrought-iron hook for attachment to a support extends approximately two inches from the center of the waist. The lowest layers of paint include a resinous red (possibly Dragon's Blood) over metallic leaf, charcoal blacks, lead white, and cinnabar iron oxide. Conserved (consolidated), 1984, Intermuseum Conservation Association, Oberlin, Ohio.

PROVENANCE
Herbert P. Weissberger, Madrid, Spain; ❦ David T. Owsley, New York, New York, 1984.

REFERENCES
(Former accession number: L84.008.2.) ❦ New York, Sotheby's. *Important European Works of Art, Armor, Tapestries, and Furniture.* March 2, 1984, lot number 8, illustrated.

RELATED WORKS
Unidentified maker, Spanish, *Corpus of Christ*, 13th century, wood, life-size, The Art Institute of Chicago, Chicago, Illinois.

Unidentified maker, Spanish, *Christ from a Deposition Group*, second half of the 12th century, wood, 122 × 95 cm, Isabella Stewart Gardner Museum, Boston, Massachusetts.

REMARKS
Note regarding provenance: A significant portion of the Herbert P. Weissberger collection, known as the Almoneda Collection, was sold in an American Art Association auction, April 26-30, 1921. The Muncie sculpture was not among the works sold. The collection was formed largely by Herbert P. Weissberger with the participation of his brother. Many of the eighteenth-century works in the collection were inherited from his father.

Unidentified Maker

French (14th century)
active Isle de France, France, 14th century

Head of the Virgin, circa 1330–1350

stone (limestone), traces of metal (gilt), traces of paint
20.0 × 14.0 × 14.0 cm; 7⅞ × 5½ × 5½ inches

Museum purchase, Museum of Art Alliance Fund
86.005

PROVENANCE
Gwynne M. Andrews; ❦ Gwynne M. Andrews estate; ❦ The Metropolitan Museum of Art, Gwynne M. Andrews Collection, New York, New York, 1931 (deaccessioned, June 11, 1984); ❦ Royal Athena Galleries, Beverly Hills, California, and New York, New York.

REFERENCES
Royal Athena Galleries. *Art of the Ancient World, VI.* New York: Royal Athena Galleries, 1985, page 124, catalogue number 379. ❦ Millard, Nancy. "Ball State Gallery Acquires *Head of the Virgin.*" *Muncie Star*, Sunday March 30, 1986.

REMARKS
The Muncie head probably derives from a half-life-size statue of the Madonna and Child.

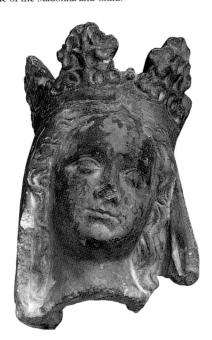

Master of the Bracciolini Chapel

Italian (14th-15th century)
active Pistoia, Tuscany, Italy, late 14th-early 15th century

Coronation of the Virgin, circa 1380-1400

tempera, metal (gilt) on panel (poplar?, cradled)
109.3 × 61.1 cm; 43⅛₆ × 24⅛₆ inches

Gift of Mr. and Mrs. William H. Thompson
40.033

INSCRIPTIONS
Labels, etc: bears a cream paper Luigi Grassi & Sons, Paintings by Old Masters, 94 Via Cavour, Florence label, cradle, upper center.

CONDITION and TECHNIQUE
The ground and paint layers are generally secure. There is minor inpainting overall. The varnish is matte. The losses to the bottom right angel are extensive. The tooled gold

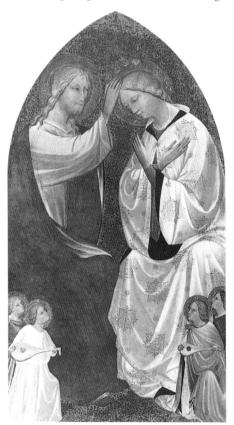

background is rubbed. The upper paint layers on Christ's robe are largely gone. Conserved, 1969-1970, Alfred Jakstas, Art Institute of Chicago, Chicago, Illinois.

PROVENANCE
Possibly Sansedoni family, Siena, Italy, since the eighteenth century; ❦ Arturo Grassi, Florence, Italy; ❦ Mr. and Mrs. William H. Thompson, Indianapolis, Indiana, December, 1939.

REFERENCES
(Former accession number: 000.467.) ❦ Peat, Wilbur D. "Italian Paintings in the W.H. Thompson Collection at Muncie, Indiana." *The Art Quarterly*, Autumn 1941, pages 259-260, illustrated page 263, as Giovanni del Biondo. ❦ Ball State, 1947, page 4, as Giovanni del Bionde. ❦ Berenson, Bernard. *Italian Pictures of the Renaissance: A List of the Principal Artists and Their Works with an Index of Places, Florentine School*. London: Phaidon Press, Inc., 1963, volume I, page 86, volume II, page 25, as Giovanni del Biondo. ❦ Unpublished letter from Dr. Miklos Boskovits, Istituto di Storia dell'Arte, Universita degli Studi, Bologna, Italy, dated Bologna, November 17, 1969, suggesting an attribution to Carlo da Camerino. ❦ Fredericksen, Burton B., and Federico Zeri. *Census of Pre-Nineteenth Century Italian Paintings in North American Collections*. Cambridge, Massachusetts: Harvard University Press, 1972, page 126, as Master of the Bracciolini Chapel. ❦ Brown, Howard Mayer. "A Corpus of Trecento Pictures with Musical Subject Matter." *Imago Musicae*, 1985, page 262, illustrated page 263, as Master of the Bracciolini Chapel. ❦ Marchi, Andrea G. De. "Il Maestro della Cappella Bracciolini e l'avvio del tardogotico a Pistoia," *Estratto da Storia dell'Arte*, number 74, 1992, pages 6, 12, 23, as Master of the Bracciolini Chapel.

RELATED WORKS
Master of the Bracciolini Chapel. *L'Incoronazione della Vergine*. (Brunetti, Givlia "Gli affreschi della Cappella Bracciolini in San Francesco a Pistoia," *Rivista D'Arte*, volume 17, 1935, page 243, figure 9.)

Master of the Bracciolini Chapel. *Madonna and Child Enthroned Surrounded by Four Saints*, circa 1380-1400, tempera on panel, 100.4 × 51.2 cm, The Denver Art Museum, Denver, Colorado.

REMARKS
Art historians have assigned the designation "Master of the Bracciolini Chapel" to the unnamed artistic personality who painted the Bracciolini Chapel in the Church of S. Francesco, Pistoia, Italy.

Unidentified Maker, Vignory workshop

French or Flemish (15th century)
active Vignory area, Marne to Northern Lotharingia
(Lorraine), France, early 15th century

Crucifixion with Mary and Saint John,
circa 1400–1430

stone (limestone)
59.6 × 36.7 × 15.8 cm; 23½ × 14½ × 6¼ inches

Gift of the Ball State University Foundation on the
occasion of the seventy-fifth anniversary of Ball State
University
93.029.2

NSCRIPTIONS
Inscribed in brown ink, right side, bottom: 36812.

Labels, etc.: bears a small white paper label, right side,
center, inscribed in green pen: 336; ❦ and square white
paper Bob Jones University Collection, Greenville, South
Carolina label, inscribed in black ink: S138.

PROVENANCE
Larcade Collection, Paris, France; ❦ Blumka Gallery, New
York, New York.

EXHIBITIONS
Greenville, South Carolina, Bob Jones University Art Gallery
and Museum, before 1965.

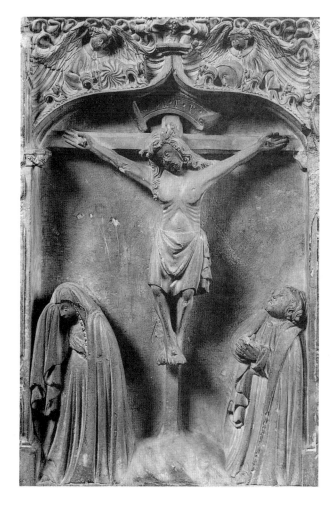

Unidentified Maker, circle of Anton Pilgrim, Austrian (circa 1460–1515)

Austrian (15th-16th century)
active South Germany or Austria, late 15th-early 16th century

Saint Wolfgang, circa 1480-1510

stone (limestone), paint (polychrome)
94.6 × 37.0 × 25.4 cm; 37¼ × 14⅝ × 10 inches

Gift of David and Nancy Galliher in honor of Nancy Huth and Alain Joyaux
92.038.04

With its downcast eyes and head inclined slightly toward us, this figure of Saint Wolfgang projects an aura of melancholy serenity and serves as an excellent example of late Gothic sculpture from Austria.

Sculptural representation from the Gothic period is particularly important, for it was in the Middle Ages that a rise in church building occasioned an outpouring of carving. Along with small-scale works of art, such as illuminated manuscripts and altar furnishings, sculpture for architectural settings was one of the Gothic artist's major means of expression. Along with the life-size figure of Christ (see entry), representing the sculpture of the earlier Romanesque era, the Gothic *Saint Wolfgang* provides an example of stylistic trends in the later Middle ages.

By the end of the fifteenth century, when this work was made, the Gothic style in northern Europe had developed into a mode characterized by a striking realism of parts. With its deeply etched features surrounded by thick curls, the saint's face is almost portrait-like. One expressively bony hand clutches a staff, visually setting off a tumble of heavy drapery that falls in a bulky swirl around the saint's body. Additional heavy folds surround the figure's feet. Along

with the convincing bulk of the figure, the naturalistic carving of the face and hair give *Saint Wolfgang* an exceptional liveliness and strength of presence typical of late Gothic sculpture.

Tucked beneath the drapery along the saint's right leg sits a model of a church. According to his legend, Wolfgang, a tenth-century bishop, single-handedly built a church in the Austrian alps. As a reminder of this feat, he is shown either holding a model of a church or standing beside one, as in this example. He also holds a carpenter's hatchet, a further reference to the church construction and to the legend that he threw his hatchet to determine where to build his church. Revered primarily in the German-speaking countries—the land where he built his church—Wolfgang is the patron saint of carpenters and butchers. Suitable to his station within the Church, he wears a bishop's miter and holds a staff that at one time bore a cross (probably the two-crossbar form carried by bishops) or a carved curl, making the staff a crosier (also associated with bishops).

Aside from the missing cross or crosier and chipped right hand, the sculpture is in excellent condition. Historically, most sculpture was painted, and *Saint Wolfgang* retains an exceptional amount of the original paint. Although the figure is finished on all sides, the relative flatness of his back suggests that he was originally placed in a shallow niche.

SOURCES
Reau, Louis. *Iconographie de l'art chrétien.* Tome 3, *Iconographie des saints.* Paris: Presses Universitaires de France, 1955-1959.

CONDITION and TECHNIQUE
The piece was cleaned and consolidated before its acquisition. Substantial original paint is present. The staff in the figure's left hand was apparently a bishop's cross or crosier. The top of the staff is broken off just above the carved depiction of the textile sack that could be raised to cover and protect the decorative top section.

PROVENANCE
Private collection, America, before 1965; ❦ Blumka II Gallery, New York, New York.

EXHIBITIONS
Muncie, Ball State University Museum of Art. *Objects of Desire: A Vision for the Future.* October 11–November 8, 1992, no catalogue.

RELATED WORKS
Unidentified maker, circle of Anton Pilgrim. *Saint Florian,* circa 1480-1510, painted limestone, 87-cm-high, former collection Blumka II Gallery, now in private collection, Switzerland. This and the Muncie work are by the same hand and were acquired from the same private American collection.

Michael Pacher. *High Altar* (or *Saint Wolfgang Altar*), begun 1471, completed 1481, Saint Wolfgang Parish Church, Saint Wolfgang, Austria.

see color plate I

Giovanni Bellini and Studio

Italian (circa 1430-1516)
born Venice or Padua, Italy, circa 1430
died Venice, Italy, November 29, 1516

Madonna che tiene il Bambino in piedi, circa 1489–1490
(*Madonna and Child*)

paint (oil) on panel (poplar?, cradled)
66.0 × 52.7 cm; 26 × 20¾ inches

Permanent loan from the E. Arthur Ball Collection, Ball Brothers Foundation
L51.198

INSCRIPTIONS
Recto: signed in white oil paint, lower right: Zuan Bellino.

Verso: inscribed in black felt pen, center: 17083; ❦ and in black felt pen, upper center: F17083; ❦ and in pencil, upper center: New York.

Labels, etc.: bears blue-bordered white paper label, upper left, inscribed: 774d; ❦ and red-bordered white paper label, upper left, inscribed: N.Y. 178; ❦ and red paper label, center, inscribed: Rep-23.

CONDITION and TECHNIQUE
The panel is cradled and all cradle members are locked. There is related tenting (past and recent) in the paint and ground layers. There are several generations of old restorations (estimate 30 percent of Virgin's face and 40 percent of Child's face) and multiple layers of discolored varnish. X-rays reveal compositional changes including the sleeve of the Virgin's cloak, her left arm, her left hand, the child's right arm, and the flowers the child suspends from his right hand (see remarks). The sky is natural ultramarine mixed with white lead; the upper layer is of large and small particles of ultramarine with white lead, the lower layer is of lesser ultramarine mixed with white lead. The Virgin's robe is also natural ultramarine. In the Virgin's headdress, light passages are painted in white lead and dark areas have been executed with paint that is slightly more opaque. The mid-tone white is thinly painted, allowing the ground to show through. Conserved (minor surface cleaning), 1970, Alfred Jakstas, Art Institute of Chicago, Chicago, Illinois.

PROVENANCE
Comtesse Ducrocq, France; ❦ Wildenstein and Company Galleries, Paris, France, and New York, New York, by 1928; ❦ E. Arthur Ball, Muncie, Indiana; ❦ Ball Brothers Foundation, Muncie, Indiana, 1950.

EXHIBITIONS
Muncie, Ball State Teachers College Art Gallery. *Beneficence Continues: Paintings from the E. Arthur Ball Collection.* March 18-?, 1951, page 5, catalogue number 6.

REFERENCES
(Former accession number: AC-51-198.) ❦ Unpublished authentication by Bernard Berenson dated June 1, 1928, as Giovanni Bellini painted about 1490. ❦ Gronau, Georg. *Giovanni Bellini, Des Meisters Gemalde.* Stuttgart and Berlin: Deutsche Verlags-Anstalt, 1930, page 209, catalogue number 110; 4, as copy after Giovanni Bellini. ❦ Morse, John D. *Old Masters in America.* Chicago: Rand McNally, n.d. (1955), page 14. ❦ Heinemann, Fritz. *Giovanni Bellini e i Belliniani.* Venice: Neri Pozza, n.d. (1962), catalogue numbers 36 and 36h, as probably a school copy after the Glasgow version. ❦ Frederickson, Burton B., and Federico Zeri. *Census of Pre-Nineteenth-Century Italian Paintings in North American Collections.* Cambridge, Massachusetts, Harvard University Press, 1972, page 22 and 598, as school, shop, or studio of Giovanni Bellini. ❦ Hamilton, Vivien. "A Study on the Madonna and Child by Giovanni Bellini in the Burrel Collection," The Burrel Collection, Glasgow Museum

and Art Galleries. November, 1987 (typewritten), pages 18–19 and 38, as studio copy after the Glasgow version.

RELATED WORKS

Giovanni Bellini (and Studio?). *Madonna che tiene il Bambino in piedi*, circa 1489-1490, oil on panel, 62 × 47.6 cm, The Burrell Collection, Glasgow Museum and Art Galleries, Glasgow, Scotland.

REMARKS

The relationship between the Muncie and Glasgow paintings remains unresolved. Heinmann (1962) accepts the Glasgow painting as the original though notes that his judgement is based solely on photographs of the Muncie Painting. Berenson (1928), however, accepts the Muncie painting as the original. Infrared photographs and x-rays made in the mid-1980s reveal information not available to these earlier scholars that is vital to this dispute. Both the infrared photographs and x-rays of the Muncie painting indicate a number of alterations in the composition which make it unlikely that the Muncie painting was executed after the Glasgow version. In addition to the minor alterations noted under condition, a cluster of berries and leaves was once suspended from the string in the Child's hand approximately 15 cm above the Virgin's hand. The cluster of berries and leaves was subsequently painted out and replaced by the present cluster of flowers. Unfortunately, it has not been possible to compare the infrared photographs and x-rays of the Muncie painting to similar documentation on the Glasgow version.

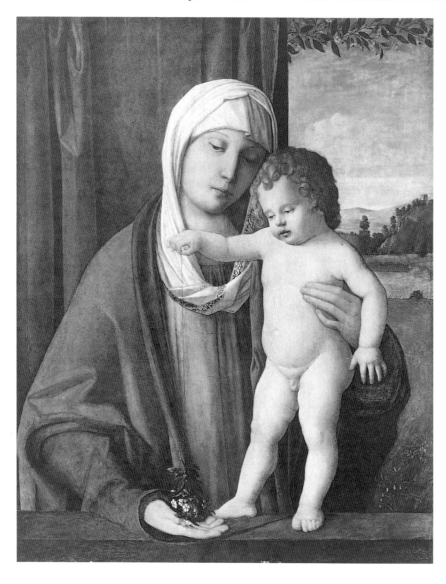

Benvenuto di Giovanni

Italian (1436-1509/1517)
born Siena, Italy, September 13, 1436
died Italy, 1509 or 1517

and

Girolamo di Benvenuto

Italian (1470-1524)
born Siena, Italy, 1470
died Siena, Italy, 1524

Saint John the Evangelist in a Vat of Boiling Oil (a predella panel), circa 1490–1500

paint (tempera) on panel (poplar?)
22.3 × 57.1 cm; 8⅜ × 22½ inches

Lent by David T. Owsley
L93.007.2

INSCRIPTIONS
Verso: inscribed in pencil, in an old hand, panel, center, lower left: Del Bugiardina.

Labels, etc.: bears red wax seal, panel, verso, center left, with an indecipherable coat of arms; ✌ and green-bordered white paper Royer Emballeur d'Objets et Art label, frame, upper member (now in object file).

CONDITION and TECHNIQUE
The left and right panel edges are original, the top and bottom edges are probably original (each now with a 1-cm-wide wood strip added). Though there are minor losses and associated inpainting, the paint surface and panel are in excellent condition.

PROVENANCE
David T. Owsley, New York, New York, 1993.

REFERENCES
New York, Christie's. *Important Old Master Paintings.* January 14, 1993, lot number 125, illustrated in color.

RELATED WORKS
Benvenuto di Giovanni and Girolamo di Benvenuto. *The Virgin and Child Enthroned with Saints Augustine, Nicholas of Tolentino, Monica, and John the Evangelist,* circa 1490-1500, tempera on panel transferred to canvas, 185.5 × 231 cm, Harvard University Art Museums, Cambridge, Massachusetts.

REMARKS
It has been suggested that the Muncie panel may once have been a predella panel from the altarpiece formerly in the Church of S. Agostino, Acquapendente, Italy, and now in the Harvard University Art Museums (see related works).

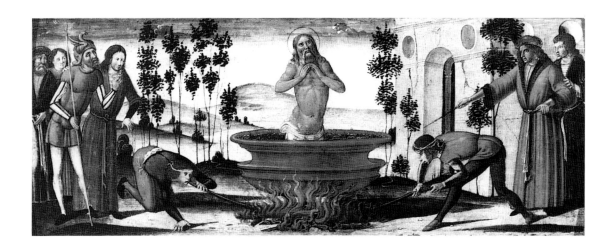

Studio of Benedetto da Maiano (or Benedetto di Leonardo)

Italian (1442-1497)
born Florence, Italy, 1442
died Florence, Italy, 1497

Virgin and Child with Saint John the Baptist (the lunette depicting *God the Father*), circa 1491-1497

stucco, wood, paint (polychrome, oil)
106.5 × 65.3 × 12.7 cm; 42 × 25¾ × 5 inches

Gift of Mr. and Mrs. William H. Thompson
40.019

CONDITION and TECHNIQUE
This piece is made essentially of three components: a polychrome stucco relief panel, a small painted lunette panel, and an arched tabernacle-style frame. The stucco relief panel measures 67 × 46 cm and includes the Virgin and Child and John the Baptist with two cherubs above and a lower section with a large cherub head. The stucco panel appears to be a single molded piece. The wooden panel measures approximately 46 × 23 cm and is an integral part of the frame. The frame is made of fifteen separate pieces of wood (including the lunette panel). The cresting molding at the top of the frame is now missing. The polychrome layer on the stucco panel has been extensively abraded, and examination suggests multiple layers of paint on some areas. The paint layer on the lunette is in good condition.

PROVENANCE
Arturo Grassi, Florence, Italy; ❧ Mr. and Mrs. William H. Thompson, Indianapolis, Indiana, November or December, 1931.

REFERENCES
(Former accession number: CD-40-4.) ❧ Peat, Wilbur D. "Italian Paintings in the W.H. Thompson Collection at Muncie, Indiana." *The Art Quarterly*, Autumn 1941, page 259, as Benedetto da Maiano. ❧ Ball State, 1947, page 27, as Benedetto da Maiano.

REMARKS
Multiple versions of this relief exist, in both stucco and terra cotta and varying in quality and decorative details. Some examples include the large cherub head in the lower register, some include plant-like decoration, and some have no lower register. (Kaiser Friedrich Museum, Berlin; Delmar Collection, Budapest; Victoria and Albert Museum, London, etc.) The design is by Benedetto da Maiano. Whether the stucco and terra cotta versions derive from a lost marble prototype is unknown. (Pope-Hennessy, John. *Catalogue of Italian Sculpture in the Victoria and Albert Museum*. London: Her Majesty's Stationery Office, 1964, volume I, pages 161-162, volume III, pages 118-119.)

Bartolomeo di Giovanni (1442-1497?) may have painted the stucco relief and the lunette of *God the Father*. Though not of high quality, the frame may have been executed by the workshop of the architect Guiliano da Maiano, Benedetto's eldest brother. (Radcliffe, Anthony, Malcom Baker, and Michael Maek-Gerard. *The Thyssen-Bornemisza Collection: Renaissance and Later Sculpture*. London: Sotheby's Publications, 1992. Radcliffe, Anthony. "Multiple Production in the Fifteenth Century: Florentine Stucco Madonnas and the Della Robbia Workshop.")

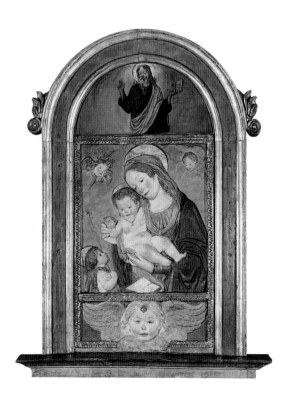

School of Lorenzo di Credi, probably "Tommaso"

Italian (1459?-1537)
born Florence, Italy, 1459?
died Florence, Italy, 1537

Madonna and Child, circa 1494

paint (oil or transitional tempera and oil technique)
on panel (poplar?, balsa wood panel)
60.5 × 48.7 cm; 23⅞ × 19³⁄₁₆ inches

Gift of Mr. and Mrs. William H. Thompson
40.015

Before a crystalline landscape background a young woman regards the squirming infant in her lap. Like a multitude of Renaissance paintings, this work shows the Virgin Mary (the "Madonna"—Italian for "my lady") holding the Christ child. Emphasizing Mary's role as the mother of Christ, these images also refer symbolically to the Incarnation (or the Word made flesh). The many Renaissance representations of the Madonna and Child that survive today attest to the image's power as a devotional aid.

Because of their popularity in Renaissance Italy, images of the Madonna and Child were a common production of artists' workshops. In the Renaissance and for centuries beyond, master artists had large workshops employing several apprentices and assistants. The workshop system provided young artists with training and master artists with assistants. Members of a workshop were trained to paint in the style of the master so that the entire crew could undertake large commissions that, when finished, appeared to have been painted by one person. Production of smaller works like this one was frequently left to assistants who would follow designs by the master artist.

Lorenzo di Credi, who in his apprenticeship years had worked alongside Leonardo da Vinci, later operated a bustling workshop in Florence. There a large and fluctuating population of assistants produced myriad Madonna and Child images. Scholars note, however, that their works cannot be unquestionably identified, since the contract initiating a painting typically would have named only the master artist.

Like many artists trained in the tradition of fifteenth-century Florentine painting, di Credi and his assistants took special care with drawing and the rendering of bodily structure. To articulate the figures' anatomy, the author of this panel makes the pair appear three-dimensional with subtle gradations of light and shadow. Crisp outlines define the shapes of the two figures and the landscape behind them. Clear yellows and blues, typical of Florentine painting, fill the scene.

SOURCES
Brewers, Robert. *A Study of Lorenzo di Credi.* Florence: tipografia giuntina, 1970. ❦ Zeri, Federico. *Italian Paintings in the Walters Art Gallery.* Baltimore: Walters Art Gallery, 1976.

INSCRIPTIONS
Labels, etc.: bears cream paper Luigi Grassi and Sons, Paintings by Old Masters, 88 Via Cavour, Florence, label, frame, upper member.

CONDITION and TECHNIQUE
The panel consists of two members, probably poplar, quarter cut. The vertical join is in the middle of the panel. At some point in its history, the verso was planed down and a cradle added. The paint layer may be oil or a transitional technique between tempera and oil. The blue of the Madonna's robe is natural ultramarine with a slight addition of azurite. The condition of the paint layer is exceptionally good. The 1965 conservation treatment included removal of the cradle and its replacement with a balsawood and wax-resin cement auxiliary support. Conserved, 1965, Intermuseum Conservation Association, Oberlin, Ohio.

PROVENANCE
Aimé-Charles-Horace His de la Salle (1795-1878), Paris, France, probably acquired in Italy, circa 1826-1830; ❦ Baron M.A. Lazzaroni, Rome, Italy; ❦ Luigi Grassi and Sons, Florence, Italy; ❦ John Levy Galleries, New York, New York, by December, 1931; ❦ Mr. and Mrs. William H. Thompson, Indianapolis, Indiana, May, 1934.

EXHIBITIONS
Detroit, Detroit Institute of Arts. *The Sixteenth Loan Exhibition of Old Masters: Italian Paintings of the XIV to XVI Century.* March 8-30, 1933, catalogue number 33. ❦ Grand Rapids, Michigan, Grand Rapids Art Museum. *University Art Museums of the Month Program.* December 2-31, 1962, no catalogue. ❦ Huntington, New York, Heckscher Museum. *Salute to Small Museums.* May 8-June 21, 1970, page 28, catalogue number 13, illustrated in color, page 29. ❦ Tulsa, Oklahoma, Philbrook Art Center. *Gloria Dell'Arte: A Renaissance Perspective.* October 28, 1979-January 27, 1980, catalogue number 142.

REFERENCES
(Former accession numbers: AC-171 and 000.354.) ❦ Unpublished authentication by Adolfo Venturi dated Paris, France, May 25, 1931, as Lorenzo di Credi. ❦ John Levy Galleries. *Madonna and Child by Lorenzo Di Credi.* New York: privately printed, circa 1934, includes an English translation of Venturi's authentication. ❦ Peat, Wilbur D. "Italian Paintings in the W.H. Thompson Collection at Muncie, Indiana." *The Art Quarterly*, Autumn 1941, pages 265-266, illustrated page 264, as Lorenzo di Credi. ❦ Ball State, 1947, page 8, as Lorenzo di Credi. ❦ Berenson, Bernard. *Italian Pictures of the Renaissance: A List of the Principal Artists and Their Works with an Index of Places, Florentine School.* London: Phaidon Press, 1963, volume I, page 116, volume II, page 25, as Lorenzo di Credi. ❦ Fredericksen, Burton B., and Federico Zeri. *Census of Pre-Nineteenth Century Italian Paintings in North American Collections.* Cambridge, Massachusetts: Harvard University Press, 1972, page 110, as school, shop, or studio of Lorenzo di Credi. ❦ Unpublished letter from Everett Fahy dated New York, February 15, 1978, suggesting an attribution to "Tommaso."

REMARKS
The Muncie painting was probably executed by "Tommaso," who may actually be Giovanni Cianfanini (1462-1542). In 1890 Giovanni Morelli first suggested assigning a group of paintings attributed to Lorenzo di Credi to a distinct artist he named "Tommaso." Concerned that this designation would lead to confusion with Tommaso di Stefano, an entirely different artist, in 1938 Bernard

Berenson accepted the assigned name with reservations, suggesting Morelli's "Tommaso" might actually be the Giovanni Cianfanini mentioned by Giorgio Vasari (1511-1574) in his *Lives.*

The 1966 catalogue of the Samuel H. Kress Collection, Brooks Memorial Art Gallery, Memphis, Tennessee, proposed renaming Morelli's "Tommaso" the Master of the Tondi and noted that Berenson listed fifteen tondi by Tommaso, with the Brooks Memorial Art Gallery Kress Collection tondo increasing the number to sixteen.

see color plate II

Studio of Bernardino Luini (or Lovino or del Lupino)

Italian (circa 1475-1532)
born Luino, Italy, circa 1475
died Italy, 1532

Salome, circa 1525-1530

paint (oil, tempera?) on canvas
44.1 × 35.3 cm; 17⅜ × 13⅞ inches

Gift of Mr. and Mrs. William H. Thompson
40.032

Beneath an elaborately braided coiffure, a beautiful young woman averts her gaze from some distasteful subject. On the left, an older woman with a prominent nose peers over the girl's shoulder; and on the right, two rounded, cropped forms intrude into this sedate but mysterious scene.

Salome was the biblical young woman whose dance before Herod so pleased him that he offered her anything she wanted. Under direction from her mother Herodias (associated with the woman on the left), Salome asked for the head of John the Baptist, who had been decrying Herod and Herodias's marriage as

unlawful. (According to medieval versions of the story, Heriodius had been the wife of Herod's brother, Philip. Herod stole her from Philip, taking her as his own spouse.)

Now reduced by nearly half its width, the painting originally included an executioner (a portion of his forearm is still visible), clutching the Baptist's severed head by a lock of hair, and dangling it above a salver (a flat serving tray mounted on a foot) that Salome touches with just the tips of her white fingers. Conservators believe the painting was cut down in the nineteenth century, and the remaining offending bits of this gruesome subject painted over.

In his home city of Milan, Bernardino Luini had become interested in the work of Leonardo da Vinci during Leonardo's lengthy stay there. While in Milan, Leonardo not only painted the *Last Supper*, but he attracted many followers with his new style. Leonardo had developed a smoky, soft modelling (called *sfumato*) that dissolves edges in shadow rather than sharply defining them. Although trained in a more rigid manner, Luini adopted Leonardo's *sfumato* and the dark backgrounds Leonardo often employed in portraits. In painting Salome's face, Luini superficially followed Leonardo's softened manner, but the work does not necessarily demonstrate a concern for what Leonardo called "the intention of [the] soul"—what we understand as psychological expression. Steeped in a more conservative tradition, Luini seems to have been primarily interested in a clear telling of the story.

SOURCES
Cleveland Museum of Art. *European Paintings of the 16th, 17th, and 18th Centuries, The Cleveland Museum of Art Catalogue Series, Catalogue of Paintings,* pt. 3. Cleveland: The Cleveland Museum of Art, 1982. ❦ Freedberg, S.J. *Painting in Italy 1500-1600.* Second edition, *Pelican History of Art.* New York: Penguin Books Ltd., 1983. ❦ Ricci, Corrado. *North Italian Painting of the Cinquecento:*

Piedmont, Liguria, Lombardy, Emilia. New York: Hacker Art Books, 1976.

INSCRIPTIONS
Verso: inscribed in blue crayon, stretcher, left member, center: #23543.

Labels, etc: bears white circular paper tag, stretcher, bottom member, left, inscribed in blue ink: 1212; ❦ and red-bordered white paper tag, left member, bottom, inscribed in blue ink: 7365 / 7.

CONDITION and TECHNIQUE
Approximately half of the original painting is lost. Before conservation, overpaint hid Salome's right arm, the figure on the left, and the left edge of the salver. The x-ray also indicates that approximately three centimeters have been trimmed from the lower edge of the painting. Paint loss, abrasion, and inpainting to the half of the painting that remains is minimal. Conserved, 1989-1990, Intermuseum Conservation Association, Oberlin, Ohio.

PROVENANCE
John Levy Galleries, New York, New York, by 1930; ❦ Arturo Grassi, Florence, Italy; ❦ Mr. and Mrs. William H. Thompson, Indianapolis, Indiana, 1939.

EXHIBITIONS
Indianapolis, Indiana, Herron Museum of Art (Indianapolis Museum of Art). *Indiana Colleges Collect.* October 4-November 1, 1964, catalogue number 7.

REFERENCES
(Former accession number: AC-40-32.) ❦ Venturi, Adolfo. "An Unpublished Portrait by Bernardino Luini." *The Burlington Magazine*, volume LVII, number CCCXXX, September, 1930, pages 121-122, illustrated page 120, as Bernardino Luini. ❦ Peat, Wilbur. "Italian Paintings in the W.H. Thompson Collection at Muncie, Indiana." *The Art Quarterly*, Autumn 1941, pages 262 and 265, illustrated figure 7, page 269, as Bernardino Luini. ❦ Ball State, 1947, page 17, as Bernardino Luini. ❦ Ottino della Chiese, Antonio. *Bernardino Luini.* Novara: Instituto Geografico de Agostini, 1956, page 121, catalogue number 182, illustrated plate 161, as Bernardino Luini. ❦ Fredericksen, Burton B., and Federico Zeri. *Census of Pre-Nineteenth Century Italian Paintings in North American Collections.* Cambridge, Massachusetts: Harvard University Press, 1972, page 114, as school, shop, or studio of Bernardino Luini. ❦ Trutty-Coohil, Patricia. "Studies in the School of Leonardo da Vinci: paintings in public collections in the United States with a chronology of the activity of Leonardo and his pupils

and catalogue of auction sales." Ph.D. dissertation, The Pennsylvania State University, 1982, pages 173–177, illustration 37.

RELATED WORKS
Circle of Bernardino Luini. *Salome with the Head of Saint John the Baptist*, oil on panel transferred to canvas, Cleveland Museum of Art, Cleveland, Ohio.

School of Bernardino Luini. *Erudiade* (*Herodias*), oil on wood panel, Galleria degli Uffizi, Florence, Italy.

Bernardino Luini. *Salome Receiving the Head of John the Baptist*, oil on canvas, 62 × 55 cm, Musée du Louvre, Paris, France.

REMARKS
The Muncie painting is the left half of a composition that once included two additional figures and the head of John the Baptist held suspended above a salver. Complete versions of the painting are in the Uffizi and the Cleveland Museum of Art. Though currently questioned, both complete versions were once accepted by scholars as autograph. Ottino della Chiesa (1956), Adolpho Venturi (1930), and Wilbur D. Peat (1941), consider the Muncie painting as autograph; Fredericksen and Zeri (1972) consider the work a copy and place it at the end of the fifteenth century. Not available to any of the above scholars was an x-ray of the Muncie painting, taken in 1959, that clearly indicates that the Muncie painting was once identical to the Cleveland and Uffizi versions and reduced in size at a later date. In the Fine Arts Gallery, San Diego, California, a painting attributed to Luini duplicates the Muncie version before the overpaint was removed. To our knowledge, this version has not been x-rayed.

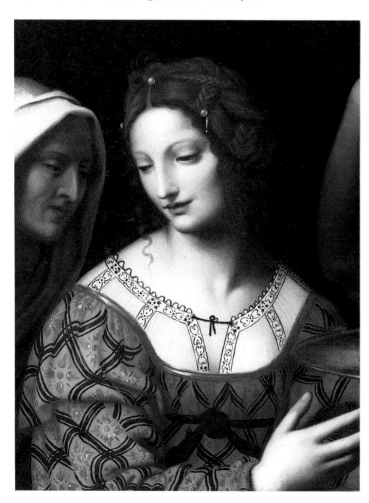

Hans Holbein the Younger and Studio

German (1497 or 1498-1543)
born Augsburg, Germany, 1497 or 1498
died London, England, November, 1543

Erasmus of Rotterdam, 1530-1532

paint (oil, tempera?) on panel (oak, cradled)
18.2 × 14.2 cm; 7⅛ × 5⅝ inches

Permanent loan from the E. Arthur Ball Collection,
Ball Brothers Foundation
L51.204

Rendered in minute detail, the scholar *Erasmus of Rotterdam* appears against a plain blue background. Many portraits of this particular sitter—by a variety of Renaissance artists—survive, testifying to Erasmus's habit of exchanging portraits with his friends and admirers. Before the age of photography, friends, colleagues, and potential spouses commonly exchanged small portraits as tokens of friendship, a tradition that survives in our habit of exchanging snapshots. Muncie's diminutive painting was a cabinet picture: a work not intended for display on a wall, but kept in a cabinet or drawer to be pulled out and admired from time to time.

In a 1524 letter Erasmus wrote, "And again I have lately sent two pictures of myself to England, done by a very elegant artist. He took a picture of me to France." That "elegant artist" was Hans Holbein the Younger. The two had first met about nine years earlier when Holbein did illustrations for the publication of Erasmus's *The Praise of Folly*. Particularly impressed with Holbein's work, Erasmus that same year commissioned the first of several portraits of himself from the artist.

From that year on, Holbein stayed for several extended periods in Erasmus's home city of Basel until, in 1526, with the scholar's encouragement and letter of recommendation in hand, Holbein left for England. By this time, the climate of the Reformation—with its attendant iconoclasm—was becoming repressive to artists, who earned so much of their living making religious paintings.

In 1528, Holbein returned to Basel and remained there until 1532 when he settled in England for good. During these four years, the artist and his studio produced a number of bust and half-length portraits of Erasmus, probably to satisfy the demand of Erasmus's admirers for his likeness. After sitting for an initial portrait, Erasmus could then order copies of it as the need arose. Several portraits of Erasmus similar to the Ball State painting exist, including a roundel in the art museum in Basel, which art historians now believe is the original that Holbein and his assistants copied as needed.

SOURCES
Erasmus. Letter to Willibald Perckheimer (see remarks). ❦ Ganz, 1956. ❦ Langdon, Helen. *Holbein*. Oxford: Phaidon Press, 1976. ❦ Rowlands, 1985. ❦ Snyder, James. *Northern Renaissance Art: Painting, Sculpture, the Graphic Arts from 1350 to 1575*. Englewood Cliffs, New Jersey: Prentice-Hall, 1985 and New York: Abrams, 1985.

INSCRIPTIONS
Recto: inscribed in brown oil paint, lower right: 421.

Verso: inscribed in pencil, cradle, lower cross member: 7466.

CONDITION and TECHNIQUE
Considerable old woodworm damage is present in the right half of the work. There are accompanying surface deformations from poor fills and extensive old retouchings and overpaint, especially to right half of the painting and approximately 20 percent of the face. The infrared photograph indicates that there is noticeably more facial hair depicted than is now visible, making the Muncie version closer to the Basel roundel and the Metropolitan half-length portrait than it currently appears. Conserved (surface cleaning), 1971, Alfred Jakstas, Art Institute of Chicago, Chicago, Illinois. Conserved (varnish touched up), 1975, Indianapolis Museum of Art, Indianapolis, Indiana.

PROVENANCE

Duke George IV the Bearded (1471-1539), Elector of Saxony (1500-1539). (The painting was probably a gift from Erasmus, see remarks.); ❦ Royal Collection Saxony, Dresden, Germany; ❦ by descent, Albertine Line (also Wittenberg Line, House of Wettin); ❦ Gemaldegalerie, Dresden, Germany; ❦ Prince Ernst Heinrich of Saxony, apparently 1920s; ❦ Wildenstein and Company Galleries, Paris, France, and New York, New York, by 1928; ❦ E. Arthur Ball, Muncie, Indiana; ❦ Ball Brothers Foundation, Muncie, Indiana, 1950.

EXHIBITIONS

Dresden, Kunstkammer, founded in 1560 by Augustus (1526-1586), Elector of Saxony (1553-1586). ❦ Dresden, Royal Picture Gallery (Gemaldegalerie), founded in 1722 by Augustus II or Augustus the Strong (1670-1753), Elector of Saxony (1694-1733). ❦ Los Angeles, Los Angeles Museum. *Five Centuries of European Painting: From the Early Renaissance to the Modernists.* November 25-December 31, 1933, number 8, illustrated. ❦ San Francisco, California Palace of the Legion of Honor. *Five Centuries of European Painting: From the Early Renaissance to the Modernists.* Early 1934, catalogue number 8, illustrated. ❦ Indianapolis, John Herron Museum of Art (Indianapolis Museum of Art). *Holbein and His Contemporaries: A Loan Exhibition of Paintings in France, the Netherlands, Germany, and England.* October 22-December 24, 1950, catalogue number 35, illustrated, plate 35. ❦ Muncie, Ball State Teachers College. *Beneficence Continues: Paintings from the E. Arthur Ball Collection.* March 18-?, 1951, page 4, catalogue number 3. ❦ Indianapolis, John Herron Museum of Art (Indianapolis Museum of Art). *Indiana Colleges Collect.* October 4-November 1, 1964, catalogue number 5.

REFERENCES

Inventory of the Royal Saxon Picture Gallery, commenced in 1722 under the direction of Baron Raymond le Plat and continued until 1728 by Chamberlain and Inspector Steinhauser, as Hans Holbein. ❦ 1765 inventory of the Royal Saxon Picture Gallery, as after Hans Holbein. ❦ Hubner, Julius, revised by B.S. Ward. *Catalogue of the Royal Picture Gallery in Dresden.* Dresden: William Hoffmann, 1880, page 370, number 1896, as after Hans Holbein. ❦ Woermann, Karl, trans. B.S. Ward. *Catalogue of the Royal Picture Gallery in Dresden.* Dresden: William Hoffmann, 1899, page 205, catalogue number 1893, as after Hans Holbein. ❦ Woermann, Karl. *Katalog der Königlichen Gemäldegalerie zu Dresden.* Dresden: 1908, page 614, catalogue number 1893, as after Hans Holbein. ❦ Ganz, Paul. *Hans Holbein D.J., Des Meisters Gemälde.* Stuttgart, Berlin, and Leipzig: Deutsche Verlags-Anstalt, 1912,

catalogue number S.91, as after Holbein. ❦ Unpublished authentication by Paul Ganz dated Basel, July 15, 1930, and a second dated Brussels, September 30, 1930. ❦ Unpublished authentication by Dr. Hensch dated Dresden, August 29, 1931. ❦ Kuhn, Charles L. *A Catalogue of German Paintings of the Middle Ages and Renaissance in American Collections.* Cambridge, Massachusetts: 1936, pages 80-81, catalogue number 357, plate LXXIV. ❦ Schmid, Heinrich Alfred. *Hans Holbein der Jüngere*, Basel: Im Holbein-Verlag, 1948, Textband, part II, pages 313-314. ❦ Ganz, Paul. *Hans Holbein: Die Gemälde.* Basel, 1950, catalogue number 50, illustrated, as Hans Holbein. ❦ Parks, Robert O. *Holbein and His Contemporaries.* Indianapolis: John Herron Art Museum, 1950, unpaginated, catalogue number 35, illustrated, plate 35, as Hans Holbein. ❦ Morse, John D. *Old Masters in America.* Chicago: Rand McNally, 1955, page 108. ❦ Ganz, Paul. *The Paintings of Hans Holbein*, first complete edition. New York: Phaidon Press, 1956, page 238, number 58, illustrated, figure 16, as Hans Holbein. ❦ Wishon, John. "Portrait of Erasmus of Rotterdam." The *Indianapolis Star*, April 28, 1957, page 34, illustrated page 34. ❦ Morse, John D. *Old Master Paintings in North America.* New York: Abbeville Press, n.d. (1979), page 184, illustrated. ❦ Rowlands, John. *Holbein: The Paintings of Hans Holbein the Younger.* Oxford: Phaidon Press, 1985, catalogue number 34 (C), pages 135-136, as studio of Hans Holbein after the portrait of Erasmus now in the Metropolitan Museum of Art, New York.

REMARKS

Paul Ganz (1956) and John Rowlands (1985) catalogue the New York portrait of Erasmus (Metropolitan Museum of Art, Robert Lehman Collection, New York; Ganz catalogue number 57) as the best and probably autograph version of a group of half-length cabinet pictures of Erasmus executed to satisfy the demand for portraits of the scholar. The remainder are catalogued as studio works executed in 1531 and 1532. Both scholars catalogue the Basel roundel portrait of Erasmus (Offentliche Kunstsammlung, Basel; Ganz catalogue number 60) as autograph and the version likely painted from life, making it the first of the half-length type of cabinet portrait.

A copy of the Basel roundel, by Georg Pencz (circa 1500-circa 1550), signed and dated 1532, is mentioned by Ganz (Lanckoronski Collection, Vienna). Both Ganz and Rowlands mention the copy of the Muncie painting by Georg Pencz, signed and dated 1537 (Royal Collection, Windsor Castle, London). The circumstances of Pencz's access to the Basel roundel and the Muncie half-length portraits of Erasmus are not clear.

That Erasmus did, on occasion, give portraits of himself to friends and patrons is verified in his letters. See for example, his 1524 letter to Willibald Perckheimer: "And again I have lately sent two pictures of myself to England, done by a very elegant artist. He took a picture of me to France." (Erasmus, Desiderius. *The Correspondence of Erasmus*. trans. R.A.B. Mynors and Alexander Dalzell, annotated by James E. Estes, Toronto, Buffalo: University of Toronto press, volume 10, page 278-279.) The letter apparently refers to the Holbein portraits of circa 1523-1524 today in the Radner Collection (Longford Castle, England), the Musée du Louvre? (Paris) and Basel (Offentliche Kunstsammlung), respectively. For a discussion of Erasmus and his portraitists, see: Gerlo, Alois. *Erasmus et ses portraitistes: Metsijs, Dürer, Holbein*. Nieuwkoop: B. de Graff, 1969.

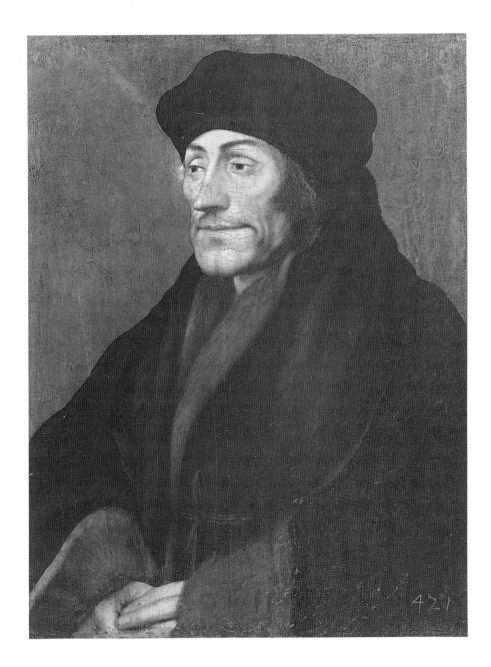

Unidentified Maker

Italian (16th century)
active Bologna?, Genoa?, or Parma?, Italy, 16th century

Portrait of a Gentleman, circa 1540-1550

paint (oil) on canvas
101.3 × 76.8 cm; 39⅞ × 30¼ inches

Gift of Mr. and Mrs. William H. Thompson
40.014

INSCRIPTIONS
Verso: bears unidentifiable circular stamp, stretcher, center member, scribbled over with pencil, possibly identical to the stamp on bottom stretcher bar (see below); ❦ and circular stamp in black ink (circular border with writing in border surrounding an apparent coat of arms, partially covered by lining edge): stretcher, lower member, ???RE B??ETTI D'A?TE; ❦ and stamped seal, frame, upper member: RT2; ❦ and inscribed in black pen, frame, upper member: 0-170.

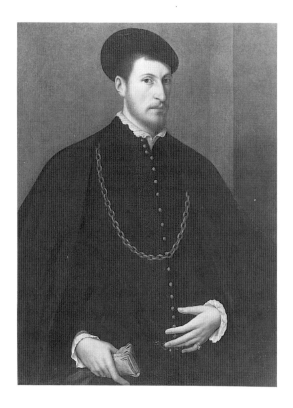

Labels, etc.: bears cream paper Luigi Grassi & Sons, Paintings by old Masters, 88 Via Cavour, Florence label, frame, left member.

CONDITION and TECHNIQUE
The painting is glue lined to a second canvas support. There is scattered overpaint throughout and significant overpaint on the sitter's cap.

PROVENANCE
Stefano Bardini, Florence, Italy; ❦ Luigi Grassi and Sons, Florence, Italy; ❦ Mr. and Mrs. William H. Thompson, Indianapolis, Indiana, Summer 1933.

REFERENCES
(Former accession number: AC-40-170.) ❦ Suida, Wilhelm. "New Light on Titian's Portraits." *The Burlington Magazine*, June, 1934, page 272, illustrated plate number IA, as Titian, circa 1546. (Suida examined the painting in Florence in circa 1933.) ❦ Suida, Wilhelm. *Le Titien*. Paris: A. Weber, 1935, page 186, plate number 316, as Titian. ❦ Peat, Wilbur D. "Italian Paintings in the W.H. Thompson Collection at Muncie, Indiana." *The Art Quarterly*, Autumn 1941, pages 267-268, illustrated page 270, as unidentified Venetian painter, circa 1550. ❦ Ball State, 1947, page 23, as Titian. ❦ Wethey, Harold E. *The Paintings of Titian*. London: Phaidon Press, 1971, volume II, *The Portraits*. page 168, catalogue number x-54, as North Italian School, circa 1550. ❦ Fredericksen, Burton B., and Federico Zeri. *Census of Pre-Nineteenth Century Italian Paintings in North American Collections*. Cambridge, Massachusetts: Harvard University Press, 1972, page 225, as Genoa School, 16th century.

REMARKS
The authors note a similarity worthy of further examination to Francesco Maria Rondani's (Parma, Italy, 1490-1584) *Portrait of a Bearded Gentleman* (circa 1522, oil on panel, 58.8 × 45.7 cm, former collection of Viscount Gaye and David Carritt). (Russell, Frances. "Rondani's Masterpiece and a Neglected Correggio." *Apollo*, volume CIII, number 167, January, 1976, pages 13-15. Sold London, Christie's, December 10, 1993, lot number 79.)

Unidentified Maker

Italian (16th-17th century)
active Bologna?, Naples?, or Padua?, Italy, late
16th-17th century

The Mystic Marriage of Saint Catherine, circa 1585-1625

paint (oil) on canvas (linen)
119 × 99 cm; 47 × 39 inches

Permanent loan from the Frank C. Ball Collection, Ball
Brothers Foundation
L29.053

INSCRIPTIONS
Verso: inscribed in black chalk, frame, top member, left and
right: 338; ❦ and in light blue chalk, frame, top member,
center: 53/??? (GHS?); ❦ and in blue chalk, frame, top
member, center: 53.

Labels, etc.: bears rectangular paper card-stock label, tacked
to frame, right member, center, inscribed in blue paint:
2630; ❦ and white circular paper label, stretcher, left
member, top, inscribed in pencil: 30/3R Florence; ❦ and
white circular paper label, left member, center, inscribed in
pencil: 1531.

CONDITION and TECHNIQUE
The painting is relined to a second canvas. There is
significant flattening of the impasto from a past relining and
a large repaired and inpainted hole, lower left. The canvas
was once folded over a shorter stretcher, and there is
associated paint loss and inpaint at the top and bottom. The
paint film was applied over a dark ground and combined
both transparent and opaque passages. Over time, these
color passages have become more transparent, allowing the
darker lower layers to darken the overall tonality of the
painting. Conserved, 1993, Intermuseum Conservation
Association, Oberlin, Ohio.

PROVENANCE
George A. Hearn, New York, New York, before 1908; ❦
George A. Hearn estate, New York, New York, 1917; ❦
Frank C. Ball, Muncie, Indiana, 1918; ❦ Ball Brothers
Foundation, Muncie, Indiana, 1936.

EXHIBITIONS
Muncie, Ball State University Museum of Art. *Objects of
Desire: A Vision for the Future.* October 11-November 8,
1992, no catalogue.

REFERENCES
(Former accession number: AC-29-53.) ❦ Hearn, George A.
*Catalogue of the Collection of Foreign and American
Paintings Owned by Mr. George A. Hearn.* New York:
privately printed (The Gilliss Press), 1908, page 142,
catalogue number 181. ❦ New York, American Art
Association. *Notable Art Collection Formed by the Late
George A. Hearn.* February 28, 1918, lot number 338,
illustrated, as Italian school. ❦ Ball State, 1936, page 5. ❦
Ball State, 1947, page 15.

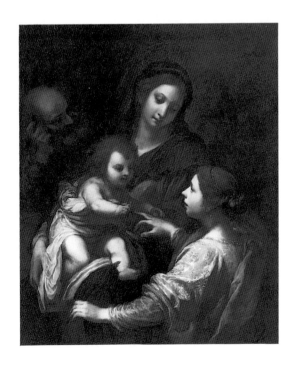

Massimo Stanzione

Italian (1585-1656)
born Orta di Atella, Italy, 1585
died Naples, Italy, 1656

The Martyrdom of Saint Lawrence, circa 1625

paint (oil) on canvas
208.2 × 178.3 cm; 82 × 70⅛ inches

Lent by David T. Owsley
L93.007.1

Stripped of all but a loin cloth, a young man—his body arranged in a striking diagonal—looks heavenward. There a small angel flies in bearing a palm (here a symbol of victory over death) as if to hand it to the dying saint. At about eye level, we see a glowing fire and realize that the man is laid over a large grill. Seemingly calm boys stoke the fire while a similarly detached group of older men looks on.

The subject of this gruesome scene is the martyrdom of Saint Lawrence. Lawrence was born in Spain and became an archdeacon to Sixtus II. In 258 he was killed by being roasted over a gridiron. As the largest area of a light color, Lawrence's pale skin draws our eyes. He seems to struggle against the grip of one of his torturers, either to attempt to break free or to reach toward the angel.

Though at this point there is no documentation describing the painting's history or origin, its size and the angle of the main figure suggest it was probably painted to hang over an altar (such works are called "altarpieces"). In the museum, the painting's installation approximates its original height on the wall.

Like many seventeenth-century artists, Massimo Stanzione travelled regularly to fulfill commissions. Documentation reveals that he spent the years 1625-1630 working in Rome and in 1630 returned to Naples, painting in all the major churches there. Other artists were working internationally. Since Flanders and parts of Italy were under Spanish rule, Spanish artists were working in Italy, Flemish artists were sending paintings to Spain, and Italian artists were working for Spanish patrons. Wherever a forceful artistic personality went, other artists learned from his style, sometimes directly borrowing motifs and poses of figures. The Italian painter Michelangelo Caravaggio and the Spanish painter Jusepe de Ribera were imitated in this way.

In Rome and Naples, where Stanzione worked, he would have been able to see the work of the painter Caravaggio, as well as paintings by Caravaggio's followers. The strong contrasts of light and shadow (chiaroscuro), and the realistic appearance of the figures are two phenomena that recur over and over in the work of Caravaggio and his followers. In particular, art historians note a resemblance between Stanzione's work and that of the Spanish painter and printmaker Jusepe de Ribera, also working in Naples. Ribera executed several martyrdoms, including a Martyrdom of Saint Lawrence and a Martyrdom of St. Bartholemew, the latter arranged very much like Stanzione's painting. Before leaving Naples for Rome, Stanzione could have seen Ribera's work, borrowing elements of the Spanish artist's treatment of martyrdom.

SOURCES
De Rinaldis, Aldo. Neapolitan Painting of the Seicento. New York: Hacker Art Books, 1976. ❦ Schütze, 1992. ❦ Whitfield, Clovis, and Jane Martineau, eds. Painting in Naples 1606-1705: from Caravaggio to Giordano. London: Royal Academy of Arts and Weidenfeld and Nicolson, 1982.

INSCRIPTIONS
Labels, etc.: bears red-bordered white paper Delaware Art Museum exhibition label.

PROVENANCE
Carlo Croce, Philadelphia, Pennsylvania, circa 1989; ❦
David T. Owsley, New York, New York, 1993.

EXHIBITIONS
Wilmington, Delaware Art Museum. *Mostly Baroque:
Italian Paintings and Drawings from the Carlo Croce
Collection*. April 24-June 14, 1992, no catalogue.

REFERENCES
London, Sotheby's. *Old Master Paintings*. April 19, 1989,
lot number 141, as Neapolitan school. ❦ Schütze, Sebastian,
and Thomas C. Willette. *Massimo Stanzione, L'opera
completa*. Naples: Electa Napoli, 1992, page 254, as
possibly Benardo Cavallino and related to catalogue number
C45. ❦ Christie's. *Christie's International Magazine*,
volume X, number X, January, 1993, page 3, illustrated in

color plate 2. ❦ New York, Christie's. *Important Old
Master Paintings*. January 14, 1993, lot number 176,
illustrated in color, catalogue entry by Wolfgang Prohaska as
Massimo Stanzione.

RELATED WORKS
Massimo Stanzione. *Martirio di san Lorenzo*, n.d., oil on
canvas, 215 × 154 cm, Galleria Regionale, Palermo, Italy.

Jusepe de Ribera (1591-1652). *Martyrdom of St.
Lawrence*, circa 1618-1624, oil on canvas, 204 × 154 cm,
private collection, London, and another version, Nelson-
Atkins Museum of Art, Kansas City, Missouri.

Jusepe de Ribera. *Martyrdom of St. Bartholemew*, 1624,
etching, 32.4 × 23.9 cm.

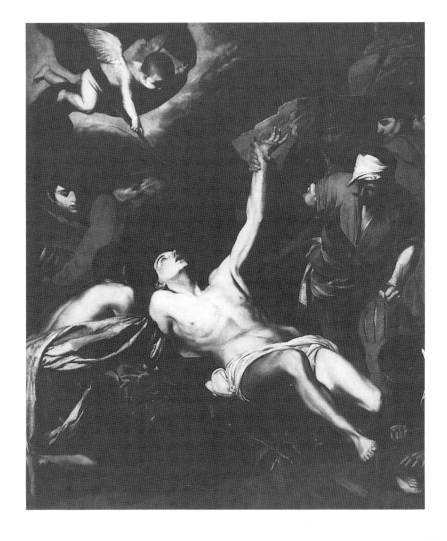

Justus Susterman (or Sustermans, etc.)

Flemish (1597–1681)
born Anvers, Flanders, September 28, 1597
died Florence, Italy, April 23, 1681

Margherita di Cosimo II,
circa 1626–1630
(***Portrait of a Medici Princess***)

paint (oil) on canvas
112.8 × 87.8 cm; 45⅛ × 35⅛ inches

Permanent loan from the Frank C. Ball Collection, Ball
Brothers Foundation
L29.080

INSCRIPTIONS
Verso: inscribed in pencil, stretcher, left member, top: #20;
❦ and in blue crayon, stretcher, bottom member, center:
241; ❦ and in blue crayon, frame, upper left corner: 447; ❦
and in blue crayon, frame, lower member, center: 241957.

Labels, etc.: bears circular serrated-edged white paper label,
stretcher, upper member, left, inscribed in brown ink: G; ❦
and circular serrated-edged white paper label, stretcher,
upper member, left, inscribed in brown ink: K; ❦ and white

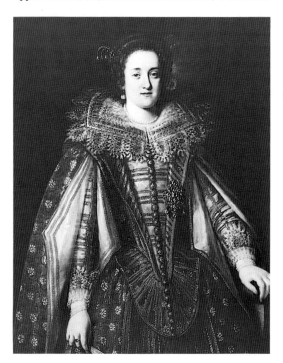

paper tag, upper member, center, inscribed in brown ink:
B244; ❦ and white paper tag, upper member, center,
inscribed in brown ink: Susterman; ❦ and white paper
Thomas Agnew and Sons label, inscribed in black ink: 9395;
❦ and remnant of white paper label, printed: Artist:
Subject: inscribed Susterm??? Yerkes C???; ❦ and red wax
stamp, upper member, left: Collection Brandus New York;
❦ and red-bordered white paper tag, frame, upper member,
left, inscribed in brown ink: 886 Susterman; ❦ and white
paper Thomas Agnew and Sons label, upper member,
center; ❦ and remnant of white paper label, upper member,
center, printed: I. ??? ROSE, Fine Picture Frames, Dealers in
Fine Paintings, 45 E. 20th St., New York.

CONDITION and TECHNIQUE
Conserved, 1988, Intermuseum Conservation Association,
Oberlin, Ohio.

PROVENANCE
Thomas Agnew and Sons, London, England; ❦ Charles T.
Yerkes, New York, New York; ❦ Edward Brandus
Collection, New York, New York, April, 1910; ❦ George A.
Hearn, New York, New York; ❦ George A. Hearn estate,
New York, New York, 1917; ❦ Frank C. Ball, Muncie,
Indiana, 1918; ❦ Ball Brothers Foundation, Muncie, Indiana,
1936.

REFERENCES
(Former accession number: AC-29-80.) ❦ New York,
American Art Association. *Deluxe Catalogue. C.T. Yerkes
Collection Sale.* April 5–8, 1910, lot number 183, illustrated
(regular catalogue has no illustrations), as Lambert
Susterman. ❦ New York, American Art Association.
*Notable Art Collection Formed by the Late George A.
Hearn.* March 1, 1918, lot number 417, illustrated. ❦ Ball
State, 1947, page 23.

RELATED WORKS
Justus Susterman. *Margherita di Cosimo II*, circa 1622, oil
on canvas, 185 × 127 cm, Galleria degli Uffizi, Florence,
Italy.

Justus Susterman. *Margherita di Cosimo II*, 1628, oil on
canvas, 201 × 139 cm, Palazzo Pitti, Florence, Italy. A full-
length portrait painted on the occasion of her marriage to
Odoardo Farnese of Parma.

Justus Susterman. *Margherita di Cosimo II*, 1630, oil on
canvas, 203 × 116 cm, Museo di S. Matteo, Pisa. A copy of
the 1628 marriage portrait. A half-length copy is in an
English private collection.

Matthias Stomer

Flemish (circa 1600-after 1650)
born Amersfoort, Flanders, circa 1600
died Sicily, after 1650

Saint Jerome in His Study,
circa 1633-1639

paint (oil) on canvas (linen)
91.5 × 132.0 cm; 36 × 52 inches

Lent by David T. Owsley
L91.011.9

CONDITION and TECHNIQUE
Conserved, 1990, Michael Melnitsky, New York, New York.

PROVENANCE
David T. Owsley, New York, New York, 1988.

REFERENCES
New York, Christie's. *Important Paintings by Old Masters*.
June 2, 1988, catalogue number 72, illustrated in color.

RELATED WORKS
Matthias Stomer. *The Four Evangelists* (three are
unlocated). *Saint Paul*, circa 1633-1639, oil on canvas, 82
× 113 cm, Mark Allen, Burford, Oxfordshire, England.

Matthias Stomer. *The Four Evangelists* (*Saint Paul* is
unlocated). *Saint John the Evangelist*, circa 1633-1639, oil
on canvas, 110-130 cm, Musées de Rennes, Rennes, France.
Saint Mark, circa 1633-1639, oil on canvas, 110 × 130 cm,
Musées de Rennes, Rennes, France. *Saint Luke* (engraving
by F. Langee after a lost painting by Stomer

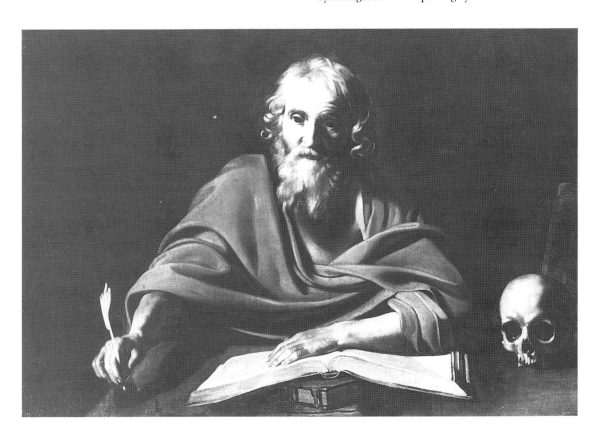

formerly in the Musées de Rennes, published in the Annales du Musée, 1807).

Matthias Stomer. *The Four Latin Fathers of the Church* (two may be unlocated). *Saint Ambrose* or *Saint Augustin*, circa 1633-1639, oil on canvas, 110 × 130 cm, Musées de Rennes, Rennes, France. *Saint Gregory the Great*, circa 1633-1639, oil on canvas, 108 × 125 cm, private collection, Paris, France.

Matthias Stomer. *Four Latin Fathers of the Church* (two may be unlocated). *Saint Ambrose* or *Saint Augustin*, circa 1633-1639, oil on canvas, 89.5 × 115.5 cm, Offentliche Kunstsammlungen, Basel, Switzerland. *Saint Gregory the Great*, circa 1633-1634, oil on canvas, 89.5 × 115.5 cm, Offentliche Kunstsammlungen, Basel, Switzerland.

Matthias Stomer. *Saint Jerome as a Pentitent*, n.d., oil on canvas, collection of Jose Lazaro, Madrid, before 1948, Museo Lazaro Galdiano?, Madrid. (A photograph of the painting is on file in the Frick Art Reference Library. Though no size is listed, it compares proportionally to both series of *The Four Fathers of the Latin Church*.)

Jusepe de Ribera (1591-1652). *Saint Jerome*, circa 1624, oil on canvas, 127 × 100.6 cm, Harvard University Art Museums, Cambridge, Massachusetts.

REMARKS
For detailed discussions of Stomer's Evangelists and Latin Fathers of the Church see Walsh, John Jr. "Stomer's Evangelists." *The Burlington Magazine*, volume CXVIII, number 880, July, 1976, pages 504-508; and Nicolson, Benedict. "Stomer Brought Up-to-Date." *The Burlington Magazine*, volume CXIX, number 889, April, 1977, pages 230-245.

The Muncie painting may have originally figured in the larger size series of *The Four Fathers of the Latin Church*. If so, approximately eighteen and a half centimeters is apparently now lost from the original height of the painting. (To date, the painting has not been x-rayed.)

Ottavio Vannini

Italian (1585-1643)
born Florence, Italy, September 16, 1585
died Florence, Italy, 1643

Il miracolo della manna, circa 1635
(*The Gathering of Manna*)

paint (oil) on canvas (linen)
202.3 × 254.4 cm; 79⅝ × 100¼ inches

Gift of John W. and Janice B. Fisher
88.002

In her effort to scoop from the ground small white pieces of manna, a woman in red crawls toward us. Beside her a naked toddler hungrily shoves the food into his mouth. *The Gathering of Manna* illustrates a scene from the *Old Testament* story of Moses and the Israelites after their escape from Egypt. Described in the Bible as tiny round pieces of bread, manna appeared with the morning dew, God's gift of food for the lost and wandering Israelites during their forty-year desert sojourn.

For the faithful, *Old Testament* images prefigured *New Testament* events. To them the white manna represented the host used in the Catholic mass, and in feeding the Israelites Moses was like Christ feeding the multitudes with a few loaves and fishes. In Vannini's painting Moses, with his staff raised heavenward, points toward the source of the manna. With his left hand he indicates the evidence of divine blessing on the ground. Behind Moses's left shoulder his brother Aaron, in the dress of a Jewish high priest, expresses his wonder in a theatrical gesture. Around these two, figures representing the Israelites gather, eat, and store the precious food.

In the seventeenth century, when Vannini painted this canvas, *Old Testament* scenes were particularly popular among patrons in Florence.

Ottavio Vannini painted this and three additional *Old Testament* scenes, *The Sacrifice of Isaac*, *Susanna and the Elders*, and *Moses Striking the Rock* for Andrea del Rosso's home in Florence. Wealthy grain merchants, the del Rossos were among the most prolific art collectors of their day. Vannini painted for them on a number of occasions, and they owned several of his paintings of saints. But it was *The Gathering of Manna* and its three companion scenes that contemporary biographers regarded as Vannini's best works.

With its bold lighting and vivid action Vannini's scene seems to invite our participation. While the woman in the lower right appears almost to crawl off the canvas, in the center of the painting the artist has cleared a space for us to enter. Moses seems to beckon, inviting us to take part in the activity. Dramatic sideways lighting (called *chiaroscuro*—literally "clear/obscure," or "light/dark"), creates dark shadows next to harsh highlights. These touches of realism are typical of the style scholars call *Baroque*, and Vannini's painting is an important example of the style.

SOURCES
Hibbard, Howard, and Joan Nissam. *Florentine Baroque Art from American Collections*. New York: The Metropolitan Museum of Art, 1969. ❧ Martin, John Rupert. *Baroque*. New York: Harper and Row, Icon Editions, 1977. ❧ Wittkower, Rudolf. *Art and Architecture in Italy, 1600-1750*. Third edition, *Pelican History of Art*. Harmondsworth, Middlesex: Penguin Books, Ltd., 1973; reprint, 1985. ❧ Wardropper, Ian. "Ottavio Vannini and the Italian Baroque." Lecture presented in celebration of the Ball State University Museum of Art's acquisition of Ottavio Vannini's *The Gathering of Manna*, Ball State University, Muncie, Indiana, October 8, 1988. (Manuscript)

CONDITION and TECHNIQUE
The painting is wax lined to a second canvas. There is minor surface abrasion and substantial losses at edges, corners, and central canvas seam. The ground is earth-red, the paint layers are complex, and significant glazing is present.

PROVENANCE
Ottavio Vannini; ❧ Andrea del Rosso, Florence, Italy, circa 1635 (commissioned for family home on Via Chiara); ❧ Antonio del Rosso, Florence, Italy, 1644; ❧ Ottavio del Rosso, Andrea del Rosso, and Lorenzo del Rosso, Florence, Italy, 1644 or later; ❧ Antonio del Rosso, Giovanni Battista del Rosso, Florence, Italy, 1719; ❧ still in Florence, Italy in 1956; ❧ John and Janice Fisher, Muncie, Indiana, 1988.

REFERENCES
Cinelli, Giovanni. *Le Bellezze della Citta di Firenze*. Florence: Gio. Gugliantini, 1677, page 163-164. ❧ 1689 inventory of the del Rosso Family collections drawn up by Andrea del Rosso, Florence. ❧ Baldinucci, Filippo. *Notizie de'Professori del disegno da Cimabue in qua, secolo V dal 1610 al 1670*, volume VI. Florence: 1728, page 145. ❧ Gualandi, Michelangelo. *Memorie originali Risguardanti le belle arti*, volume II. Bologna: 1840-1845, page 115-128. ❧ Baldinucci, Filippo. *Notizie dei Professori del Disegno da Cimabue in Qua. . .*, volume IV. Florence: V. Batelli, 1846, page 437. ❧ Longhi, Roberto. "Un collezionista di pittura napoletana nella Firenze del '600." *Paragone*, March, 1956, number 75, pages 61-64, figures 38-39. ❧ Haskell, Francis. *Patrons and Painters: Art and Society in Baroque Italy*. New York: Icon Editions, 1971, pages 211-212. ❧ New York, Christie's. *Important Paintings by Old Masters*. January 15, 1988, lot number 115, illustrated in color. ❧ Slabaugh, Katie. "*The Gathering of Manna* installed in BSU Gallery." *Muncie Star*, March 20, 1988, page 10, illustrated.

RELATED WORKS
Ottavio Vannini. *Moses Striking the Rock* (or *Moses Drawing Water*) circa 1635, oil on canvas, 202×254.5 cm, present location unknown. Christie's, New York, May 31, 1989. The present location of the remaining two paintings is also unknown.

see color plate III

Pieter Janszoon van Asch

Dutch (1603-1678)
born Delft, Holland, 1603
died Delft, Holland, June 6, 1678

Landscape in Gelderland, circa 1655

paint (oil) on canvas (linen)
127.0 × 154.7 cm; 50 × 60⅞ inches

Permanent loan from the Frank C. Ball Collection, Ball Brothers Foundation
L29.009

Against a broad sky, a clump of trees stands in bold silhouette. In front of these a road stretches in a diagonal from the lower left to the middle right side of the canvas, crossing a brook that passes under a rustic bridge and extends deep into the far background. Animals and people on horseback are among the inhabitants of the road, the background bridge, and the landscape. *Landscape in Gelderland* may seem atypical of Dutch landscape painting in the seventeenth century. (The flat landscapes of the coastal region are more often reproduced in art books.) Gelderland is inland, a province of the eastern Netherlands, and has a more diverse, less flat landscape.

In the seventeenth century a wide range of new subjects appeared and flourished, including, especially in the north of Europe, landscape, still life, and genre scenes (images of everyday life). In the Netherlands, parts of which (including Gelderland) threw off Spanish rule and became Protestant, non-religious subjects were particularly popular. A wealthy and prosperous middle class created a demand for pictures. In landscape painting alone, there was such a demand that artists could specialize in a particular kind of imagery, such as winter or night scenes, or forest interiors.

By mid-century, Dutch landscape artists sought to achieve more monumental effects, and Van Asch presents us with a vast panorama in which human activity takes place against a grandiose vista of trees and sky. Scholars refer to the 1650s and 1660s as the "classical phase" of Dutch landscape painting, noting greater contrasts of color, light, and shadow, and forms against the sky. Often in works of these two decades a single motif (like the clump of trees here) will dominate, creating a monumental presence by standing in contrast to the sky.

When scholars use the word *classical* in reference to stylistic elements, they are often referring to the clarity of the composition's organization, especially an emphasis on horizontal and vertical elements. *Landscape in Gelderland* is a masterpiece of organization: the foreground road and waterway form an X leading our eyes throughout the entire scene; the horizontal organization of the leaves in the main group of trees is echoed by the horizontal of the bridge in the middle ground and the horizon line in the far distance. Against these horizontals, tree trunks, the rocky banks of the stream and the lines in the background buildings form a series of verticals.

Unfortunately, we know very little about Van Asch, except that he was rather popular in his own time. (Some scholars suspect that some of his paintings have been attributed to his better-known colleagues.) Paintings were so popular among the Dutch that the demand supported a host of artists. Names and details of biography for many of them do not survive.

SOURCES
Rosenberg, Jakob, Seymour Slive, and E.H. ter Kuile. *Dutch Art and Architecture: 1600 to 1800.* Third edition, *Pelican History of Art.* Harmondsworth, Middlesex: Penguin Books, Ltd., 1977; reprint, 1984.

INSCRIPTIONS
Recto: signed in black oil paint, lower left: P. v Asch.

Verso (inscriptions and labels from the late 19th century frame no longer with the work): inscribed in black crayon, frame, upper member, left: 440; ❦ and in black crayon, frame, upper member, left and right: 440.

Labels, etc.: bears remnant of a white paper label, frame, upper member, center: ???HE FRAMES / ???MUR SON???.

CONDITION and TECHNIQUE
X-ray photographs of the upper right and left corners indicate that the canvas was originally rectangular. The present canvas shape was probably created in the eighteenth century. Conserved, 1986, Intermuseum Conservation Association, Oberlin, Ohio.

PROVENANCE
George A. Hearn, New York, New York; ❦ George A. Hearn estate, New York, New York, 1917; ❦ Frank C. Ball, Muncie, Indiana, 1918; ❦ Ball Brothers Foundation, Muncie, Indiana, 1936.

REFERENCES
(Former accession number: AC-29-9.) ❦ New York, American Art Association. *Notable Art Collection Formed by the Late George A. Hearn.* March 1, 1918, lot number 440. ❦ Ball State, 1936, page 7. ❦ Ball State, 1947, page 3. ❦ Harris, Betty. "A Quiet Battle: Painting Restoration." *Arts Indiana*, December, 1988, page 8.

RELATED WORKS
Pieter Janszoon van Asch. *Wooded Landscape* (*Boomrijk Landschap*), n.d., oil on panel, 100 × 73 cm, Rijkesmuseum, Amsterdam, Holland.

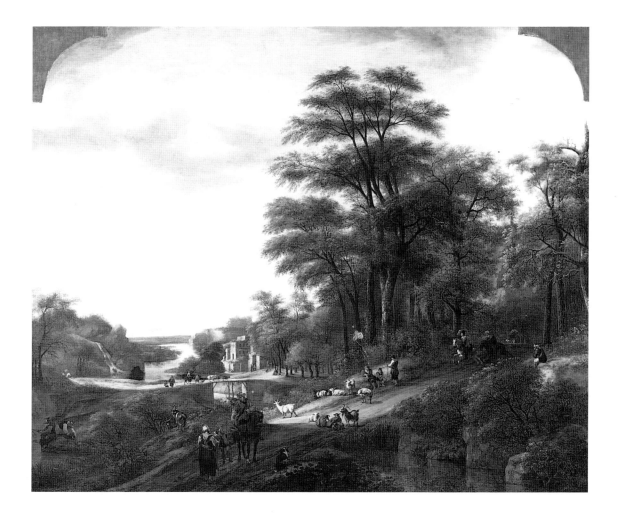

Jean-Baptiste Monnoyer

French (1636-1699)
born Lille, France, July 19, 1636
died London, England, February 16, 1699

Flowers in a Vase, circa 1660-1670

paint (oil) on canvas
126.0 × 100.5 cm; 49⅝ × 39⅝ inches

Gift of David T. Owsley
92.017.1

INSCRIPTIONS
Recto: signed in brown oil paint, lower right on edge of stand: J.B. Monnoyer.

Verso: inscribed in white chalk, frame, top member, center: lot 27 1098; ❦ and in white chalk, frame, right member, center: lot 27.

Labels, etc.: bears red-bordered white paper label, frame, top member, left, inscribed: (illegible); ❦ and white paper label, frame, left member, top, inscribed in pencil: 461.

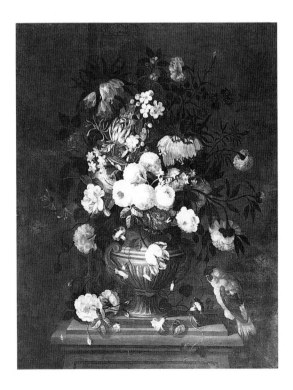

CONDITION and TECHNIQUE
The painting is wax relined to a secondary support. There are scattered losses and inpainting. The varnish is dull and discolored. The paint film was applied over a tan-colored ground and combined both opaque and transparent passages. Over time, thin color passages have become more transparent, allowing the darker lower layers to darken the overall tonality of the painting.

PROVENANCE
David T. Owsley, New York, New York, October, 1957.

REFERENCES
New York, Parke-Bernet Galleries. *French Furniture and Objects of Vertue*. October 18-19, 1957, lot number 261. ❦ Paviere, Sydney H. *J.B. Monnoyer*. London: F. Lewis Publishers, Ltd., 1966, page 18, catalogue number 14, illustrated plate 37. ❦ New York, Christie's. *Important Paintings by Old Masters*. May 31, 1990, lot number 27, illustrated in color (bought in).

Jan Albertsz Rootius

Dutch (1615-1674)
born Medemblik, Holland, 1615
died Hoorn, Holland, 1674

Alida Schouten (at age 18), 1661

paint (oil) on canvas (linen)
102.0 × 99.1 cm; 48¼ × 38 inches

Permanent loan from the Frank C. Ball Collection, Ball Brothers Foundation
L29.066

Rendered in costly ultramarine-blue pigments, the lace-covered dress, along with the elaborately decorated fan, attest to the sitter's stature and the portrait's purpose. Probably painted to commemorate a wedding—the pose, dress, and fan are all associated with wedding portraits— the portrait may also record a relative of one of Europe's important sea explorers. During a recent cleaning of this painting, conservators discovered an inscription on the back of the

canvas: "Alida Schouten, age 18, 1661 (translated)." Alida may have been the granddaughter or granddaughter in-law of Wilhelm Cornelius Schouten (1567?-1625) of Hoorn, Holland. In 1616, while searching for an alternative to the Straits of Magellan, Schouten and his crew rounded the southern extremity of South America and named the headland Cape Hoorn (Horn) after their homeland.

In the seventeenth century the Netherlands had for the most part become Protestant, though many religions were tolerated. In general, the Protestant denominations tended to be iconoclastic, and did not commission religious paintings as did the mostly Catholic Italians. Instead, Dutch artists turned their brushes to portraiture, landscape, and still life. For their part, the middle class proved to be steady patrons.

SOURCES
Hough, Richard Alexander. *The Blind Horn's Hate*. New York: Norton, 1971. ❦ Rosenberg, Jakob, Seymour Slive, and E.H. ter Kuile. *Dutch Art and Architecture: 1600 to 1800*. Third edition, *Pelican History of Art*. Harmondsworth, Middlesex: Penguin Books, Ltd., 1977; reprint, 1984.

INSCRIPTIONS
Recto: signed, in black oil paint, upper right corner: ARotius.fec.1661-.

Verso: inscribed in oil paint, upper center of original canvas: Alida Schouten..AEtitas. 18..1661-; ❦ and in blue chalk, stretcher, center vertical member: 429 / 48 1/4 × 38; ❦ and in pencil, stretcher, transverse member: 404; ❦ and in black crayon, frame, upper member, right: 415; ❦ and in black paint, frame, upper member, center: 1260.

Labels etc.: bears white paper label, stretcher, transverse member left, inscribed in white partially lost (now in object file): May 11 1896 / T.J. Blakesley, Esq?? / Blakesley Purchased th? / Dowderswell ? Dowderswell / 160 New Bond Street / London, England.

CONDITION and TECHNIQUE
The inscription on the verso of the original canvas was uncovered during conservation when the old relining canvas was removed (and covered over again by a new lining canvas). The impasto of the paint has been flattened somewhat from excess heat during an old relining. The ground layer of paint is red and is covered with a grey layer. The blue of the dress comprises two layers; the lower is azurite, lead white and smalt, the upper glaze is largely very high quality ultramarine with some smalt. Conserved, 1991, Intermuseum Conservation Association, Oberlin, Ohio.

PROVENANCE
Dowderswell and Dowderswell, London, England; ❦ T.J. Blakesley, New York, New York, apparently May 11, 1896; ❦ George A. Hearn, New York, New York, before 1898; ❦ George A. Hearn estate, New York, New York, 1917; ❦ Frank C. Ball Collection, Muncie, Indiana, 1918; ❦ Ball Brothers Foundation, Muncie, Indiana, 1936.

EXHIBITIONS
New York, Lotos Club. *Paintings from the Collection of Mr. George A. Hearn*. January 28-February 1, 1898, catalogue number 6.

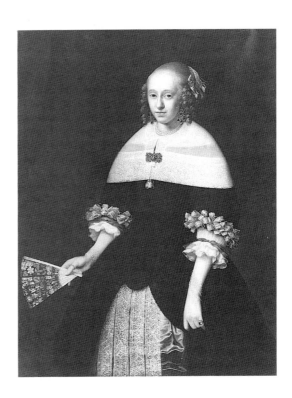

REFERENCES

(Former accession number: AC-29-66.) ❦ Hearn, George A. *Catalogue of the Collection of Foreign and American Paintings Owned by Mr. George A. Hearn.* New York: privately printed (The Gilliss Press), 1908, page 119, catalogue number 147. ❦ New York, American Art Association. *Notable Art Collection Formed by the Late George A. Hearn.* March 1, 1918, lot number 415, illustrated. ❦ Ball State, 1947, page 20.

RELATED WORKS

Attributed to Jan Albertsz Rootius. *Portrait of a Lady*, oil on canvas, 123.2 × 98.4 cm, Christie's, New York, October 9, 1991, lot number 154, illustrated. (Though depicting different sitters, the two paintings are so similar in pose, costume, and accessories that it is difficult to explain the relationship between the two works. According to the Christie's catalogue, a label on the verso of the painting indicates that it was inscribed on the verso of the original canvas now hidden by the present lining: Hill??onda.? oul. 21. Jaers.)

Sir Peter Lely (or Pieter van der Faes)

English (1618-1680)
born Saest (Westphalia), Holland, October 14, 1618
died London, England, 1680

Anne Hyde, Duchess of York, circa 1664-1666

paint (oil) on canvas (linen)
218.5 × 130.0 cm; 86 × 51⅜ inches

Permanent loan from the Frank C. Ball Collection, Ball Brothers Foundation
L29.055

With heavy-lidded eyes, a lavishly-dressed woman in a garden stares at us from her full-length portrait. We are struck by the lushness of surfaces and setting—not to mention the grandiose size and full-length pose. Depicting Anne Hyde, the seventeenth-century Duchess of York, this painting serves as an example of royal portraiture in the Baroque age.

Whereas earlier portraits focus on the forcefulness of the sitter's personality, Baroque portraits tend to concentrate on the sitter's noble rank. Art historians often refer to the Baroque period (roughly the seventeenth century) as the age of the royal portrait; artists aggrandize the kings, queens, princes, and nobles that fill their canvases. Through an elaboration of costume and setting, painters emphasize the exalted status of their aristocratic sitters.

This rather idealized image of aristocrats was the standard set by two of the most celebrated portrait painters of the time: Peter Paul Rubens and Anthony Van Dyck. Both of international repute, Rubens and Van Dyck travelled widely, taking with them a colorful and lively style of painting. While living in England (where Van Dyck spent his later years), Sir Peter Lely, the painter of this canvas, learned of Van Dyck's work and collected paintings by him and other artists.

Born in Holland, Lely trained as a painter in Haarlem, but it was his portrait work in England that made him famous. Scholars believe Lely arrived in London in the early 1640s and began to paint for the royalty. By the time he painted this Anne Hyde (one of several versions he painted of the duchess), Lely's popularity was such that to meet his sitters' demands, he operated a large studio with numerous assistants who painted "postures," backgrounds, draperies, and ornaments.

With such a demand for his work came a standardization of poses: by 1670, Lely had formalized his poses into a numbered series from which patrons could select a format. Predetermined poses also provided a framework for Lely's assistants. In this painting the scarf falling from Anne Hyde's shoulders is typical of the elements Lely included in his portraits of

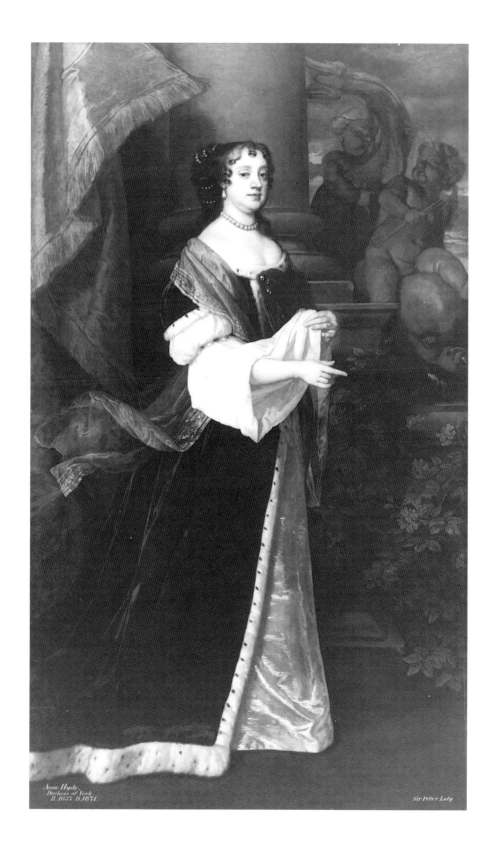

Anne Hyde,
Duchess of York
B. 1637 D. 1671.

Sir Peter Lely

women at this time. The elaborate fountain with cherubs, the column and curtain in the background, and the figure set within a landscape were all elements Lely introduced into fashionable portraiture, many of which would become standard in British portrait painting.

SOURCES
Waterhouse, Ellis. *Painting in Britain 1530-1790*. Fourth edition, *Pelican History of Art*. Harmondsworth, Middlesex: Penguin Books, Ltd., 1978; reprint 1986.

INSCRIPTIONS
Recto: inscribed in white oil paint, lower left: Anne Hyde / Duchess of York / B. 1637 D.1671; ❦ and in white oil paint, lower right: Sir Peter Lely; ❦ (Both inscriptions are apparently later additions.)

Verso: inscribed in black chalk, frame, upper member, left and right corners: 449; ❦ and in black chalk, frame, upper member, center: 8; ❦ and in black paint, frame, right member, center: 4181; ❦ and in black chalk, frame, lower member, center: 8; ❦ and in black paint, frame, right member, center: 4181.

CONDITION and TECHNIQUE
There is moderate loss to the design layers in the upper right background, some abrasion to the upper paint layer, and the impasto has been flattened during early lining procedures. The ground is greyish-purple and composed of ivory black, iron oxide, yellow chalk, and white lead. Conserved, 1988, Intermuseum Conservation Association, Oberlin, Ohio.

PROVENANCE
Earl of Romney, England; ❦ Constance, Countess of Romney, England; ❦ Thomas M'Lean, London, England June, 1906; ❦ George A. Hearn, New York, New York, after 1908; ❦ George A. Hearn estate, New York, New York 1917; ❦ Frank C. Ball, Muncie, Indiana, 1918; ❦ Ball Brothers Foundation, Muncie, Indiana, 1936.

REFERENCES
(Former accession number AC-29-59.) ❦ London, Christie's, Manson and Woods. *Catalogue of Pictures and Drawings: The Property of Lady Currie, Deceased, also important Pictures by Old Masters and Work of Early English School*. June 30, 1906, page 30, lot number 145, not illustrated, as Sir Peter Lely, *Anne Hyde, Duchess of York*, 86 × 50 inches, property of a Lady of Title. (Algernon Graves (1970) lists the seller as the Earl of Romney and the purchaser as

Mclean. The actual seller was apparently Constance, Countess of Romney, and the purchaser Thomas M'Lean, a London dealer patronized by George A. Hearn.); ❦ New York, American Art Association. *Notable Art Collection Formed by the Late George A. Hearn*. March 1, 1918, lot number 449, illustrated. ❦ Ball State, 1947, page 16. ❦ Graves, Algernon. *Art Sales: From Early in the 18th Century to Early in the 20th Century*. London: A. Graves, 1918-1921; reprint edition, New York: Burt Franklin, 1970, volume II, page 151.

RELATED WORKS
Sir Peter Lely (Pieter van der Faes). *Anne Hyde, Duchess of York*, circa 1660-1663, oil on canvas, 182 × 143 cm, Scottish National Portrait Gallery, Edinburgh, Scotland.

Sir Peter Lely (Pieter van der Faes). *James II Duke of York*, circa 1660-1663, oil on canvas, 182.2 × 143.8 cm, Scottish National Portrait Gallery, Edinburgh, Scotland. (The pendant to the portrait cited directly above. The pair of portraits in Edinburgh was executed shortly after the marriage was made public in December, 1660.)

Lely, Sir Peter (Pieter van der Faes). *Duke and Duchess of York*, circa 1663, oil on canvas, 162.5 × 188 cm, Petworth House, England.

REMARKS
The Muncie painting depicts Anne Hyde (1637-1671), daughter of Lord Chancellor Clarendon and first wife of James (1633-1701), Duke of York, afterwards James II. They had two children who became Queen Mary (1662-1694, reigned 1689-1694) and Queen Anne (1665-1714, reigned 1702-1714).

Lely's paintings of Anne Hyde, Duchess of York, were popular and readily salable. As would be expected, some were executed by the master and many more in varying sizes by his studio. The Lely sale catalogue (London, April 18, 1682) lists one half-length painting of the duchess by his own hand, and no fewer than ten half-lengths, one head, and a double half-length of the duke and duchess by his studio. Sixteen studio portraits of the Duke of York are also recorded in the catalogue.

Samuel Pepys (1633-1704), clerk of the acts and secretary to the admiralty, records a Lely portrait of the Duchess of York in his diary on March 24, 1666, as follows:

> . . . to White Hall to . . .
> After the Committee up, I had occasion to follow the Duke into his lodgings, into a chamber where

Pieter Nason

Dutch (1612-1688 or 90)
born Amsterdam or The Hague, Netherlands, 1612
died The Hague, Netherlands, 1688 or 1690

Portrait of a Lady, 1683

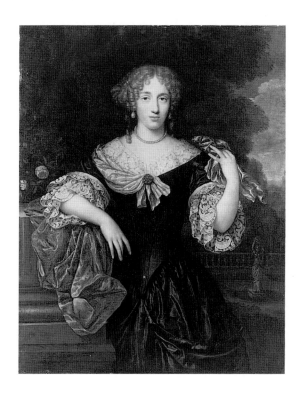

paint (oil) on canvas (linen)
124.0 × 100.3 cm; 48⅞ × 39½ inches

Permanent loan from the Frank C. Ball Collection, Ball
Brothers Foundation
L29.061

INSCRIPTIONS
Recto: signed in black oil paint, lower left (the PN in
monogram): P Nason f 1683.

Verso: inscribed in white chalk, canvas, upper right:
110 / 583; ❦ and in pencil, stretcher, upper member, left:
5/13/88 / 3; ❦ and in blue chalk, stretcher, upper member,
center: 60; ❦ and in pencil, stretcher, upper member,
center: 19; ❦ and in blue crayon, stretcher, vertical cross
member, top: 433.

Labels, etc.: bears remnant of a largely illegible white paper
label, stretcher, right member, center.

CONDITION and TECHNIQUE
The painting is glue lined to a second canvas. The canvas is
split at the tacking edge in some places. There are some
abrasions and losses to the original glazes, and multiple
layers of discolored varnish cover the work.

Antonio Molinari (or Mulinari)

Italian (1655-1704)
born Venice, Italy, 1655
died Venice, Italy, 1704

Adam and Eve, circa 1701-1704

(one of a pair of canvases; see also Antonio Balestra, *The Death of Abel*)

paint (oil) on canvas
120.5 × 150.0 cm; 47½ × 59 inches

Museum purchase with funds provided by the Joseph Johnson Charitable Trust and Richard and Dorothy Burkhardt
89.001

INSCRIPTIONS
Verso: inscribed in white paint, frame, upper member, left to right: 1816.3.1 "ADAM AND EVE" BY / CARLO LOTTI; ❦ and in black paint, frame, lower member, center: 19; ❦ and in black paint, frame, right member, lower center: BOX 61.

Labels, etc.: bears cream paper label, stretcher, left member, upper, inscribed: C-13 / ADAM AND EVE / BY /

CARLO / LOTTI; ❦ and white paper Whitney Museum of American Art label, stretcher, left member.

CONDITION and TECHNIQUE
The painting is paste lined to a second canvas support. There is cleavage, with small losses throughout, and multiple layers of extremely discolored varnish. Conserved, 1913, Pasquale Farina, Philadelphia, Pennsylvania.

PROVENANCE
Robert Fulton (1765-1815), Philadelphia, Pennsylvania, apparently acquired in England between 1804 and September, 1806; ❦ Robert Fulton, estate, Philadelphia, Pennsylvania, 1815; ❦ Pennsylvania Academy of the Fine Arts, Philadelphia, Pennsylvania, 1816 (deaccessioned in 1988).

EXHIBITIONS
Philadelphia, Pennsylvania Academy of the Fine Arts, November, 1807, on loan. ❦ Philadelphia, Pennsylvania

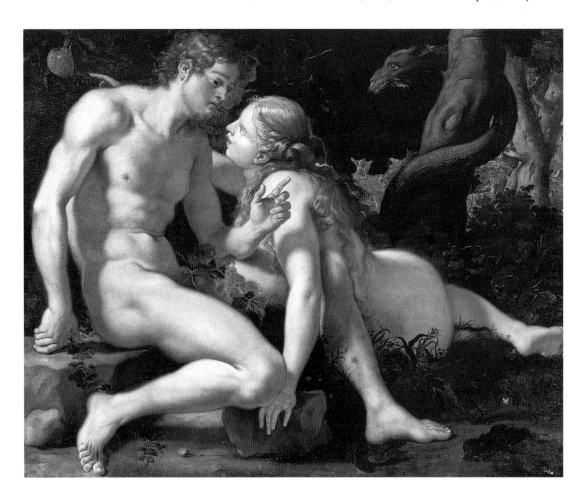

Academy of the Fine Arts, *Academy Annual*, 1811. ❧ Philadelphia, Pennsylvania Academy of the Fine Arts, between 1816 and 1870, the painting was exhibited in fifty-seven distinct exhibitions at the academy. Complete documentation of these exhibitions can be found in Rutledge (1955). ❧ New York, Whitney Museum of American Art. *Portrait of Young America: Paintings from the Pennsylvania Academy of the Fine Arts.* December 11, 1975-February 22, 1976, page 8, as by Johann Karl Loth.

REFERENCES
Letter from Robert Fulton dated Washington, November 4, 1807, to Charles W. Peale, "at the Museum, Philadelphia," The Historical Society of Pennsylvania, Philadelphia, Pennsylvania, Gratz Collection, case 7, box 3. "You will see by the invoice the boxes which contain the pictures and frames, and you will get them up in the gallery when and how you think proper." ❧ Fulton, Robert. "The Pennsylvania Academy of the Fine Arts." *American Daily Advertiser*, November 27, 1807, page 3, column 1, as unknown artist. ❧ Henderson. *The Pennsylvania Academy of the Fine Arts and Other Collections in Philadelphia* Philadelphia: 1911, page 159, as Carlo Lotti (J. Karl Loth), and as one of two pendant canvases (see also Balestra, *The Death of Abel*, 89.002). ❧ Rutledge, Anna Wells. *Cumulative Record of Exhibition Catalogues: The Pennsylvania Academy of Fine Arts, 1807-1870.* Philadelphia: The American Philosophical Society, 1955, page 132. ❧ Ewald, Gerhard. *Johann Carl Loth, 1632-1698.* Amsterdam: Menno Hertzberger, 1965, page 130, catalogue number 631, as a rejected work. ❧ New York, Whitney Museum of American Art. *Portrait of Young America, Paintings from the Pennsylvania Academy of the Fine Arts.* December 11, 1975-February 22, 1976, page 8, as Johann Karl Loth. ❧ New York, Christie's. *Important Paintings by Old Masters.* January 11, 1989, lot number 88, illustrated in color, as Antonio Molinari.

REMARKS
Robert Fulton purchased two Benjamin West paintings from Boydell's Shakespeare Gallery, London at Christie's, London, May 18-20, 1805. That the paintings were intended for the "museum" in Philadelphia was a poorly kept secret. In a letter to Barlow written in London, September, 1806, Fulton wrote: "My arbitration is finished and I have been allowed . . . [pounds] 15,000 . . . and [have] pictures worth two thousand pounds." Though Fulton departed for America in October, in his letter he informs Barlow of his intention to delay shipment of his collection: "All my pictures, prints, and other things . . . about April next, when the risk will be inconsiderable." In his November 27, 1807, article in the *American Daily Advertiser*, Fulton notes that the collection includes sixteen pictures. Given Fulton's travels and limited financial resources before his return to London on May 19, 1804, it is assumed that he acquired the remaining fourteen works in England between May, 1804, and September, 1806. (For the full text of Fulton's letter to Barlow see: Dickinson, Henry W. *Robert Fulton: Engineer and Artist, His Life and Works.* Freeport: Books for Libraries Press, 1971, pages 198-200.)

Balestra, Antonio

Italian (1666-1740)
born Verona, Italy, 1666
died Verona, Italy, 1740

The Death of Abel, circa, 1701-1704
(one of a pair of paintings; see also Antonio Molinari, *Adam and Eve*)

paint (oil) on canvas (linen)
120.5 × 150.0 cm; 47½ × 59 inches

Museum purchase, Margaret Ball Petty Memorial Fund
89.002

In silent communication *Adam and Eve* point out to one another the agents of their approaching downfall. Languidly draped across Adam's leg, Eve stretches toward the fruit, while Adam lifts his finger toward the dragon-faced serpent slithering up the tree behind Eve. *Adam and Eve's* sluggish gestures contrast with the implicit violence of *The Death of Abel*, the painting that continues the story. In this second canvas, Adam and Eve's son, victim of his brother's jealousy, sprawls across a pile of broken wood, clutching his bleeding temple.

Even though they are currently assigned to two different artists, scholars believe these two paintings were conceived as a pair. In the eighteenth century, paired pictures were a popular acquisition, having the decorative potential of hanging on either side of a door,

window, or fireplace. Perhaps these two hung on either side of a wide doorway. If you view the *Adam and Eve* from an acute angle from the right side of the painting, and *The Death of Abel* from a similar angle to the painting's left, the proportions of both Eve's bulging hip and Abel's elongated torso appear more accurate than when either of the paintings is viewed straight on. Historically, artists seem to have been acutely aware of the angles from which their finished works would be viewed, altering proportions and the play of light and shadow to accommodate intended points of view.

Pairing two pictures such as these also enhanced their collective content. In a 1989 lecture celebrating the museum's acquisition of these works, Leslie Griffin Hennessey noted, "The suspense of Adam and Eve's intimacy, moments before the apple is plucked, is all the more poignant when the death of their son, the fruit of their passion, is placed close at hand."

SOURCES
Haskell, Frances. *Patrons and Painters: A Study in the Relations Between Italian Art and Society in the Age of the Baroque.* Revised edition. New Haven and London: Yale University Press, 1980. ❦ Hennessey, Leslie Griffin. "Balestra, Molinari and the Venetian School of Painting." Lecture presented in celebration of the Ball State University Museum of Art acquisition of *Adam and Eve* and *The Death of Abel*, Ball State University, Muncie, Indiana, September 16, 1989. (Manuscript)

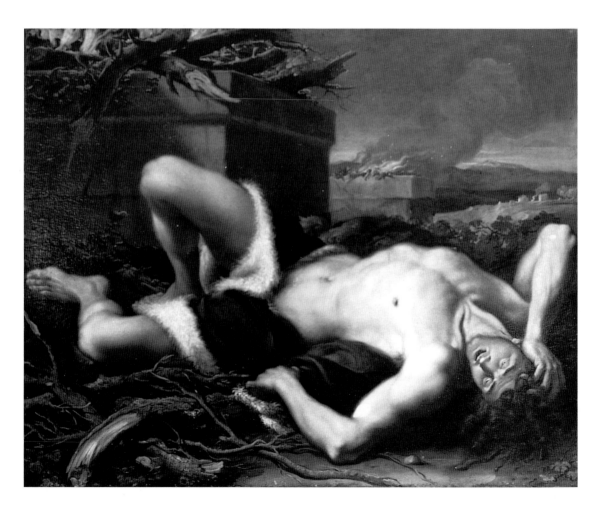

INSCRIPTIONS

Verso: inscribed in white paint, frame, upper member, left to right: 1816:3.2 DEATH OF ABEL-BY-CARLO LOTTI; ❦ and in black paint, frame, right member, center: B19; ❦ and in black paint, stretcher, upper member, right: B20; ❦ and in white paint, stretcher, lower member, right: 1816:3.2.

Labels, etc.: bears cream paper label, stretcher, left member, top, inscribed: C-11 / DEATH OF ABEL / BY / CARLO LOTTI.

CONDITION and TECHNIQUE

The painting is paste lined to a second canvas support. There is cleavage and there are small losses throughout and multiple layers of extremely discolored varnish. Conserved, 1913, Pasquale Farina, Philadelphia, Pennsylvania.

PROVENANCE

Robert Fulton (1765-1815), Philadelphia, Pennsylvania, apparently acquired in England between 1804 and September, 1806; ❦ Robert Fulton estate, Philadelphia, Pennsylvania, 1815; ❦ Pennsylvania Academy of the Fine Arts, Philadelphia, Pennsylvania, 1816 (deaccessioned in 1988).

EXHIBITIONS

Philadelphia, Pennsylvania Academy of the Fine Arts, November, 1807, on loan. ❦ Philadelphia, Pennsylvania Academy of the Fine Arts, *Academy Annual*, 1811. ❦ Philadelphia, Pennsylvania Academy of the Fine Arts, between 1816 and 1870, the painting was exhibited in forty-seven distinct exhibitions at the academy. Complete documentation of these exhibitions can be found in Rutledge (1955). ❦ New York, Whitney Museum of American Art. *Portrait of Young America; Paintings from the Pennsylvania Academy of the Fine Arts.* December 11, 1975-February 22, 1976, page 8, as by Johann Karl Loth.

REFERENCES

Letter from Robert Fulton dated Washington, November 4, 1807, to Charles W. Peale, "at the Museum, Philadelphia," The Historical Society of Pennsylvania, Philadelphia, Pennsylvania, Gratz Collection, case 7, box 3. "You will see by the invoice the boxes which contain the pictures and frames, and you will get them up in the gallery when and how you think proper." ❦ Fulton, Robert. "The Pennsylvania Academy of the Fine Arts." *American Daily Advertiser*, November 27, 1807, page 3, column 1, as unknown artist. ❦ Henderson. *The Pennsylvania Academy of the Fine Arts and Other Collections in Philadelphia* Philadelphia: 1911, page 159, as Carlo Lotti (J. Karl Loth) and as one of two pendant canvases (see also Molinari,

Adam and Eve, 89.001). ❦ Rutledge, Anna Wells. *Cumulative Record of Exhibition Catalogues: The Pennsylvania Academy of Fine Arts, 1807-1870.* Philadelphia: The American Philosophical Society, 1955, page 132. ❦ Ewald, Gerhard. *Johann Carl Loth, 1632-1698.* Amsterdam: Menno Hertzberger, 1965, page 130, catalogue number 633, as a rejected work. ❦ New York, Whitney Museum of American Art. *Portrait of Young America, Paintings from the Pennsylvania Academy of the Fine Arts.* December 11, 1975-February 22, 1976, page 8, as Johann Karl Loth. ❦ New York, Christie's. *Important Paintings by Old Masters.* January 11, 1989, lot number 88, illustrated in color, as Antonio Balestra.

RELATED WORKS

Antonio Balestra. *Morte di Abele*, n.d., chalk on paper, Accademia Nazionale di San Luca, Rome, Italy.

Antonio Balestra. *Cain and Abel*, circa 1698-1705, oil on canvas, 200 × 200 cm, Musei di Castelvecchio, Verona, Italy.

Antonio Balestra. *Cain and Abel*, 1733, oil on canvas, 174.6 × 162.5 cm, Sheffield Museum, Sheffield, England.

REMARKS

(See Antonio Molinari, *Adam and Eve*, for remarks on the pair of paintings.)

Antoine or Jean-Antoine Watteau, after François de Troy (1645-1730)

French (1684-1721)
born Valenciennes, France, October 10, 1684
died Nogent-sur-Marne, Flanders, July 18, 1721

Frère Blaise de Sainte-Marie Donât, circa 1714

paint (oil) on canvas (linen)
53.9 × 36.7 cm; 21³⁄₁₆ × 14½ inches
(or 20 × 14 pouces, see remarks)

Permanent loan from the E. Arthur Ball Collection, Ball Brothers Foundation
L51.206

INSCRIPTIONS
Verso: inscribed in red chalk, stretcher, upper right: 5542; ❦ inscribed in black ink, stretcher, crosspiece, center (though the painting has been lined, the original stretcher was re-used): Mme la Comte de la Roche-aymon / rue St. Guillaume no 29.

Labels, etc.: bears blue-bordered white paper label, stretcher, upper member center inscribed: Cte de Goyon; ❦ and blue-bordered white paper label, stretcher, lower member center, inscribed: 5542; ❦ and blue-bordered white paper label, frame, upper right inscribed: 466/5542 "Frère Blaise, Feuillant" OXXX/-.

CONDITION and TECHNIQUE
The painting is glue lined to a second canvas. There is a small amount of overpaint and the varnish is moderately disfiguring.

PROVENANCE
Comtesse de la Roche-Aymon (died 1832?), 29, Rue St. Guillaume, Paris, France; ❦ probably Antoine-Charles-Etienne-Paul, Marquis de la Roche-Aymon (1772–1849), Paris, France; ❦ Charles-Marie-Michel De Goyon, Duc de Feltre (September 14, 1844–January 19, 1930). (Charles-Marie-Michel de Goyon was the son of Charles-Martial-Augustin de Goyon and Oriane-Henriette de Montesquiou-Fezonsac; she was the daughter of Duc Raymon and Mathilde Clarke; in turn, Mathilde Clarke was the daughter of Henry-Jacques-Guillaume Clarke (1765–1818) and Elisabeth-Christiane Alexander. To date, no relationship has been found between the Roche-Aymon and Goyon families.); ❦ Wildenstein and Company Galleries, Paris, France and New York, New York, 1930; ❦ E. Arthur Ball, Muncie, Indiana; ❦ Ball Brothers Foundation, Muncie, Indiana, 1950.

EXHIBITIONS
London, Wildenstein and Company, Ltd. *Watteau and His Contemporaries.* 1936, unpaginated, catalogue number 32. ❦ Muncie, Ball State Teachers College Art Gallery. *Beneficence Continues: Paintings from the E. Arthur Ball Collection.* March 18–?, 1951, page 5, catalogue number 7.

REFERENCES
(Former accession number: AC-51-206.) ❦ Jullienne, Jean de. *L'Oeuvre d'Antoine Watteau Peintre du Roy en son Académie Royale de Peinture et Sculpture gravé d'après ses Tableaux & Desseins originaux Tirez du Cabinet du Roy & et des plus curieux de l'Europe par les Soins de M. de Jullienne.* Paris, n.d. (1735), volume I, plate 117 engraved by Benot Audran II. (The inclusion of the work within the oeuvre catalogue supports the attribution to Watteau. The engraved title reads: "de Troy pin.") ❦ Robert-Dumesnil, A.P.F. *Le peintre-graveur français.* Paris: G. Warée (and others), 1835–1871, volume VII, page 305, catalogue number 281. ❦ LeBlanc, Charles. *Manuel de l'amateur d'estampes.* Paris: P. Jannet, 1854–1890, volume I, page 78, catalogue number 29. ❦ Goncourt, Edmond and Jules. *L'Art au XVIIIᵉ Siècle.* Paris: 1859–1875, *Notules*, volume XII, page 27. ❦ Portalis, Baron Roger, and Henri Beraldi. *Les Graveurs du Dix-Huitième Siècle.* Paris, 1880, volume I, page 50, catalogue number 11. ❦ Dacier, Emile, and Albert Vuaflart. *Jean de Jullienne et les Graveurs de Watteau au XVIIIᵉ Siècle.* Paris: Société pour l'Etude de la Gravure Française, 1921–1929, volume II, 1922, page 58 and volume III, 1922, page 58, catalogue number 117, illustrated plate 117, as Watteau after de Troy. ❦ Wildenstein, Georges. "Une énigme dévoilée: le portrait de Frère Blaise Feuillant par Watteau." *Actes du XIVᵉ Congrès International d'histoire de l'art*, volume I, 1936, page 128, as Watteau after de Troy. ❦ Wildenstein, Georges. "Le portrait de Frère Blaise par Watteau." *Gazette des Beaux-Arts*, 1936, pages 149-155, illustrated pages 151 and 153, as Watteau after de Troy. ❦ Detroy, Paul. "François de Troy." *Etudes d'Art.* Musée National d'Alger, volume 12-13, 1955–1956, page 242. ❦ Adhemar, Helene. *Watteau, sa vie—son oeuvre.* Paris: Editions Pierre Tisne, 1950, page 220, catalogue number 150, illustrated plate 81, as Watteau after de Troy. ❦ Camesasca, Ettore, and Pierre Rosenburg. *Tout l'Oeuvre Peint de Watteau.* Paris: Flammarine, n.d. (1970), catalogue number 149, illustrated, as possibly Watteau. ❦ Camesasca, Ettore, Pierre Rosenberg, and John Sunderland. *The Complete Paintings of Watteau.* London: Weidenfeld and Nicolson, n.d. (1970), catalogue number 149, illustrated, as possibly Watteau. ❦ Frerre, Jean. *Watteau.* Madrid: Athena, 1972, volume 3, page 78, as possibly Watteau. ❦ Morse, John D. *Old Master Paintings in North America.* New York: Abbeville Press, n.d. (1979), page 298. ❦ Unpublished letter from Pierre Rosenberg dated Paris, October 14, 1983, suggesting an attribution to François de Troy. ❦ Posner, Donald. *Antoine Watteau.* Ithaca: Cornell University Press, 1984, page 289, note 30, as Watteau after de Troy. ❦ Michel, Marianne Roland. *Watteau: An Artist of the Eighteenth Century.* New York: Alpine Fine Arts Collection, Ltd., 1984, page 260, as Watteau after de Troy. ❦ Grasselli, Margaret Morgan, and Pierre Rosenberg. *Watteau, 1684-1724.* Paris: Editions de la Réunion de Musées Nationaux, 1984 (trans. Thomas D. Bowie, Washington: National Gallery of Art, 1984), pages 362 and 365, illustrated figure 2, as François de Troy.

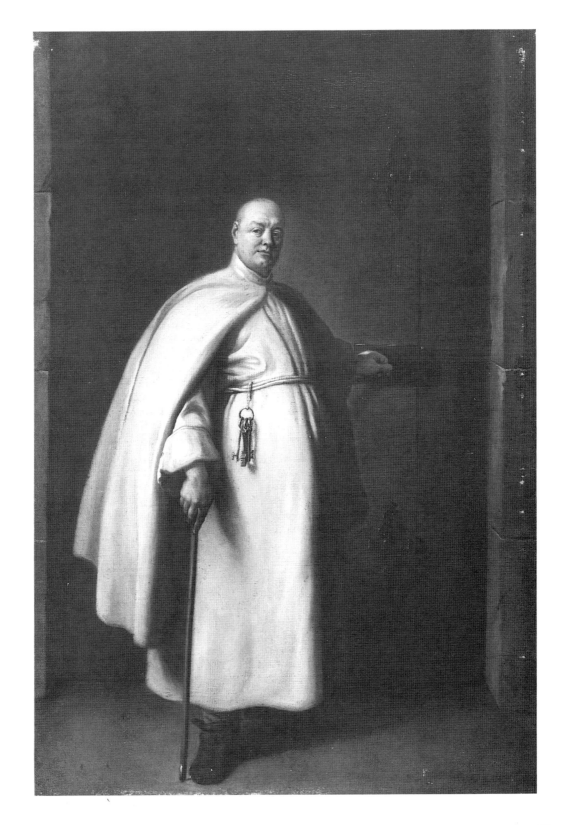

Benoit Audran, II (1700-1772). *Frère Blaise*, n.d., etching and engraving, 49.3 × 33.7 cm. (Portalis, 1880, catalogue number 11; Dacier, 1922, catalogue number 117). (The Audran etching after the Muncie painting was included in the Jean de Jullienne portfolio of the works of Watteau. For a complete discussion of the Jullienne portfolio, or *Recueil*, as it is typically called, see Dacier, 1922 and Michele, 1984.)

François de Troy (1645-1730). *Frère Blaise*, circa 1704, oil on canvas, approximately 48.7 × 37.9 cm, (or 18 × 14 pouces) former collection of Louis Bérault de la Haye (1677-1754), France, present location unknown. (Frère Blaise, né Bicellaire at Douanne, France, was caretaker of the Feuillants Convent, Rue St. Honoré, Paris. Apparently he joined the convent in October, 1672 and died January 25, 1709 or 1719).

REMARKS

The relationship between the Watteau and de Troy portraits of *Frère Blaise* is problematic. Assuming that the date of death for *Frère* Blaise is recorded correctly as 1709, the de Troy painting would have been executed circa 1704. Stylistically, the Muncie painting appears to be circa 1714, and it has been suggested that it was executed at the request of Jean de Jullienne, who later had it engraved by Audran for the *Recueil* or oeuvre catalogue. We note that Jullienne studied at the Academy briefly with François de Troy. Both Posner and Rosenberg had viewed the Muncie painting before 1984 and agreed with the attribution to Watteau. Later a Rosenberg student discovered a 1754 sale record for Louis Bérault de la Haye's collection which listed a *Mezetin* and a *Portier des Feuillants* (*Frère Blaise*) by François de Troy. Based on the description in the catalogue, Rosenberg (1983) suggested that the Muncie painting was the lost de Troy.

Though Rosenberg later published (Grasselli, 1984) the Muncie painting as a de Troy and identified the de Troy *Mezetin*, today in the Musée Condé, as the other painting sold as lot 105 in the Louis Bérault de la Haye sale, his conclusion is problematic. Hesitantly, we offer an alternative suggestion, that is plausible but indicates the need for additional research.

The provenance of the de la Haye *Mezetin* and *Portier des Feuillants* is as follows: Louis Bérault de la Haye (born December 30, 1677, died March 24, 1754); ☙ Madame de la Haye (née de Mézières), Paris, France, 1754; ☙ De la Haye sale, Paris, 1754. (*Catalogue de Tableaux, Bronzes, Marbres, et Desseins de Cabinet de feu Monsieur de la Haye*, lot number 105, "Deux Tableaux pendans peints sur

toile, par de Troy Pere, représentans l'un de *Portier des Feuillans*, l'autre *Mezetin*, de 18 pouces de haut sur 14 pouces de large, dans leurs bordurs dorées." The Frick Art Reference Library copy of the catalogue is annotated with prices and purchases. Lot numbers 99 through 105 are annotated: "de la Hay, retines."); ☙ possibly Madame de la Haye sale, Paris, 1778. (*Catalogue de Tableau Originaux de… après le décès de Madame veuve de M. de la Haye, Fermier-Général*, December 1, 1778, lot number 71, "Plusieurs tableaux que l'on détaillera." Unfortunately, the Frick copy of the 1778 catalogue is not annotated, and thus it is not possible to determine whether the lot included one or both of the de Troy paintings and if so, the purchaser(s).)

Little specific information is known about the de Troy *Mezetin* in the Musée Condé, Chantilly, France (oil on canvas, n.d., 47 × 38 cm, or 17.5 × 14 pouces, collection Lenoir). Though it is likely that the painting was once in the collection of Alexandre Lenoir and a part of his gift to the Louvre in 1817, there is no further provenance. That the painting was executed by de Troy and represents Angelo Constantini in the role of Mezetin is based upon the relationship between the painting and a Cornelis Martinus Vermeulen print (after the painting?) with an engraved title reading: "A. Constantini, dans le Rôlê de Mezetin, Corneille Vermeulen exc. F. del Roy pin." (Gruyer, F.-A. *Chantilly: Musée Condé, Notice des Peintures*. Paris: Braun, Clement et cie, 1899, pages 339-340.) The print would appear to date circa 1705-1707.

We hesitantly suggest that it is more likely that the Vermeulen print was executed after another de Troy *Mezetin* (the original? de Troy *Mezetin*): specifically, that sold in the Jean-François de Troy (1679-1752) sale, Paris, Didot, April 9-19, 1764. (*Catalogue d'une Collection de très beaux Tableaux, Desseins, et Estampes… Partie de ces effets viennent de la succession de feu Mr. J.B. de Troy…*, lot number 106, "François de Troy. Un *Mezetin*, dont on trouve l'Estampe qui a été gravée par Vermeulen: il est sur bois, et ponte 17 pouces de haut, sur 13 de large.") Note that the de la Haye *Mezetin* is listed as oil on canvas whereas this example is listed as on wood.

That we should expect to find multiple copies of some of de Troy's paintings is clear from the literature on de Troy (for example Detroy, 1955-1956, and Mercure de France, May 1, 1730) and on his students. Hubert Drouais (1699-1767), while a student of de Troy's, executed a large number of copies of de Troy portraits for his master. (Gabillot, C. "Les Trois Drouais." *Gazette des Beaux-Arts*, 1905, pages 182-183.) The list of assets that accompanied the February 3, 1750, marriage contract of the painter Villebois includes

two copies of François de Troy's portrait of his wife and copies of a de Troy *Notre Seigneur* and *La Samaritaine*. (Rambaud, Mireille. *Documents du Minutier Central Concernant L'Histoire de L'Art* (1700–1750). Paris: S.E.V.P.E.N., 1971, volume II, page 945.)

Little appears to be known about Louis Bérault de la Haye as a collector beyond the substantial list of works sold in 1754. Certainly he was in a position to acquire works directly from de Troy. Whether such works would have been "originals" or "copies" by de Troy or by de Troy's students is open to conjecture. So too is how "copies" by or after de Troy would have been recorded within his collection. Certainly the de Troy paintings recorded as lot 105 in the 1754 de la Haye sale were de Troy compositions. Whether they were originals completed by the master is perhaps open to debate. Are we on firmer footing if we assume that the *Mezetin* in the Jean-François de Troy sale is an original by his father François de Troy?

In absence of a complete provenance for the *Mezetin* today in the Musée Condé, it is not possible to be certain that it is one of the two paintings in the de la Haye sale. Although the provenances of the Muncie painting and the pair in the de la Haye sale are more complete, if used to ascertain whether they record two distinct paintings of Frère Blaise or the same work, the provenances remain inconclusive.

On stylistic grounds, the Muncie painting has traditionally been assigned to Watteau. Its appearance in the Jullienne *Recueil* or oeuvre catalogue supports the attribution, whereas the engraved title "de Troy pin" raises questions not easily set aside. The prevalence of copies by and after de Troy offers an answer but requires further examination. We suggest that the Muncie painting is indeed a Watteau copy after a lost de Troy original as was proposed by Wildenstein (1936). Hesitantly, we suggest that the de Troy *Mezetin* today in the Musée Condé is a copy of the de Troy *Mezetin* once owned by Jean-François de Troy and sold in 1764 and that it is this "original?" that is recorded in the print by Vermeulen. A critical issue remains: does the "original?" *Mezetin* face left as in the print and the Musée Condé painting, or right, as would be expected given the mirror image reversal of the majority of reproductive prints? If the Vermeulen print reverses the de Troy "original?," the Musée Condé *Mezetin* was certainly executed after the print and not the painting. We further suggest that the authorship of the *Mezetin* today in the Musée Condé deserves thorough examination. On stylistic grounds, it is tempting to relate the Musée Condé *Mezetin* to Watteau's early paintings and to his circa 1709–1710 drawings for the *Figures de Modes* and circa 1709–1715 drawings for the *Figures Françoises et comiques*.

Jean-François de Troy

French (1679-1752)
born Paris, France, January 27, 1679
died Paris, France, January 26, 1752

Vertumnus Wooing Pomona,
circa 1717-1723

paint (oil) on canvas
153.0 × 119.0 cm; 60¼ × 46¾ inches

Lent by David T. Owsley
L91.042.1

Disguised as an elderly woman, the god Vertumnus gazes longingly into the eyes of the nymph Pomona as he clasps her fair hand in his own. For her part, Pomona, with lowered eyelids, appears to acquiesce. Like many of Jean-François de Troy's paintings, this work is based on a tale from Ovid's *Metamorphoses* (14:623-697, 765-771), an ancient anthology of myths devoted to the theme of physical transformation.

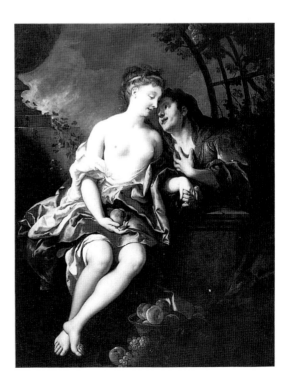

In Ovid's tale, a young god, Vertumnus, must take on the appearance of an old woman to be able to profess his love for the wood nymph Pomona, who daily tended her beloved gardens, shunning her many suitors. In the painting, as in the story, the two sit in Pomona's orchard as Vertumnus, having gained access to Pomona through his womanly disguise, proclaims his love. According to the story, in his now female form, the god kissed Pomona, admired her autumn gardens, and praised a handsome young man named Vertumnus, who loved her deeply.

Ovid's *Metamorphoses* was one of de Troy's favorite sources of subject matter, and, as was his tendency, the painter here takes a few liberties with the story. In de Troy's painting, Pomona appears compliant, whereas in Ovid's version, when the disguised Vertumnus explained his secret passion to the nymph, she remained unmoved. According to Ovid, it was only after the young god returned to his true, masculine form that Pomona, seeing him in all his glory, fell instantly in love.

Throughout his career, de Troy painted scenes based on Ovid's tales for wealthy Parisian patrons. Son of a popular portrait painter, by the 1720s Jean-François was exhibiting canvases based on the *Metamorphoses* at the official French exhibition, the Salon, and amassing a rapidly growing list of clients. These included Louis XV and Marie Leczinska, for whom he decorated rooms at Versailles and Fontainebleau. Despite his work for the king and queen, he was denied an official court appointment, regarded as confirmation of an artist's worth and prowess. Nevertheless, de Troy enjoyed an immensely successful career as a painter of decorative mythologies like *Vertumnus Wooing Pomona*.

SOURCES
Bordeaux, 1989. ❦ Talbot, William. "Jean-François de Troy: Pan and Syrinx." *Bulletin of the Cleveland Museum of Art*, number 61, October, 1974, pages 250–259.

INSCRIPTIONS
Recto: signed in black oil paint, right edge, center: de Troy filius pinxit.

Verso: inscribed in white chalk, stretcher, upper member: Rel 3-6-88 E 1562 Per La Vascongada SL.

Labels, etc.: bears blue-bordered rectangular white paper label, stretcher, right member, bottom inscribed: 2; ❦ and white paper label, cut from a publication, stretcher, upper member, center, printed: TROY (JEAN-FRANÇOIS DE.) / 41.-Vertumne et Pomona. / Allegorie. / T.-H. 1m, 70. L., 1m, 21.

PROVENANCE
Apparently an unidentified collection, Northern Spain; ❦ David T. Owsley, New York, New York, 1989.

EXHIBITIONS
Muncie, Ball State University Museum of Art. *The Renaissance Tradition*. September 8–October 13, 1991, no catalogue.

REFERENCES
New York, Sotheby's. *Important Old Master Paintings*. January 12, 1989, lot number 158, illustrated in color. ❦ Bordeaux, Jean-Luc. "Jean-François de Troy—Still an Artistic Enigma: Some Observations on His Early Work." *Artibus et Historiae*, NR 20 (x), Vienna, 1989, page 147.

RELATED WORKS
Antoine Coypel (engraved by B. Audran). *Vertumne et Pomone*, circa 1695–1705, oil on leather, 29.8 × 21.7 cm, former collection of Pierre Crozat, Paris, to Hermitage, St. Petersburg in the 1772 and published in the 1774 catalogue, present location unknown.

Attributed to Antonio Montauti

Italian (circa 1685–after 1748)
born Florence, Italy, circa 1685
died Florence, Italy, circa 1748

A Male Saint (probably *Thomas Aquinas*), circa 1725

ceramic (terra cotta)
47.0 × 23.5 × 18.5 cm; 8½ × 9¼ × 7¼ inches

Gift of John W. and Janice B. Fisher
92.038.11

As if caught in a lofting wind, the drapery of this standing saint seems to almost lift the figure off its base. The grace of the figure's gesture and pose place it within the tradition of later Baroque/early Rococo sculpture, and the material relates it to the preparatory stages of a full-scale sculpture. Relatively small in scale, this sculpture—made of baked earthenware clay called terra cotta—may have been made in preparation for the carving of a monumentally sized figure. This standing saint serves as an excellent example of early eighteenth-century sculpture in Italy while providing clues to the working methods of sculptors.

In the eithteenth century, sculptors continued to execute large-scale projects for churches as devotion to saints remained strong in the Catholic countries. But before carving a monumentally sized marble statue, sculptors prepared maquettes: highly finished, small-scale versions—usually of terra cotta—of the final composition. Consistent with the typical maquette in material, size and degree of finish, works like the Muncie figure could be presented to patrons for approval and also serve as a guide to studio assistants carrying out the actual carving of the finished work. Relatively soft and prone to breakage, terra cotta in such an expansive form rarely survives the centuries intact.

Wearing a friar's robe, his head shaved in a tonsure—a reference to the relinquishing of worldly vanity—this figure may represent the Dominican saint, Thomas Aquinas. Canonized in 1323, Aquinas is usually—and uniquely among the saints—identified by the sun on his chest. Here, rays of light have been transformed into a smiling-faced sun pendant that hangs around the figure's neck. Additional attributes include the book in his left hand and the volumes stacked at his feet. As the author of the theological treatise *Summa theologica*, Thomas Aquinas is often shown with books, a reference to his learning and scholarship.

Less commonly associated with Aquinas, the miter (typically worn by bishops, and, in unadorned form, by abbots) behind the figure's left foot appears in some images of the saint from this era; it may be included to indicate his position in Catholicism as one of the doctors of the Church. Usually held by martyred saints as a reference to their victory over death, the palm branch in the figure's left hand remains a mystery. Aquinas was not a martyr; he died quietly while attending the Council of Lyon in 1274. Since the terra cotta was probably a preliminary step in the preparation of a larger work, the mistake in symbolism may have been corrected in the later version (to date, no related carved figure has come to light to confirm or refute this hypothesis).

Finally, the saint raises his hand in a gesture associated with both blessing and teaching. Along with the Franciscans, the Dominicans were one of the earliest preaching orders, dedicated to spreading the faith. With his slightly forward-leaning pose and outstretched forearm, the saint appears to be in the act of preaching as he consults the volume on his hip.

Born in Florence, Italy, around 1685, Antonio Montauti spent his early career as a maker of

commemorative and portrait medals. By the early 1720s he was sculpting portrait busts for important patrons. At mid decade and into the 1730s he participated in a number of important projects alongside other sculptors from Florence and Rome, including a sculpture program commissioned by King John V of Portugal for the basilica he built at Mafra, and the monumental sculpture program for the niches lining the walls of St. Peter's in Rome, called the "Founders Series."

Throughout the seventeenth and eighteenth centuries the religious orders were important art patrons. At the beginning of the seventeenth

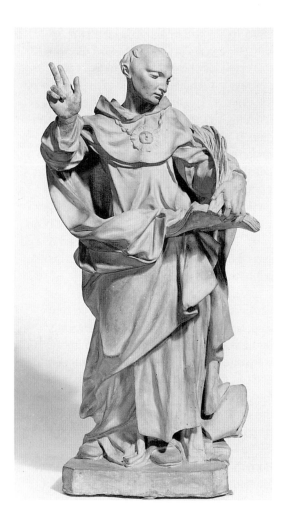

century they began commissioning monumental sculptures for the niches of St. Peter's representing their respective founders. For their niche in the series, the monks from the Benedictine mother house at Monte Cassino ordered a sculpture of St. Benedict from Montauti, which the artist completed in 1735.

Like Ball State's sculpture, Montauti's *Saint Benedict* displays similar overly large and squarish hands and feet. For the pose, Montauti looked to another sculpture from the Founder's series, the statue of *Saint Dominic* (founder of the Dominican order) by the French sculptor Le Gros (commissioned in 1701 and completed in 1706)—the first sculpture commissioned for the series. Le Gros's *Dominic* and Ball State's terra cotta share the upraised right hand and the left hand holding the top of an open book that the saint props against his hip, but in contrast to the earlier work, the terra cotta conveys a mood of greater calm.

Aquinas's torso turns slightly to his left; this turn continues through his shoulders and culminates in the position of his head. This gentle turning marks a difference between Baroque sculpture of the seventeenth century and its offspring of the eighteenth. Whereas Baroque figures often exhibit an agitated spiral resulting from a twist and countertwist of shoulders and hips, this dramatic pose becomes softened during the eighteenth century. Early eighteenth-century Italian sculpture like Montauti's *Aquinas* sits on a stylistic cusp between the energized Baroque and the more lighthearted and playful eighteenth-century style called *Rococo.* Some scholars call this transitional style "Barochetto." In contrast to Baroque sculpture, early eighteenth-century Italian sculpture tends toward greater grace and elegance: here the cloak wafts gently about his body, and his face wears a soft, melancholy expression seen on many sculptures of the time.

SOURCES
Engass, Robert. *Early Eighteenth-Century Sculpture in Rome*. University Park: The Pennsylvania State University Press, 1976. ❦ Held, Julius S., and Donald Posner. *Seventeenth and Eighteenth-Century Art: Baroque Painting, Sculpture, Architecture. Library of Art History Series*, H.W. Janson, ed. Englewood Cliffs, New Jersey: Prentice-Hall, 1971; New York: Abrams, 1971. ❦ Male, Emile. *L'Art Religieux de la Fin du XVIe Siècle, du XVIIe Siècle, et du XVIIIe Siècle: Etude sur L'Iconographie Apres le Concile de Trente, Italie—France—Espagne—Flandres*. Paris: Librairie Armand Colin, 1951. ❦ Reau, Louis. *Iconographie de l'art chrétien*. Tome 3, *Iconographie des saints*. Paris: Presses Universitaires de France, 1955-1959.

INSCRIPTIONS
Inscribed in black ink, base underside: 12179; ❦ and in red ink, base underside: 9341.

Labels, etc: bears white paper label on base, back, typed (now in object file): TC 45.

CONDITION and TECHNIQUE
The figure's right hand has been broken at the wrist and re-attached, and the second finger of the right hand has been broken and re-attached. The terra cotta appears to be modelled solid rather than cast and/or constructed in parts.

PROVENANCE
Private collection, America; ❦ Michael Hall Fine Art, New York, New York, circa 1970-1980.

EXHIBITIONS
Muncie, Ball State University Museum of Art. *Objects of Desire: A Vision for the Future*. October 11-November 8, 1992, no catalogue.

REFERENCES
Michael Hall Fine Art inventory number TC2.18, as Antonio Corradini, *Unidentified Saint*.

RELATED WORKS
Pierre Le Gros. *Saint Dominic*, 1701-1706, marble, larger than life size, St. Peter's, Rome, Italy.

Antonio Montauti. *Saint Benedict*, 1735, marble, larger than live size, St. Peter's, Rome, Italy.

REMARKS
The figure carries a palm, a reference to martyrdom, although Aquinas was not a martyr. Popular legend, however, held that Aquinas was poisoned—an anecdote to which Dante refers in the *Purgatorio*. Montauti's contemporary biographer notes that the artist owned a copy of the *Divine Comedy*, possibly the artist's source for an erroneous reference to Aquinas's murder.

Jean-Baptiste-Siméon Chardin

French (1699-1779)
born Paris, France, November 2, 1699
died Paris, France, December 6, 1779

La Serinette, circa 1751
(*Dame variant ses amusements; The Bird-Song Organ; Lady Varying Her Amusements*)

paint (oil) on canvas (linen)
50.0 × 42.5 cm; 19⅝ × 16¾ inches

Permanent loan from the E. Arthur Ball Collection, Ball Brothers Foundation
L51.199

INSCRIPTIONS
Verso: inscribed in blue ink, stretcher (probably original), upper member, center: 5264; ❦ inscribed in light blue-brown ink (in an old hand), upper member, left: No. 30; ❦ frame (probably original), blind stamped, upper member, center: JBL.

Labels, etc.: bears remnant of 18th century canvas, tacked to stretcher, cross member, center, inscribed in brown ink: Chardin; ❦ bears remnant of 18th century canvas, stamped, upper member, center: (illegible); ❦ bears blue-bordered white paper tag, frame, upper member, left: 5264.

CONDITION and TECHNIQUE
The painting is paste lined to a second canvas. There is a restored hole in center right of the sitter's skirt and overpaint on the sitter's face, right. The varnish has yellowed and the retouchings have discolored.

PROVENANCE
Etienne-François, Comte de Stainville, Duc de Choiseul, Château de Chanteloup, Indre-et-Loire, France; ❦ Duc de Choiseul estate, Château de Chanteloup, Indre-et-Loire, France, May 8, 1785; ❦ probably Louis-Jean-Marie de Bourbon, Duc de Penthièvre, Château de Chanteloup, Indre-et-Loire, France; ❦ probably Duc de Penthièvre estate,

Château de Chanteloup, Indre-et-Loire, France, March 4, 1793; ❧ Charles-Antoine Rougeot (founder and director of the Musée de Tours and author with his son-in-law Jean-Jacques Raverôt of the inventory of the Château de Chanteloup drawn up on March 19, 1794, for the department d'Indre-et-Loire, France), Tours, France, 1794; ❧ Jean-Jacques Raverôt (son-in-law of Rougeot), Tours, France; ❧ M. Raverôt, Jr., Loches, France; ❧ M. Augéard (grandson of Raverôt, Jr.), Châtellerault, France, 1932; ❧ Wildenstein and Company Galleries, Paris, France, and New York, New York; ❧ E. Arthur Ball, Muncie, Indiana; ❧ Ball Brothers Foundation, Muncie, Indiana.

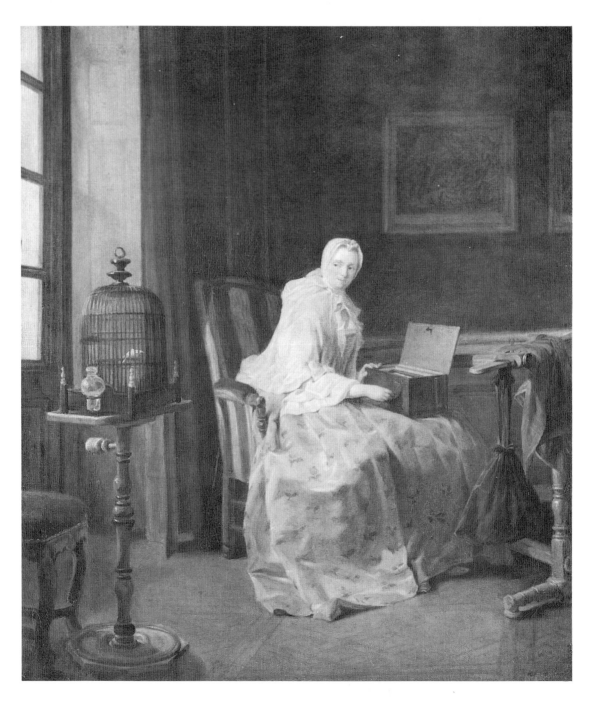

EXHIBITIONS

Muncie, Ball State Teachers College Art Gallery. *Beneficence Continues: Paintings from the E. Arthur Ball Collection.* March 18, 1951, page 4, catalogue number 4. ❦ Notre Dame, The Art Gallery, University of Notre Dame. *18th Century France: A Study of Its Art and Civilization.* March 12–May 15, 1972, catalogue number 18.

REFERENCES

(Former accession number: AC-51-199.) ❦ Seen in Tours, France, in 1854 by M. Clément de Ris, and described in a letter to Bocher (see below, Bocher and remarks). ❦ Bocher, E. *Les Graveurs Françaises du XVIIIᵉ Siècle.* Paris, 1875–1882, volume III, page 50, number 47. ❦ Wildenstein, Georges. *Chardin.* Paris, les Beaux-Arts, 1921, page 178, catalogue number 264, illustrated. ❦ The Frick Collection. *The Frick Collection: An Illustrated Catalogue,* volume II, *Paintings.* New York: The Frick Collection, 1968, pages 40–47. ❦ Wildenstein, Georges. *Chardin.* Revised and enlarged edition, David Wildenstein, Greenwich: New York Graphic Society, 1969, page 197, number 228, illustrated page 196. ❦ Morse, John D. *Old Master Paintings in North America.* New York: Abbeville Press, n.d. (1979), page 48. ❦ Rosenberg, Pierre. *Chardin: 1699–1779.* Paris: Editions de la Réunion de Musées Nationaux, 1979, pages 285–289, illustrated page 286 (English edition, Cleveland Museum of Art in Association with Indiana State University Press, 1979, pages 286–290, illustrated page 186). ❦ Nakayama, Kimio. *Sekai No Meiga (Les Grands Maîtres de la Peinture Occidentale)*, volume 19, *Chardin.* Tokyo: Chao Koron-sha and Japan Art Center, Inc., 1981. ❦ Rosenberg, Pierre. *Tout l'Oeuvre Peint de Chardin.* Paris: Flammarion, 1983, catalogue number 133B, illustrated.

RELATED WORKS

Jean-Baptiste-Siméon Chardin. *La Serinette* or *Dame Variant ses Amusements,* 1751, oil on canvas, 50 × 43 cm, Musée du Louvre, Paris, France. (For a comprehensive discussion of the Louvre version see Rosenberg, 1979 and 1983.)

Jean-Baptiste-Siméon Chardin. *Lady with a Bird-Organ* or *La Serinette,* 1751?, oil on canvas, 50.8 × 43.2 cm, The Frick Collection, New York, New York. (For a comprehensive discussion of the Frick version see The Frick Collection, 1968, and Turner, Evan H. "La Serinette by Jean-Baptiste Chardin: A Study in Patronage and Technique." *Gazette des Beaux-Arts,* May–June, 1957, pages 299–310.)

Laurent Cars. *La Serinette,* circa 1753, etching on paper, dedicated to the Marquis de Vandières; Portalais and Beraldi number 1. (The Cars etching reproduces the version of the
painting exhibited in the Salon of 1751, and is illustrated in Normand, Charles. *Les Artistes Célèbres, J.-B. Siméon Chardin.* Paris: Librairie de l'art, n.d., page 58. The fallen embroidery thread that appears on the sitter's lap in the etching appears in both the Frick and Louvre paintings but not the Muncie painting.

REMARKS

Pierre Rosenberg (1983) accepts three versions of the composition, but Wildenstein (Wildenstein, 1921 and 1969) catalogues only the Frick and Muncie versions. (Rosenberg viewed the Muncie version in 1983.) Until the 1979 exhibition, the Frick version had generally been considered to be the one that was exhibited in the Paris Salon of 1751. Rosenberg proposes in the catalogue of the 1979 exhibition that it is the Louvre version (then in a Paris private collection) that was exhibited in the Salon and thus moves much of the early provenance of the Frick painting to the Paris version. He does, however, note that the Frick version's provenance is surely Houdetôt and Morny.

Bocher (1875–1882) quotes an 1854 letter from Clement de Ris wherein he finds the Muncie version very superior to the one in the Morny sale. "M. Clément de Ris… m'a écrit avoir vu à Tours en 1854 une répétition de *la Serinette* bien supérieure à cella de la vente Morny." At that date, the Muncie painting was owned by Jean-Jacques Raverôt. The earlier provenance of the Muncie version, as published by Wildenstein (1921 and 1969), is unfortunately problematic.

On December 22, 1750, Etienne-François, Comte de Stainville, Duc de Choiseul, married Louise-Honorine Crozat du Chantel, the paternal granddaughter of Antoine Crozat (Crozat the Rich as distinguished from Pierre Crozat, called Crozat the Poor). The wedding reception took place in the Hotel Crozat on the Rue de Richelieu, a residence the couple later inherited with a considerable portion of the Crozat fortune.

As early as 1750, the Duc de Choiseul was collecting works of art and amassed a considerable collection in subsequent decades. In April, 1772, with the loss of the king's support ("lettre de cachet" dated December 24, 1770) and the resulting financial difficulties, the Duc de Choiseul was forced to sell a significant portion of the collection installed in his Paris home. On February 24, 1761, Choiseul had purchased the Château de Chanteloup close to Amboise, France; the significant collection housed there was not included in the 1772 sale. Shortly after Choiseul's death on May 8, 1785, the chateau and the majority of its contents were sold to Louis-Jean-Marie de Bourbon, Duc de Penthièvre. (In 1783 or 1784, Choiseul had initiated

negotiations to sell Chanteloup. These were interrupted by his death and later concluded by his executor.) The Duc de Penthièvre died March 4, 1793. Chanteloup was inherited by his daughter. Penthièvre's wife, Louise-Honorine, retired to the Convent des Recollets, Paris, with a single servant. Louise-Honorine died in 1801.

The March 19, 1794, inventory of the Château de Chanteloup does not include the Muncie painting (Nouvelles Archives de l'Art Francais, 1879, pages 186-192, also including the contents of the Château d'Amboise). Moreover, it must be noted that the inventory records the possessions of the recently deceased Duc de Penthièvre, and not Choiseul's possessions. Thus, there appears to be no documentation for the Choiseul ownership of the painting.

The 1794 inventory does, however, list a number of works that are documented elsewhere as having been owned by Choiseul, and it is recorded that Penthièvre acquired most of its contents when he purchased the Château de Chanteloup in July, 1786. Penthièvre's daughter, Louis-Marie-Adelaïde de Bourbon Penthièvre, the wife (April 5, 1769) of Louis-Philippe-Joseph d'Orléans, Duc de Chartres, inherited Chanteloup on March 4, 1793. The Muncie painting is not listed in the inventories of works seized during the revolution from either the Penthièvre or d'Orléans families. Nor is it listed among the works returned to Madame Bourbon-Penthièvre, wife of the Duc d'Orléans on April 22, 1796.

A careful reading of the 1794 inventory provides a clue to the probable provenance of the Muncie painting. It is critical that we recognize that the "Inventaire des tableaux et objets d'art des Châteaux d'Amboise et de Chanteloup (29 ventose an II-19 mars 1794)" is not an itemized inventory of the contents of either residence. First, its authors inform the reader that the listed works are those "que nous ayons trouvé dans ledit ci-devant châteaux de Chanteloup, qui puissent être consideres utiles aux sciences et aux art." Unfortunately, the criteria used to identify that which was "considered useful to the sciences and arts" are absent.

The authors of the inventory further inform the reader that the inventory does not include "les tableaux et autres objects qui sont déposés dans le garde-meuble, dans lequel nous n'avons pu entre, étant scellé du scel du juge de paix qui s'est trouvé absent." that are scheduled for sale. Though the authors note that the district commissioners agreed to postpone the sale and allow those works "considered useful" to be identified, the inventory ends with the paintings and other objects stored in the garde-meuble secured under a court seal, not examined and not inventoried.

For a chateau of eighty-four guest bedrooms, each with a dressing room, and some larger apartments, the 1794 inventory lists surprisingly few works. We also note that those listed in the inventory tend to be large and less mobile. The larger part of the collections, a collection formed by the Duc de Choiseul and added to by the Duc de Penthièvre, would appear to have been removed to the garde-meuble before March 19, 1794. Assuming that Wildenstein is correct in listing a Choiseul, Château de Chanteloup and a Rougeot provenance, the work was probably purchased by Rougeot sometime after March 19, 1794 but before April 22, 1796. To date, documentation of the sequence of events that must have included the examination of the contents of the garde-meuble for those works "considered useful" and the disposition of the remainder of the collection has proven elusive.

Francesco Guardi

Italian (1712-1793)
born Venice, Italy, 1712
died Venice, Italy, 1793

Capriccio arco rovinato e una villa nello sfondo, circa 1760-1770
(*Veduta di fantasia*)

paint (oil) on canvas (coarse weave)
34.0 × 51.4 cm; 13⅜ × 20¼ inches

Permanent loan from the Frank C. Ball Collection, Ball Brothers Foundation
L29.044

INSCRIPTIONS
Verso: inscribed in blue crayon, stretcher, lower member, center: 213; ✷ and in blue crayon, frame, upper right corner: 365; ✷ and in blue crayon, frame, lower member, right: 213 B (?); ✷ and in blue crayon, frame, right member, lower: 213 Boy Gla n (?).

Labels, etc: bears white paper Thomas M'Lean, London, label, frame, lower member, center.

CONDITION and TECHNIQUE

The ground is composed of reddish-brown earth, quartz, and calcium carbonate in an oil medium. The paint layers are coarsely ground pigments in an oil medium; pigments include natural ultramarine blue, vermillion, orpiment, white lead, calcium carbonate, calcium sulphate, and bone black. There are a moderate number of small losses throughout and the surface has been moderately abraded. Conserved, 1992, Intermuseum Conservation Association, Oberlin, Ohio.

PROVENANCE

Thomas M'Lean, London, England; ❧ George A. Hearn, New York, New York, before 1904; ❧ George A. Hearn estate, New York, New York, 1917; ❧ Frank C. Ball, Muncie, Indiana, 1918; ❧ Ball Brothers Foundation, Muncie, Indiana, 1936.

REFERENCES

(Former accession number: AC-29-44.) ❧ Simonson, George A. *Francesco Guardi, 1712-1793.* London: Methune and Company, n.d. (1904), page 93, catalogue number 176, as

Francesco Guardi. ❧ Hearn, George A. *Catalogue of the Collection of Foreign and American Paintings Owned by Mr. George A. Hearn.* New York: privately printed (The Gilliss Press), 1908, page 150, catalogue number 189, as Francesco Guardi. ❧ New York, American Art Association. *Notable Art Collection Formed by the Late George A. Hearn.* March 1, 1918, lot number 365, illustrated, as Francesco Guardi. ❧ Ball State, 1936, page 4, as Francesco Guardi. ❧ Ball State, 1947, page 13, as Francesco Guardi. ❧ Fredericksen, Burton B., and Federico Zeri. *Census of Pre-Nineteenth-Century Italian Paintings in North American Collections.* Cambridge, Massachusetts: Harvard University Press, 1972, page 96, as school, shop, or studio of Francesco Guardi.

RELATED WORKS

Francesco Guardi. *Capriccio con arco rovinato e una villa nello sfondo,* circa 1760-1770, oil on canvas, 30.5 × 49 cm. A.E. Hamill Collection, Ackland Museum of Art, Chapel Hill, North Carolina (Morassi catalogue number 987). (Morassi, Antonio. *Guardi: Antonio e Francesco Guardi.* Venice: Alfieri Edizioni D'Arte, 1973, volume I, catalogue numbers 987, 988, and 989, volume II figures 870, 871, and 872.)

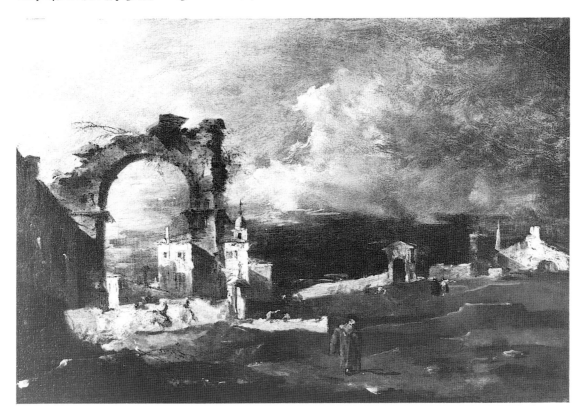

Francesco Guardi. *Capriccio con arco rovinato e una villa nello sfondo*, circa 1760-1770, oil on canvas, 33 × 50 cm, Galtrucco Collection, Milan (Morassi catalogue number 988).

Francesco Guardi. *Veduta di fantasia*, circa 1760-1770, pen and ink on paper, 19 × 26.2 cm, Correr Museum, Venice, Italy (Moschini figure 123). (Moschini, Vittorio. *Francesco Guardi*. Milan: Aldo Martello, 1952, figure 123.)

REMARKS

The Muncie painting is apparently a study for, or simply another version of, paintings with the same title in the Galtrucco Collection (which is itself a pendant to another work in the same collection, Morassi catalogue number 989) and in the Hamill Collection. With minimal alterations, the Muncie work appears to be based directly on the drawing in the Correr Museum, Venice, Italy. While also close to the Correr drawing, both the Galtrucco and Hamill paintings differ in architectural details and in the number and placement of the figures. These alterations support identification of the Muncie painting as perhaps an intermediary between the drawing and other versions of the composition.

François-Hubert Drouais

French (1727-1775)
born Paris, France, December 14, 1727
died Paris, France, October 21, 1775

Marquise de Caumont-La Force, 1767

paint (oil) on canvas (linen)
99.1 × 80.3 cm; 39 × 31⅝ inches

Permanent loan from the E. Arthur Ball Collection, Ball Brothers Foundation
L51.200

Garbed in a lavish rose-colored gown that spreads to fill the bottom of the painting, the *Marquise de Caumont-La Force* gazes benignly from the intimacy of her chambers. In 1767, the year she sat for this portrait, the marquise was officially presented to the court of Louis XV (1710-1774). This formal introduction to the king may have occasioned her being recorded by one of the court's most fashionable portraitists: François-Hubert Drouais.

During Louis XV's reign, Drouais was much sought after as a painter, especially of women and children. In an age that admired "good manners" in painting, patrons valued Drouais's portraits for their faithful and attractive likenesses. Appointed as a portraitist to the court of Louis XV, Drouais became the favorite painter of the king's mistress, Madame de Pompadour (1721-1764), herself an important patroness of the arts. In addition to Mme. de Pompadour, Drouais painted Madame du Barry, another of Louis's mistresses, in 1765, 1769, and 1774, and other members of the royal family and the aristocracy.

Drouais's painting of the *Marquise de Caumont-La Force* is typical of eighteenth-century portraiture: accessories are kept to a minimum, and the pose is relatively informal. As in many female portraits of that era, the marquise's embroidery table figures prominently, evidence of her industriousness and skill, needlework being one of the few acceptable pastimes for a gentlewoman.

Some of Drouais's critics deprecated his paintings as being superficially pleasant and overly sweet, lacking in the revelatory spark of the sitter's personality that would make the work come alive. Yet scholars report that for most of Drouais's contemporaries, the appeal of the sitters themselves was what truly mattered. In the eighteenth century, the merit of a painting was inseparable from the merit of the subject matter. When Drouais exhibited a portrait of two court children (see remarks) at the Salon in 1763, it was considered one of the exhibition's best works. According to members of the court, the

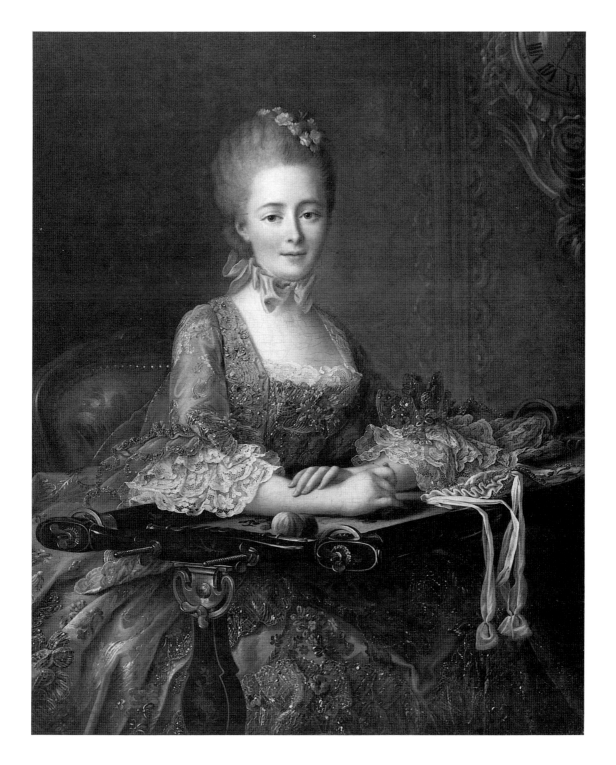

two were "the cutest one could see." When captured by Drouais's brush, the success of the sweet children translated into success for the painter.

SOURCES
Kalnein, Wend Graf, and Michael Levey. *Art and Architecture of the Eighteenth Century in France. The Pelican History of Art.* Harmondsworth, Middlesex: Penguin Books Ltd., 1972. ❦ Rosenberg, Pierre. *The Age of Louis XV: French painting 1710-1774.* Toledo: The Toledo Museum of Art, 1975. ❦ Wildenstein, Georges. "A propos des portraits peints par François-Hubert Drouais." *Gazette des Beaux Arts* 51, February, 1958, pages 97-104.

INSCRIPTIONS
Recto: signed in black oil paint, center left, above chair: Drouais 1767.

Verso: inscribed in blue chalk, upper stretcher, upper member: 5242; ❦ inscribed in red chalk, frame, right member: 2338 VALA; ❦ and in white chalk, frame, upper member: Wildenstein / B???.

Labels, etc.: bears blue-bordered white paper label, stretcher, cross member, center: 5242; ❦ and Lamaire Fils label, stretcher, cross member, top; ❦ and Andre Chenne label, frame, upper member, inscribed: #5242; ❦ and red-bordered white paper label, frame, upper member, inscribed: 736?/3.

CONDITION and TECHNIQUE
The painting is paste lined to a second canvas. The varnish and old repaint are discolored and moderately disfiguring.

PROVENANCE
Marquis de Caumont-La Force, Paris, France; ❦ Marquise de Caumont-La Force, Paris France; ❦ Marquis de Dampierre (probably Jacques de Dampierre, born 1874), Château de Chillon, France; ❦ Wildenstein and Company Galleries, Paris, France and New York, New York, before November, 1934; ❦ E. Arthur Ball, Muncie, Indiana, circa 1936; ❦ Ball Brothers Foundation, Muncie, Indiana, 1950.

EXHIBITIONS
Muncie, Ball State Teachers College Art Gallery. *Beneficence Continues: Paintings from the E. Arthur Ball Collection.* March 18-?, 1951, page 4. ❦ Indianapolis, John Herron Museum of Art (Indianapolis Museum of Art). *Indiana Colleges Collect.* October 4-November 1, 1964, catalogue number 3. ❦ New York, Wildenstein and Company. *Paris–New York: A Continuing Romance.* November 2-December 17, 1977, page 47, catalogue number 34, illustrated figure 39.

REFERENCES
(Former accession number: AC-51-200.) ❦ Comstock, Helen. "The Connoisseur in America, the Drouais Portrait of the Comtesse de Caumont." *Connoisseur*, November, 1934, pages 332-333, illustrated opposite page 334.

RELATED WORKS
François-Hubert Drouais. *Madame de Pompadour,* 1763-1764, oil on canvas, 217 × 156.8 cm, National Gallery, London, England.

REMARKS
Though the portrait has traditionally been called the *Comtesse de Caumont* (née Brassigny), this appears to be inaccurate. No recorded comtesse was born de Brassigny in the Caumont-La Force family, and the name de Brassigny appears to be unknown in the French nobility. The sitter is apparently Adelaïde-Luce-Madeleine de Galard de Brassac de Bearn, born December 9, 1739, died October, 1825. She was the daughter of Anne-Hillarion de Galard, Comte de Bearn, and Olympe de Caumont. Adelaïde-Luce-Madeleine married Chevalier Bertrand-Nompar de Caumont de Beauville (1724-1773), Marquis de Caumont-La Force (1724-1773) on June 5, 1757; by 1767, when this portrait was painted, she would have been the Marquise de Caumont-La Force. Bertrand-Nompar de Caumont de Beauville, Marquis de Caumont-La Force was admitted to the court of Louis XV on July 15, 1767. Adelaïde-Luce-Madeleine de Galard de Brassac de Bearn, Marquise de Caumont-La Force, was presented to the court of Louis XV on August 12, 1767.

In 1775, shortly after the death of her husband, the marquise became the governess of the Comte d'Artois's child, Charles-Philippe (1757-1836), the younger brother of Louis XVI. In 1763 Drouais had painted a portrait (signed and dated) of the same Charles-Philippe de France and his sister Madame Clotilde (1759-1802). (*Le comte d'Artois et sa soeur, Madame Clotilde,* oil on canvas, 129.5 × 97.5 cm, Musée du Louvre, Paris, France.)

In 1714, François de Troy painted a portrait of Anne-Marie de Beuzelin de Bosmelet, *Duchess de La Force,* wife of Henri-Jacques-Nompar de Caumont, Duc de La Force and great-aunt of the Marquise de Caumont (oil on canvas, 144 × 111 cm, Musée des Beaux-Arts, Rouen, France).

The provenance of the Muncie portrait is certainly the Caumont-La Force family. Adelaïde-Luce-Madeleine bore five sons and seven daughters, three of whom were alive at her death. The painting does not appear in the May 31–June 3, 1868 Duchesse of Caumont-La Force sale, Paris, Château de Creteil. The authors assume that the portrait was purchased by a member of the Dampierre family in the mid to late nineteenth century and note that, to date, no connection has been discovered between the Caumont-La Force and Dampierre families.

Jean-Honoré Fragonard

French (1732–1806)
born Grasse, France, April 4, 1732
died Paris, France, August 22, 1806

Sultane sur une ottomane,
circa 1772–1776

(*La petite sultane*; *Sultana on an Ottoman*; *The Small Sultana*)

paint (oil) on paper (mounted on walnut panel, edged with mahogany, cradled)
32.2 × 24.0 cm; 12¾ × 9⁷⁄₁₆ inches
33.5 × 25.1 cm; 13³⁄₁₆ × 9⅞ inches

Permanent loan from the E. Arthur Ball Collection, Ball Brothers Foundation
L51.201

Seeming to glow with a colorful fluorescence and flutter on its breezy brushstrokes, this small painting is a perfect expression of eighteenth-century tastes and sensibilities. Jean-Honoré Fragonard chose as his fanciful subject a "sultana" seated in a cross-legged pose on a kind of sofa called an "ottoman." In eighteenth-century France, the appeal of pseudo-Turkish subjects spawned paintings such as this. Although the girl depicted appears typically French, the pantaloons she wears and the ottoman upon which she sits demonstrate the vogue of exoticism—a necessary ingredient, along with

the more dominant themes of love—in the escapist subjects that so delighted 18th-century French taste. Apparently the "sultana" theme was so popular that Fragonard made several versions of it—four are known today.

Nearly frothing off the surface, the work is painted in what critics called his "quick sketch" style. Proud of his skill and facility in handling paint, Fragonard often noted on the backs of portraits done in the same manner that they had been "painted… in an hour's time." For other works (such as *The Swing*, Wallace Collection, London, one of the artist's most famous paintings), Fragonard employed a more finished, decorative style. But it was his colorful, painterly technique that twentieth-century eyes admired when they made him—along with François Boucher—one of the eighteenth-century artists most revered in this century.

SOURCES
Kalnein, Wend Graf, and Michael Levey. *Art and Architecture of the 18th Century in France. Pelican History of Art.* Harmondsworth, Middlesex: Penguin Books, Ltd., 1972 ❦ Liebmann, Lisa. "Fragonard's Fancies." *Artnews*, number 87, February, 1988, pages 98–103. ❦ Rosenberg, 1988.

INSCRIPTIONS
Verso: inscribed in white oil paint, panel, upper center, left: No. 5777; ❦ and in pencil, panel, center: 5777; ❦ and in black chalk, frame, top: Ex 67.

Labels, etc: bears white paper label, panel, upper left inscribed: D&M #6.

PROVENANCE
M[orel or Morelle], Paris?, France; ❦ Arthur? Veil-Picard, Paris, France; ❦ Wildenstein and Company Galleries, Paris, France and New York, New York; ❦ E. Arthur Ball, Muncie, Indiana, circa 1941; ❦ Ball Brothers Foundation, Muncie, Indiana, 1950.

EXHIBITIONS
Muncie, Ball State Teachers College Art Gallery. *Beneficence Continues: Paintings from the E. Arthur Ball Collection.* March 18–April ?, 1951, page 5, catalogue

number 8, illustrated. ❦ Indianapolis, John Herron Museum of Art (Indianapolis Museum of Art). *Indiana Colleges Collect.* October 4–November 1, 1964, catalogue number 4. ❦ New York, M. Knoedler and Company. *Masters of the Loaded Brush: Oil Sketches from Rubens to Tiepolo.* April 4–29, 1967, pages 93–94, catalogue number 68, illustrated plate 68. ❦ Paris, Galeries Nationales du Grand Palais. *Fragonard.* September 24, 1987–January 4, 1988 (also New York, The Metropolitan Museum of Art, February 2–May 8, 1988), pages 451–453, catalogue number 219, illustrated in color page 452, as *La Petite Sultane* (*The Small Sultana*). ❦ Tokyo, Odakya Grand Gallery. *Three Masters of French Rococo: Boucher, Fragonard, Lancret.* April 4–April 22, 1990 (also Umeda-Osaka, Daimaru Museum, May 9–May 21, 1990; Hokkaido, Hakodate Museum of Art, May 26–June 24, 1990; Yokohama, Sogo Museum of Art, July 4–August 12, 1990), catalogue number 45, illustrated page 84.

REFERENCES

Paris, M[orel or Morelle] and others sale, May 3, 1786, lot number 178, as *L'Esquisse de la Sultane.* ❦ Goncourt, Edmond, and Jules de. *Fragonard.* Paris: 1865, page 333. ❦ Nolhac, Pierre de. *J.-H. Fragonard 1732–1806.* Paris: Goupil 1906, page 145. ❦ Morse, John D. *Old Masters in America.* Chicago: Rand McNally, 1955, page 74. ❦ Wilhelm, J. "In Search of Some Missing Fragonard Paintings." *Art Quarterly,* Winter 1955, page 372. ❦ Wildenstein, Georges. *The Paintings of Fragonard.* New York: Phaidon Press, 1960, catalogue number 337, illustrated figure 146, page 272. ❦ M. Knoedler and Company. *Masters of the Loaded Brush: Oil Sketches from Rubens to Tiepolo.* New York: Columbia University, 1967, pages 93–94, illustrated plate 68, catalogue entry by Edwin C. Vogel. ❦ Posner, Donald. "Baroque and Rococo Oil Sketches." *Burlington Magazine,* June, 1967, pages 360–363, illustrated figure 48, page 361. ❦ Wildenstein, Daniel, and Gabriele Mandel. *L'Opera Completa di Fragonard.* Milan: Rizzoli, 1972, catalogue number 353. ❦ Mesuret, R. *Les Expositions de L'Academie Royal de Toulouse de 1751 à 1791.* Toulouse: 1972, page 415. ❦ Morse, John D. *Old Master Paintings in North America.* New York: Abbeville Press, n.d. (1979), page 128. ❦ Rosenberg, Pierre. *Fragonard.* Paris: Editions de la Réunion des Musées Nationaux, 1987, pages 451–453, illustrated in color page 452. (English edition New York: The Metropolitan Museum of Art, 1988, trans. Jean-Marie Clarke and Anthony Rogers.) ❦ Cuzin, Jean-Pierre. *Jean-Honoré Fragonard: Life and Work.* New York: Harry N. Abrams, 1988, page 322, catalogue number 325, illustrated, illustrated in color page 208, plate 254. ❦ Marandel, J. Patrice. *Three Masters of French Rococo: Boucher, Fragonard, Lancret.* Tokyo: TG Concepts, Inc., 1990, catalogue number 45, illustrated page 84. ❦ Dawson, Deidre. "La lettre dans la vie et l'oeuvre de Fragonard." *La lettre au xviii^e siècle et ses avatars,* Paris: Groupe de Récherché en Etudes Francophones, 1994.

RELATED WORKS

Jean-Honoré Fragonard. *Portrait of a Young Woman as a Sultana* or *Sultana Resting on an Ottoman,* circa 1772, oil on canvas, 97 × 81 cm, private collection, former collection of Randon de Boisset (Cuzin, 1988, number 266).

Jean-Honoré Fragonard. *Sultana Seated on a Sofa,* circa 1772, 47.5 × 32.5 cm, private collection, Roberto Polo sale, Paris, France, June 2, 1988 (Cuzin, 1988, number 267).

Jean-Honoré Fragonard. *Sultana Seated on a Sofa* or *The Little Sultana,* circa 1772, 16 × 11 cm, private collection (Cuzin, 1988, number 268).

The version closest to the Muncie painting is Cuzin (1988) number 267 and it is likely that the Muncie painting is a highly finished sketch for it. There are also two drawings related to the Muncie painting, and to Cuzin, 1988, numbers 267 and 268.

La Sultane, n.d., 22.3 × 16.1 cm, private collection, Paris, former collection of M. de Vieux-Viller (sale, Paris, France, 1788). (Ananoff, Alexandre. *L'Oeuvre dessin de Jean-Honoré Fragonard.* Paris: F. de Nobele, n.d. (1961–1970), catalogue number 192.)

La Sultane, n.d., 37.8 × 32.4 cm, private collection, Bordeaux, former collection M. de Vieux-Viller (sale, Paris, France, 1788), (Ananoff, 1961–1970, number 740).

Carle Vanloo. *A Sultana Playing a Stringed Instrument,* 1754, oil on canvas, private collection, Paris, France.

Carle Vanloo. *A Sultana Taking Coffee,* 1755, oil on canvas, The Hermitage, St. Petersberg, Russia.

REMARKS

The discussion of the painting in Rosenberg (1987 and 1988) is excellent in all respects. Of the four versions of the Sultana known today, the Muncie painting is, as the author of the Morel (1786) sales catalogue notes, "known through the large finished painting which was in the collection of M. de Boisset. This lovely piece is of the most brilliant color and the lightest touch" (translation from Cuzin, 1988).

Though it has been suggested that the Muncie work is a portrait of Marguèrite Gérard, Fragonard's sister-in-law, there appears to be no basis for this suggestion. Rosenberg (1987 and 1988) proposes that the work may be a portrait of the Comtesse Violette de Vismes.

see color front cover

Marie Elizabeth-Louise Vigée-Lebrun

French (1775–1842)
born Paris, France, April 16, 1775
died Paris, France, March 30, 1842

Mademoiselle d'Holbach,
circa 1780–1785

paint (oil) on canvas (linen, oval stretcher)
60.3 × 48.8 cm; 23¾ × 19¼ inches

Permanent loan from the E. Arthur Ball Collection,
Ball Brothers Foundation
L51.205

INSCRIPTIONS
Verso: inscribed in blue ink, stretcher, cross member,
center right: 5121; ❦ inscribed in blue chalk, frame, upper
member: 359 Bie???.

Labels, etc: bears blue-bordered white paper tag, stretcher,
cross member, center left, inscribed: 5121.

CONDITION and TECHNIQUE
Wax resin lined to a second canvas. Minor areas of
disfiguring inpainting and dull and slightly yellowed varnish.
Conserved, 1981, Alfred Jakstas, Art Institute of Chicago,
Chicago, Illinois.

PROVENANCE
Probably Paul Heinrich Dietrich d'Holbach; ❦ Amélie
Susanne d'Holbach or Laure Pauline d'Holbach; ❦ M.
Franclieu, Toulouse, France; ❦ Wildenstein and Company
Galleries, Paris, France, and New York, New York; ❦ E.
Arthur Ball, Muncie, Indiana, circa 1940; ❦ Ball Brothers
Foundation, Muncie, Indiana, 1950.

EXHIBITIONS
Muncie, Ball State Teachers College Art Gallery. *Beneficence
Continues: Paintings from the E. Arthur Ball Collection.*
March 18–?, 1951, page 4, catalogue number 2.

REFERENCES
(Former accession number: AC-51-205.)

REMARKS
The Muncie painting depicts either Amélie Susanne or Laure
Pauline d'Holbach, the daughters of Baron Paul Heinrich
Dietrich d'Holbach. Paulus Thiry d'Holbach (note Thiry or
Thiery are Palatine forms of Theodoric or Dietrich), was

born in Edesheim, Germany, December, 1723, and died in
Paris, France, January 21, 1789. Paul d'Holbach's first wife,
Basile-Geneviève died in 1754. His second wife was
Charlotte Susanne d'Anie (1734–1814), and there were two
daughters, Amélie Susanne and Laure Pauline. One
daughter was born in 1760, the other slightly later. One
daughter married Pierre de Nolivos (Marquis de Nolivas,
October, 1782), the other the Marquis de Chatenay-Berlize.
Without additional information on the daughters, it is not
possible to identify the Muncie portrait. (Wickman, W.H.
Baron d'Holbach: *A Prelude to the French Revolution.*
New York: Augustus M. Kelley, 1968, pages 233–235.)

Whether the painting depicts Amélie Susanne or Laure
Pauline while still a d'Holbach is also not clear. Portraits of
Madame de Chatenay, dated 1782 and *Madame de
Chatenay, mère*, dated 1787 are listed in the literature.
Assuming that the portrait described by Nolhac (1908,
pages 95–96) is that of 1782, it would appear that the
Muncie portrait represents the girl who was or would
become the Comtesse de Nolivos. (Blum, André. *Madame
Vigée-Lebrun, Peintre des Grandes Dames du XVIIIᵉ Siecle.*
Paris: H. Piazza, n.d. (1919), page 96, *Madame de
Chatenay*, 1782, Salon de 1785, collection de M. Feral and
page 98, *Madame de Chatenay, mère*, 1787.)

That Vigée-Lebrun knew Paul d'Holbach is recorded by
Nolhac. "Une de ses plus anciennes amies, Madame de
Verdun, la mena dîner chez le baron d'Holbach; il y avait
chez lui une réunion de philosophes qu'elle ne comprit
pas." (Nolhac, Pierre de. *Madame Vigée-Lebrun, Peintre
de la Reine Marie Antoinette, 1755–1842.* Paris: Goupil et
Cⁱᵉ, 1908, page 237.)

Claude Michel, called Clodion

French (1738-1814)
born Nancy, France, December 20, 1738
died Paris, France, March 28, 1814

Satyre et enfants satyres,
circa 1781-1785 (modelled);
circa 1800-1810 (cast)
(*Satyr and Satyr Children*)

metal (bronze, gold), stone (marble)
33.2 × 23.7 × 18.8 cm; 13\frac{1}{16} × 9\frac{5}{16} × 7\frac{3}{8} inches
39.8 × 25.5 × 27.7 cm; 15\frac{7}{8} × 10\frac{1}{16} × 10\frac{7}{8} inches

Gift of Ned H. Griner and Gloria Griner in memory of
Florence and Romain Griner
93.023.1

INSCRIPTIONS
Signed in cast, rear of rocks: CLODION.

Labels, etc.: bears small white paper label, base edge, rear,
inscribed in blue pen: E36; ❦ and small white paper label,
upper surface of gilt bronze base and underside of marble
section, inscribed in blue pen: 465/129; ❦ and small white
paper label, underside of base, printed in black with red
numbers: No. 69613.

CONDITION and TECHNIQUE
The marble section of the base is modern, the gilt bronze
section is probably eighteenth century but not original to
the piece.

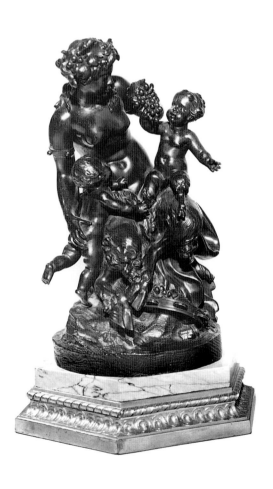

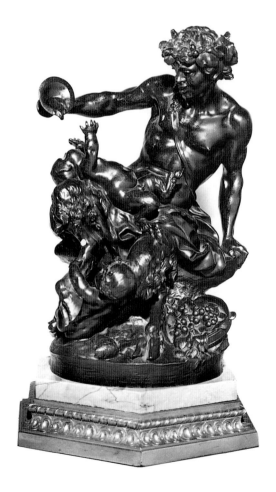

The piece is cast in two parts, a primary section of the satyr and child, and a secondary section of the fallen child (joined at the leg of the satyr). The surface is extensively tooled to add detail, especially to the rock section. Two narrow fillets of wrought bronze have been soldered to the underside of the base and drilled recently for attachment to the marble and gilt bronze base. The gilt bronze base is cast in a single section and extensively tooled. The upper surface has a large center hole and small hole at each corner (marked with a punch with roman numerals VII to XI with the one left unnumbered).

PROVENANCE
Possibly Richard Wallace, Brighton and London, England, and Paris, France; ❦ possibly John Murray Scott, London, England; ❦ possibly Lady Sackville, London, England; ❦ unidentified dealer, London or Brighton, England; ❦ Michael Hall Fine Arts, New York, New York, circa 1965-1970.

EXHIBITIONS
Notre Dame, University of Notre Dame Museum of Art. *Eighteenth Century France: A Study of Its Art and Civilization.* March 12-May 15, 1972, catalogue number 61, illustrated.

REFERENCES
Michael Hall Fine Arts inventory number: GR17.

RELATED WORKS
Claude Michel, called Clodion. *Satyre et enfants satyres,* terra cotta, present location unknown. (Thirion, H. *Les Adams et Clodion.* Paris: A. Quantin, 1885, page 285, illustrated).

Claude Michel, called Clodion. Terra Cotta Decorations for the Court Facade of the Hotel de Bourbon-Condé, circa 1781, terra cotta, now in the Musée du Louvre, Paris, France, and The Metropolitan Museum of Art, New York, New York.

REMARKS
The inventory of Clodion's studio after his death lists a large quantity of fragments: heads, busts, arms, feet, and hands, both in terra cotta and plaster. This collection suggests a considerable workshop and a combining modelling and casting to create his figures. Such an approach would have been common in contemporary ceramics factories.

Claude Michel, called Clodion

French (1738-1814)
born Nancy, France, December 20, 1738
died Paris, France, March 28, 1814

Satyresse et enfants satyres,
circa 1781-1785 (modelled);
circa 1800-1810 (cast)
(*Satyress and Satyr Children*)

metal (bronze, gold), stone (marble)
$30.7 \times 20.6 \times 17.5$ cm; $12\frac{1}{16} \times 8\frac{1}{8} \times 6\frac{7}{8}$ inches
$37.6 \times 25.5 \times 22.7$ cm; $14\frac{13}{16} \times 10\frac{1}{16} \times 10\frac{7}{8}$ inches

Gift of Ned H. and Gloria Griner in memory of Florence and Romain Griner
93.023.2

Hoofed and human babies clamor on the laps and around the legs of a satyr and satyress in this pair of bronze sculptures by Claude Michel, known as Clodion. Reaching toward a cup of wine or a bunch of grapes, the children and their adult companions express the air of joyful decadence typical of Clodion's small works. In the happy, uninhibited world of Clodion's small-scale sculpture, half-human, half-goat satyrs and satyresses, human and satyr babies, nymphs and youthful gods carouse and tumble. In ancient mythology, these creatures were the various, often intoxicated, companions and devotees of the god Dionysus, also known as Bacchus. Grasping succulent bunches of grapes, their tambourines or pipes at their feet and their heads surmounted by wreaths of grape leaves, the figures are adorned with the symbols associated with the god of wine and inspirer of music and poetry.

Clodion was most famous for his spontaneously formed clay sculptures of the followers of Bacchus, a theme he explored in endless variety. To help meet the demands of a host of wealthy clients desiring diminutive decorative sculptures

appropriate to the small, intimate rooms of their Parisian townhouses, Clodion employed a large workshop of assistants including three of his ten siblings and the young Joseph-Charles Marin (see entry). Describing the workshop as a veritable "factory," scholars have sought to discover its production methods. In addition to casting multiple clay infants and other figures that, while still moist, could be posed and manipulated and their surfaces re-worked for use in his compositions, Clodion also had some of his works, like the pair seen here, cast in bronze, a practice that continued after the artist's death. Working through dealers, his workshop apparently supplied clay models for clocks, and other decorative objects to be cast in bronze or porcelain.

SOURCES
Levey, Michael. *Painting and Sculpture in France 1700-1789*. New Haven and London: Yale University Press, 1972. ❦ Poulet, Anne L. *Clodion Terracottas in North American Collections*. New York: The Frick Collection, 1984.

INSCRIPTIONS
Signed in cast, rear of rocks: CLODION.

Labels, etc.: bears small white paper label, base edge, rear, inscribed in blue pen: E36; ❦ and small white paper label, upper surface of gilt bronze base and underside of marble section, inscribed in blue pen: 465/129.

CONDITION and TECHNIQUE
The marble section of the base is modern; the gilt bronze section is probably eighteenth century but not original to the piece.

The piece is cast in three parts, the base and figure, the child at her side, and the child on her knee (the standing child includes the satyress's arm to the band at mid upper arm). The surface is extensively tooled to add detail, especially to the rock section. Two narrow fillets of wrought bronze have been soldered to the underside of the base and drilled recently for attachment to the marble and gilt bronze base. The gilt bronze base is cast in a single section and extensively tooled. The upper surface has a large central hole and smaller holes at each corner (marked with a punch . / .. / ... / / .. / VI).

PROVENANCE
Possibly Richard Wallace, Brighton and London, England, and Paris, France; ❦ possibly John Murray Scott, London, England; ❦ possibly Lady Sackville, London, England; ❦ unidentified dealer, London or Brighton, England; ❦ Michael Hall Fine Arts, New York, New York, circa 1965-1970.

EXHIBITIONS
Notre Dame, University of Notre Dame Museum of Art. *Eighteenth Century France: A Study of Its Art and Civilization*. March 12-May 15, 1972, catalogue number 61, illustrated.

REFERENCES
Michael Hall Fine Arts inventory number: GR17.

RELATED WORKS
Claude Michel, called Clodion. *Satyresse et enfants satyres*, terra cotta, present location unknown (Thirion, H. *Les Adams et Clodion*. Paris: A. Quantin, 1885, page 233, illustrated).

Claude Michel, called Clodion. Terra Cotta Decoration for the Court Facade of the Hotel de Bourbon-Condé, circa 1781, terra cotta, now in the Musée du Louvre, Paris, France, and The Metropolitan Museum of Art, New York, New York.

REMARKS
The inventory of Clodion's Studio after his death lists a large quantity of fragments: heads, busts, arms, feet and hands, both in terra cotta and plaster. This collection suggests a considerable workshop and a method combining modeling and casting to create his figures. Such an approach would have been common in contemporary ceramics factories.

Gilbert (Charles) Stuart

American (1755-1828)
born shore of Petaquamscott Pond, Narragansett
County, Rhode Island, December 3, 1755
died Boston, Massachusetts, July 9, 1828

Anne Allston (at age 17), circa 1808

paint (oil) on canvas (linen)
74.0 × 61.0 cm; 29⅛ × 24 inches

Permanent loan from the Elisabeth Ball Collection,
George and Frances Ball Foundation
L83.026.29

INSCRIPTIONS
Verso: bears William Macbeth, Inc., inventory stamp, frame,
upper member: 3654.

Labels, etc.: bears William Macbeth, Inc., label, verso,
frame, upper member.

CONDITION and TECHNIQUE
The painting is paste lined to a second canvas support.
Discolored old restorations include a poorly repaired tear
running 15 cm into the painting from the left edge. The
varnish is yellow and disfiguring.

PROVENANCE
Mrs. John Francis (Martha Allston) Pyatt, sister of the sitter,
South Carolina; ❦ Martha Pyatt Heyward (granddaughter); ❦
Mr. J. B. Heyward (son); ❦ Mrs. J. B. Heyward, Oakland,
California; ❦ William Macbeth Inc., New York, New York,
November 9, 1927; ❦ Mr. and Mrs. George A. Ball, Muncie,
Indiana, December, 1927; ❦ Elisabeth Ball, Muncie, Indiana,
before 1957; ❦ George and Frances Ball Foundation,
Muncie, Indiana, 1982.

EXHIBITIONS
Muncie, Ball State University Art Gallery. *The Elisabeth Ball
Collection of Paintings, Drawings, and Watercolors: The
George and Frances Ball Foundation*. January
15-February 26, 1984, page 39, catalogue number 29,
illustrated in color, page 28.

REFERENCES
Sawisky, William. "Some Unrecorded Portraits by Gilbert
Stuart: Part III, Portraits Painted in America." *Art in
America*, volume 21, number 3, June, 1933, page 82,

illustrated page 85. ❦ Unpublished Stock Disposition Card-
Sold Pictures, December, 1927, William Macbeth, Inc.,
number 3655. ❦ Unpublished invoice dated April 1, 1928,
William Macbeth, Inc., to Mrs. George A. Ball. ❦ Joyaux,
Alain G. *The Elisabeth Ball Collection of Paintings,
Drawings, and Watercolors: The George and Frances Ball
Foundation*. Muncie: Ball State University Art Gallery,
1984, page 39, catalogue number 29, illustrated in color
page 28.

REMARKS
According to William Sawisky, Anne Allston was the
youngest daughter of Benjamin Allston, a rice planter and
resident of Georgetown, South Carolina. She was a cousin
of the artist Washington Allston, who apparently executed a
portrait of Anne's sister Martha. Family tradition states that
the Stuart portrait of Anne was painted after she was
seventeen years old and that she died ten years later. She
was educated at Morovian College, Bethlehem,
Pennsylvania, and at Madame Buvards, Philadelphia,
Pennsylvania. During the Madison administration, she
apparently spent considerable time in Washington as a guest
of Senator and Mrs. Hunger of South Carolina.

Anne's sister, Martha Allston, married John Frances Pyatt of
South Carolina. Because of Anne Allston's early death, the
Muncie portrait descended in the Pyatt family until 1927.
The Washington Allston portrait of Martha Allston (Pyatt)

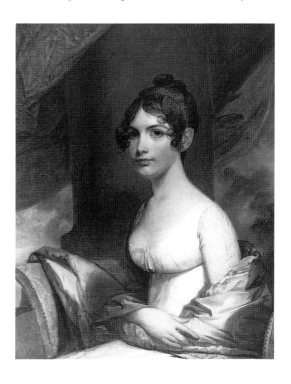

was owned by Charlotte T. Pyatt of Georgetown, South Carolina, great-granddaughter of Martha Allston Pyatt, as of 1954. Martha Allston and John Pyatt had two children, both of whom were painted by Thomas Sully. Joseph Benjamin Pyatt sat in 1846 and Miss Pyatt in 1842.

Sir Henry Raeburn

English (1756–1823)
born Stockbridge, Scotland, March 4, 1756
died Edinburgh, Scotland, July 8, 1823

Catherine Munro of Culcairn, 1813

paint (oil) on canvas
75.0 × 62.8 cm; 29½ × 24¾ inches

Promised gift of Lucina Ball Moxley
L89.031.01

Against a stark, black backdrop the face and figure of a woman coalesce on the canvas. True to Raeburn's creed that "nothing ought to divert

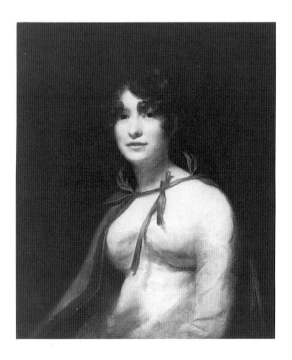

the eye from the principal object: the face," a dramatic light reveals her features. Slightly parted lips, piercing eyes, and a scarlet cape haphazardly tossed over one shoulder lend this portrait an aura of mystery and spontaneity. Even his biggest competitor, English painter Thomas Lawrence (who received most of Scotland's official portrait work), praised Raeburn's style as "freedom itself." In his typical manner, with a minimum of colors and seemingly as few brush strokes, Henry Raeburn has created a lively portrait of the dark-eyed Catherine Munro.

Raeburn's spontaneous technique—he worked without the aid of preparatory drawings and, according to contemporary accounts, painted directly from the sitter before him—belies his early efforts as a miniaturist. While in his teens, Raeburn was apprenticed to a goldsmith, making miniature watercolor portraits in his spare time— his first attempts at portraiture. In the early 1780s Raeburn and a few fellow Edinburgh artists organized informal life drawing sessions in the green room of a local theater. There Raeburn found he was not suited to the task, and scholars have suggested that his lack of interest in the skill of life drawing may account for the awkward rendering of anatomy in his portraits.

From Edinburgh, Raeburn travelled first to London, where he could immerse himself in the rich tradition of English portrait painting. He then proceeded to Italy, an indispensable trip for all aspiring artists. Upon returning to Edinburgh in 1787, he became the preferred portraitist of Scotland's doctors, lawyers, and Highland chiefs.

By the time Raeburn painted *Catherine Munro*, his financial situation had taken a turn for the worse. In 1808 his son's business undertaking failed, forcing Raeburn to sell the house he had built and equipped with a studio and gallery space. To make ends meet, he offered his

services as a copyist, making replicas of works by other artists (unusual for an established painter), raised his prices, and began charging clients for his time in travel.

Despite this downturn of affairs, Raeburn received prestigious accolades in the last years of his career. In 1815 Raeburn's English colleagues recognized his stature by electing him a full member of the Royal Academy in London. Two years later, largely because of the expense and unavailability of his English rival Thomas Lawrence, Raeburn received an important official commission from the noblemen and gentlemen of Fife for their county hall. Finally, in 1822, the year before his death, Raeburn was knighted during the king's visit to Scotland.

Scorned by critics for his bold use of dark shadows, admired by rival artists, and beloved by his fellow Scots as one of their most important painters, Raeburn left a legacy of canvases recording the faces of his countrymen.

SOURCES
Irwin, David and Francina. *Scottish Painters at Home and Abroad, 1700-1900*. London: Faber and Faber, 1975.

INSCRIPTIONS
Verso: inscribed in brown pen, canvas, upper quadrant (now covered by second canvas): Catherine Munro of Culcairn / Painted by H. raeburn / 1813; ❦ and stamped, canvas, upper center, with gallery identification: MS / MAX SAFRON / NEW YORK; ❦ and inscribed in black ink, frame, upper member, right: MSG.

Labels, etc.: bears remains of white paper label, stretcher, center member, center, illegibly inscribed.

PROVENANCE
Possibly Mr. Campbell Munro, England; ❦ Dowdeswell and Dowdeswell, London, England; ❦ Victor Morawitz (Morawetz?), New York, New York, before 1911; ❦ Mrs. Victor Morawitz (Morawetz?), New York, New York, 1938; ❦ Max Safron Galleries, New York, New York; ❦ William H. Ball, Muncie, Indiana, 1945; ❦ Lucina Ball Moxley, Indianapolis, Indiana, 1950.

REFERENCES
Possibly, Armstrong, Walter, biographical and descriptive catalogue by J.L. Caw. *Sir Henry Raeburn*. London: W. Heinemann, 1901, page 109, as *Mrs. Munro*. (Should this be accurate, the sitter is clearly not the mother of Sir Thomas Munro. It is however more likely that the Muncie portrait depicts Sir Thomas Munro's wife and is not recorded by Armstrong.) ❦ Greig, James. *Sir Henry Raeburn R.A.: His Life and Works with a Catalogue of His Pictures*. London: The Connoisseur (Otto, Ltd.), 1911, page 54, illustrated plate 2, as *Mrs. Munro*. ❦ Unpublished Lucina Ball Moxley Collection Notebook number 40.

Joseph-Charles Marin

French (1759-1834)
born Paris, France, 1759
died Paris, France, September 18, 1834

Bacchante avec un enfant, 1817

ceramic (terra cotta)
$53 \times 17.1 \times 14.2$ cm; $20\frac{7}{8} \times 6\frac{3}{4} \times 5\frac{5}{8}$ inches

Gift of the Ball State University Foundation in honor of the Ball Family on the occasion of the seventy-fifth anniversary of Ball State University
93.029.1

Beneath a crown of agitated hair falling in corkscrew curls over her shoulders and across her back, a young bacchante—a female follower of the god Bacchus—leans against a tree trunk, her arms raised. Following her downward gaze we discover at her feet an infant, clutching a bunch of grapes to his chubby chest with one hand, and with the other reaching toward the grapes the bacchante holds aloft. Behind her, a goatskin—reference to the beast Bacchus demanded as sacrifice—has been tossed across the tree-trunk. Like Clodion (born Claude Michel), whom he served as a studio assistant, Joseph-Charles Marin delighted in giving form to the followers of Bacchus. While Clodion's stock-

in-trade was groups of figures in terra cotta, Marin tended toward single figures, seemingly derived from Clodion's groups of nymphs or bacchantes with satyrs (see Claude Michel entry).

Whereas painters made preparatory drawings, over the centuries sculptors made preliminary "sketches" in clay in varying degrees of finish. Literally "cooked earth" the term *terra cotta* is commonly used to mean "baked clay" or the sculptures made from that material. In the mid-eighteenth century patrons began to value such sculptures as works of art in their own right and not merely as presentation or preparatory devices (see Montauti entry). Sculptors of marble or bronze also made small-scale terra cottas, and some, like Clodion and Marin, made them their specialty.

Small-scale terra cottas like this one were immensely popular in the eighteenth and early-nineteenth centuries. Not only were they useful as decorative additions to the intimate eighteenth-century interior, but collectors and connoisseurs sought terra cotta sculptures for their freshness and as a record of the artist's touch. In this work, agitated tool marks in the bacchante's hair and the trunk behind her all speak of the presence of the artist as he worked in the still-moist clay before it was dried and fired.

Like collectors of drawings, connoisseurs of terra cottas saw such works as a truer record of the artist's intentions. Bronze sculptures were cast in a mold taken from some other material (clay, wax, or plaster), and marble sculptures were usually replicated with the aid of a mechanical technique called pointing from a full-scale plaster model, itself based on a work in clay. Whereas sculpture in marble or bronze was always at least once or twice removed from the original conception, terra cotta sculpture, formed directly by the artist's hands, alone retained his touch.

SOURCES
Avery, Charles. *Fingerprints of the Artist: European Terra-Cotta Sculpture from the Arthur M. Sackler Collections.* Washington: The Arthur M. Sackler Foundation, 1981; Cambridge: The Fogg Art Museum, 1981. ❦ Draper, James David. "French Terracottas." *The Metropolitan Museum of Art Bulletin*, Winter, 1991-1992. ❦ Hodgkinson, Terence. *The James A. de Rothschild Collection at Waddesdon Manor: Sculpture.* Fribourg, Switzerland: Office du Livre, 1970; London: National Trust for Places of Historic Interest of Natural Beauty, London, 1970. ❦ Levey, Michael. *Painting and Sculpture in France 1700-1789.* New Haven: Yale University Press, 1972.

INSCRIPTIONS
Signed with stylus in the wet clay, tree trunk, rear, center: MARIN.

CONDITION and TECHNIQUE
The thyrse has been broken and reattached at the Bacchante's right hand (approximately 1.5 cm of the thyrse shaft has been lost). The 1914 auction sale illustrates the piece with a tambourine leaning against the tree trunk at the Bacchante's right.

PROVENANCE
Joseph-Charles Marin; ❦ Bousquet (possibly Jacques Bousquet, 1883-1939), Paris, France, 1914; ❦ Larcade Collection, Paris, France; ❦ Blumka Gallery, New York, New York.

REFERENCES
Paris, Hotel Drouot, salle number 6. *Catalogue des Objets d'Art et d'Ameublement, Faiences, Boîtes, Jades, Sculptures par Clodion, Marin, etc., Meubles* May 29, 1914, page 22, lot number 34, illustrated opposite page 21. (The piece is listed as signed and dated 1817. Assuming that the authors of the catalogue were correct, the date must have been incised into the now-missing tambourine.) ❦ Quinquenet, Maurice. *Un élève de Clodion: Joseph-Charles Marin, 1759-1834.* Paris: Les Editions Renée Lacoste, 1948, page 60.

RELATED WORKS
Joseph-Charles Marin. *Bacchante couchee*, 179(3?) terra cotta, approximately 25 cm long, Musée Petit Palais, Paris, France.

see color frontispiece

John Constable, R.A.

English (1776-1837)
born East Bergholt, England, June 11, 1776
died London, England, April 1, 1837

Hampstead Heath, circa 1820

paint (oil) on canvas (linen)
25.5 × 30.6 cm; 10 × 12 inches

Permanent loan from the Frank C. Ball Collection, Ball Brothers Foundation
L29.025

INSCRIPTIONS

Verso: bears stamp in ink, canvas, center: BROWN / 163 / HIGH HOLBORN / LONDON; ❦ inscribed in black crayon, stretcher, right member, lower: 44x; ❦ and in blue crayon, stretcher, lower member, left, upside down: 44x; ❦ bears blind stamp, stretcher, right member: BROWN / 163 / HOLBORN; ❦ inscribed in blue crayon, frame, lower member, left, upside down: 44x; ❦ and in pencil, frame, top member, left: 390; ❦ and in pencil, frame, top member, left: B?ouilat? L?????????.

Labels, etc.: inscribed in pencil on decaying paper tape, stretcher, left member, upper: Constable / Hampstead Heath; ❦ bears rectangular white paper Thomas M'Lean label, stretcher, bottom member, center; ❦ and small round white label, stretcher, right member, upper, inscribed: M?? / 17.

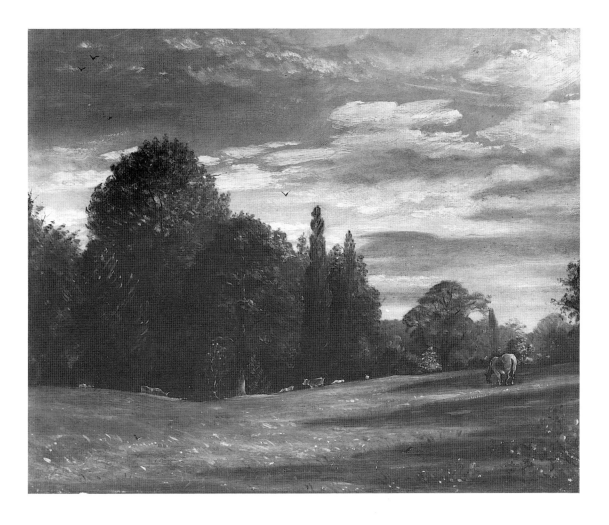

CONDITION and TECHNIQUE
The canvas is unlined and has two small tears in the sky.
The varnish is yellow and disfiguring.

PROVENANCE
John Constable; ❦ probably John Constable estate, 1837; ❦
probably Morton, ?, England; ❦ Thomas M'Lean, London,
England; ❦ George A. Hearn, New York, New York, before
1908; ❦ George A. Hearn estate, New York, New York,
1917; ❦ Frank C. Ball, Muncie, Indiana, 1918; ❦ Ball
Brothers Foundation, Muncie, Indiana, 1936.

EXHIBITIONS
Milwaukee, University of Wisconsin, Milwaukee Art History
Galleries. *Constable Symposium and Exhibition.* April
2-14, 1976.

REFERENCES
(Former accession number AC-29-25.) ❦ London, Foster and
Sons. *A Catalogue of the Valuable Finished Works,
Studies, and Sketches by John Constable, Esq., R.A.* May
15-16, 1838, page 9, lot number 44, two paintings:
Hampstead Heath and *Waterloo Bridge.* (The annotated
copy of the catalogue at the Frick Art Reference Library lists
the purchaser as Morton.) ❦ possibly London, Christie's.
Thomas M'Lean Collection. November 16, 1901, page 6,
lot number 25, as *Landscape with Cattle.* ❦ Hearn, George
A. *Catalogue of the Collection of Foreign and American
Paintings Owned by Mr. George A. Hearn.* New York:
privately printed (The Gilliss Press), 1908, page 41,
catalogue number 45. ❦ New York, American Art
Association. *Notable Art Collection Formed by the Late
George A. Hearn.* March 1, 1918, lot number 376,
illustrated. ❦ Morse, John D. *Old Masters in America.*
Chicago: Rand McNally, n.d. (1955), page 33. ❦ Ball State,
1947, page 7. ❦ Graves, Algernon. *Art Sales: From Early
in the 18th Century to Early in the 20th Century.* London:
A. Graves, 1918-1921; reprinted edition, New York: Burt
Franklin, 1970, volume I, page 123. ❦ Morse, John D. *Old
Master Paintings in North America.* New York: Abbeville
Press, n.d. (1979), page 56.

REMARKS
Though the lot number appears on the Muncie painting no
fewer than three times, and the price realized is to be
expected for a small-scale work, it is not possible to identify
the Muncie painting with that in the 1838 Constable sale
with certainty. The authors also note that Graves (1970)
records the purchaser of lot 44 as Morton and that the
Muncie painting bears a small white paper label inscribed
M?? / 17. Another possibility is the small Constable painting
entitled *Hampstead Heath* (catalogue number 292) that the
executors of the estate of Isabel Constable (1822-1888,
daughter) loaned to the 1889 exhibition at the Grosvenor
Gallery, London, entitled *A Century of British Art,* which
included a large number of Constables.

Thomas Cole

American, born England (1801-1848)
born Bolton-le-Moors, Lancashire, England, February
1, 1801
died Catskill, New York, February, 1848

Storm King of the Hudson,
circa 1825-1827
(*Storm King on the Hudson*)

paint (oil) on canvas (linen)
58.4 × 81.3 cm; 23 × 32 inches

Permanent loan from the Frank C. Ball Collection, Ball
Brothers Foundation
L37.127

> The tallest mountain, with its feet in the
> Hudson at the Highland Gap, is officially
> the Storm King—being looked to, by
> the whole country around, as the most
> sure foreteller of a storm. When the
> white cloud-beard descends upon his
> breast in the morning (as if with a nod
> forward of his majestic head), there is
> sure to be a rain-storm before night.
> Standing aloft among the other
> mountains of the chain, this sign is
> peculiar to him. He seems the monarch,
> and this seems his stately ordering of a
> change in the weather. Should not
> STORM-KING, then, be his proper title?
>
> — Nathaniel Parker Willis (1855)

Storm King Mountain, on the west bank of the
Hudson River north of West Point, was known as
"Butter Hill" in Thomas Cole's day. In the young

painter's canvas of the scene, gnarled and distorted trees bending in the wind sit atop severe cliffs that drop into a bottomless darkness. Behind this foreboding landscape the mountain rises, bathed in an ethereal light and a tumult of grays, whites, and blues suggesting a gathering storm.

In 1825 Thomas Cole took his first trip to the Hudson River Highlands, sketching and making notes about the landscape. There he encountered the ruins of Fort Putnam, a revolutionary war post, and the face of Storm King Mountain a few miles upstream. The untamed wilderness, the fort lying in ruins, and the Hudson River below made a deep impression on the young artist. Sketches and notes from that trip and subsequent tours up the Hudson

River Valley and into the Catskill mountains over the next few years inspired this and many of Cole's other early canvases.

For Cole, the American scenery that filled his paintings was fraught with rich associations. In the face of encroaching civilization, the unspoiled landscape of America reverberated with spiritual overtones. In his 1835 "Essay on American Scenery" Cole wrote:

> There are those who regret that with the improvements of cultivation the sublimity of the wilderness should pass away: for those scenes of solitude from which the hand of nature has never been lifted, affect the mind with a more deep toned emotion than aught which the hand of man has touched. Amid

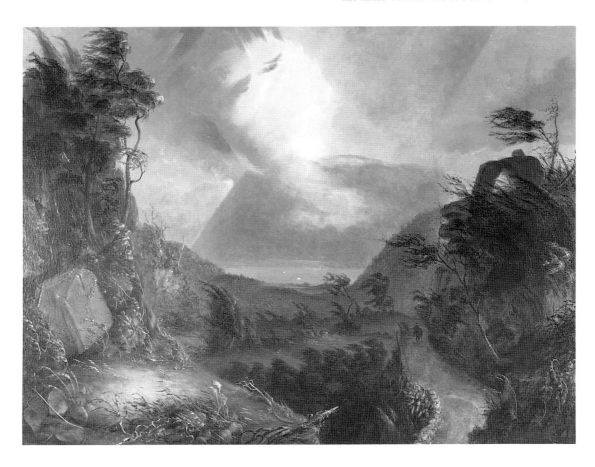

them the consequent associations are of God the creator—they are his undefiled works, and the mind is cast into the contemplation of eternal things.

Born in 1801 in Bolton-le-Moors, Lancashire, England, at the age of seventeen Cole moved with his family to America. His efforts to wrest an education in art along with a living from his adopted country took him to Philadelphia, delaying his moving with his family as they settled first in Ohio, then New York City. Returning to the studio in his father's New York house after his 1825 sketching trip up the Hudson, Cole painted several landscapes based on his drawings of the sites he had encountered. Three sold almost immediately to prominent artists John Trumbull, William Dunlap, and Asher B. Durand. Their interest in and promotion of Cole among New York artists and patrons helped secure his reputation as America's premier landscape painter.

SOURCES
Baigell, Matthew. *Thomas Cole*. New York: Watson-Guptill Publications, 1981. ❦ Cole, Thomas. "Essay on American Scenery." 1835. Quoted in John W. McCoubrey. *American Art 1700-1960*, pages 98-109. *Sources and Documents in the History of Art Series*. Englewood Cliffs, New Jersey: Prentice Hall, Inc., 1965. ❦ Dunwell, 1991. ❦ Handley, 1990. ❦ Noble, Louis Legrand. *The Life and Works of Thomas Cole*. 1853; reprint, Cambridge, Massachusetts: Harvard University Press, Belknap Press, 1964. ❦ Powell, Earl A. *Thomas Cole*. New York: Harry N. Abrams, 1990. ❦ Willis, Nathaniel Parker. *Outdoors at Idlewild or the Shaping of a Home on the Banks of the Hudson*. New York: Charles Scribner, 1855, 188. Quoted in Dunwell, 1991, pages 63-64.

INSCRIPTIONS
Recto: signed in grey oil paint, on rock at right edge, center: T Cole.

CONDITION and TECHNIQUE
The painting is wax lined to a second canvas, the varnish matte. Conserved, 1981, Alfred Jakstas, Art Institute of Chicago, Chicago, Illinois.

PROVENANCE
Frank C. Ball, Muncie, Indiana; ❦ Ball Brothers Foundation, Muncie, Indiana, 1937.

EXHIBITIONS
Rosyln, New York, Nassau County Museum of Fine Art. *American Artists Abroad*. June 2–September 2, 1985, page 88, illustrated figure 21, page 31, illustrated in color, plate 4, page 34.

REFERENCES
(Former accession number : AC-37-127.) ❦ Ball State, 1947, page 7. ❦ Alasko, Richard-Raymond. *Nineteenth Century American Paintings: Art Gallery, Ball State University*. Muncie: Ball State University, n.d. (1972?), unpaginated, page 7, illustrated page 6. ❦ Handley, Laurie. "Thomas Cole and Early American Landscape Painting." In *Gallery Notes*. Muncie: Ball State University Art Gallery, 1990, illustrated in color page 1. ❦ Dunwell, Frances F. *The Hudson River Highlands*. New York: Columbia University Press, 1991, page 50, illustrated in color, second plate after page 108.

REMARKS
The painting depicts Storm King Mountain near West Point, New York. Cole's actual view is taken from very near what is now Route 9D, three or four miles north of Cold Spring, New York.

Richard Parkes Bonington

English (1801–1828)
born Arnold, near Nottingham, England, October 25, 1801
died London, England, September 23, 1828

Une procession sur le quai des esclavons à Venise, circa 1827–1828
(*A Procession On the Quay*)

paint (oil) on canvas (linen)
115.0 × 164.2 cm; 44 7/8 × 63 3/4 inches

Permanent loan from the Frank C. Ball Collection, Ball Brothers Foundation
L29.017

INSCRIPTIONS
Recto: inscribed in brown oil paint, lower left (the signature has been significantly reinforced): Bonnington 1827.

Verso: bears stamp, canvas, left and right side (now covered by a second canvas): T. Brown / 163 High Holborn, / London; ❦ and inscribed in black chalk, stretcher, top member, right: 370(?); ❦ and scratched, stretcher, top member, center: 64; ❦ and in blue crayon, frame (original? but no longer with the work), upper member, center: 64.

Labels, etc.: bears red-bordered, rectangular paper label, stretcher, top member, right, inscribed in pencil (now in object file): 3992/1.; ❦ and red-bordered rectangular paper label, stretcher, inscribed illegibly in ink; ❦ and old green-bordered hexagonal paper label, stretcher, inscribed illegibly in ink; ❦ and a small remnant of a white paper label, frame, inscribed in paint: ington.

CONDITION and TECHNIQUE
The painting is wax lined to a second canvas. The paint layers are thinly applied, with signs of the pencil grid used to transfer the design to the canvas showing through in the sky. The signature is probably a later edition. The lower right corner was damaged, abraded, and heavily restored before 1973. Conserved, 1973, Alfred Jakstas, Art Institute of Chicago, Chicago.

PROVENANCE
Possibly W. Webb, Paris, France; ❦ Comte Ernest? de Ganay, Paris, France. (The painting does not appear in the Ganay sales at the Hotel Drouot, Paris in 1881, 1903, 1904, 1906, or 1907.); ❦ Paul Mersch, Paris, France; ❦ George A. Hearn, New York, New York, 1908; ❦ George A. Hearn estate, New York, New York, 1917; ❦ Frank C. Ball, Muncie, Indiana, 1918; ❦ Ball Brothers Foundation, Muncie, Indiana, 1936.

EXHIBITIONS
Indianapolis, John Herron Art Museum (Indianapolis Museum of Art). *Early British Masters: 17th, 18th, and Early 19th Centuries*. March 8–April 20, 1941, catalogue number 1, illustrated plate 1.

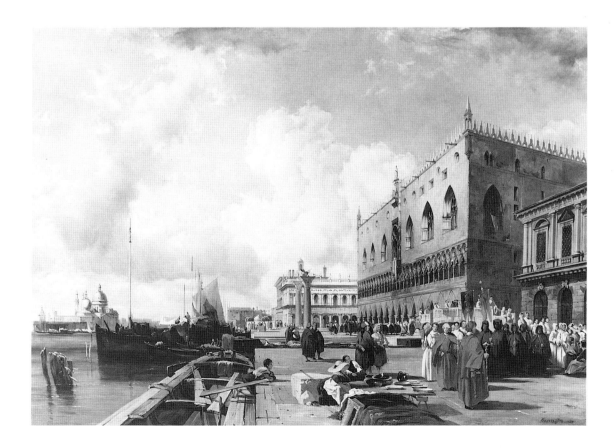

REFERENCES

Possibly, Paris, Hotel Place de la Bourse. *Notice de Tableaux de Dessins au Lavis Peints par Bonington, et Quelques Tableaux Italiens et Flamands, Collection Formée par M. W[ebb]*. May 23, 1837, lot number 51, *Place Saint-Marc, grand tableau non terminé*. (The sale included fifty-two paintings and six watercolors by Bonington. Though it is possible that the Muncie painting was lot number 51 in the sale, this has not been determined with any certainty.) ❧ Paris, Hotel Drouot. *Catalogue des Tableaux Anciens par . . . Composant la Collection de M.P.M. [Paul Mersch]*. May 8, 1908, lot number 2, *Une Procession sur le Quai des Esclavons, à Venise*. ❧ *Le Bulletin de l'Art*. May 23, 1908, page 164. ❧ New York, American Art Association. *Notable Art Collection Formed by the Late George A. Hearn*. March 1, 1918, lot number 445, illustrated. ❧ Ball State, 1936, page 9. ❧ "British Masters Seen in Indianapolis." *Art Digest*, April 15, 1941, page 9, illustrated. ❧ Ball State, 1947, page 5. ❧ Morse, John D. *Old Master Paintings in North America*. New York: Abbeville Press, n.d. (1979), pages 19–20.

RELATED WORKS

Richard Parkes Bonington. *The Doge's Palace, Venice*, 1828, oil on canvas, 114.2 × 162.5 cm, The Tate Gallery, London. (Exhibited: British Institution, 1828, number 314 and 1843, number 137. Reviewed: *Literary Gazette*, February 9, 1828, number 577, page 90, and *London Weekly Review*, volume II, 1828, pages 124 and 348.)

Attributed to Richard Parkes Bonington. *The Doge's Palace, Venice*, n.d., oil on canvas, 119.4 × 167.5 cm, former collection of the Malden Public Library and Art Gallery, Malden, Massachusetts, sold New York, Sotheby's February 16, 1994, lot number 20. (Exhibited: Indianapolis, John Herron Museum of Art. *The Romantic Era: The Birth and Flowering, 1750–1850*. February 21–April 11, 1965, catalogue number 36, illustrated.)

Antonio Canal called Canaletto (1697–1768). For Canal's views of the same subject and the probable sources of Bonington's composition, see Constable, W.G. *Canaletto: Giovanni Antonio Canal*. Second edition, revised by J.G. Links, Oxford: Clarendon Press, 1976, catalogue numbers 87–89 and 91.

REMARKS

Bonington here depicts a view of the Molo looking west with the Ducal Palace on the right. Arriving in Venice on April 20, 1826, Bonington departed shortly thereafter. By 1827 he was back in England working on paintings from his Italian sketches.

Prosper-Georges-Antonine Marilhat

French (1811–1847)
born Vertaizon, Auy-de-Dome, France, March 20, 1811
died Thiers, France, September 13, 1847

Vue prise sur les bords du Gardon, circa 1835–1845

(*Edge of the Forest*)

paint (oil) on canvas
44.5 × 58.5 cm; 17½ × 23 inches

Permanent loan from the Frank C. Ball Collection, Ball Brothers Foundation
L29.056

INSCRIPTIONS

Verso: inscribed in ink, stretcher, vertical member, illegibly; ❧ inscribed in black crayon, frame, upper member, left and right: 211; ❧ and in black ink, frame, lower member, left: 161; and in white chalk, frame, upper member, center: 19.

Labels, etc.: bears corner of a red-bordered paper label, stretcher, upper member, left, inscribed: B; ❧ and a remnant of a red-bordered paper label, frame, upper member, left, inscribed: 9; ❧ and red star-shaped paper label, frame, upper member inscribed: 60; ❧ (The George A. Hearn sale catalogue (see references) notes that there was a label from a Paris auction house on the verso of the painting listing the title as *Vue prise sur les bords du Gardon*. The label is no longer extant.)

CONDITION and TECHNIQUE

The varnish is discolored and disfiguring. The design extends onto the left and lower tacking margins.

PROVENANCE

Prosper-Georges-Antoine Marilhat; ❦ possibly Prosper-Georges-Antoine Marilhat estate, 1849; ❦ George A. Hearn, New York, New York, before 1908; ❦ George A. Hearn estate, New York, New York, 1917; ❦ Frank C. Ball, Muncie, Indiana, 1918; ❦ Ball Brothers Foundation, Muncie, Indiana, 1936.

REFERENCES

(Former accession number: AC-29-56.) ❦ Paris, Hôtel Des Ventes Mobilières. *Catalogue d'une Collection de Tableaux, Etudes peintes et dessinées d'après nature, par feu Marilhat* (atelier sale). December 13-15, 1849, lot number 52, as *Etude aux bords du Gardon*. (Though it is possible that this is the Muncie painting, the loss of the label recorded in the George A. Hearn sale catalogue makes it difficult to confirm.) ❦ Hearn, George A. *Catalogue of the Collection of Foreign and American Paintings Owned by Mr. George A. Hearn*. New York: privately printed (The Gilliss Press), 1908, page 94, catalogue number 114. ❦ New York, American Art Association. *Notable Art Collection Formed by the Late George A. Hearn*. February 27, 1918, lot number 211, illustrated. ❦ Ball State, 1947, page 17.

Labels, etc.: bears blue-bordered round white paper label, frame, right member, right, inscribed: 10; ❦ and blue-bordered white paper label, frame, upper member, left, inscribed: No 1 Huntsman / Bon??? of ?M.p? / Pall Mall May 5, 187? (possibly 3, 4, or 8).

CONDITION and TECHNIQUE

The painting is paste lined to a second canvas. There is an old tear, now filled and liberally overpainted, in the sky. The natural resin varnish is extremely disfiguring.

PROVENANCE

Frank C. Ball, Muncie, Indiana; ❦ Ball Brothers Foundation, Muncie, Indiana, 1937.

REFERENCES

(Former accession number: AC-37-130.) ❦ Ball State, 1947, page 9. ❦ Alasko, Richard-Raymond. *Nineteenth Century American Paintings: Art Gallery, Ball State University*. Muncie: Ball State University, n.d. (1972?), unpaginated, page 5, illustrated page 4.

Thomas Doughty

American (1793–1856)
born Philadelphia, Pennsylvania, July 19, 1793
died New York, New York, July 24, 1856

Huntsman, 1838

(*Landscape*)

paint (oil) on canvas
91.4 × 73.5 cm; 36 × 28¹⁵⁄₁₆ inches

Permanent loan from the Frank C. Ball Collection, Ball Brothers Foundation
L37.130

INSCRIPTIONS
Recto: signed in brown oil paint, bottom center: T. Doughty 1838.

Jean-François-Théodore Gechter

French (1796–1844)
born Paris, France, 1796
died Paris, France, December 11, 1844

Charles Martel combattant Abderame, roi des Saracens, 1839

(*Charles Martel Fighting Abderame, King of the Saracens*)

metal (bronze)
59.0 × 55.8 × 35.5 cm; 23¼ × 22 × 14 inches

Lent by David T. Owsley
L91.027.2

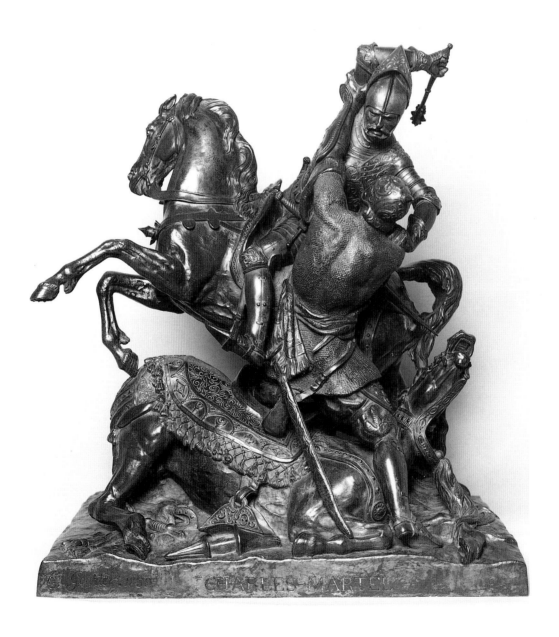

INSCRIPTIONS
Inscribed in cast, front base: C Gechter.1839 / CHARLES
MARTEL.

CONDITION and TECHNIQUE
The piece has an extensively tooled surface; it is cast in
three primary sections: the base, the fallen horse, the figure
on the fallen horse (joined at left knee and at both
forearms), and the standing horse and figure (except for this
figure's left hand, which is cast with the figure on the fallen
horse). Miscellaneous separately cast parts include Charles
Martel's right forearm and mace, his helmet visor, his sword
handle, and the two sections of the handle cross member.

PROVENANCE
David T. Owsley, New York, New York, 1991.

EXHIBITIONS
Dallas, Dallas Museum of Art. *Sculpture: East and West,
Selections from the David T. Owsley Collection.* December
15, 1993-June 15, 1994, no catalogue.

REFERENCES
New York, Christie's. *19th Century European Paintings,
Drawings, Watercolors and Sculpture Including Barbizon,
Realist and French Landscape Paintings.* May 23, 1991,
lot number 83, illustrated.

RELATED WORKS
The Muncie bronze is a reduction of the group
commissioned in 1833 by the Ministry of Commerce and
Industry, Paris, France and exhibited in the Salon of that
year, as catalogue number 2589.

REMARKS
Charles Martel (689?-741), grandfather of Charlemagne,
succeeded his father Pepin as ruler of the Franks in 715. In
732, he defeated the Caliph's army under the command of
Abd-er-Rahman at Tours, ending the Muslim invasion of
France. Abd-er-Rahman (Abderame), the Emir of Spain from
731 to 732, and Governor of Southern Gaul (France) from
721, led the Caliph's army through the western Pyrenees
into France in 732. He was killed in battle at Tours the same
year.

Hiram Powers

American (1805-1873)
born Woodstock, Vermont, July 29, 1805
died Florence, Italy, June 27, 1873

Proserpine, 1839-1843 (conceived); 1844-1849 (this version executed)

stone (marble)
52.6 × 40.6 × 22.8 cm; 20¾ × 16 × 9 inches

Lent by David T. Owsley
L91.027.1

Emerging from a nest of leaves, Hiram Powers's
marble sculpture *Proserpine* presents this
character's godly attributes. As he planned this
bust, Powers himself described the subject at
length:

> She was daughter of Jupiter and Ceres
> and gathering flowers when very young
> and exceedingly beautiful, was discov-
> ered by Pluto who seized her in his arms
> and bore her down through a neighbor-
> ing lake to his own infernal dominions.
> Her mother sought her a long time in
> vain, but at last found out her fate and
> besought Jupiter to release her, which
> request was granted on condition that
> "Proserpine" had eaten nothing while
> with Pluto. But unhappily she had eaten
> a pomegranate in his garden and so a
> compromise was made, viz, she should
> come back to earth half the year and
> remain with her husband the other half.
> And so she appears in the bust with a
> wreath of wheat in bloom on her head
> and rising out of an acanthus (emblem of
> immortality) around her waist (1838).

Despite the violent overtones of the story,
Powers here shows Proserpine as expressionless
and perfectly calm—emphasized by the
smoothness of her marble "skin." Before moving

to Florence, Italy, in 1837 (from where he never returned), Powers was known primarily for his realistic portrait busts that recorded sitters with their imperfections intact. *Proserpine* marks his turn to a new mode: the artist referred to this work as an "ideal bust," implying that he sought to create a sculpture perfected in proportions, facial type, and refinement of textures. *Proserpine's* expressionless features and sense of frozen calm speak to the notion of reason over emotion that characterized Neoclassical thought and art.

Although *Proserpine* represents one of Powers's first attempts at idealized sculpture, it would become one of his most popular works. Scholars estimate that the artist filled up to two hundred orders for this marble sculpture in various sizes and versions. As early as 1838 Powers seems to have started thinking about creating a bust of

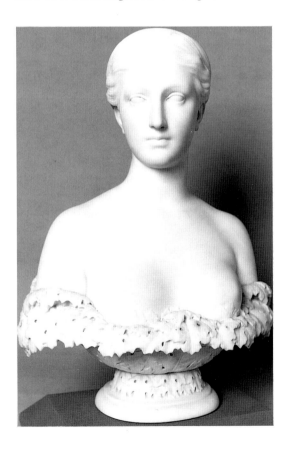

Proserpine. In a letter dated November 5 of that year (quoted above), Powers described the sculpture to Nicholas Longworth, the friend and patron who had financed his move to Italy. Scholars disagree about when Powers made the original model, variously dating the task between 1839 and 1843.

The bust seen here represents Powers's second version of *Proserpine*. In the first, the same expressionless head emerges from an intricately carved woven basket edged with flowers (apparently known in only one marble, now in the Honolulu Academy of Arts, Honolulu, Hawaii). This complex design proved too time consuming for the stone carvers in Powers's studio to produce efficiently. In 1844 Powers altered the design in a second version, substituting for the basket a bed of acanthus leaves (a Mediterranean plant with thistle-like leaves, appearing in carved form on innumerable ancient architectural motifs). Five years later, with orders still pouring in, Powers again simplified the design, producing a third version in which a bead and leaf border surrounds the figure. His studio also produced abbreviated versions of the bust, in one cropping the figure just above the breasts, and in another, including just the upper chest. Most of the versions were available in three sizes, approximately 40, 52, and 63 cm.

Such vast output was possible only with the aid of his studio of skilled stone carvers. In the nineteenth century, many American artists went to Europe to study; some, like Powers, took up residence there. Sculptors flocked to Italy not only to steep themselves in the classical tradition, visible in both ancient sculpture and in the new classical work being done by Europeans like Antonio Canova, but also for the plentiful high quality marble available from quarries at Carrera and Seravezza, and for the skilled Italian carvers who would render in marble the artist's original clay or plaster model.

SOURCES

Craven, Wayne et al. *200 Years of American Sculpture*. New York: Whitney Museum of American Art, 1976. ❦ Crane, Sylvia E. *White Silence: Greenough, Powers and Crawford, American Sculptors in Nineteenth-Century Italy*. Coral Gables: University of Miami Press, 1972. ❦ Greenthal, Kathryn, Paula M. Kozol, and Jan Seidler Ramirez. *American Figurative Sculpture in the Museum of Fine Arts Boston*. With an Introductory Essay by Jonathan L. Fairbanks. Boston: Museum of Fine Arts Boston, 1986. ❦ Menconi, Susan E. *Uncommon Spirit: Sculpture in America 1800-1940*. New York: Hirschl and Adler Galleries, Inc., 1989. ❦ Powers, Hiram. Letter to Nicholas Longworth, Cincinnati. November 5, 1838. Quoted in Crane, 1972, page 192. ❦ Wunder, 1991.

INSCRIPTIONS

Inscribed on underside back of torso: H. POWERS / Sculp:.

PROVENANCE

Annette Senft Davis; ❦ Annette Senft Davis estate; ❦ David T. Owsley, New York, New York, 1991.

REFERENCES

Wunder, Richard P. *Hiram Powers: Vermont Sculptor, 1805-1873*, volume II, *Catalogue of Works*. Newark: University of Delaware Press, 1991, catalogue numbers 219-221, pages 187-204, other examples illustrated, possibly example 153. ❦ New York, William Doyle Galleries. *American Paintings and Sculpture*. April 17, 1991, lot number 55, illustrated in color.

REMARKS

Wunder records 156 replicas of the bust with the acanthus leaf socle and border or the plain beaded border; there were more than one hundred examples of the 63.5-cm-high version, and approximately 40 of the 40.5-cm-high version. The ten remaining recorded examples range from 38 to 61 cm high. The Muncie marble may be Wunder number 153 (sold, Sotheby's, Belgravia, London, November 26, 1973) or an unrecorded example.

A plaster model of the 63.5-cm-high version with its bronze pointing pins still imbedded is in the Galleria d'Arte Moderna, Florence, Italy, and a plaster of the head only, also with bronze pointing pins, is in the National Museum of American Art, Washington, D.C.

Jean-François Millet

French (1814-1875)
born Gruchy, France, October 4, 1814
died Barbizon, France, January 20, 1875

Bûcheron, circa 1850
(*The Woodchopper; Wood Chopper*)

paint (oil) on canvas (linen)
39.8 × 34.0 cm; 15⅝ × 13⅜ inches

Permanent loan from the Elisabeth Ball Collection, George and Frances Ball Foundation
L83.026.22

Aiming a heavy blow toward a dense tree trunk, a man swings an ax over his shoulder. Jean-François Millet rendered the scene in thick, flat strokes of paint that assume a substance that seems somehow similar to the materials it represents: wood, coarse fabric, flat earth. Within the limited vista, the figure assumes a monumental presence while at the same time he is depicted matter-of-factly in a way that neither aggrandizes nor shrinks from the fact of his labor.

Art historians place Jean-François Millet among the Realist artists. In contrast to the historical themes endorsed by the art academies, Realist painters focused their attention on scenes from contemporary life. Although the Realists were hailed by progressive artists and thinkers as creators of an art that finally, and rightly, focused on the common man, the public generally greeted such images of the peasant class as both ugly and threatening. Both the conservative public and progressive artists and writers viewed such images as political: making the former group aware of the social ills enforced on the peasantry, and the latter group aware of the potential threat the peasant class posed to Parisian society.

Although often read as political statements both

now and in their own time, Millet's canvases were not intended to be read as propaganda. Schooled in the classics of literature and the masterpieces of art, an ardent student of the Bible and Virgil, Millet viewed his work as (in the words of art historian Robert Herbert), "Not a cry for change, but the age-old struggle of man for existence, a struggle which would continue forever, unchanged." Millet expressed his views in a letter:

> You are sitting under a tree, enjoying all the comfort and quiet which it is possi-ble to find in this life, when suddenly you see a poor creature, loaded with a heavy [bundle of sticks] coming up the narrow path opposite. The unexpected and always striking way in which this figure appears before your eyes reminds you instantly of the sad fate of humani-ty—weariness (1851).

Millet's contemporary, the critic Castagnary, was one of the few who understood the painter's ideas. Writing of the artist's famous painting, *The Gleaners*, Musée de Louvre, Paris, that depicts three women picking up the scraps from the field after the harvest, Castagnary wrote:

> This canvas, which recalls frightening miseries, is not at all, like some paintings by Courbet [another Realist painter], a political harangue or a social thesis: it is a very beautiful and very simple work of art, free of all declaiming. The motif is poignant, it is true, but treated so hon-estly, it raises itself above partisan pas-sions and reproduces [. . .] one of these pages of true and grand nature that Homer and Virgil found.

Although writing about another painting, Castagnary might as well have been commenting on Muncie's *Woodchopper*, which in both

imagery and technique can easily be misread as a comment on social ills. But in addition to the intentions expressed in his remarks above, Millet also saw his peasant paintings as a way of transforming the themes of myth and religion into comprehensible secular terms. Although religious and mythological subjects were highly prized by the academies, they were considered outmoded and irrelevant among progressive artists. Nevertheless, Herbert has identified most of Millet's paintings as "transpositions of religious or mythological themes." For instance, the labors in which Millet's peasants often engage—sowing, gathering sticks or chopping wood—are the traditional labors and activities used to illustrate medieval calendars.

Although this small painting is one of the museum's few Realist works, and on the surface appears as a simple image of a man at work, in the traditions of earlier art, it resonates with multiple meanings.

SOURCES
Castagnary. *Philosophie du Salon de 1857*. *Salons 1857-1870*, volume 1. Paris: 1892, 24. Quoted in Herbert, page 48. ❧ Herbert, Robert. "City vs. Country: The Rural Image in French Painting from Millet to Gauguin." *Art Forum*, February, 1970, pages 44-55. ❧ Millet, Jean-François to Sensier, February 1, 1851. Moreau-Nelaton, Etienne. *Millet raconté par lui-meme*, volume 1. Paris: 1921, page 91. Quoted in Herbert, page 47. ❧ Rosenblum, Robert, and H.W. Janson. *19th-Century Art*. New York: Harry N. Abrams, Inc. 1984.

INSCRIPTIONS
Recto: signed in red oil paint, lower left: J. F. Millet.

Verso: inscribed in yellow chalk, stretcher, lower member: S29; ❧ inscribed in black crayon, frame, upper member: X69; ❧ and in yellow chalk, frame, lower member: S29.

Labels, etc.: bears remnant of a white paper auction house label, frame, upper member, inscribed: consign no. / S1-5 / lot no. 35; ❧ and remnant of a white paper dealer's label, frame, upper member: J.F. Millet #1497 / FR ??? HL Gallery / AMBASSADOR HOTEL.

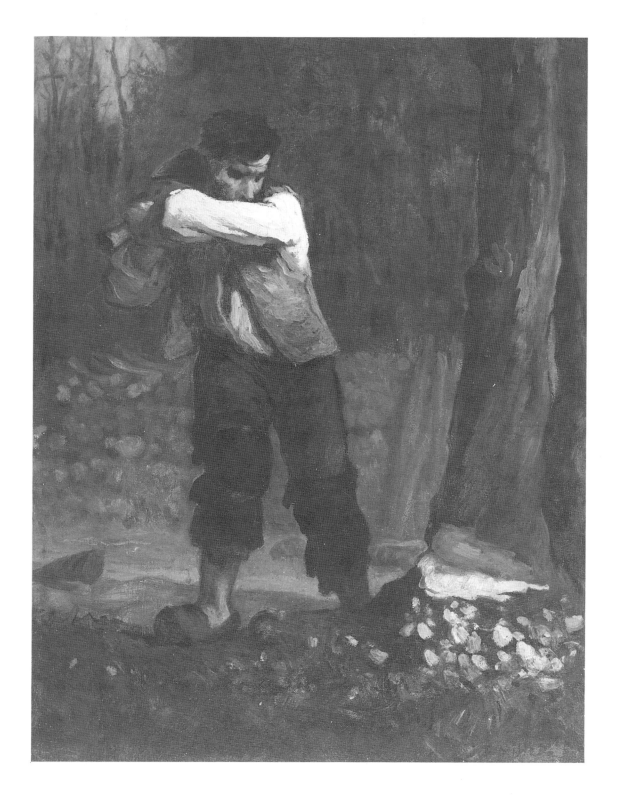

Conserved, 1991, Intermuseum Conservation Association, Oberlin, Ohio.

PROVENANCE
Probably Baron Courtier, Paris, France; ❦ probably Baron Papelon, Paris, France; ❦ M. Knoedler and Company, Paris and New York, by 1883; ❦ Stendhal Galleries, Paris, France; ❦ John Levy Galleries, New York, New York; ❦ James G. Shepherd, New York, New York, 1926; ❦ Mrs. James G. Shepherd, New York, New York; ❦ Mr. and Mrs. George A. Ball, Muncie, Indiana, November 7, 1935; ❦ Elisabeth Ball, Muncie, Indiana, before 1957; ❦ George and Frances Ball Foundation, Muncie, Indiana, 1982.

EXHIBITIONS
New York, National Academy of Design. *Pedestal Fund Art Loan Exhibition.* December, 1883, catalogue number 76, as *The Wood-Chopper.* ❦ Indianapolis, John Herron Art Museum (Indianapolis Museum of Art). *Indiana Collects: A Loan Exhibition of European and Latin-American Paintings Owned by Collectors in the State of Indiana.* October 9-November 6, 1960, catalogue number 61, as *Wood Chopper.* ❦ Muncie, Ball State University Art Gallery. *The Elisabeth Ball Collection Paintings, Drawings, and Watercolors: The George and Frances Ball Foundation.* January 15-February 26, 1984, page 32, catalogue number 22, illustrated. ❦ Southhampton, Parrish Art Museum. *In Support of Liberty: European Paintings at the 1883 Pedestal Fund Art Loan Exhibition.* June 29-September 1, 1986 (also New York, National Academy of Design, September 18-December 7, 1986), page 171, catalogue number 63, illustrated page 124, plate XXXI. ❦ Tokyo, Tokyo Bunkamura Museum. *Jean-François Millet Exhibition: A Retrospective.* August 15-September 25, 1991 (also Kyoto, Kyoto Municipal Museum of Art, October 3-27, 1991; and Kofu, Yamanashi Prefectural Museum of Art, November 3, 1991-December 8, 1991), catalogue number 20, illustrated in color.

REFERENCES
Paris, Hotel Drouot. *Catalogue des Tableaux Modernes Composant la Collection de M. Le Baron C[ourtier].* March 9, 1857, page 12, lot number 27. ❦ Paris, Hotel Drouot. *Catalogue des Tableaux Modernes Composant la Collection de M. Le Baron P[apelon].* February 17, 1859, page 10, lot number 40. ❦ Soullie, Louis. *Peintures aquarelles, pastels, dessins de Jean-François Millet relevés dans les catalogues de ventes de 1849-1900.* Paris: Librarie spéciale des catalogues de ventes annotés, 1900, page 17. ❦ New York, American Art Association, Anderson Galleries, Inc. *The James G. Shepherd Collection of*

Important Paintings and Barye Bronzes. Foreword by Leslie A. Hyam. November 7, 1935, pages 8 and 59, lot number 69, illustrated, as *The Woodchopper.* ❦ Unpublished invoice dated November 7, 1935, American Art Association, Inc., to Mr. and Mrs. George A. Ball. ❦ Joyaux, Alain G. *The Elisabeth Ball Collection of Paintings, Drawings, and Watercolors: The George and Frances Ball Foundation.* Muncie: Ball State University Art Gallery, 1984, page 32, catalogue number 22, illustrated. ❦ O'Brien, Maureen C. *In Support of Liberty: European Paintings at the 1883 Pedestal Fund Art Loan Exhibition.* Southhampton: Parrish Art Museum, 1986, page 171, catalogue number 13, illustrated page 124, plate XXXI.

RELATED WORKS
Jean-François Millet. *Fagot Gatherers,* 1850, oil on canvas, 38 × 46 cm, Art Museum of the Palm Beaches (Norton Gallery of Art), West Palm Beach, Florida.

Jean-François Millet. *Two Peasants Splitting Wood,* 1848-1851, crayon on paper, 40 × 28 cm, Ashmolean Museum, Oxford, England.

Camille Jean-Baptiste Corot

French (1796-1875)
born Paris, France, July 16, 1796
died Ville-d'Avray, France, February 22, 1875

Environs de Ville d'Avray, circa 1860-1875

paint (oil) on canvas (linen)
52.0 × 85.5 cm; 20½ × 33¹¹⁄₁₆ inches

Permanent loan from the Frank C. Ball Collection, Ball Brothers Foundation
L37.128

INSCRIPTIONS
Recto: signed in black oil paint, lower right: COROT.

Verso: inscribed in black paint, stretcher, lower member, left: 130; ❦ inscribed in black pen, frame, upper member, center: O-128; ❦ and in black pen, frame, upper member top: 152; ❦ and in black pen, frame, left member, bottom: 152.

Labels, etc.: bears remains of a red-bordered paper label, stretcher, upper member, left; ❦ and white paper label, stretcher, center member, top, inscribed: EXPOSITION / d'oeuvres prêtées de feu / JEAN BAPTISTE CAMILLE COROT / AU SALON DE ST. SULPICE / 9, Rue Sirvandoni, Faubourg St. Germain, Paris / Février 1876 / nom de l'oeuvre: Environs de Ville d'Avray / Numéro: 25 / Addresse de propriétaire: M. Breysse, 9 Rue Pavée / Prix ne pas pour le vendre; ❦ and white paper label, stretcher, upper member, right inscribed: No.4606 / Picture; ❦ and small red-bordered paper label, frame, upper member, right inscribed: 7365/2.

CONDITION and TECHNIQUE
The painting is unlined but patched in three places. The thick natural resin varnish is markedly to moderately disfiguring. Infrared photographs indicate a major compositional change on the right side of the painting, pentimenti which are now visible. As originally conceived, a group of trees arched into the composition from the right side.

PROVENANCE
M. Breysse, Paris, France, before 1876. ❦ (The painting does not appear in either the Breysse, February 4, 1893, or December 23, 1898 sales, Hotel Drouot, Paris.); ❦ Frank C. Ball, Muncie, Indiana, 1918; ❦ Ball Brothers Foundation, Muncie, Indiana, 1936.

EXHIBITIONS
Paris, Salon de St. Sulpice. *Exposition d'oeuvres prêtées de feu Jean Baptiste Camille Corot.* February, 1876, catalogue number 25. ❦ Indianapolis, John Herron Museum of Art (Indianapolis Museum of Art). *Indiana Colleges Collect.* October 3–November 1, 1964, catalogue number 2.

REFERENCES
(Former accession number: AC-37-128.) ❦ Ball State, 1947, page 7. ❦ Morse, John D. *Old Master Paintings in North America.* New York: Abbeville Press, n.d. (1979), page 62.

Narcisse Virgile Diaz de la Peña

French (1807–1876)
born Bordeaux, France, August 20, 1807
died Menton, France, November 18, 1876

Landscape, circa 1860–1875

paint (oil) on panel (mahogany)
37.0 × 45.7 cm; 14⁹⁄₁₆ × 18¹⁄₁₆ inches

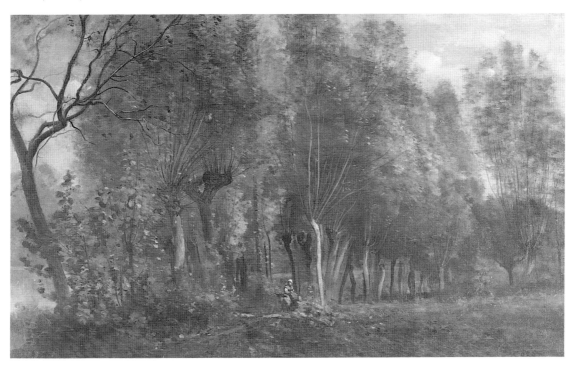

Permanent loan from the Frank C. Ball Collection, Ball Brothers Foundation
L29.033

CONDITION and TECHNIQUE
The paint surface is partially obscured by multiple layers of yellowed varnish with a slight bloom.

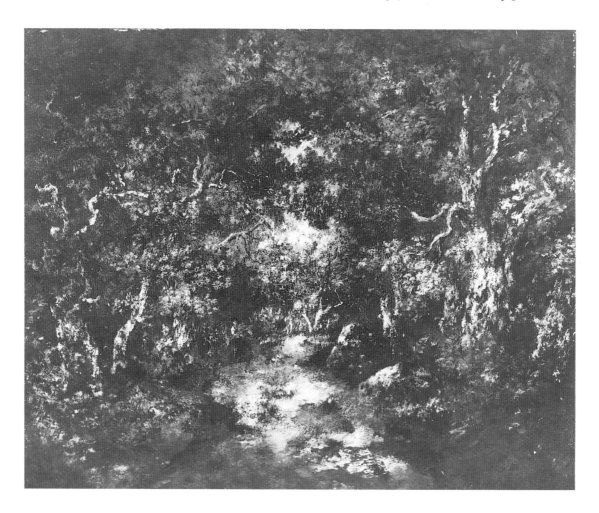

Adolphe-Joseph Thomas Monticelli

French (1824-1886)
born Marseilles, France, October 16, 1824
died Marseilles, France, June 29, 1886

Le Concert, circa 1863-1869
(*The Concert*; *Garden Scene*; *Music*)

paint (oil) on panel (mahogany, cradled)
43.5 × 66.6 cm; 17⅛ × 26¼ inches

Permanent loan from the Elisabeth Ball Collection,
George and Frances Ball Foundation
L83.026.23

INSCRIPTIONS
Recto: signed in red oil paint, lower left: Monticelli.

Labels, etc.: bears white paper tag, verso, center, stamped
in red: 7413.

CONDITION and TECHNIQUE
There are areas of overpaint at the panel seam, two inches
from bottom edge. The varnish is thick, crazed, and
disfiguring.

PROVENANCE
Madame Moreau, Paris, France; ❦ Chester H. Johnson
Galleries, Chicago, Illinois; ❦ Mr. and Mrs. George A. Ball,
Muncie, Indiana, February 23, 1924; ❦ Elisabeth Ball,
Muncie, Indiana, before 1957; ❦ George and Frances Ball
Foundation, Muncie, Indiana, 1983.

EXHIBITIONS
Indianapolis, John Herron Museum of Art (Indianapolis
Museum of Art). *Indiana Collects: A Loan Exhibition of
European and Latin-American Paintings Owned by
Collectors in the State of Indiana.* October 9-November 6,
1960, unpaginated, catalogue number 64, as *Music*. ❦
Muncie, Ball State University Art Gallery. *The Elisabeth Ball
Collection Paintings, Drawings, and Watercolors: The
George and Frances Ball Foundation.* January
15-February 26, 1984, catalogue number 23.

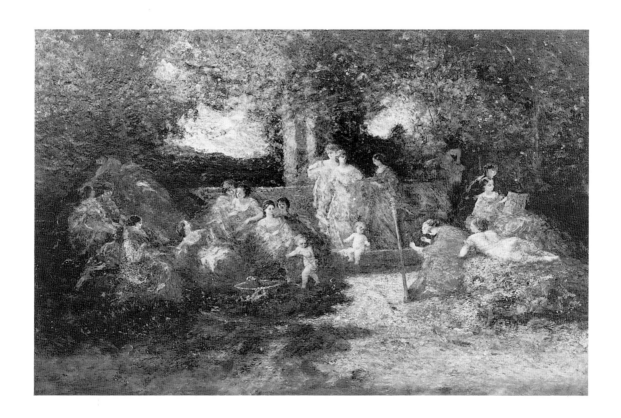

REFERENCES

Unpublished invoice dated February 25, 1924, Chester H. Johnson Paintings. ❦ possibly Coquiot, Gustave. *Monticelli*. Paris: Albin Michel, 1925, page 249, as *Le Concert*. ❦ Joyaux, Alain G. *The Elisabeth Ball Collection of Paintings, Drawings, and Watercolors: The George and Frances Ball Foundation*. Muncie: Ball State University Art Gallery, 1984, page 33, catalogue number 23, illustrated.

RELATED WORKS

Adolphe-Joseph Thomas Monticelli. *Scène du Décaméron*, 1869, oil on panel, 46 × 72 cm, Musée de Lille, Lille, France.

Adolphe-Joseph Thomas Monticelli. *Allegory*, circa 1863-1865, oil on panel, 34.3 × 68.3 cm, Walters Art Gallery, Baltimore, Maryland.

Adolphe-Joseph Thomas Monticelli. *Sylvan Idyll*, circa 1863-1865, oil on panel, 20 × 39.6 cm, Academy of Arts, Honolulu, Hawaii.

Alexander H. Wyant

American (1836-1892)
born Port Washington, Ohio, January 11, 1836
died New York, New York, November 29, 1892

Near Conway, North Wales, 1868

paint (oil) on canvas (linen)
51.8 × 69.2 cm; 21⅜ × 27¼ inches

Permanent loan from the Frank C. Ball Collection, Ball Brothers Foundation
L37.157

INSCRIPTIONS
Recto: signed in black oil paint, lower right center: A.H. Wyant, 1868.

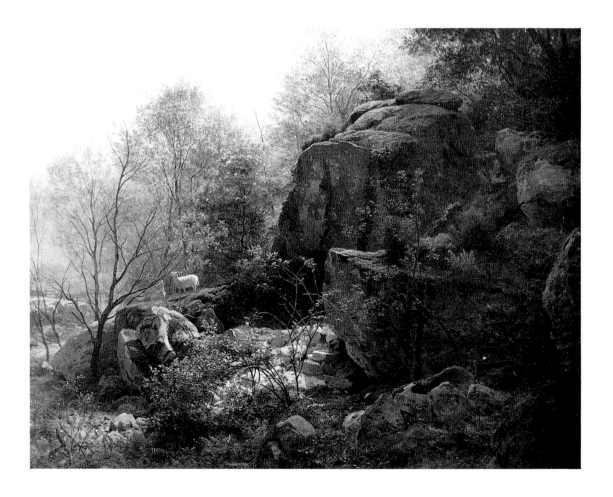

Verso: inscribed in black crayon, frame, upper member: #40; ❦ and in black crayon, frame, left member: 37; ❦ and in black crayon, frame, right member: 37.

CONDITION and TECHNIQUE
Conserved, 1972, Peter Kulesh, Winnetka, Illinois.

PROVENANCE
Gustave Reichard; ❦ Holland Art Galleries, New York, New York; ❦ James Buchanan Brady, New York, New York; ❦ Frank C. Ball, Muncie, Indiana, 1918; ❦ Ball Brothers Foundation, Muncie, Indiana, 1936.

REFERENCES
(Former accession number: AC-37-157.) ❦ New York, American Art Association. *Valuable Modern Paintings Collected by James Buchanan Brady*. January 14, 1918, lot number 37, illustrated. ❦ Unpublished invoice dated January 14, 1918, American Art Association to Frank C. Ball. ❦ Ball State, 1931, page 11. ❦ Ball State, 1947, page 25. Alasko, Richard-Raymond. *Nineteenth Century American Paintings: Art Gallery, Ball State University*. Muncie: Ball State University, n.d. (1972?), unpaginated, page 13, illustrated page 12.

Sanford Robinson Gifford

American (1823-1880)
born Greenfield, New York, July 10, 1823
died New York, New York, August 24, 1880

A Twilight Sketch in Venice,
June–July, 1869
(*Venice, City-Scape*; *Venice City Scene*)

paint (oil) on canvas (commercially primed linen)
30.1 × 16.5 cm; 11⅞ × 6½ inches

Gift of Mrs. Frederick J. Petty
54.007.2

INSCRIPTIONS
Verso: bears estate sale stamp, canvas, upper center, in red: S.R. GIFFORD SALE; ❦ inscribed in black chalk, stretcher, upper member, left and right: 1125 FS.

PROVENANCE
Frank C. Ball, Muncie, Indiana; ❦ Margaret Ball Petty, Muncie, Indiana.

EXHIBITIONS
New York, Metropolitan Museum of Art. *Second Loan Exhibition of The Metropolitan Museum of Art*. Winter 1880-1881, catalogue number 150.

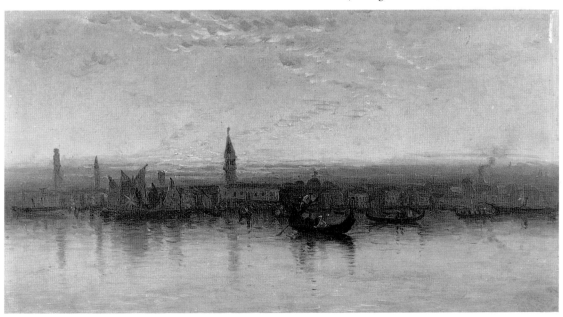

REFERENCES

(Former accession number AC-54-222.) ❦ Weir, John F. *A Memorial Catalogue of the Paintings of Sanford Robinson Gifford.* New York: Metropolitan Museum of Art, 1881, page 37, catalogue number 536, as owned by the Gifford estate. ❦ New York, Thomas E. Kirby and Company. *Catalogue of Valuable Oil Paintings, Works of Famous Artists, Sanford R. Gifford.* 1881 (estate sale), catalogue number 150. ❦ Alasko, Richard-Raymond. *Nineteenth Century American Paintings: Art Gallery, Ball State University.* Muncie: Ball State University, n.d. (1972?), unpaginated, page 11, illustrated page 10. ❦ Weiss, Ila. *Poetic Landscape: The Art and Experience of Sanford R. Gifford.* Newark: University of Delaware Press, 1987, page 277, illustrated page 276. ❦ Lovell, Margaretta. *A Visitable Past: Views of Venice by American Artists, 1860-1915.* Chicago: University of Chicago Press, 1989, pages 52-53, illustrated page 52.

REMARKS

Gifford spent June 6 through July 18, 1869, in Venice, Italy, his second of two trips to Italy.

George Henry Smillie

American (1840-1921)
born New York, New York, October 29, 1840
died New York, New York, November 10, 1921

Landscape, 1870

paint (oil) on canvas (commercially primed linen)
56.2 × 91.7 cm; 22⅛ × 36⅛ inches

Permanent loan from the Frank C. Ball Collection, Ball Brothers Foundation
L37.153

INSCRIPTIONS

Recto: signed in black oil paint, lower left: Geo. H. Smillie 1870.

Verso: inscribed in pencil, stretcher, upper member, left: 29417 od / $100; ❦ inscribed, in black crayon, frame, upper member, left: x33; ❦ and in pencil, frame, left member, center: 22 × 36 #102; ❦ and in pencil, frame, left member, with an illegible name: S???.

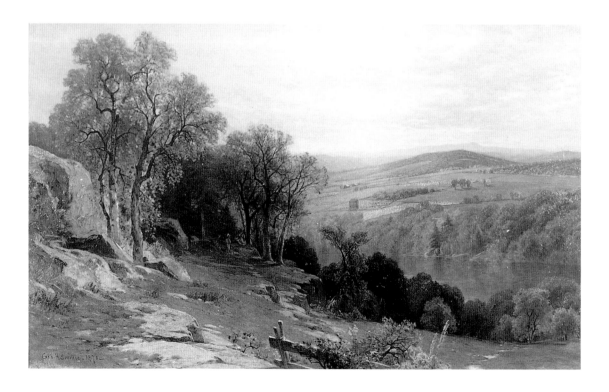

Labels, etc: bears remnant of a paper M. Knoedler and Company, label, frame, upper member, center; ❧ and paper auction house label ?, frame, upper member, left, inscribed: lot 159.

CONDITION and TECHNIQUE
The painting is unlined. The varnish is discolored, and there are traces of old varnish residue at the edges and interstices of canvas.

PROVENANCE
M. Knoedler and Company, New York, New York; ❧ Frank C. Ball, Muncie, Indiana; ❧ Ball Brothers Foundation, Muncie, Indiana, 1937.

REFERENCES
(Former accession number: AC-37-153.) ❧ Alasko, Richard-Raymond. *Nineteenth Century American Paintings: Art Gallery, Ball State University*. Muncie: Ball State University, n.d. (1972?), unpaginated, page 17, illustrated page 16.

CONDITION and TECHNIQUE
The piece is cast in four primary sections, the base and central figure to the waist, the upper section of the central figure (joined at left wrist and plow handle), the right cherub (joined at central figure's left arm), and the left cherub. The surface was extensively tooled after casting.

PROVENANCE
David T. Owsley, New York, New York, 1991.

EXHIBITIONS
Dallas, Dallas Museum of Art. *Sculpture: East and West, Selections from the David T. Owsley Collection*. December 15, 1993–June 15, 1994, no catalogue.

REFERENCES
New York, Christie's. *19th Century European Paintings, Drawings, Watercolors and Sculpture Including Barbizon, Realist and French Landscape Paintings*. May 23, 1991, lot number 88, illustrated.

Albert-Ernst Carrier-Belleuse

French (1824–1887)
born Anizy-le-Chateau, France, June 12, 1824
died Sevres, France, June 3, 1887

An Allegorical Group of Autumn, circa 1870–1885

metal (bronze)
54.5 × 40.0 × 24.7 cm; 21½ × 15¾ × 9¾ inches

Lent by David T. Owsley
L91.027.3

INSCRIPTIONS
Inscribed in cast, base, right surface: A. CARRIER.

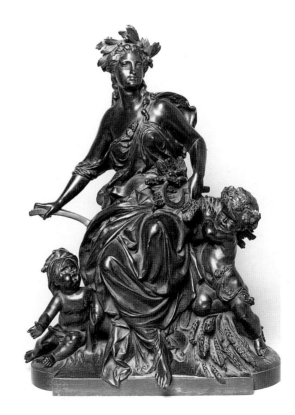

Winslow Homer

American (1836-1910)
born Boston, Massachusetts, February 24, 1836
died Prout's Neck, Maine, September 29, 1910

The Blue Boy, June, 1873

paint (watercolor), graphite on paper
23.0 × 34.0 cm; 9¹⁄₁₆ × 13⅜ inches

Permanent loan from the Elisabeth Ball Collection,
George and Frances Ball Foundation
L83.026.12

From a sunny, flower-covered hillside, two boys gaze into the distance. One of the many watercolors Winslow Homer painted in the summer of 1873 in Gloucester, Massachusetts, *The Blue Boy* represents Homer's first extensive foray into the liquid medium. In the 1860s, while making a living as an illustrator, Homer had enjoyed early success with his oil paintings of Civil War scenes, inspired by his illustration work for *Harpers Weekly* during the war. Inclusion of two of these works in the 1867 Paris Universal Exposition took Homer to France for the opening, where he then stayed for ten months.

By 1873 Homer was still working as a free-lance illustrator, work he apparently had grown to despise. Although he was making oil paintings, his commercial work had trained him in the technique of wash drawings, in which he applied India ink, diluted with water to achieve varying degrees of gray, to his drawings to indicate areas in shadow. In June of 1873, Homer left his New York City studio for a watercolor painting excursion to the New England coast at Gloucester, Massachusetts. *The Blue Boy* is typical of his work there, where he chose the local children as his theme.

Like Homer's other early watercolors, *The Blue Boy* is composed of sharp outlines, distinct masses of color, and striking contrasts of light and dark—characteristics that Homer had incorporated into his illustrations as an aid to the engraver. In *The Blue Boy*, he uses the white of the paper to indicate the white shirt of the boy resting on the hill; only the shadows are painted. Homer also brought techniques from his experience painting in oil, namely the opacity of oil paint (versus the translucency of watercolor). In his Gloucester paintings, Homer used an extraordinary amount of gouache—an opaque watercolor paint. In *The Blue Boy* he used gouache to render the hillside grasses against which the flowers—also in gouache—appear as flecks of sparkling light.

Subsequent trips to other New England coast towns, the Adirondacks, Canada, and the Caribbean spawned hundreds of watercolors (scholars know of at least 685 that survive). Each site presented a new subject, from the children of Gloucester to the guides of the Adirondacks and the fishermen of the Caribbean. Over the next two decades, Homer grew more adept in handling the medium, producing compositions filled with the feel of the outdoors that had become his trademark.

SOURCES
Cooper, Helen A. *Winslow Homer Watercolors.*
Washington: National Gallery of Art, 1986; New Haven:
Yale University Press, 1986.

INSCRIPTIONS
Recto: signed in dark blue watercolor, lower left: HOMER June 1873 (the work was completed or altered after the signature was applied); ❦ signed in pencil, on original white pressed paperboard window mat, lower right corner (now in object file): Winslow Homer N.A. / 1873.

Verso: inscribed in black grease pencil, original pressed paper board frame backing, upper right: 10824.

Labels, etc: bears white paper William Macbeth, Inc., label, original frame backing, upper center (now in object file); ❦ before conservation, the watercolor was glued to a piece of

watercolor board stamped: Fredericks Company, New York. (now in object file).

CONDITION and TECHNIQUE
The significant glue stains at the right and the random staining throughout the sky were reduced substantially when the piece was conserved in 1989. The watercolor is thinly applied in the background, flat opaque color is used for accents, shadows, cows, and some foliage. The signature and date are partially covered with green foliage. Conserved 1984, Heugh, Edmondson Conservation Services, Kansas City, Missouri.

PROVENANCE
Winslow Homer; ❦ Mr. and Mrs. Charles Savage Homer, West Townsend, Massachusetts, 1910; ❦ Mrs. Arthur P. Homer, 1937; ❦ William Macbeth, Inc., New York, New York, February 10, 1941; ❦ Elisabeth Ball, Muncie, Indiana, May 8, 1942; ❦ George and Frances Ball Foundation, Muncie, Indiana, 1983.

EXHIBITIONS
Prout's Neck, Prout's Neck Association. *Century Loan Exhibition: As a Memorial to Winslow Homer.* Foreword by Robert Macbeth, essay by Booth Tarkington, 1936, catalogue number 28, illustrated number 28, incorrectly dated 1872. ❦ New York, New York, William Macbeth, Inc. *An Introduction to Homer.* December 15, 1936-January 18, 1937, catalogue number 38, illustrated number 38. (Both of the above exhibition catalogues illustrate the work with approximately 6.2 cm of the right side cropped. The cropped image corresponds with the signed original window mat, see remarks below.) ❦ Muncie, Ball State University Art Gallery. *The Elisabeth Ball Collection of Paintings, Drawings, and Watercolors: The George and Frances Ball Foundation.* January 15-February 26, 1984, page 21, catalogue number 12, illustrated before conservation and with the additional 6.2 cm visible at right side.

REFERENCES
Graham, Lois Homer. "An Intimate Glimpse of Winslow Homer's Art." *Vassar Journal of Undergraduate Studies*, volume X, May, 1936, pages 2-3, illustrated figure 1, incorrectly dated 1872. ❦ Unpublished record and sketch, June, 1936, Lloyd Goodrich papers (per correspondence with Lloyd Goodrich). ❦ Unpublished invoice dated May 8, 1942, William Macbeth, Inc. ❦ Unpublished stock Disposition Card-Sold Pictures, William Macbeth, Inc., number A1334. ❦ Hendricks, Gordon. *The Life and Works of Winslow Homer.* New York: Harry N. Abrams, 1979, page 96. ❦ Unpublished letter dated December 27, 1983,

Lloyd Goodrich to Alain Joyaux, Director, Ball State University Art Gallery. ❦ Joyaux, Alain G. *The Elisabeth Ball Collection of Paintings, Drawings, and Watercolors: The George and Frances Ball Foundation.* Muncie: Ball State University Art Gallery, 1984, page 21, catalogue number 12, illustrated before conservation.

RELATED WORKS
Winslow Homer. *Three Boys on the Shore*, 1873, watercolor on paper, 21 × 35.5 cm, Terra Collection, Terra Museum of American Art, Chicago, Illinois.

Winslow Homer. *Watching the Harbor*, 1873, watercolor on paper, 21 × 33.5 cm, private collection.

Winslow Homer. *The Berry Pickers*, 1873, watercolor on paper, 23.8 × 34.5 cm, Harold T. Pulisfer Memorial Collection, on loan to Colby College Museum of Art, Waterville, Maine.

REMARKS
When acquired by Elisabeth Ball, the watercolor was already framed and matted. Correspondence (now in object file) with Lloyd Goodrich indicates that the pencil signature on the lower right corner of the original window mat is Homer's (the signature is now in the object file). The window mat covered approximately 6.2 cm of the right side of the image and Homer's signature on the mat indicates that this was a design choice made by the artist. The signature also indicates a heretofore unknown exhibition of the work during the artist's lifetime.

see color plate IV

Homer Dodge Martin

American (1836-1897)
born Albany, New York, October 28, 1836
died St. Paul, Minnesota, February 12, 1897

On the Seine, circa 1876-1890

paint (oil) on canvas (linen)
56.0 × 76.0 cm; 22 × 30 inches

Permanent loan from the Frank C. Ball Collection, Ball
Brothers Foundation
L29.058

INSCRIPTIONS
Recto: signed in black oil paint, lower right: H.D. Martin.

Verso: incised on frame, upper member, center: #1741 / 19
(m within a circle) 17 / Carrig-Rohane Shop, Inc. / RC. NM
Vose / Boston.

CONDITION and TECHNIQUE
The painting is paste lined to a second canvas. The paint
and ground are cupping and crackled, the varnish is thick,
uneven, and disfiguring.

PROVENANCE
Ralph Cudney, Chicago, Illinois, before 1913; ❦ Vose
Gallery, Boston, Massachusetts, by 1917; ❦ probably Dr. A.
H. Humphreys, New York, New York; ❦ Frank C. Ball,
Muncie, Indiana, before 1929; ❦ Ball Brothers Foundation,
Muncie, Indiana, 1936.

REFERENCES
(Former accession number: AC-29-58.) ❦ Carroll, Dana H.
Fifty-Eight Paintings by Homer D. Martin. New York:
privately printed, 1913, page 68, illustrated page 69. ❦ Ball
State, 1947, page 17. ❦ Alasko, Richard-Raymond.
*Nineteenth Century American Paintings: Art Gallery, Ball
State University.* Muncie: Ball State University, n.d.
(1972?), unpaginated, page 21, illustrated page 20.

REMARKS
The painting's Arts and Crafts style frame was executed in
the Carrig-Rohan frame shop, Winchester, Massachusetts.
Opened in 1903 by Hermann Dudley Murphy and Charles
Prendergast, the shop was sold to Vose Gallery, Boston, in
1915. Though the Muncie frame is dated 1917, it was
designed and carved by Murphy.

William Morris Hunt

American (1824-1879)
born Brattleboro, Vermont, March 31, 1824
died Appledore, New Hampshire, September 8, 1879

The Rapids, Sister Island, Niagara, 1878

paint (oil) on canvas (linen)
76.2 × 109.2 cm; 30 × 43 inches

Permanent loan from the Frank C. Ball Collection, Ball
Brothers Foundation
L29.050

Deep green water turns to opalescent foam as it
breaks over the rocks in William Morris Hunt's
painting of *The Rapids, Sister Islands, Niagara.*
Although artists and tourists had been attracted
to the falls throughout the nineteenth century,
Hunt with this canvas painted a less common
view of the rapids above. Brushstrokes replicate
the texture of the water as it cascades and erupts
over the rapids. In this intimate and serene view
we perch—along with the painter—on the
brown bank at the foreground of the painting,

dangerously close to the swirling water, seemingly unaware of the drop of the falls just yards away.

Taking time off from his career as a portraitist in Boston, Hunt vacationed at Niagara Falls in the late spring of 1878. "There is nothing like Niagara in June," Hunt wrote enthusiastically to a pupil. Overcome by the magnificence of the falls and the quality of the light, Hunt quickly sent for his assistant and his studio van: a horse-drawn cart, constructed by a builder of gypsy wagons, equipped with sleeping room and storage drawers for pots, pans, and painting materials. Once outfitted, Hunt painted numerous views of both the falls and the rapids—paintings that proved to be his last landscapes.

Hunt's most significant training had been in France in the early 1850s. Having recently left behind early success in the French official exhibition, the Salon, and studies with the Parisian painter Thomas Couture, Hunt sought out the artist Millet (see entry) in the French town of Barbizon in the Fontainebleau forest. Under Millet's guidance and his commitment to study from nature, Hunt learned to render the appearance of objects revealed by light and shrouded in shadow. Under Millet, Hunt continued his work in figure painting, focusing on unsentimentalized images of young women reading or spinning, rather than on the more grandiose and didactic historical and biblical subjects favored by the Parisian art establishment.

In 1855 Hunt returned to America for good, settling in Boston, where he married the daughter of a prominent local family. Back in America, Hunt soon realized that portraiture would be his only means to continue his work in figure painting. Although he received several important commissions, outside of Boston his work was poorly received.

Committed to promoting the work of contemporary American and French painters, Hunt purchased their paintings and organized exhibitions of their works. Through Hunt's efforts, Bostonian collectors were among the first to acquire the canvases of Millet and the Barbizon landscape painters, creating an audience for these artists in America well before they were sanctioned by Parisians.

By the late 1860s Hunt was feeling increasingly stifled by his work in portraiture and began to turn occasionally to landscape. In 1872 a devastating fire in Boston destroyed Hunt's studio, most of his work and his collection of work by his French contemporaries. To restore himself after the fire Hunt vacationed in Florida where he took up the challenge of painting the exotic landscape soaked in humidity. The construction of the painting van a few years later was a manifestation of his commitment to painting and sketching out of doors. With the horse-drawn cart, he made a number of landscape painting excursions in Massachusetts in conjunction with or between portrait commissions. By mid-decade he was apparently making more landscapes than portraits.

While at Niagara, Hunt received a commission to paint murals in the assembly chamber at the New York state capital at Albany: *The Flight of Night* and *The Discoverer* (now destroyed). Exhausting work, painting the murals occupied him non-stop for over a year. Shortly after completing the murals, Hunt drowned while visiting friends at Appledore, Isle of Shoals.

SOURCES
Hoppin, Martha J., and Henry Adams. *William Morris Hunt: A Memorial Exhibition*. Boston: Museum of Fine Arts Boston, 1979. ❦ McGurn, 1976. ❦ Webster, 1991.

INSCRIPTIONS
Verso: inscribed in black ink, frame, upper member, right: 155; ❦ and in pencil, frame, upper member, right:

172 / Macbeth N 11102 (?); ❧ and in red chalk, frame, upper member, center: 141; ❧ and in black ink, frame, bottom member, right: 155.

Labels, etc.: bears remnant of white paper (Macbeth Gallery?) label, frame, upper member, center, inscribed in black ink: The Rapids, Sister / Islands, Niagara. / William Morris Hunt; ❧ and white paper label, frame, upper member, right, printed and inscribed in pencil: American Art Association / Lot No. 1 / Consignment / No. / 31; ❧ and small red-bordered paper label, frame, upper member, center, inscribed in black ink: 172 / 30. 42 1/2.

CONDITION and TECHNIQUE
Wax resin lined to a second canvas with only minor inpainting. Conserved, 1975, Alfred Jakstas, Art Institute of Chicago, Chicago, Illinois.

PROVENANCE
William Morris Hunt; ❧ William Morris Hunt, estate 1879; ❧ Louisa Hunt, Boston, Massachusetts; ❧ Louisa Hunt estate sale, 1880; ❧ Frank C. Ball, Muncie, Indiana, January, 1918; ❧ Ball Brothers Foundation, Muncie, Indiana, 1936.

EXHIBITIONS
Boston, Museum of Fine Arts, Boston. *Exhibition of the Works of William Morris Hunt.* November 11, 1879-January 31, 1880, catalogue number 59. ❧ possibly New York, William Macbeth, Inc., 1906. ❧ Rochester, New York, Memorial Art Gallery of the University of Rochester. *Inaugural Exhibition.* 1913. ❧ College Park, University of Maryland Art Gallery. *The Late Landscapes of William Morris Hunt.* January 15-February 22, 1976 (also Albany, Albany Institute of History and Art, March 13-April 25, 1976), page 98, catalogue number 26, illustrated page 77. ❧ Washington, D.C., The Corcoran Gallery of Art. *Niagara: Two Centuries of Changing Attitudes, 1697-1901.* September 21-November 24, 1985 (also Buffalo, New York, Albright-Knox Art Gallery, July 13-September 1, 1985; and New York, New York, The New York Historical Society, January 22-April 27, 1986), page 145, catalogue number 112, illustrated. ❧ Rochester, Memorial Art Gallery of the University of Rochester. *Looking Back: A Perspective on the 1913 Inaugural Exhibition.* October 8-November 20, 1988, page 38, catalogue number 45, illustrated.

REFERENCES
(Former accession number: AC-29-50.) ❧ Boston, Horticultural Hall. *William Morris Hunt Estate Sale,* second session. February 4, 1880, catalogue number 56, as *Rapids, Between Luna and Goat Islands, from the Bridge.* ❧ Boston, Warren Chambers. *Luisa Hunt Sale,* first session.

February 23, 1881, catalogue number 21. ❧ Ball State, 1936, page 11. ❧ Ball State, 1947, page 15. ❧ Alasko, Richard-Raymond. *Nineteenth Century American Paintings: Art Gallery, Ball State University.* Muncie: Ball State University, n.d. (1972?), unpaginated, page 9, illustrated page 8. ❧ McGurn, Sharman Wallace, and Marchal E. Landgren. *The Late Landscapes of William Morris Hunt.* College Park: The University of Maryland Art Gallery, 1976, page catalogue number 26, illustrated page 77. ❧ Adamson, Jeremy Elwell. *Niagara: Two Centuries of Changing Attitudes, 1697-1901.* Washington, D.C.: The Corcoran Gallery of Art, 1985, page 145, catalogue number 112, illustrated. ❧ Webster, Sally. *William Morris Hunt, 1824-1879.* Cambridge: Cambridge University Press, 1991, page 146, illustrated page 150.

RELATED WORKS
William Morris Hunt. *Rapids, Sister Islands,* 1878, oil on academy board, 28.5 × 43.4 cm, The Corcoran Gallery of Art, Washington, D.C.

see color plate V

Ralph Albert Blakelock

American (1847-1919)
born New York, New York, October 15, 1847
died Elizabethtown (Adirondacks), New York, August 9, 1919

Golden Glow, circa 1880-1900

paint (oil) on canvas (linen)
57.1 × 91.5 cm; 22½ × 36 inches

Permanent loan from the Frank C. Ball Collection, Ball Brothers Foundation
L29.014

INSCRIPTIONS
Recto: signed in black oil paint, lower right: R.A. Blakelock.

Verso: inscribed, in pencil, frame, left member, center: 8; ❧ and in pencil, frame, right member, center: Ball / 5816 / 8 / 322.

Labels, etc: bears white paper Babcock Gallery, New York, New York label, stretcher, vertical member, inscribed: #3947; ❦ and red-bordered paper label, frame, lower member, left, inscribed: 7365.

CONDITION and TECHNIQUE
The painting is paste lined to a second canvas and partially obscured by multiple coats of varnish.

PROVENANCE
Frank C. Ball, Muncie, Indiana; ❦ Ball Brothers Foundation, Muncie, Indiana, 1936.

EXHIBITIONS
Indianapolis, John Herron Museum of Art (Indianapolis Museum of Art). *Indiana Colleges Collect.* October 4-November 1, 1964, catalogue number 1. ❦ Lincoln, Nebraska, Sheldon Memorial Art Gallery. *Ralph Albert Blakelock, 1847-1919.* January 14-February 9, 1975 (also Trenton, New Jersey State Museum, May 4-June 1, 1975), page 37, catalogue number 28.

REFERENCES
(Former accession number: AC-29-14.) ❦ University of Nebraska, Lincoln. Blakelock Inventory number NU-575. ❦ Ball State, 1947, page 5. ❦ Alasko, Richard-Raymond. *Nineteenth Century American Paintings: Art Gallery, Ball State University.* Muncie: Ball State University, n.d. (1972?), unpaginated, page 19, illustrated.

Thomas Eakins

American (1844-1916)
born Philadelphia, Pennsylvania, July 25, 1844
died Philadelphia, Pennsylvania, June 25, 1916

Shad Fishing at Gloucester-on-the-Delaware, June, 1881
(*Shad Fishing at Gloucester on the Delaware River*, *Shad Fishing on the Delaware River*)

paint (oil) on canvas
30.4 × 45.9 cm; 12 × 18 inches

Permanent loan from the Elisabeth Ball Collection, George and Frances Ball Foundation
L83.026.09

INSCRIPTIONS
Verso: inscribed in black crayon, frame, upper member, center: #43.

Labels, etc.: bears William Macbeth, Inc., label, verso, frame, upper member.

CONDITION and TECHNIQUE
The painting is paste lined to a second canvas. There is minor abrasion in the thinly painted areas such as the figures in the boat and a moderately disfiguring varnish.

PROVENANCE
Thomas Eakins (probably sold from 1883 Chicago exhibition); ❦ Julius Weizner, New York, New York; ❦ William Macbeth, Inc., New York, New York, 1936; ❦ Mr. and Mrs. George A. Ball, Muncie, Indiana, January 30, 1937; ❦ Elisabeth Ball, Muncie, Indiana, before 1957; ❦ George and Frances Ball Foundation, Muncie, Indiana, 1982.

EXHIBITIONS
Cincinnati. *Ninth Cincinnati Industrial Exhibition: Catalogue of the Art Department.* September 8-October 9, 1881, catalogue number 112, as *Shad Fishing on the Delaware River.* ❦ Brooklyn, Brooklyn Art Guild, December, 1881. ❦ Utica, New York, January, 1882. ❦ New York, National Academy of Design. *Annual Exhibition.* 1882, catalogue number 374. ❦ Providence, Rhode Island, Providence Art Club, 1882 or 1883. ❦ Chicago, Illinois Art Association, October, 1883. ❦ Detroit, Detroit Institute of Arts. *Eighteenth Annual Exhibition of American Art.* April 2-May 3, 1937, page 8, catalogue number 6, as *Shad*

Fishing at Gloucester-on-the-Delaware. ❦ New York, M. Knoedler and Co. *A Loan Exhibition of the Works of Thomas Eakins, 1844-1944, Commemorating the Centennial of His Birth.* June-July, 1944 (also Wilmington, Delaware, Wilmington Society of Fine Arts, October 1-29, 1944; Boston, Doll and Richards, Inc., November 4-21, 1944; Raleigh, Museum, November 26-December, 1944), catalogue number 23, as *Shad Fishing at Gloucester on the Delaware.* ❦ Washington, D.C., National Gallery of Art. *Thomas Eakins, A Retrospective Exhibition.* October 7-November 12, 1961 (also Chicago, Art Institute of Chicago, November 27-January 10, 1962; Philadelphia, Philadelphia Museum of Art, January 31-May 18, 1962), catalogue number 43. ❦ Muncie, Ball State University Art Gallery. *The Elisabeth Ball Collection of Paintings, Drawings, and Watercolors: The George and Frances Ball Foundation.* January 15-February 26, 1984, page 16, catalogue number 9, illustrated in color page 17.

REFERENCES
Unpublished Eakins records as *Shad Fishing at Gloucester-on-the-Delaware*, June, 1881. ❦ Unpublished photograph of work with authentication on verso by Susan Macdowell (Mrs. Thomas) Eakins. ❦ Detroit Institute of Arts. *Eighteenth Annual Exhibition of American Art.* Detroit: Detroit Institute of Arts, 1937, page 8. ❦ Goodrich, Lloyd.

Thomas Eakins: His Life and Work. New York: Whitney Museum of American Art, 1933, reprinted New York: AMS Press, 1970, number 154 as *Shad-Fishing at Gloucester on the Delaware River.* ❦ Unpublished Stock Disposition Card-Sold Pictures, William Macbeth, Inc., number 8874. ❦ Goodrich, Lloyd. *Thomas Eakins.* Cambridge: Harvard University Press, 1982, pages 206-212, illustrated page 211, number 94, as *Shad Fishing at Gloucester on the Delaware River.* ❦ Joyaux, Alain G. *The Elisabeth Ball Collection of Paintings, Drawings, and Watercolors: The George and Frances Ball Foundation.* Muncie: Ball State University Art Gallery, 1984, page 16, catalogue number 9, illustrated in color page 17. ❦ Homer, William Inness. *Thomas Eakins, His Life and Art.* New York: Abbeville Press, 1992, pages 102-105, illustrated plate 132.

RELATED WORKS
Thomas Eakins. *Hauling the Seine*, 1882, oil on canvas, 31.7 × 45.6 cm, illustrated in *Arts Magazine*, February, 1984, collection of Andrew Crispo Gallery, New York, and subsequently Sotheby's, New York, December 3, 1987, present location unknown (damaged and extensively restored).

Thomas Eakins. *Shad Fishing at Gloucester on the Delaware River*, 1881, oil on canvas, 30.8 × 46 cm, Philadelphia Museum of Art, Philadelphia, Pennsylvania.

Eugène-Louis Boudin

French (1824–1898)
born Honfleur, France, July 12, 1824
died Deauville, France, August 8, 1898

Le Havre, sortie du port, 1883
(*Leaving the Port of Le Havre*; *Shipping*)

paint (oil) on canvas
118.1 × 160.0 cm; 46½ × 63 inches

Permanent loan from the Frank C. Ball Collection, Ball
Brothers Foundation
L37.124

Dominating the canvas, a vast, cloud-filled sky dwarfs the ships and rowboats tossed on murky, tortured waves. In the last two decades of his life, Eugène-Louis Boudin repeatedly turned his attention to rendering the port of Le Havre, his home town on the Normandy coast. In his canvases depicting Le Havre, such as *Leaving the Port of Le Havre*, the horizon is low, the cloudy sky dominates, and ships and rowboats inhabit the waters.

Boudin was a master of capturing specific effects of weather, and for this he attracted the attention of the Impressionists and the critics. Claude Monet, a native of Le Havre, sought Boudin as an early teacher, and the writer Charles Baudelaire noted that in Boudin's paintings viewers could guess "the very season, the time of day, and the wind." Boudin's success in replicating atmospheric effects resulted from his commitment to painting out of doors (though he probably completed his larger—and rarer—canvases inside his studio). Said the artist, "Everything that is painted directly on the spot

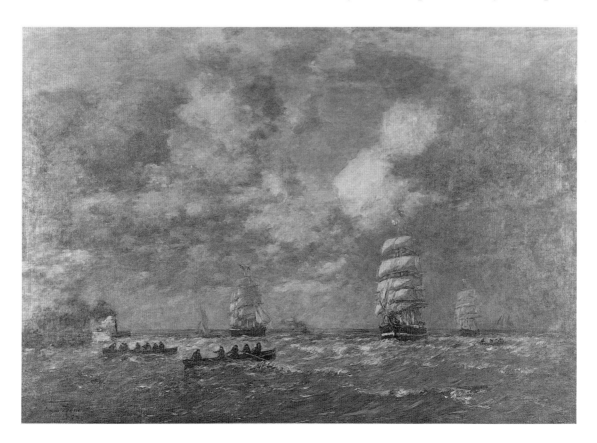

has always a strength, a power, a vividness of touch that one doesn't find again in the studio."

Son of a ship's captain, Boudin spent most of his life on the Normandy coast. In Le Havre, at the age of twenty, he opened a stationery and frame shop where he framed works by some of the artists who spent their summers at the port. Conversations with the painter Millet (see entry), who visited Le Havre in 1845, persuaded Boudin to relinquish frame-making for a career as a painter. His earliest public success came when he exhibited small-scale spontaneously brushed paintings of the colorfully garbed vacationers on the beaches of Trouville and Deauville.

This may be one of two of the largest works that Boudin ever painted. Along with its companion *Entering the Port of Le Havre*, it may have been exhibited in the 1883 annual state-sponsored art exhibition in Paris, the Salon. Although an unusually large size for Boudin (who preferred a very small format), the dimensions of *Leaving the Port of Le Havre* are typical for a Salon painting. At the Salon, paintings were hung from floor to ceiling with all wall surfaces covered. Artists learned that the larger the painting, the more likely it was to capture public and critical attention.

SOURCES
Harrison, Jefferson C. *The Chrysler Museum, Handbook of the European and American Collections, Selected Paintings, Sculpture and Drawings.* Norfolk: The Chrysler Museum, 1991. ❦ Jean-Aubry, G., and Robert Schmidt. *Eugène Boudin.* Neuchâtel, Switzerland: Editions Ides et Calendes, 1968. ❦ Rewald, John. *The History of Impressionism.* Fourth edition. New York: Museum of Modern Art, 1973. ❦ Rosenblum, Robert, and H.W. Janson. *19th-Century Art.* New York: Abrams, 1984.

INSCRIPTIONS
Recto: signed in black oil paint, lower left corner: E. Boudin / 1883.

Verso: inscribed, in black crayon, frame, upper member, left and right: 250; ❦ and in black crayon, frame, upper member, right: 5029; ❦ and in black ink, frame, right member, center: I / B / 957500.

CONDITION and TECHNIQUE
The painting is wax lined to a second canvas. Traces of older resin varnish underlie the surface varnish. Conserved, 1973, Alfred Jakstas, Art Institute of Chicago, Chicago, Illinois.

PROVENANCE
George A. Hearn, New York, New York, before 1898; ❦ George A. Hearn estate, New York, New York, 1918; ❦ Frank C. Ball, Muncie, Indiana, 1918; ❦ Ball Brothers Foundation, Muncie, Indiana, 1936.

EXHIBITIONS
New York, Lotos Club. *Paintings from the Collection of Mr. George A. Hearn.* January 28–February 1, 1898, catalogue number 1.

REFERENCES
(Former accession number: AC-37-124.) ❦ Hearn, George A. *Catalogue of the Collection of Foreign and American Paintings Owned by Mr. George A. Hearn.* New York: privately printed (The Gilliss Press), 1908, page 87, catalogue number 102. ❦ New York, American Art Association. *Notable Art Collection Formed by the Late George A. Hearn.* February 27, 1918, lot number 250, illustrated. ❦ Ball State, 1947, page 5. ❦ Schmit, Robert. *Eugène Boudin, 1824–1898: Catalogue raisonné de l'oeuvre peint.* Paris: Editions Robert Schmit, 1973, volume II, page 167, catalogue number 1724, illustrated.

REMARKS
In 1883 Boudin sent two paintings of Le Havre to the Salon. (*Société des Artistes Français pour L'Exposition des Beaux-Arts de 1883. Salon de 1883*, page 29, catalogue numbers 320 and 321.) The catalogue simply lists the two paintings as *L'Entrée* and *La Sortie*. Though it is likely that the Muncie painting is one of the two paintings exhibited, no record of inscriptions that might have appeared on the stretcher were made before its conservation in 1973.

Childe Hassam

American (1859-1935)
born Dorchester (Boston), Massachusetts, October 17, 1859
died East Hampton, Long Island, New York, August 27, 1935

Montmartre, 1889

paint (oil) on canvas (linen, solid wood insert in verso of stretcher)
39.5 × 44.2 cm; 15½ × 17⅜ inches

Permanent loan from the Elisabeth Ball Collection, George and Frances Ball Foundation
L83.026.10

In the spring of 1886, the American painter Childe Hassam departed for Paris, where he rented an apartment and studio in the artists' neighborhood of Montmartre. In 1889, the last summer of his Paris sojourn, Hassam painted *Montmartre*, showing the Place du Tertre about three blocks from his studio. Applying his paint thickly, Hassam rendered the buildings lining the curved street in tans and reddish browns, and he created the pedestrians out of a few well-placed strokes.

In painting *Montmartre* Hassam followed closely the efforts of the French Impressionists. Focusing on the scenes of daily life they witnessed while painting out of doors, the French Impressionists emphasized effects of reflected light and glittering color in canvases painted with unblended, textural brushstrokes. During his stay in Paris, Hassam had ample opportunity to study the work of his French colleagues, witnessing their continued experiments and incorporating their ideas into this work. With its stress on the effects of light, and its textured strokes of paint, *Montmartre* testifies to Hassam's early understanding of the French style.

Today devotees of American art recognize Childe Hassam as one of America's foremost Impressionist painters. His decision to study abroad was crucial to his emergence as an American Impressionist leader. Born in Dorchester, Massachusetts, Hassam began training as an illustrator, then continued studying drawing in Boston. Already familiar with the work of the mid-nineteenth-century French artists promoted and exhibited by his distant relative William Morris Hunt (see entry), Hassam chose to live in Paris after having met a group of artists who had studied there.

Through exhibitions and notices in the press, French Impressionism had already attracted some attention in America by the time Hassam painted *Montmartre*. In the 1880s, a series of New York exhibitions introduced selected French Impressionist paintings to the American public. In 1883 American painters William Merritt Chase and Carroll Beckwith organized one of the first of these exhibitions, a fund-raiser to build the pedestal for the Statue of Liberty. (Muncie's Millet painting was included in this exhibition; see entry.) Three years later, the Parisian art dealer Durand-Ruel sent three hundred paintings to New York for an exhibition that opened at the

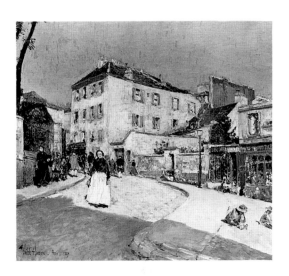

American Art Association and later moved to the National Academy of Design. Durand-Ruel's exhibition presented Impressionism as a more colorful offspring of earlier French landscape. All the excitement generated by these exhibitions must have helped sway Hassam's decision to go to France to seek out the new, modern style in Paris.

In France, the Impressionist movement drew to its close around 1886, but the exhibitions of French Impressionist paintings in the United States had created a taste for this colorful, flickering style among Americans. The popularity of Impressionism in America created a receptive climate for Hassam's paintings when he returned to New York in 1889, and he quickly became the leader in the style that many American painters would come to adopt as their own.

SOURCES
Joyaux, 1985.

INSCRIPTIONS
Recto: signed in brown oil paint, lower left: Childe Hassam. Paris. 1889.

Verso: signed in vermillion oil paint, with monogram, wood stretcher insert, center: CH (encircled) 1889; ❦ inscribed in black pen, stretcher, upper member, right: 28; ❦ and in pencil, stretcher, upper member, right: Place du Tertre.

Labels, etc: bears E. & A. Milch, Inc., label, verso, frame, upper member, center.

CONDITION and TECHNIQUE
The painting is paste lined to a second canvas (possibly by the artist). The paint layers are partially obscured by a moderately disfiguring varnish.

PROVENANCE
Childe Hassam; ❦ E. & A. Milch, Inc., New York, New York; ❦ Mr. and Mrs. George A. Ball, Muncie, Indiana, April 12, 1924; ❦ Elisabeth Ball, Muncie, Indiana, before 1957; ❦ George and Frances Ball Foundation, Muncie, Indiana, 1983.

EXHIBITIONS
Muncie, Ball State University Art Gallery. *The Elisabeth Ball Collection of Paintings, Drawings, and Watercolors: The George and Frances Ball Foundation*. January 15-February 26, 1984, page 19, catalogue number 10, illustrated. ❦ Muncie, Ball State University Art Gallery. *Childe Hassam in Indiana*. November 3-December 8, 1985, page 28, catalogue number 1, illustrated in color page 34.

REFERENCES
Unpublished invoice dated April 12, 1924, E. and A. Milch, Inc., to Mrs. George A. Ball. ❦ Joyaux, Alain G. *The Elisabeth Ball Collection of Paintings, Drawings, and Watercolors: The George and Frances Ball Foundation*. Muncie: Ball State University Art Gallery, 1984, page 19, catalogue number 10, illustrated. ❦ Joyaux, Alain G., Brian Moore, and Ned H. Griner. *Childe Hassam in Indiana*. Muncie: Ball State University Art Gallery, 1985, page 28, catalogue number 1, illustrated in color page 34.

RELATED WORKS
Childe Hassam. *Rue Montmartre*, 1888. oil on canvas, 45.7 × 38 cm, collection of Mr. and Mrs. Murry Handwerker. (University of Arizona Museum of Art. *Childe Hassam, 1859-1935*. Tucson: University of Arizona Museum of Art, 1972, catalogue number 29, illustrated page 67.)

Daniel Chester French

American (1850-1931)
born Exeter, New Hampshire, April 20, 1850
died Stockbridge, Massachusetts, October 7, 1931

The Concord Minute Man of 1775,
circa 1889 (plaster reduction);
circa 1913-1930 (cast)

metal (bronze)
82.5 × 40.0 × 45.7 cm; 32½ × 15¾ × 18 inches

Permanent loan from the Frank C. Ball Collection, Ball Brothers Foundation
L37.003

To express the idea of the volunteer soldier who could be ready "in a minute," Daniel Chester French depicted the decisive moment. Turning from his work—his hand still on the plow across which his coat has been hastily thrown—the young man heeds the call to arms, rifle in hand, with a resolute forward stride. An 1881 critique of the large-scale version of the sculpture noted the potential for movement implicit in the work:

> The young fellow at his plow… hears the tidings of the coming of the "regulars." The announcement is a surprise, though not unexpected. He is seemingly "on the jump" for military duty at once. He drops the handle of his implement, and swings his musket from the back forward for its proper use. He is full of determination and fire.

The Concord Minute Man of 1775 exemplifies the type of commemorative statuary that held popular sway among Americans in the nineteenth century. Its maker became one of the most sought-after artists of his day. Among his many commissions, French completed the famous *Seated Lincoln* in the Lincoln Memorial in Washington D.C. (1922) and, a few years before his death, began work on Ball State University's *Beneficence* (1931). *The Concord Minute Man of 1775*—a reduction of a larger-than-life Minuteman commissioned by French's home town of Concord Massachusetts in 1873—represents French's very first attempt at full-scale sculpture.

By 1873, French had only recently begun his artistic career. After studying drawing and anatomy, first in Concord, then Boston, he spent one month under the tutelage of the American sculptor John Quincy Adams Ward in Ward's New York studio. After being awarded the commission for *The Concord Minute Man*, French took a year to complete the full-scale

plaster model from which the Minuteman would be cast in bronze, then left for Europe to continue his training.

To refine the Minuteman's pose, French looked to a plaster cast of the *Apollo Belvedere* in the Boston Antheneum, a nearby museum. As part of their early collections, many museums had plaster casts of famous Greek and Roman sculptures. For young artists eager to grasp the classical tradition, these casts provided rich source material. Named for its location in the Belvedere museum of the Vatican, the original *Apollo Belvedere* (a late fourth-century Roman marble copy, probably of a first-century B.C. Greek original), shows the god Apollo striding forward, his left arm outstretched. In the process of resolving the specific placement of the Minuteman's feet, French sketched the legs and feet of the plaster cast of the *Apollo*, reversed

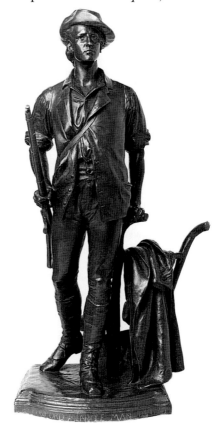

them, and transcribed the pose to his young hero.

More than fifteen years later, at the request of a committee of Concord citizens, French made a smaller version of the Minuteman for the city of Concord to present to the U.S. Navy for mounting on its new gunboat, the *U.S.S. Concord*. Having by this time trained in Florence and Paris, French reworked the sculpture, which was installed on the ship in 1891. As the sculpture grew in popularity, in 1913 French authorized the production of additional bronze casts of this small-scale version of the Minuteman. Muncie's bronze is one of nine such reductions known today.

SOURCES
[Critique of the Minuteman]. *Boston Commonwealth*. June 25, 1881. Quoted in Richman, 1972, pages 101–102. ❦ Richman, Michael. *Daniel Chester French: An American Sculptor*. New York: Metropolitan Museum of Art for the National Trust for Historic Preservation, 1976. ❦ Richman, Michael. "The Early Public Sculpture of Daniel Chester French." *The American Art Journal*, number 4, November, 1972, pages 101–102. ❦ Craven, 1976.

INSCRIPTIONS
Inscribed in cast, base, front: THE CONCORD MINVTE MAN OF 1775; ❦ and in the cast, left side of base, rear: D.C. FRENCH Sc.; ❦ and in the cast, right side of base, front: JNO WILLIAMS FOUNDER / NEW YORK; ❦ and stamped after casting, underside of base, center: 1800.

CONDITION and TECHNIQUE
The piece is cast in two primary sections (the base, the plow less one handle and the draped coat; and the figure with one of the plow handles); the gun with or without the forearm may also be cast separately. The screw that attaches the strap to the powder horn is missing.

PROVENANCE
Grand Central Art Galleries, Inc., New York, New York; ❦ Frank C. Ball, Muncie, Indiana, 1937; ❦ Ball Brothers Foundation, Muncie, Indiana, 1937.

EXHIBITIONS
Muncie, Ball State Teachers College. *Exhibition of Paintings and Sculpture by Leading American Artists*

from the Grand Central Art Galleries, Inc. March ?–April 8, 1937, not in catalogue. ❦ New York, Whitney Museum of American Art. *200 Years of American Sculpture*. March 16–September 26, 1976, pages 50–51 and 340, catalogue number 73, illustrated page 51.

REFERENCES
(Former accession number: CA-37-3.) ❦ Ball State, 1947, page 26. ❦ Craven, Wayne, et al. *200 years of American Sculpture*. New York: Whitney Museum of American Art, 1976, pages 50–51 and 340, catalogue number 73, illustrated page 51. ❦ Gorham Company, Small Bronze Division Records, Archives of American Art.

RELATED WORKS
Daniel Chester French. *The Concord Minute Man of 1775*, circa 1889, plaster, 82.5 cm high, private collection.

REMARKS
Between 1918 and 1936, the Small Bronze Division of Gorham cast ten 34.2-cm-high reductions of *The Concord Minute Man of 1775*. Though the records include the 82.5-cm-high Minuteman, no casts are listed.

Hilaire-Germain-Edgar Degas (or de Gas)

French (1834–1917)
born Paris, France, July 19, 1834
died Paris, France, September 26, 1917

Femme enceinte, circa 1890–1900 (cast 1919)

metal (bronze)
$43.0 \times 17.8 \times 14.0$ cm; $16^{15}/_{16} \times 7 \times 5^{1}/_{2}$ inches

Gift of the Margaret Ball Petty Foundation, the Ball Brothers Foundation and the Petty Family in memory of Edmund F. Petty
86.016

Across the lumpy, uneven surface appears evidence of the artist's hand: a smeared fingerprint here, a bump there, where Edgar Degas pinched a pliant material between his

fingers. Alive with the activity of his touch as he built up and reworked the form, the figure seems to emerge before our eyes. Unsteadily, her right leg just beginning to flex, the woman leans forward as if pulled by the weight of her swelling stomach. Between its agitated surface and mysterious shape, this small bronze allows us to peek into Degas's private world.

Known primarily for his work as an Impressionist painter and draftsman, during the last thirty or so years of his life Degas also made small-scale sculptures. But in his long career he exhibited only one sculpture: a half-life-size figure in tinted wax, *The Little Dancer of Fourteen Years* (exhibited 1881). When Degas died in 1917, his dealer and heirs discovered more than 150 small sculptures in his studio. Formed of balls of warmed wax and a non-hardening modelling material called plasteline, pressed and spread atop one another over wire armatures, were the same forms that peopled his paintings, prints, and pastels: horses, dancers, and nudes. *Femme Enceinte* was among them.

Degas's friend and dealer, Joseph Durand-Ruel who, along with Ambroise Vollard, was called in to make an inventory of the contents of the artist's studio, described the discovery:

> When I made the inventory of Degas' possessions, I found about 150 pieces [of sculpture] scattered over his three floors in every possible place. Most of them were in pieces, some almost reduced to dust. We put apart all those that we thought might be seen, which was about one hundred, and we made an inventory of them. Out of these[,] thirty are about valueless; thirty badly broken up and very sketchy; the remaining thirty are quite fine.

In January 1918, a photographer recorded about one-third of the wax sculptures in Degas's studio. Housed today in the collection of the Musée d'Orsay in Paris, these photographs show the works with the wire armatures Degas used to stabilize the often precarious poses of his figures. In the studio photograph of the wax *Femme Enceinte*, a wire tacked to the piece of wood on which she stands arcs up and over her, ending in a loop around the wax figure's neck. With this wire support from above, Degas could alter the pose of the figure and stabilize its forward movement.

Degas's heirs authorized the Parisian bronze foundry of A.A. Hébrard to cast *Femme Enceinte* along with seventy-two of the artist's other wax sculptures. In 1919, Hébrard brought in his

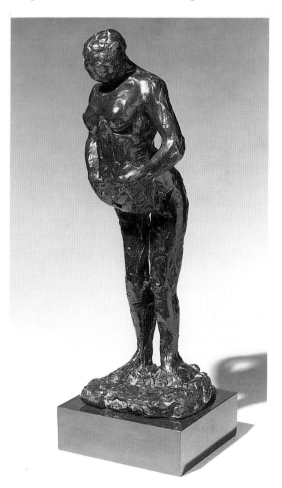

skilled Italian technician, Albino Palazzolo, to do the delicate casting. Palazzolo removed the exterior wire supports and repaired the sculptures where necessary before making a pliable gelatin mold of each. With this mold he made duplicates, also in wax, of Degas's works; he then used the duplicates to cast the bronze edition. Each of the seventy-three designated works was cast twenty-three times. Muncie's *Femme Enceinte* was the fifth cast of the twenty-three.

Roughly translating as "pregnant woman," Degas did not assign the title to this piece. Instead, when Hébrard first exhibited the bronzes in 1921 he, reportedly with the help of Durand-Ruel, assigned names to the works (except for the various versions of *The Little Dancer of Fourteen Years*) based on each figure's pose. For this reason, and the fact that Degas often exaggerated the forms and positions of his figures until he felt he had achieved the perfect balance, Degas scholars caution against a literal reading of the titles. For this work, the initial inspiration was a male figure.

In 1877, Degas had attended the annual Impressionist exhibition, where a painting of bathers by Paul Cézanne attracted his attention. In his notebook, Degas made two quick sketches from Cézanne's painting, both of the central male figure leaning forward slightly, apparently pulling on his drawers. But in Degas's drawing, the figure becomes more effeminate: Degas sketched the fellow with a slimmer waist and without the action of the hands. These small, rough sketches appear to be the original source of the wax sculpture he made years later, and the museum's bronze. Beyond that, the title's accuracy remains a mystery.

Unlike many of his small sculpted females, this figure does not appear in two-dimensional form in the artist's paintings, prints, or pastels, clothed as a dancer, or draped with a towel as a bather, informing us of her intended purpose. The only known related drawing, of a female in a similar pose, shows a less protruding stomach. Driven by a desire to explore the human form in often awkward, tenuous poses, Degas's work frequently focuses on a suspended moment within a larger movement, like the beginning of a forward step implied here. Many of his sculpted figures exhibit an exaggerated sway-back pose and fleshy girth, but none that survives has proportions like those of *Femme Enceinte*.

Some scholars see the figure's swollen stomach as a counter to her arching back. Writing on Degas's sculpture in 1976 Charles Millard (114) observed:

> It has generally been referred to as being pregnant, but this is by no means clear, the distention of the stomach being ambiguous in nature. . . . The hands are all but obliterated, the elbows thrust out in a gesture meaningless expressively but crucial sculpturally, the legs spread apart and thrusting in opposite directions, the mass of the stomach used as a counterpoise to that of the buttocks.

Nevertheless, especially viewed from the side, the figure is convincingly pregnant. If Degas were working from an expecting model, it would be a rare image in his day, but not the first time he flouted convention. In his search to capture momentary action, Degas populated his works with unconventionally ungraceful women getting into or out of bathtubs and dancers adjusting their costumes or scratching themselves. Like the unexpected form of *Femme Enceinte*, these precarious and fleeting postures become in Degas's hands sublime records of the human form arrested in motion.

SOURCES
Brettell, Richard R., and Suzanne Folds McCullagh. *Degas in The Art Institute of Chicago*. New York: Abrams, 1984. ❧ Durand-Ruel, Joseph, Paris to Royal Cortissoz, New York, June 7, 1919, Typescript in Beinecke Library, Yale University. Quoted in Millard, page 26. ❧ Failing, Patricia. "Cast in Bronze: the Degas Dilemma." *Art News*, January, 1988, pages 136-141. ❧ Millard, 1976. ❧ Pingeot, 1991. ❧ Rewald, 1944.

INSCRIPTIONS
Signed with estate stamp (in cast), base, left: Degas; ❧ bears foundry stamp (in cast), back of base: CIRE / PERDUE / AA HEBRARD; ❧ and foundry stamp (after cast), back of base: 24/E (E cast of sculpture number 24); ❧ inscribed in black ink, underside of base: HMSG; ❧ and in white ink, underside of base: 66.1289.

Labels, etc.: bears linen tape label, underside of base, inscribed in black and red pen (now in object file): S.58.22 / DEGAS; ❧ and gummed paper label, underside of base, with typed inscription (now in object file): S58.22 / DEGAS; ❧ and gummed paper label, underside of base, inscribed in pen (now in object file): 10; ❧ and masking tape label, underside of base, inscribed in pen (now in object file): BOX 32 / 4.

PROVENANCE
Galerie A.A. Hébrard, Paris, France, sold before 1931; ❧ Atelier. (A.A. Hébrard's account book lists five complete sets of sculpture sold before 1936. The purchaser of the E set is listed simply as Atelier.); ❧ Halverson, London, before July, 1931; ❧ Max Kaganovitch, Paris, France; ❧ Hanover Gallery, London, England; ❧ Joseph H. Hirshhorn, New York, New York, before 1959; ❧ Hirshhorn Museum and Sculpture Garden, Smithsonian Institution, Washington, D.C., apparently 1966 (deaccessioned in circa 1986).

EXHIBITIONS
Detroit, Detroit Institute of Arts. *Sculpture in Our Time: France, Germany, Russia, Spain, Great Britain, the United States, Collected by Joseph H. Hirshhorn*. May 5-August 23, 1959, page 18, catalogue number 21. ❧ Toronto, Art Gallery of Ontario, October-November, 1959, on loan.

REFERENCES
Rewald, John. *Degas Works in Sculpture: A Complete Catalogue*. Translated from the French manuscript by John Coleman and Noel Moulton. New York: Parthenon Books, Inc., 1944, page 128, illustrated plate LXIII (another cast is illustrated). ❧ Rewald, John. *Degas: Sculpture, the Complete Works*. New York: Abrams, n.d. (1956), page 155, catalogue number LXIII, illustrated plate 65 (another cast is illustrated). ❧ Millard, Charles W. *The Sculpture of Edgar Degas*. Princeton: Princeton University Press, 1976, page 113, illustrated plate 127 (another cast is illustrated). ❧ New York, Christie's. *Impressionist and Modern Paintings and Sculpture, Part I*. May 14, 1986, lot number 4, illustrated in color. ❧ Rewald, John. *Degas's Complete Sculpture: Catalogue Raisonné*. San Francisco: Alan Wolfsy Fine Arts, new edition, 1990, page 164, catalogue number LXIII (another cast and the original wax are illustrated). ❧ Pingeot, Anne. *Degas Sculptures*. Paris: Réunion des Musées Nationaux, 1991, pages 179-180, catalogue number 57, illustrated pages 110, 111, 179, and 180 (another cast, the original wax, and the Vollard archive photograph are illustrated).

RELATED WORKS
Edgar Degas. *Femme enceinte*, circa 1890-1900, wax, plasteline, cork (metal armature), 43 cm high, National Gallery of Art, Washington, D.C., Mr. and Mrs. Paul Mellon collection.

Edgar Degas. *Femme Enciente*, circa 1890-1900 (cast 1919), bronze (master cast) 43 cm high, Norton Simon Art Foundation, Pasadena, California.

Edgar Degas. *Notebook Twenty-eight*, folio three, study after the central figure in Paul Cézanne's *Baigneurs au Repos* (Barnes Foundation, Merion, Pennsylvania), circa 1877, crayon on paper, paper size 26 × 35 cm, private collection, Paris.

Edgar Degas. *Etude pour femme enceinte*, circa 1890-1900, pencil on paper, 60 × 39 cm, present location unknown. (*Vente Degas IV*, Paris, 1919, lot number 162; later H. Dudley Wright Collection, sold Phillips, London, June 29, 1988, lot number 1, illustrated.)

Ambroise Vollard record photograph taken in Degas's studio in January, 1918, before the restoration of the waxes by Hébrard for casting, Musée d'Orsay, Paris, France.

George Inness

American (1825–1894)
born Newburg, New York, May 1, 1825
died Bridge-of-Alan, Scotland, August 3, 1894

Golden Glow, 1894

(*The Golden Sun*)

paint (oil) on canvas
61.0 × 91.5 cm; 24 × 36 inches

Permanent loan from the Frank C. Ball Collection, Ball
Brothers Foundation
L29.051

Rather than presenting a specific place, in
Golden Glow Inness paints a conglomerate but
precisely ordered landscape. The scene is
shrouded in a thick, misty atmosphere, achieved
through his technique of rubbing and scraping

the paint after applying it to the canvas. Such
effects may have been inspired by the writings of
the eighteenth-century scientist and mystic
Emanuel Swedenborg, of whom Inness was a
follower. "Objects cannot be seen except in
space," wrote Swedenborg, "therefore in the
spiritual world where angels and spirits are, there
appear to be spaces like the spaces on earth; yet
they are not spaces, but appearances; since they
are not fixed and constant, as spaces are on
earth."

Painted in the last year of the artist's life, *Golden
Glow* represents the culmination of Inness's
theories, techniques, and beliefs. In his final
works, Inness used the landscape to convey the
deep emotions and spiritual responses that the
contemplation of nature inspired in him. Inness
described his perceptions of nature's
reverberations and their attendant effects on his
landscape painting:

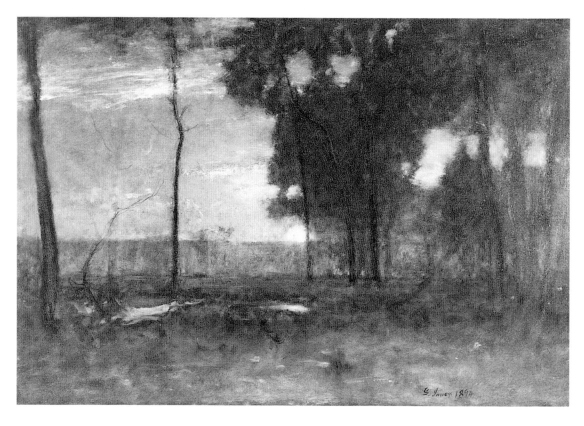

The highest art is where has been most perfectly breathed the sentiment of humanity. Rivers, streams, the rippling brook, the hill-side, the sky, clouds—all things that we see—can convey that sentiment if we are in the love of God and the desire of truth. Some persons suppose that landscape has no power of communicating human sentiment. But this is a great mistake. The civilized landscape peculiarly can; and therefore I love it more and think it more worthy of reproduction than that which is savage and untamed. It is more significant. Every act of man, every thing of labor, effort, suffering, want, anxiety, necessity, love, marks itself wherever it has been. In Italy I remember frequently noticing the peculiar ideas that came to me from seeing odd-looking trees that had been used, or tortured, or twisted—all telling something about humanity. American landscape, perhaps, is not so significant; but still every thing in nature has something to say to us (1878).

In his late works, Inness resolved objective visual recording with subjective emotional response in a body of work that is considered his most artistically successful.

SOURCES
Bermingham, Peter. *American Art in the Barbizon Mood*. Washington, D.C.: Smithsonian Institution Press, 1975. ❧ Cikovsky, Nicolai. *George Inness*. New York: Praeger, 1971. ❧ Inness, George. "A Painter on Painting." *Harper's New Monthly Magazine*, number 56, February, 1878, page 461. Quoted in The Metropolitan Museum of Art, page 236. ❧ The Metropolitan Museum of Art. *American Paradise: The World of the Hudson River School*. With an introduction by John K. Howat. New York: Metropolitan Museum of Art, 1987. ❧ Swedenborg, Emanuel. *Divine Love and Wisdom*. Paragraph 7, n.d., quoted in Cikovsky, page 58.

INSCRIPTIONS
Recto: signed in black oil paint, lower left: G. Inness 1894.

Verso: inscribed in black pen, frame, upper member, right: GOLDEN GLOW-O (the rest is covered by a label); ❧ and in black pen, frame, right member, center: 139 (cancelled); ❧ and in pencil, frame, right member, upper, inverted three-tined fork, encircled.

CONDITION and TECHNIQUE
The painting has been wax lined to a second canvas; the varnish appears matte and uneven. Conserved, 1970, Louis Pomerantz, Chicago, Illinois.

PROVENANCE
George Inness; ❧ George Inness estate, 1895; ❧ William N. Peak, Brooklyn, New York; ❧ Henry Reinhardt and Company, Chicago, Illinois; ❧ Ralph Cudney, Chicago, Illinois, by 1913; ❧ Ralph Cudney estate, Chicago, Illinois, 1935; ❧ Grand Central Art Galleries, New York, New York, 1935; ❧ Frank C. Ball, Muncie, Indiana, 1935; ❧ Ball Brothers Foundation, Muncie, Indiana, 1936.

EXHIBITIONS
New York, Fine Arts Building. *Inness Memorial Exhibition*. December 27, 1894, catalogue number 87. ❧ Chicago, Moulton and Ricketts Galleries, March, 1913, catalogue number 18, illustrated, as *The Glowing Sun*. ❧ New York, Babcock Galleries, n.d. (probably before 1935). ❧ New York, Grand Central Art Galleries, n.d. (before 1935). ❧ Jacksonville, Florida, Cummer Gallery of Art. *George Inness in Florida, 1890-1894 and the South, 1844-1894*. April 11-May 25, 1980, pages 30-31, catalogue number 42, illustrated page 30. ❧ New York, Grand Central Art Galleries (organizer). *American Tonalist Painting Exhibition*. (Phoenix, Phoenix Art Museum, March 12-April 25, 1982; Huntington, New York, Heckscher Museum, May 8-June 6, 1982; and New Britain, Connecticut, New Britain Museum of American Art, June 13-July 11, 1982.), page 74, catalogue number 45, illustrated in color, page 9.

REFERENCES
(Former accession number: AC-29-51.) ❧ New York, Fifth Avenue Art Gallery. *Inness Executor's Sale*. February 12-14, 1895, catalogue number 63, as *The Glowing Sun*. ❧ Dangerfield, Elliott. *Fifty Paintings by George Inness*. New York: privately printed (Frederick Fairchild Sherman), 1913, plate 42, as *Golden Glow*. ❧ Unpublished letter dated December 9, 1935, from Erwin Barrie, Grand Central Art Galleries to Frank C. Ball, regarding the provenance of the painting. ❧ Ball State, 1947. ❧ Ireland, LeRoy. *The Works of George Inness: An Illustrated Catalogue Raisonné*.

Austin: University of Texas Press, 1965, page 397, catalogue number 1509, illustrated. ❦ Alasko, Richard-Raymond. *Nineteenth Century American Paintings: Art Gallery, Ball State University.* Muncie: Ball State University, n.d. (1972?), unpaginated, page 23, illustrated front cover. ❦ Cummer Gallery of Art. *George Inness in Florida, 1890-1894 and the South, 1844-1894.* Jacksonville: Cummer Gallery of Art, 1980, pages 30-31, catalogue number 42, illustrated page 30. ❦ Grand Central Art Galleries. *American Tonalist Painting Exhibition.* New York: Grand Central Art Galleries, 1982, page 74, catalogue number 45, illustrated in color page 9.

Augustus Saint-Gaudens

American, born Ireland (1848-1907)
born Dublin, Ireland, March 1, 1848
died Cornish, New Hampshire, August 3, 1907

Amor Caritas, 1898 (modeled and started reduction); 1898-1907 (casts)

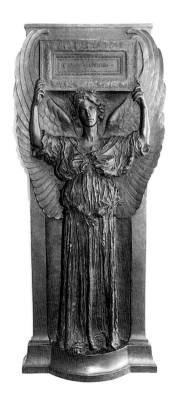

metal (bronze)
100.7 × 44.7 × 11.8 cm; 39⅝ × 17⅝ × 4⅝ inches

Gift of Edmund F. Ball, Janice Ball Fisher, and Adelia Ball Morris
80.010.03

At the turn of the century, American sculptors sought to embody in their work lofty ideals and noble virtues, often in the form of graceful, classically garbed females. Among the artists most successful in personifying these moral sentiments was Augustus Saint-Gaudens. With the "Amor Caritas" (latin for "Love Charity") inscription boldly displayed on the tablet in the figure's raised hands, the artist makes clear the association between the angelic woman and the two virtues. Her strict vertical pose, the solemn expression of her face, and the rigid architectural niche in which she stands all lend the sculpture a further air of dignified grace. (Daniel Chester French's *Beneficence* on the Ball State University campus is in this same tradition.)

Muncie's *Amor Caritas* is one of a series of approximately twenty casts of the sculpture that Saint-Gaudens began producing in 1899. If an artist produced a sculpture that attracted a great deal of attention, he would quite often have it cast several times to meet a demand for additional examples.

Her slightly mournful expression provides a clue to the origins and evolution of the figure. In the late 1870s Saint-Gaudens began work on a marble tomb sculpture for the former governor of Connecticut, Edwin Morgan, in the form of three angels. Davida Johnson Clark, the artist's mistress and mother of their son, posed for the figures. Over the next two decades the central figure from this group evolved into the relief sculpture Saint-Gaudens ultimately titled *Amor Caritas*.

Just into his teens, Saint-Gaudens began his career as a cameo cutter's apprentice, first to a stone cameo cutter, then to a shell cameo cutter. This early experience working in very low relief manifested itself throughout his career in the numerous portrait plaques he made as well as in the coins he designed late in his life. Some of the artist's most successful larger works, including *Amor Caritas*, were also relief sculptures. The large-scale version of the work was among the sculptures that helped Saint-Gaudens win the grand prize when he exhibited at the Universal Exposition in Paris in 1900. (In relief sculpture the image comes out of and is part of a background surface; the image on a coin is an example of low relief sculpture; *Amor Caritas*, in which the figure seems almost three-dimensional, is an example of high relief.)

During his student days in Paris, Saint-Gaudens adopted a "parisian mode" that emphasized the potential of bronze to reproduce exactly the effects of the clay model and subtle differences in textures. From the extreme smoothness of the "skin" of the figure to the slightly roughened surface of the architectural niche and the intricately pleated gown, textures lend a liveliness to the figure through the differing ways they variously capture or reflect light.

Saint-Gaudens became one of the most important and successful sculptors of his day. Scholars note that he almost single-handedly pioneered a new kind of imagery for American sculpture that turned away from idealized classically inspired works like Hiram Powers's *Proserpine* (see entry) toward female figures that personified abstractions and allegories. In the words of the sculpture historian Wayne Craven (1984, 376-77),

> In the last quarter of the century the personification of ideas and values in American sculpture took on a new form, expelling the images of the revival styles; a new breed of robed maidens who possessed a kind of timelessness was devised to represent such ideas as Justice, Peace, Victory, Industrial Power and so on. Saint-Gaudens' "Silence" [an early work of about 1874—over two decades before *Amor Caritas*] was the prototype for the many allegorical and personifying maidens that were to follow in the next decades. They became abstract symbols of things Americans thought and felt and did… Augustus Saint-Gaudens played a leading role in the invention of this new kind of American imagery.

SOURCES
Craven, Wayne, et al. *200 Years of American Sculpture*. New York: Whitney Museum of American Art, 1976. ❦ Craven, Wayne. *Sculpture in America*. Second edition. Newark: University of Delaware Press, 1984; New York and London: Cornwall Books, 1984. ❦ Dryfhout, John H. *The Work of Augustus Saint-Gaudens*. Hanover and London: University Press of New England, 1982.

INSCRIPTIONS
Inscribed in cast, on tablet: *AMOR* CARITAS; ❦ and in cast, column base, left side: AVGVSTVS / SAINT GAVDENS / M.D.C.C.X.C. VIII; ❦ and cold stamped into cast, bottom edge, right side: COPYRIGHT MDCCCXCVIII BY / AUGUSTUS SAINT GAUDENS.

PROVENANCE
Bertha Crowsley (Mrs. Edmund Burke) Ball, Muncie, Indiana; ❦ Edmund F. Ball, Janice Ball Fisher, and Adelia Ball Morris, Muncie, Indiana, 1957.

RELATED WORKS
Augustus Saint-Gaudens. *Amor Caritas* (heroic versions), 287.5 cm high, The Musée d'Orsay, Paris, France, cast 1898 and The Metropolitan Museum of Art, New York, New York, cast 1918. A plaster model is owned by the Saint-Gaudens National Historic Site, Cornish, New Hampshire.

Related works also include the Anna Maria Smith Tomb, Island Cemetery, Newport, Rhode Island; the Cornelius Vanderbilt II House mantlepiece (today in The Metropolitan Museum of Art, New York, New York); and the planned and only partially executed Edwin D. Morgan Tomb, Cedar Hill Cemetery, Hartford, Connecticut.

Saint-Gaudens cast approximately twenty reductions of the
1898 heroic version of *Amor Caritas*, marketing them in
New York through Tiffany and Company and Boston
through Doll and Richards. A number of the reductions
were sold with tabernacle-style wood frames designed by
Stanford White (1853–1906).

John Ottis Adams

American (1851–1927)
born Amity, Indiana, July 8, 1851
died Indianapolis, Indiana, January 28, 1927

In Poppyland, 1901
(*Poppy Field*)

paint (oil) on canvas
55.9 × 81.6 cm; 22 × 32⅛ inches

Permanent loan from the Frank C. Ball Collection, Ball
Brothers Foundation
L37.219

Recto: signed in green paint, lower right: J. Ottis Adams /
1901.

Conserved, 1990, Indianapolis Museum of Art, Indianapolis,
Indiana.

J. Ottis Adams; ❦ Frank C. Ball, Muncie, Indiana, before
1936; ❦ Ball Brothers Foundation, Muncie, Indiana, 1937.

Indianapolis, H. Lieber Co. *A Collection of Oil Paintings,
Scenes from the Vicinity of Brookville by J. Ottis Adams.*
December 2–7, 1901, catalogue number 6. ❦ Indianapolis,

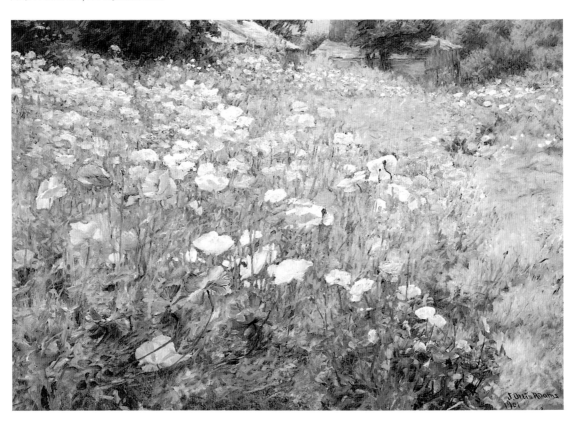

John Herron Art Institute (Indianapolis Museum of Art). *Memorial Exhibition of the Paintings of John Ottis Adams*. October, 1927, catalogue number 78. ❦ Indianapolis, Indianapolis Museum of Art. *The Passage: Return of Indiana Painters from Germany, 1880-1905*. November 24, 1991-February 2, 1992 (also Cologne, Wallraf-Richartz Museum, November 14, 1990-January 27, 1991; Mainz, Mainz Landesmuseum, February 24-May 19, 1991), pages 204-205, catalogue number 86. ❦ Muncie, Ball State University Museum of Art. *The Hoosier Group in Context*. July 12-August 30, 1992, no catalogue. ❦ Muncie, Minnetrista Cultural Center. *J. Ottis Adams: A Sense of Place*. November 7, 1992-February 14, 1993, catalogue page IV, illustrated in color front cover. ❦ Traverse City, Dennos Museum Center. *J. Ottis Adams, 1851-1927: American Impressionism in Leland*. September 12-November 14, 1993, catalogue page 16.

REFERENCES
(Former accession number: AG-37-116.) ❦ Ball State, 1936, page 14. ❦ Ball State, 1947, page 3. ❦ Krause, Martin. *The Passage: Return of Indiana Painters from Germany, 1880-1905*. Indianapolis: Indianapolis Museum of Art and Indiana University Press, 1990, pages 204-205, catalogue number 86, illustrated in color.

Childe Hassam

American (1859-1935)
born Dorchester (Boston), Massachusetts, October 17, 1859
died East Hampton, Long Island, New York, August 27, 1935

Entrance to the Siren's Grotto, Isle of Shoals, 1902

paint (oil) on canvas (commercially primed)
45.7 × 55.9 cm; 18 × 22 inches

Gift of the Muncie Art Association
71.010b

INSCRIPTIONS
Recto: signed, lower left: Childe Hassam 1902.

Verso: inscribed in black ink, stretcher, right member, top: 10s (or 105).

CONDITION and TECHNIQUE
The painting is unlined and covered with a thin layer of discolored varnish.

PROVENANCE
Childe Hassam; ❦ Muncie Art Association, Muncie, Indiana, May 29, 1907; ❦ Muncie Art Students' League, Muncie, Indiana, March 2, 1925 (as custodian for inactive Muncie Art Association); ❦ Muncie Art Association, Muncie, Indiana, September, 1928.

EXHIBITIONS
Muncie, Muncie Art Association. *Second Annual Exhibition of the Muncie Art Association*. May 16-27, 1907, catalogue number 35. ❦ Richmond, Indiana, Art Association of Richmond. *Eleventh Annual Exhibition of the Art Association of Richmond, Indiana*. Garfield School Building, June 11-25, 1907, catalogue number 35. ❦ Muncie, Muncie Public Library, on loan, 1907-1922. ❦ Pittsburgh, Department of Fine Arts, Carnegie Institute. *Fourteenth Annual Exhibition*. May 2-June 13, 1910, catalogue number 133. ❦ Muncie, Central High School, on loan, 1922-circa 1925. ❦ Muncie, Muncie Public Library, on loan circa 1925-1928. ❦ Muncie, Ball State University Art Gallery. *Childe Hassam in Indiana*. November 3-December 8, 1985, pages 32-33, catalogue number 5, illustrated page 32. ❦ New Haven, Yale University Art Gallery. *Childe Hassam: An Island Garden Revisited*. April 4-June 10, 1990 (also Denver, The Denver Art Museum, July 4-September 9, 1990; Washington, D.C., The National Museum of American Art, October 5, 1990-January 7, 1991), pages 181, 204, illustrated in color page 185, plate 99.

REFERENCES
(Former accession number: AC-35-109.) ❦ Unpublished minutes dated May 29, 1907, Muncie Art Association, Muncie, Indiana. ❦ Ball State, 1947, page 14. ❦ Griner, Ned. *Side by Side with Coarser Plants: The Muncie Art Movement, 1885-1985*. Muncie: Ball State University, 1985, page 43. ❦ Joyaux, Alain G., Brian Moore, and Ned H. Griner. *Childe Hassam in Indiana*. Muncie: Ball State University Art Gallery, 1985, pages 32-33, catalogue number 5, illustrated page 32. ❦ Curry, David Park. *Childe Hassam: An Island Garden Revisited*. New York: W.W. Norton and Company, 1990, pages 181, 204, illustrated in color page 185, plate 99.

see color plate VI

William Merritt Chase

American (1849-1916)
born Franklin Township, Indiana, November 1, 1849
died New York, New York, October 15, 1916

Rest by the Wayside, circa 1902

(Rest by the Roadside)

paint (oil) on panel (plywood with mahogany face)
65.2 × 51.3 cm; 25⅝ × 20¼ inches

Permanent loan from the Frank C. Ball Collection, Ball Brothers Foundation
L29.021

INSCRIPTIONS
Recto: signed in red oil paint, lower left: Wm. M. Chase.

Verso: inscribed in red paint, panel, upper left: 852:18; ❦ and in red paint, panel, lower right: 5.L.331.1.

Labels, etc: bears white paper label, panel, upper center, inscribed in ink: Rest by the Roadside / Owner: Mrs. William Chase / Price $1000.00; ❦ and white paper Henry Art Gallery, University of Washington label (now in object file).

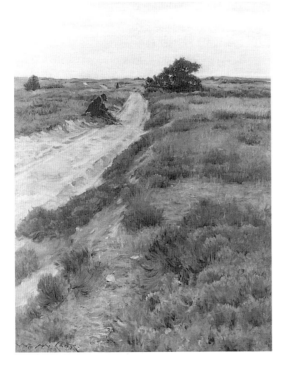

CONDITION and TECHNIQUE
There is a stable old crack at joining of the surface veneers, right side, and associated overpaint (possibly done by artist). The varnish has yellowed and is slightly disfiguring.

PROVENANCE
William Merritt Chase; ❦ Mrs. William Merritt Chase, 1916; ❦ Frank C. Ball, Muncie, Indiana, before 1929; ❦ Ball Brothers Foundation, Muncie, Indiana, 1936.

EXHIBITIONS
New York, Waldorf Art Galleries. *Spring Exhibition of Modern American Art.* 1903, page 9, catalogue number 31. ❦ Seattle, Henry Art Gallery, University of Washington. *William Merritt Chase Retrospective Exhibition.* October 1, 1983-January 29, 1984 (also New York, Metropolitan Museum of Art, March 8-June 3, 1984), page 125, illustrated.

REFERENCES
(Former accession number: AC-29-21.) ❦ Ball State, 1947, page 6. ❦ Indianapolis, John Herron Art Museum (Indianapolis Museum of Art). *Chase Centennial Exhibition.* Indianapolis: John Herron Art Museum, 1949, unpaginated, included in checklist of known work, as *Rest by the Wayside.* ❦ Alasko, Richard-Raymond. *Nineteenth Century American Paintings: Art Gallery, Ball State University.* Muncie: Ball State University Art Gallery, n.d. (1972?), page 27, illustrated page 26. ❦ Pisano, Ronald G. *A Leading Spirit in American Art: William Merritt Chase, 1849-1916.* Seattle: University of Washington, 1983, page 125, illustrated.

REMARKS
The painting was executed near Southhampton, Long Island and depicts the Shinnecock Hills.

Jean-Léon Gérôme

French (1824-1904)
born Vesoul, France, May 11, 1824
died Paris, France, January 10, 1904

Prédication dans la Mosquée, 1903
(*Sermon in the Mosque*)

paint (oil) on canvas (linen)
70.0 × 101.6 cm; 27⁹⁄₁₆ × 40 inches

Permanent loan from the Frank C. Ball Collection, Ball Brothers Foundation
L29.042

In a hazy half-light a group of turbaned men sit and stand in a semi-circle, their attention fixed on the reader in the pulpit. This quiet scene is interrupted only by the burst of light visible through the window but not quite pervading the room. At the end of his career, when this was painted, Jean Léon Gérôme turned again to a subject that had first occupied him three decades earlier: the mosque interior. Through these images, Gérôme concentrated on people in various states of private and group prayer.

In the nineteenth century and today, critics referred to near-eastern scenes like this one as Orientalist pictures. Although Gérôme painted a variety of subjects including portraits and scenes from Ancient Rome, critics consider his Orientalist canvases his finest works. Orientalist artists focussed their attention on the Islamic world of the Mediterranean Near East, particularly Egypt and Turkey. In the eighteenth and nineteenth centuries, a number of books— some of them richly illustrated—documenting the people, architecture, costumes, and customs of the Near East had been published in Europe; by the nineteenth century travel to these countries had become more common. In their views of these lands, European artists strove for

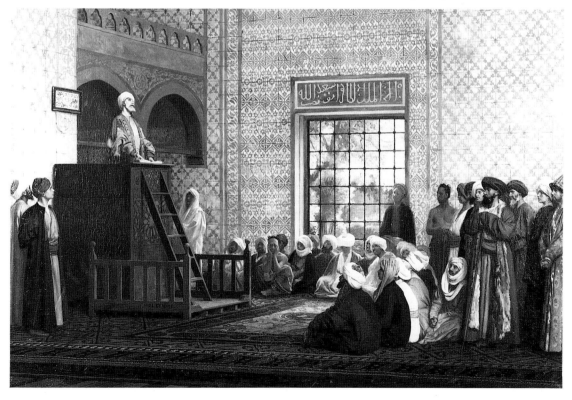

accuracy of setting and detail, although back home, French collectors saw Orientalist canvases as representative of sun-filled exotic lands. Orientalist paintings were immensely successful with the public and were the highlight of many an exhibition in the decades at the middle of the nineteenth century.

Not merely exotic scenes, Gérôme's paintings of the Near East are characterized for the most part by their accurately rendered architecture and the inclusion of figures varying in age and ethnicity. So precise are the artist's canvases that scholars have been able to identify specific buildings Gérôme included in his scenes. Throughout his career Gérôme travelled often to the Near East, taking several long trips to Egypt, a camera among his possessions. With the mid-nineteenth-century invention of photography, many artists recognized its usefulness in accurately recording vistas and details. As early as the 1850s, writers praised Gérôme's use of photography as an aid in creating his intensely realistic scenes.

Although at the height of his career Gérôme had been one of the most famous painters in France, by the time he painted *Sermon in the Mosque*, both in image and style, Gérôme was working in a manner whose hey-day was long past. With the availability of the portable camera by the late 1880s, travellers could now record their own images of the Near East. Photography, as well as artists' and critics' increasing interest in Japan, and even more exotic locales like Tahiti, prompted the speedy demise of Orientalist subjects in the last two decades of the century.

Since 1863 Gérôme had been a professor at the Academy of Fine Arts in Paris. As he had been trained, he continued to impart to his students the importance of drawing as the basis for good art. By the end of the century the pristine, precise style of the Academy had been superseded by the work of the Impressionists.

Their technique of reproducing effects of light, color, and atmosphere by applying short strokes of unblended color to the canvas appeared to dissolve the solidity of figures and buildings. Despite a lifelong friendship with the Impressionist artist Edgar Degas (see entry), Gérôme remained a strong opponent of Impressionism throughout his academic career until his death in 1904. Impressionist paintings and the more abstract styles emerging in the last decades of the century were completely antithetical to the academic style, based on the precise rendering of carefully composed scenes, that Gérôme and his colleagues practiced.

Despite the waning of Orientalism and academic styles of painting by 1900, Gérôme exhibited his *Sermon in the Mosque* in the Paris Salon of 1903, sponsored by the National Society of Fine Arts.

SOURCES
Ackerman, Gerald and Richard Ettinghausen. *Jean-Léon Gérôme (1824-1904)*. Dayton, Ohio: The Dayton Art Institute, 1972. ❦ Julian, Philippe. *The Orientalists, European Painters of Eastern Scenes*. Oxford: Phaidon Press, 1977.

INSCRIPTIONS
Recto: signed in tan oil paint on the pulpit base, lower left center: J.L. GEROME.

Verso: inscribed in blue crayon, stretcher, vertical member, top: P / 1065; ❦ and in black crayon, frame, upper member, left corner and lower member, left corner: 59.

Labels, etc.: bears cream paper label, stretcher, vertical member, top, inscribed: H.C. Hoskier, Esq / Haid.

CONDITION and TECHNIQUE
The painting is unlined. The natural resin varnish is moderately discolored.

PROVENANCE
Herman Charles Hoskier, New York, New York; ❦ Herman Charles Hoskier estate, New York, New York, 1914; ❦ Holland Art Galleries, New York, New York; ❦ James Buchanan Brady, New York, New York, 1914; ❦ James

Buchanan Brady estate, New York, New York, 1918; ❦ Frank C. Ball, Muncie, Indiana, January 14, 1918; ❦ Ball Brothers Foundation, Muncie, Indiana, 1936.

EXHIBITIONS
Paris, Société Nationale des Beaux-Arts. *Salon.* 1903, catalogue number 774, as *Prédication dans la Mosquée.*

REFERENCES
(Former accession number: AC-29-42.) ❦ Paris, Société Nationale des Beaux-Arts. *Catalogue officiel illustré des ouvrages de peinture, sculpture et gravure exposé au Champ-de-Mars.* Paris: Lemercier, 1903, catalogue number 774. ❦ New York, American Art Association. *Herman Charles Hoskier Sale.* March 2-5, 1914, number 451. ❦ New York, American Art Association. *Illustrated Catalogue of the Valuable Modern Paintings Collected by James Buchanan Brady.* January 14, 1918, number 59, illustrated. ❦ Unpublished invoice dated January 14, 1918, American Art Association, New York, New York, to Frank C. Ball. ❦ Ball State, 1936, page 8. ❦ Ball State, 1947, page 12. ❦ Ackerman, Gerald M. *The Life and Work of J.L. Gérôme.* London: Sotheby's Publications by Philip Wilson Publishers Ltd., 1986, pages 286 and 288, catalogue number 477, illustrated page 287, and in color page 157.

André Lhote

French (1885-1962)
born Bordeaux, France, July 5, 1885
died Paris, France, January 24, 1962

Sous-Bois I, 1906

(Under the Trees I)

paint (oil) on canvas
73.2 × 60.0 cm; 28¾ × 23⅝ inches

Lent by David T. Owsley
L88.007.22

Amid blue foliage, sinuous pink tree trunks wind toward the top of the canvas, where light seems to penetrate the leaves. André Lhote presents a lush forest interior in bright, saturated hues. For his early intensely colored works like these, critics linked Lhote to the artists they called the Fauves (French for "wild beasts").

A loose association of artists, the Fauves exaggerated color and simplified shapes in canvases that were shocking in their departure from visual reality. Writing on the Autumn Salon of 1905, the Paris exhibition that first presented the Fauves' works to the public, critic Louis Vauxcelles referred to the artists as "Wild Beasts." To many artists and critics, however, the Autumn Salon was the most progressive of the various annual exhibitions held in Paris around the turn of the century. At the 1907 Autumn Salon the Bordeaux artist André Lhote exhibited three works.

For the Fauve artists, landscape painting provided the opportunity to explore a traditional subject in a new way. Since landscape painting enjoyed such a prominent place in the history of French art, the challenge for the Fauves was to infuse their views with a new, more emphatic expression. In that pursuit color—bright, intense and glorious pinks, oranges, blues and yellows—became their vehicle.

Although most painters (including Henri Matisse, André Derain and Maurice de Vlaminck, the core of the group) presented views of shorelines, forests, villages, and towns from a slight distance, André Lhote takes a different approach. In *Sous-Bois I* he positions the viewpoint within a lush thicket of trees. Sky and horizon are invisible; only the pale yellows at the top of the canvas suggest the intrusion of sunlight as it dissolves the edges of leaves. The image must have intrigued the young painter; he repeated it in a second, slightly darker canvas, *Sous-Bois II* (private collection).

SOURCES
Freeman, Judi et al. *The Fauve Landscape.* New York: Abbeville Press, 1990; Los Angeles: L.A. County Museum of

Art, 1990. ❦ Musée National d'Art Moderne. *André Lhote*. Paris: Musée National d'Art Moderne, 1958. ❦ Wattenmaker, Richard J. *The Fauves*. Toronto: Art Gallery of Ontario, 1975.

INSCRIPTIONS
Recto: signed in brown oil paint, lower left: A. Lhote.

Verso: inscribed in black ink, stretcher, upper member, right: Coll. Juster; ❦ and in black ink, stretcher, upper center: 20 F; ❦ and in black ink, stretcher, upper member, left: sous bois; ❦ and in black ink, stretcher, left member: #51843 1/; ❦ and in black ink, stretcher, right member: 20 F 73x60; ❦ inscribed in black ink, frame, upper member, center: #51843 1/; ❦ and in black ink, frame, left member, center: 24430; ❦ and in black ink, frame, center member, left: #884; ❦ and in white chalk, frame, center member, left: Juster New York Harseille (?); ❦ bears illegible rubber stamp, frame, center member, center.

Labels, etc: bears cream-colored rectangular paper label, stretcher, upper member, right, printed: Arthur Lenars and Co. / Agents en Douane–Fine Arts Depnt. / 22 bis, Rue de Paradis / PRO. 30-34 Paris 10. / (added later in ball point pen) JUI NI; ❦ and white paper exhibition label, frame, upper member, right, typed and written (now in file): ANDRE LHOTE FRENCH: 1885-1962 / "SOUS-BOIS" I 1906 / Oil on canvas / 28 3/4 × 23 5/8 (73.2 × 60 cm) / Exhibition Cat. #1 / Ex. Coll Juster; ❦ and white paper label, stretcher, center member, left, printed and written (now in object file): MUSEE TOULOUSE-LAUTREC-ALBI / EXPOSITION André Lhote / 1962 No catalogue 2 / Juster Gallery N.Y.; ❦ and white paper label, stretcher, right member, printed and written (now in object file): Ministère de L'Education Nationale / REUNION DES MUSEES NATIONAUX / MUSEE NATIONAL D'ART MODERN / EXPOSITION: Lhote / AUTEUR: André Lhote / Titre de l'oeuvre: Sous Bois / Propriétaire: M. et Mrs Juster / New York / No du Catalog: 1; ❦ and white paper label, stretcher, right member, printed and written (now in object file): Ministère de L'Education Nationale / REUNION DES MUSEES NATIONAUX / MUSEE NATIONAL D'ART MODERNE / EXPOSITION: AUTEUR: / titre de l'oeuvre: Sous bois 1906 Propriétaire: A L / No du Catalogue: 1.

PROVENANCE
André Lhote; ❦ Mr. and Mrs. Leon Juster, New York, New York, before 1958; ❦ Weintraub Gallery, New York, New York; ❦ David T. Owsley, New York, New York.

EXHIBITIONS
Paris, Musée National d'Art Modern. *André Lhote*. October 29-December 28, 1958, catalogue number 1. ❦ Albi, Musée Toulouse-Lautrec. *Exposition André Lhote*. June 28-September 16, 1962, page 19, catalogue number 2.

RELATED WORKS
André Lhote. *Sous-Bois II*, oil on canvas, 72.5 × 59.2 cm, private collection, New York, New York.

see color plate VII

Cyrus Edwin Dallin

American (1861-1944)
born Springville, Utah, November 22, 1861
died Arlington Heights, Boston, Massachusetts, November 14, 1944

The Scout, 1912 (modeled); 1916-1924 (cast)

metal (bronze)
86.0 × 95.2 × 25.7 cm; 33⅞ × 37½ × 10⅛ inches

Gift of Frank C. Ball
000.273

Alert to what's before them, both horse and rider gaze just slightly to their right. Hand shielding his eyes, the apprehensive rider stares with furrowed brow while his mount, equally alert, stands perfectly still, pricking up his ears. *The Scout* is one of many sculptures of Native Americans that Cyrus Dallin produced throughout his career. (These include the Muncie public sculptures *The Passing of the Buffalo* and *Appeal to the Great Spirit*.) Because of his upbringing among the Ute Indians of Utah, Dallin's experiences as a child and his friendships with Indians later on prompted a dignified and sympathetic treatment of Native Americans

throughout his career as a sculptor. Among similar subjects by American artists, Dallin's images of Native Americans are distinguished by their faithfulness and simplicity. In both his art and his words, Dallin was eager to convey his respect for the people he frequently took as his subjects:

> Those Indians that I knew were not reservation Indians, by the way. They were a free people, proud of their heritage and their race, at liberty to come and go as they chose. . . .

> They had a culture and refinement that was lacking in [other residents of the settlement in which Dallin grew up]—as a matter of fact, the cowboys with their bluster and horseplay frightened me as a child; it was always a treat to visit my little Indian companions in the homes of their parents. They had a civilization which was in many ways superior to ours (1927).

In the summer of 1889 Buffalo Bill's Wild West Show was touring Paris. In that same city, Cyrus Dallin—like many American artists before and after him—was studying at the Académie Julian, having the previous year left Boston where he'd gone for training. Daily visiting Buffalo Bill's camp outside of Paris to make clay studies of the Indian riders, Dallin soon began the clay model for an equestrian sculpture, the *Signal of Peace* (plaster version, 1890), the first in a series of four monumental works Dallin created to chronicle the tragic relationship between Native and Anglo-Americans. (Others include *The Medicine Man* (1898), *The Protest* (1903), and *Appeal to the Great Spirit* (1908).) Over the next four decades the figure on horseback would become a recurring subject for Dallin, constituting fully one-fifth of a body of work that included more than 250 sculptures.

Returning to America in 1891, Dallin married and for the next four years lived in Boston, Salt Lake City, and Philadelphia, teaching in Philadelphia's Drexel Institute. During this time Dallin was engaged in monumental sculptural projects, at times competing with more recognized artists for important commissions. In 1896 he again travelled to Paris to continue his studies at the prestigious Academy of Fine Arts. Three years later Dallin returned to Boston, opened a studio, and began teaching at the Massachusetts State Normal Art School (now the Massachusetts College of Art).

Throughout the first decades of the new century, in public and small-scale sculptures, including a number of equestrian works, Dallin continued to explore the theme of Native Americans. In 1910 Dallin made his first version of *The Scout*, a 60-cm-high work that he enlarged in the late summer of 1914 in preparation for the 1915 Panama-Pacific exhibition in San Francisco (see Weinmann entry). There the large-scale, bronze version of *The Scout* was displayed in the

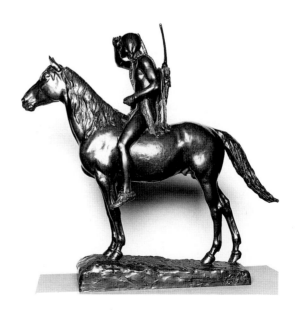

colonnade. The following year it was sent to Kansas City, Missouri, where the town's citizens raised the funds for its purchase and placement in Penn Valley Park.

Dallin was immensely successful with his equestrian sculptures of Native Americans. Both here and abroad these works brought the artist medals and recognition. At the 1893 World's Columbian Exposition in Chicago Dallin won a first-class (gold) medal for a life-size bronze version of the *Signal of Peace*; his *Medicine Man* garnered a silver medal at the Paris Exposition of 1900; a colossal plaster and straw (a mixture called staff) version of *The Protest* won a gold medal at the St. Louis World's Fair in 1904; at the Paris Salon of 1909 a half-life-size version of *Appeal to the Great Spirit* won a third-class (gold) medal. At the 1915 Panama-Pacific exhibition the monumentally sized version of *The Scout* won a gold medal.

This success translated into a demand for additional versions of his works; American sculptors commonly complied by authorizing editions of various sizes, and Dallin was no exception. In 1914 he hired a Boston firm to produce plaster reproductions of some of his Native American subjects. A few years later, Dallin arranged with the Gorham Manufacturing Company, Providence, to produce bronze reductions of some of his most popular works. (Reductions of *Appeal to the Great Spirit* had apparently become more popular than replicas of the *Statue of Liberty*, prompting Dallin to copyright the work in 1918; eleven years later the sculptor permitted a full-scale cast of *Appeal* to be made to honor Edmund Burke Ball.) The Gorham Company produced *The Scout* in 20, 60, and 86-cm-high versions.

SOURCES
Broder, Patricia Janis. *Bronzes of the American West*. New York: Abrams, 1974. ❦ Dallin, Cyrus. Interview in E. Waldo Long. "Dallin, Sculptor of Indians." *The World's Work*,

number 54, September 1927, page 565. Quoted in Broder, page 93. ❦ Greenthal, Kathryn, et al. *American Figurative Sculpture in the Museum of Fine Arts, Boston*. Boston: Museum of Fine Arts, 1986. ❦ Rell, Francis G. *Cyrus E. Dallin: Let Justice Be Done*. Springville, Utah: Springville Museum of Art, 1976. ❦ Craven, Wayne et al. *200 Years of American Sculpture*. New York: Whitney Museum of American Art, 1976.

INSCRIPTIONS
Signed in cast, base, upper surface, right corner: C.E.D. / 1910; ❦ and inscribed in cast, base, edge, front, right: COPYRIGHT 1912 C E DALLIN; ❦ stamped after casting, base, edge, rear, right: GORHAM. CO. FOUNDERS; ❦ and in cast, base, edge, right: (an oval illegible seal).

CONDITION and TECHNIQUE
The reins originally attached to the lower jaw of the horse and running to the left hand of the figure are missing, as is the vertical feather from the socket at the back of the figure's head. The piece is patinated a rich brown and cast in two primary parts, the base and the figure.

PROVENANCE
Frank C. Ball, Muncie, Indiana; ❦ installed in Elliot Hall, Ball State Teachers College, circa 1939; ❦ transferred to the Ball State University Art Gallery circa 1970.

EXHIBITIONS
Muncie, Ball State Teachers College. *Exhibition of Paintings and Sculpture by Leading American Artists from the Grand Central Art Galleries, Inc.* March ?–April 8, 1937, catalogue number 19.

REFERENCES
Ball State, 1947, page 36. ❦ Gorham Company, Small Bronze Division Records, Archives of American Art.

REMARKS
Between 1916 and 1924, the Small Bronze Division of Gorham cast seven 86-cm-high examples of *The Scout*. It is likely that the Muncie example is cast number six, cast and shipped to the Gorham Company in 1922 and sold on May 31, 1938. The usual royalty paid to Dallin for an 86-cm-high cast was $150.00. However, when cast number six was purchased, Dallin authorized a special royalty of $75.00. Between 1917 and 1937, the Small Bronze Division also cast eighty-four examples 20-cm-high and forty-four examples 60-cm-high.

Childe Hassam

American (1859–1935)
born Dorchester (Boston), Massachusetts, October 17,
1859
died East Hampton, Long Island, New York, August
27, 1935

Bowl of Goldfish, 1912

paint (oil) on canvas (commercially primed)
64.2 × 77.1 cm; 25⅛ × 30¼ inches

Permanent loan from the Frank C. Ball Collection, Ball
Brothers Foundation
L37.142

INSCRIPTIONS
Recto: signed in brown oil paint, upper left: Childe Hassam
1912.

Verso: signed in red oil paint, canvas, center, Hassam
monogram: CH 1912; ❦ bears William Macbeth, Inc.,
inventory stamp, stretcher, upper and lower members:
8423; ❦ inscribed in red paint, frame, upper member, left:
O-142; ❦ and in red paint, frame, upper member, left:
BOWL OF GOLDFISH; ❦ bears William Macbeth, Inc.,
inventory stamp, frame, upper member, center: 1757.

Labels, etc.: bears white paper William Macbeth, Inc., label,
frame, upper member, center; ❦ and Grand Central Art
Galleries label, frame, upper member, inscribed (now in
object file): #A 3672.

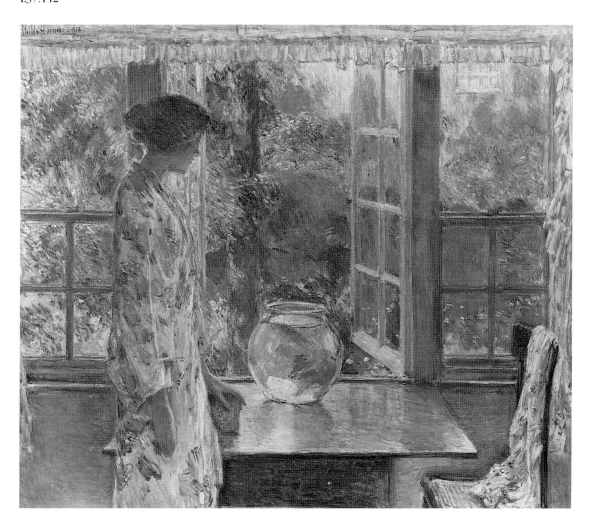

PROVENANCE

Childe Hassam; ❦ Charles V. Wheeler, circa 1913; ❦ William Macbeth, Inc., New York, New York, November 2, 1935 (consigned to ?, January 3, 1936; to the Currier Gallery of Art, Manchester, New Hampshire, December 31, 1936; to the Grand Central Art Galleries, New York, New York, February 13, 1937); ❦ Grand Central Art Galleries, New York, New York, 1937; ❦ Frank C. Ball, Muncie, Indiana, March 10, 1937; ❦ Ball Brothers Foundation, Muncie, Indiana, 1937.

EXHIBITIONS

Washington, D.C., The Corcoran Gallery of Art. *Fourth Exhibition of Oil Paintings by Contemporary American Artists.* December 17, 1912-January 26, 1913, catalogue number 136. ❦ probably Manchester, New Hampshire, Currier Gallery of Art, late 1936-early 1937; ❦ Muncie, Ball State Teachers College. *Exhibition of Paintings and Sculpture by Leading American Artists from the Grand Central Art Galleries, Inc.* March ?-April 8, 1937, not in catalogue. ❦ Muncie, Ball State University Art Gallery. *Childe Hassam in Indiana.* November 3-December 8, 1985, page 40, catalogue number 8, illustrated, illustrated in color page 39, plate IV.

REFERENCES

(Former accession number: AC-37-142.) ❦ New York, American Art Association, Anderson Galleries, Inc. *Valuable Paintings Including the Celebrated "Black Boy" by Thomas Gainsborough, R. A., Fine Examples by American Artists, Noteworthy Works of the French School.* November 1, 1935, lot number 34, illustrated page 19. ❦ Unpublished stock Disposition Cards-Sold Pictures, William Macbeth, Inc., number 8423. ❦ Ball State, 1947, page 13. ❦ Joyaux, Alain G., Brian Moore, and Ned H. Griner. *Childe Hassam in Indiana.* Muncie: Ball State University Art Gallery, 1985, page 40, catalogue number 8, illustrated, illustrated in color page 39, plate IV.

RELATED WORKS

Hassam, Childe. *The Goldfish Window,* 1916, oil on canvas, 84.4 × 127 cm, Currier Gallery of Art, Manchester, New Hampshire (a slightly larger mirror image of the Muncie painting).

REMARKS

In *Bowl of Goldfish,* Hassam apparently depicts his wife Maude, née Kathleen Maude Doane, near the window of Holley House, an artists' boarding house in Cos Cob, Connecticut.

Odilon Redon

French (1840-1916)
born Bordeaux, France, April 20, 1840
died Paris, France, July 6, 1916

Grand vase aux anémones, 1914-1915

(Anémones; Fleurs; Bouquet; Large Vase of Anemones)

pastel on paper (medium-weight, grey-green), prepared panel (see condition)
84.9 × 65.2 cm; 33¾ × 25¹¹⁄₁₆ inches

Permanent loan from the Elisabeth Ball Collection, George and Frances Ball Foundation
L83.026.26

INSCRIPTIONS

Recto: signed in black pastel, lower left: ODILON REDON.

Verso: (all verso inscriptions, labels, etc., describe the original prepared panel verso, see condition) inscribed in pencil, upper center: Jos Hessel; ❦ and in pencil, upper edge: 3/13/37/2318 W2044; ❦ and bears William Macbeth, Inc., inventory stamp, upper center: #9025.

Labels, etc: (all labels now in object file) ❦ bears white paper R. Lerondelle label, left center; ❦ and white paper Jos. Hessel label, upper center; ❦ and white paper Museum of Modern Art label, upper center, right; ❦ and white paper De Hauke and Co. label, upper center; ❦ and white paper Galerie Barbazanges label, center; ❦ and white paper Laboratoires Scientifiques label, bottom right; ❦ and white paper Ch. Dousberg, bottom center; ❦ and white paper Chenue label, bottom center; ❦ and small white paper label, upper left, illegible; ❦ and small white paper label, bottom center, right, illegible; ❦ and white paper William Macbeth, Inc. label, frame, upper member, center.

CONDITION and TECHNIQUE

Before conservation, expanded margins had been adhered to the paper on all four sides of the sheet and were folded around and adhered to the verso of the pressed paperboard secondary support. The pastel was executed on this prepared panel. Because of the deterioration and extreme warping of the prepared panel, conservation treatment was necessary. (All labels and inscriptions were retained for the object file.) Conserved, 1983, Intermuseum Conservation Association, Oberlin, Ohio.

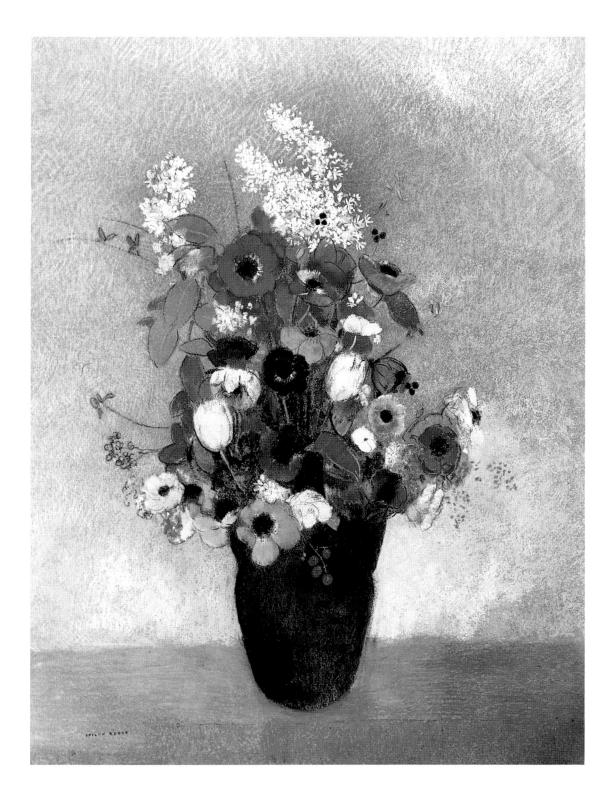

PROVENANCE
Odilon Redon; ❦ Jos Hessel, Paris, France, before 1920; ❦ Madame Jos Hessel, Paris, France, before 1923; ❦ César de Hauke, Paris and New York, before 1928; ❦ C. W. Kraushaar Art Galleries, New York, New York, before 1931; ❦ Thomas Cochran, New York, New York, before 1931; ❦ Thomas Cochran estate (Mrs. Arthur H. Savage); ❦ M. Knoedler and Company, New York, New York; ❦ William Macbeth, Inc., New York, New York, March 13, 1937; ❦ Elisabeth Ball, Muncie, Indiana, March 20, 1937; ❦ George and Frances Ball Foundation, Muncie, Indiana, 1982.

EXHIBITIONS
Paris, Galerie Barbazanges. *Exposition rétrospective d'oeuvres d'Odilon Redon (1840-1916).* May 18-June 15, 1920, catalogue number 114, as *Le Bouquet.* ❦ Paris, Laboratoires Scientifiques. *Exposition au service de la science.* April-May, 1923, as *Fleurs.* ❦ Paris, Galerie E. Druet. *Exposition d'oeuvres d'Odilon Redon, 1840-1916.* June, 1923. ❦ Paris, Musée des Arts Décoratifs. Palais du Louvre, Pavillon de Marsan. *Odilon Redon: Exposition rétrospective de son oeuvre.* March, 1926, catalogue number 130, as *Vase de fleurs.* ❦ New York, De Hauke and Co. *Exhibition of Paintings, Pastels, Drawings, Watercolors, Lithographs by Odilon Redon.* November, 1928 (exhibition checklist is a separate publication), checklist number 26, as *Grand Vase aux Anémones.* ❦ Chicago, The Art Institute of Chicago. *Exhibition of Paintings, Pastels, Drawings, Watercolors, Lithographs by Odilon Redon.* December 27, 1928-January 27, 1929 (De Hauke and Co., exhibition listed above with a number of works dropped; again exhibition checklist is a separate publication, here entitled *Catalogue of Paintings, Pastels and Drawings by Odilon Redon: 1840-1916*), checklist number 23, as *Fleurs dans un vase.* ❦ New York, C. W. Kraushaar Art Galleries. *Exhibition of Modern French Paintings, Watercolors and Drawings.* October 5-28, 1929, catalogue number 22, as *Anémones.* ❦ New York, The Museum of Modern Art. *10th Loan Exhibition: Lautrec, Redon.* February 1-March 2, 1931, catalogue number 101, as *Vase of Anemones.* ❦ Indianapolis, John Herron Art Museum (Indianapolis Museum of Art). *Indiana Collects: A Loan Exhibition of European and Latin-American Paintings Owned by Collectors in the State of Indiana.* October 9-November 6, 1960, catalogue number 73, as *Large Vase of Anemones.* ❦ Muncie, Ball State Teachers College Art Gallery. *An Exhibition of Paintings from the Collection of Elisabeth Ball.* September 27-November 3, 1961, catalogue number 20. ❦ Muncie, Ball State University Art Gallery. *The Elisabeth Ball Collection of Paintings, Drawings, and Watercolors: The George and Frances Ball Foundation.* January

15-February 26, 1984, page 36, catalogue number 26, illustrated in color front cover. ❦ Tokyo, The National Museum of Modern Art. *Odilon Redon.* March 17-May 7, 1989 (also Kobe, Hyogu Prefectural Museum of Modern Art, May 14-June 25, 1989; Nagoya, Aichi Prefectural Museum of Art, July 7-23, 1989), catalogue number 223, illustrated in color page 218. ❦ Portland, Portland Museum of Art. *Impressionism and Post-Impressionism: The Collector's Passion.* August 1, 1991-October 13, 1991, pages 59-62, catalogue number 29, illustrated page 60, as *Big Vase with Anemones.*

REFERENCES
Roger-Marx, Claude. *Introduction to Exhibition of Paintings, Pastels, Drawings, Watercolors, Lithographs by Odilon Redon.* New York and Chicago: De Hauke and Co., 1928, unpaginated, illustrated. ❦ "Two Artists." *New York Times*, page 13, column 7, November 4, 1928. ❦ "Exhibit Reveals the Fantasy of Redon." *The Art Digest*, volume 3, number 3, November 1, 1928, page 12, illustrated. ❦ Sterne, Katharine Grant. "Odilon Redon Viewed Again." *Parnassus*, volume 3, number 3, March, 1931, page 9. ❦ "List of Important Redons in the United States." *Parnassus*, volume 3, number 4, April, 1931, page 17. ❦ Unpublished Stock Disposition Card-Sold Pictures, William Macbeth, Inc., number 9025. ❦ Unpublished letter dated July 1, 1938, from Robert McIntyre for William Macbeth, Inc. to Mrs George A. Ball. ❦ Berger, Klaus. *Odilon Redon: Fantasy and Color.* New York: McGraw-Hill, 1965, catalogue number 496, as *Anemones.* ❦ Joyaux, Alain G. *The Elisabeth Ball Collection of Paintings, Drawings, and Watercolors: The George and Frances Ball Foundation.* Muncie: Ball State University Art Gallery, 1984, page 36, catalogue number 26, illustrated in color front cover. ❦ Thorn, Megan, ed. *Impressionism and Post-Impressionism: The Collector's Passion.* Portland: Portland Museum of Art, 1991, pages 59-62, catalogue number 29, illustrated page 60.

Adolph Alexander Weinmann

American, born Germany (1870-1952)
born Karlsruhe, Germany, December 11, 1870
died Port Chester, New York, August 8, 1952

Descending Night, 1914-1915 (model); circa 1915-1937 (cast)
(one of a pair)

metal (bronze)
142.2 × 117.3 × 50.1 cm; 56 × 46¼ × 19¾ inches

Permanent loan from the Frank C. Ball Collection, Ball Brothers Foundation
L37.014

INSCRIPTIONS
Signed in cast, base, top surface, rear: C (encircled) A.A. WEINMANN..FECIT.

CONDITION and TECHNIQUE
The bronze was cast in two pieces, the base and the figure.

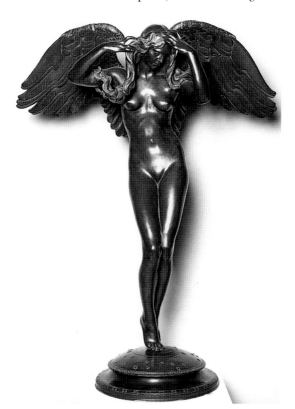

PROVENANCE
Grand Central Art Galleries, New York, New York; ❦ Frank C. Ball, Muncie, Indiana, 1937; ❦ Ball Brothers Foundation, Muncie, Indiana, 1937.

EXHIBITIONS
Muncie, Ball State Teachers College. *Exhibition of Paintings and Sculpture by Leading American Artists from the Grand Central Art Galleries, Inc.* March ?–April 8, 1937, not in catalogue.

REFERENCES
(Former accession number: CA-37-15.) ❦ Ball State, 1947, page 28.

RELATED WORKS
Adolph Alexander Weinmann. *Descending Night* (or *The Setting Sun*), 1914-1915, plaster reinforced with straw or burlap, Court of the Universe, Panama-Pacific International Exposition, San Francisco (destroyed). Five examples were cast in bronze from the artist's plaster working model. (This example and Corcoran Gallery of Art, Washington, D.C.; National Museum of American Art, Washington, D.C.; Krannert Art Museum, University of Illinois, Urbana-Champagne; Art Market, New York, circa 1990.) Reductions of the working model, 67.2-cm-high, were cast by both Cellini Bronze Works, New York, and Roman Bronze Works, New York.

Adolph Alexander Weinmann

American, born Germany (1870-1952)
born Karlsruhe, Germany, December 11, 1870
died Port Chester, New York, August 8, 1952

Rising Day, 1914-1915 (model); circa 1915-1937 (cast)

metal (bronze)
147.2 × 135.8 × 50.1 cm; 58 × 53½ × 19¾ inches

Permanent loan from the Frank C. Ball Collection, Ball Brothers Foundation
L37.020

As if to take flight from his ray-adorned base, *Rising Day* stands tensed, on his toes, his winged

arms outstretched. An unseen wind blows the hair from his upturned face. Cast as a slender, heroic youth, *Rising Day* stands in marked contrast to his voluptuous companion, *Descending Night*. Lifting her heavy hair from her face, *Night* appears as a curvaceous, winged woman. Attached to her back rather than her arms, her wings appear to curve down to enfold her. In contrast to *Day's* energetic posture, *Descending Night's* body relaxes into a sinuous curve as she alights on a base decorated with stars, emblem of the oncoming night she represents. Through the tradition of the winged figure, like the victory figures of antiquity and later images of angels, Weinmann has personified morning and nightfall. Stressing their role as representing ideas rather than specific incidents, the artist presents the figures as idealized nudes.

In 1915 San Francisco hosted the Panama-Pacific International Exposition, celebrating the joining of the Pacific and Atlantic oceans through the opening of the Panama Canal. For the part of the grounds called the "Court of the Universe," Weinmann designed *Rising Day* and *Descending*

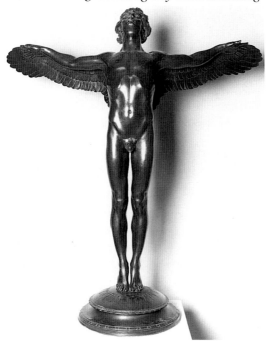

Night—fitting titles for their celestially named location. The two sculptures, rendered in staff (plaster reinforced with straw or burlap), were placed facing each other, atop two columns in the centers of two fountains.

In the decades surrounding the turn of the century, world's fairs were major events that demanded elaborate architectural and sculptural decoration. Variously called "world's fairs," "international expositions," or "exhibitions," these events provided American sculptors a venue for establishing their reputations. (Daniel Chester French, Augustus Saint-Gaudens, and Paul Manship (see entries) also made staff sculptures for the various world's fairs.) Since the fairs were finite events rarely lasting more than several months, the monumental sculptural decorations that adorned the fairgrounds were often rendered in a purposefully ephemeral medium.

Although Weinmann's staff originals were destroyed at the fair's end, at some point in the following years, the artist had his working models of *Rising Day* and *Descending Night* cast in bronze, apparently in a very limited edition: only five sets of the pair in this size are known; Muncie's *Rising Day* and *Descending Night* are one of those sets. Weinmann also had smaller (67.5-cm-high) versions of the sculptures cast for wider sale.

When Weinmann was ten years old, his widowed mother emigrated with her son to New York City. As a teenager, Weinmann served as an apprentice to a wood and ivory carver and attended art classes. Later he studied with Augustus Saint-Gaudens and one of Saint-Gaudens's students. Weinmann, who would go on to assist both Saint-Gaudens and Daniel Chester French as they completed commissions, later became known for his architectural and medallic sculpture.

SOURCES
Craven, Wayne et al. *200 Years of American Sculpture.*
New York: Whitney Museum of American Art, 1976. ❦
Solender, Katherine. *The American Way in Sculpture.*
Cleveland: Cleveland Museum of Art, 1986.

INSCRIPTIONS
Signed in cast, base, top surface, rear: A A WEINMANN
FECIT; ❦ inscribed in cast?, base, edge, rear: ROMAN
BRONZE WORKS. N.Y.

CONDITION and TECHNIQUE
The bronze was cast in two pieces, the base and the figure.

PROVENANCE
Grand Central Art Galleries, New York, New York; ❦ Frank
C. Ball, Muncie, Indiana, 1937; ❦ Ball Brothers Foundation,
Muncie, Indiana, 1937.

EXHIBITIONS
Muncie, Ball State Teachers College. *Exhibition of
Paintings and Sculpture by Leading American Artists
from the Grand Central Art Galleries, Inc.* March ?-April
8, 1937, not in catalogue.

REFERENCES
(Former accession number AC-37-14.) ❦ Ball State, 1947,
page 28.

RELATED WORKS
Adolph Alexander Weinmann. *Rising Day* (or *The Rising
Sun*), 1914-1915, plaster reinforced with straw or burlap,
Court of the Universe, Panama-Pacific International
Exposition, San Francisco (destroyed). Five examples were
cast in bronze from the artist's plaster working model. (This
example and Corcoran Gallery of Art, Washington, D.C.;
National Museum of American Art, Washington, D.C.;
Krannert Art Museum, University of Illinois, Urbana-
Champagne; Art Market, New York, circa 1990.)
Reductions of the working model, 67.2-cm-high, were cast
by both Cellini Bronze Works, New York, and Roman
Bronze Works, New York.

Alfred Henry Maurer

American (1868-1932)
born New York, New York, April 21, 1868
died New York, August 4, 1932

Buckley's Bridge, circa 1917-1923

(*Landscape*)

paint (oil) on pressed paperboard
55.0 × 48.0 cm; 21⅝ × 18⅞ inches

Gift of David T. Owsley
91.068.127

INSCRIPTIONS
Recto: signed in black oil paint, lower left: A. H. Maurer.

Verso: inscribed in pencil, panel, upper center: BAKER /
#25550; ❦ inscribed in pencil, frame, upper member, right:
139; ❦ and in black crayon, frame, right member, bottom:
X134; ❦ and in pencil, frame, left member, center: WEYHE
GALLERY 23K-Bev; ❦ and in pencil, frame, left member,
bottom: 5328 (twice); ❦ and in pencil, frame, left member,
bottom: Aug. 5 (twice).

Labels, etc.: bears white paper label, frame, upper member,
center, printed and inscribed: E. WEYHE, INC. ART BOOKS-
PRINTS / LANDSCAPE / Original oil / by / Alfred Maurer / 21
1/2 × 17 7/8 / BAKER photograph #25550 / 794
LEXINGTON AVE., NEW YORK 21; ❦ and white paper
label, frame, upper member, left inscribed: 3478/X134; ❦
and white paper Max Granick Fine Frames label, inscribed
in blue pen (now in object file): W.H. Bender Jr / 24 W. 40

st / Rm 902; ❦ and white paper label, frame, upper member, center inscribed: PD.

PROVENANCE
Weyhe Gallery, New York, New York (probably acquired in 1924); ❦ William H. Bender, Jr., New York, New York; ❦ William H. Bender, Jr. estate, Bronxville, New York; ❦ David T. Owsley, New York, New York, 1977.

REFERENCES
(Former accession number: L86.010.078.) ❦ Unpublished letter, from Erhard Wehye to William H. Bender, Jr. dated New York, April 23, 1959, concerning the history of the painting. ❦ New York, Sotheby Parke-Bernet. *American 19th and 20th Century Paintings, Drawings, Watercolors, and Sculpture*. April 14, 1974, lot number 134, illustrated.

REMARKS
The painting depicts the Japanese footbridge near Shady Brook, the boarding house where Maurer stayed in Marlboro-on-the-Hudson, New York.

Willard Leroy Metcalf

American (1858-1925)
born Lowell, Massachusetts, July 1, 1858
died New York, New York, March 9, 1925

A Grey Thaw, 1923
(*Late Winter, Vermont*)

paint (oil) on canvas (commercially primed)
66.0 × 73.5 cm; 26 × 29 inches

Permanent loan from the Elisabeth Ball Collection, George and Frances Ball Foundation
L83.026.21

INSCRIPTIONS
Recto: signed in grey oil paint, lower left: W. L. METCALF 1923.

CONDITION and TECHNIQUE
The painting is unlined and not varnished. The dry, unvarnished surface appears to have been chosen by the artist.

PROVENANCE
E. & A. Milch, Inc., New York, New York; ❦ Mr. and Mrs. George A. Ball, Muncie, Indiana, April 12, 1924; ❦ Elisabeth Ball, Muncie, Indiana, before 1957; ❦ George and Frances Ball Foundation, Muncie, Indiana, 1982.

EXHIBITIONS
New York, E. & A. Milch, Inc. (*Metcalf*). February 18-March 8, 1924. ❦ Muncie, Ball State Teachers College Art Gallery. *An Exhibition of Paintings from the Collection of Elisabeth Ball*. September 27-November 3, 1961, page 6, catalogue number 19, as *Late Winter, Vermont*. ❦ Muncie, Ball State University Art Gallery. *The Elisabeth Ball Collection of Paintings, Drawings, and Watercolors: The George and Frances Ball Foundation*. January 15-February 26, 1984, page 31, catalogue number 21, illustrated.

REFERENCES
New York American, February 24, 1924 (see Artist's Scrapbook, Archives of American Art). ❦ *American Art News*, volume XXII, March 23, 1924, page 3, number 20. ❦ Unpublished invoice dated April 12, 1924, E. and A. Milch, Inc., to Mr. and Mrs. George A. Ball. ❦ Joyaux, Alain G. *The Elisabeth Ball Collection of Paintings, Drawings, and Watercolors: The George and Frances Ball Foundation*. Muncie: Ball State University Art Gallery, 1984, page 31, catalogue number 21, illustrated.

REMARKS
The painting was probably executed near Chester, Vermont.

Paul Howard Manship

American (1885–1966)
born St. Paul, Minnesota, December 25, 1885
died New York, New York, February 1, 1966

Diana, 1925
(one of a pair)

metal (bronze, gilt)
119 × 106.5 × 41 cm; 47 × 42 × 16¼ inches

Permanent loan from the Frank C. Ball Collection, Ball
Brothers Foundation
L37.009

INSCRIPTIONS
Signed in cast, base, top surface, front center: PAUL
MANSHIP. SCULPTOR./ C (encircled) . 1925; ❦ inscribed in
cast (or stamped after), base, edge, right: Alexis Rudier /
Fondeur Paris.

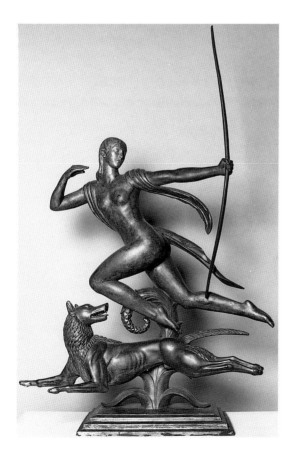

CONDITION and TECHNIQUE
After casting and assembly, the piece was patinated dark
brown, then partially gilded, and the gilding antiqued. The
gilding is noticeably rubbed in some areas, and the bow is
cracked at the joint with the hand. The piece appears to
have been cast in three primary sections (the base; the
hound and the lower half of the plant form; the figure of
Diana and the upper half of the plant form) and three
minor sections (*Diana's* left arm with the section of flowing
drapery; the upper and the lower section of the bow).

PROVENANCE
Grand Central Art Galleries, New York, New York; ❦ Frank
C. Ball, Muncie, Indiana, 1937; ❦ Ball Brothers Foundation,
Muncie, Indiana, 1937.

EXHIBITIONS
Muncie, Ball State Teachers College. *Exhibition of
Paintings and Sculpture by Leading American Artists
from the Grand Central Art Galleries, Inc.* March ?–April
8, 1937, not in catalogue.

REFERENCES
(Former accession number: CA-37-9.) ❦ Ball State, 1947,
page 27.

RELATED WORKS
Diana and *Actaeon* were originally conceived in a smaller
size in 1921. Manship enlarged the pair to almost eight feet
high in 1924 (today Brookgreen Gardens, Murrells Inlet,
South Carolina) and executed this smaller-than-life-size
version in 1925.

Pencil, ink, and crayon preparatory drawings exist. (Rand,
Harry. *Paul Manship*. Washington, D.C.: Smithsonian
Institution Press for the National Museum of America Art,
1989, page 74, figures 62 and 63.)

Paul Howard Manship

American (1885–1966)
born St. Paul, Minnesota, December 25, 1885
died New York, New York, February 1, 1966

Actaeon, 1925

metal (bronze, gilt)
121.2 × 128.7 × 31.7 cm; 44½ × 50¾ × 12½ inches

Permanent loan from the Frank C. Ball Collection, Ball Brothers Foundation

L37.010

I have done many, many subjects based on Greek mythology. It seemed to me, from my modern point of view, that in the antics of the heroes and gods of the ancient Greeks, there is a considerable feeling of humor. My *Diana* and *Actaeon* were based on a well known myth. The myths combine animal forms often with the human form, and I've loved that combination in subject matter. It is lots of fun.

— Paul Manship (1959)

Linking the two sculptures through the implied path of an arrow, sculptor Paul Manship takes some liberties with the ancient story of the virgin goddess of the hunt and her revenge on the young huntsman who by accident saw her bathing. According to the story, as Diana's nymphs bathed her in her forest grotto, the hunter Actaeon, having lost his way, stumbled

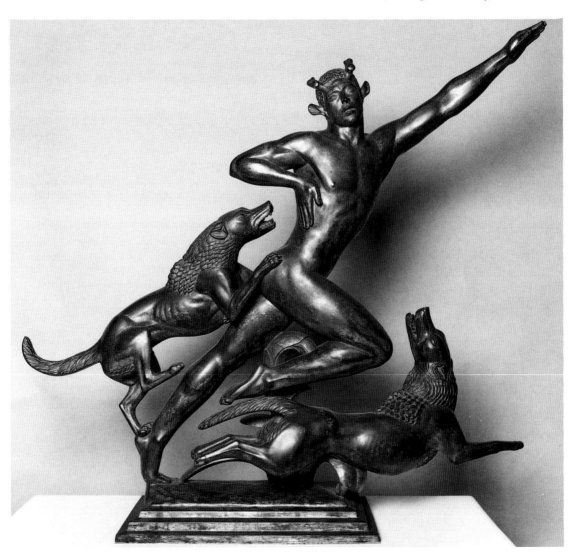

into the cave and caught a glimpse of the nude goddess. Fiercely protective of her virginity and wrathful toward anyone who might threaten it, Diana threw water on her intruder, changing him into a stag. Now a skittish animal, Actaeon ran from the scene, but his own dogs soon caught up with him, attacking and dismembering him.

In Manship's sculptures, Diana's archery skills initiate Actaeon's transformation. Leaping over— and supported by—a curling frond, her dog running beneath her, Diana twists back to direct her arrow. As the hapless object of her missile, Actaeon clutches his side and leaps in the opposite direction. Small horns sprout from his head above the pointed ears of a deer as two ferocious dogs claw at his flesh.

When the heroic versions of the sculptures were exhibited in a show of the artist's work in 1925, *Diana* and *Actaeon* marked Manship's maturity as an artist. The two bear all the marks of Manship's enormously successful style: a slight simplification and geometric smoothing of the bodies; patterning of the hair and manes; and complex movement and counter-movement. In arriving at these tendencies, Manship had studied a wide variety of Ancient, Medieval, and Renaissance sculpture during his three-year stay in Europe as the 1909 winner of the American Rome Prize. There Manship made drawings of Archaic Greek, Egyptian, and Romanesque sculpture.

Manship's work satisfied a clientele weary of the endless takes on classical sculpture and its academic derivatives, yet uneasy with the compositions of modern artists working in an abstract vein. Manship himself noted that his success was the result of being "the right man at the right time."

SOURCES
Manship, Paul. Interview by John D. Morse, February 18, 1959. Transcript Archives of American Art. Quoted in Minnesota Museum of Art, 1972, page 16. ❦ Minnesota Museum of Art. *Paul Howard Manship, An Intimate View.* St. Paul: Minnesota Museum of Art, 1972. ❦ Rand, Harry. *Paul Manship.* Washington, D.C.: Smithsonian Institution Press for the National Museum of American Art, 1989.

INSCRIPTIONS
Signed in cast, base, top surface, front center: PAUL. MANSHIP. SCULPT. / C (encircled). 1925; ❦ inscribed in cast (or stamped after), base, edge, left: Alexis Rudier / Fondeur Paris.

CONDITION and TECHNIQUE
After casting and assembly, the piece was patinated dark brown, then partially gilded, and the gilding antiqued. The gilding is noticeably rubbed on some areas. The piece appears to have been cast in three primary sections (the base, the lower half of the plant form and the lower hound; the figure of *Actaeon* and the upper half of the plant form; and the upper hound) and one minor section (*Actaeon's* left arm).

PROVENANCE
Grand Central Art Galleries, New York, New York; ❦ Frank C. Ball, Muncie, Indiana, 1937; ❦ Ball Brothers Foundation, Muncie, Indiana, 1937.

EXHIBITIONS
Muncie, Ball State Teachers College. *Exhibition of Paintings and Sculpture by Leading American Artists from the Grand Central Art Galleries, Inc.* March ?–April 8, 1937, not in catalogue.

REFERENCES
(Former accession number: CA-37-10.) ❦ Ball State, 1947, page 27.

RELATED WORKS
Diana and *Actaeon* were originally conceived in a smaller size in 1921. Manship enlarged the pair to almost eight feet high in 1924 (today Brookgreen Gardens, Murrells Inlet, South Carolina) and executed this smaller-than-life-size version in 1925.

Matthew Safferson

American, born England (1909-)
born England, 1909

Musicians, circa 1935

paint (casein) on canvas (commercially primed)
48.7 × 35.7 cm; 19³⁄₁₆ × 14¹⁄₁₆ inches

Gift of David and Mary Jane Sursa
92.038.15

With its fragmented, overlapping remnants of guitars or violins, faces, arms, and hands, Safferson's canvas, *Musicians*, serves as an excellent example of Cubism. Like Picasso, Braque, and a host of Cubist artists before him, Safferson here reduces his musicians to overlapping, colored fragments. He then arranges these simplified shapes to suggest multiple viewpoints, challenging the fixed perspective of traditional painting.

Formulated in France by Pablo Picasso and Georges Braque in the first decade of the twentieth century, Cubism transformed the course of art. Now artists were free to fragment and rearrange figures and objects. Through its various forms and derivations, Cubism remained a viable, vital force in painting through the 1930s and 1940s.

INSCRIPTIONS
Recto: signed with brush tip (?) in wet paint, lower right: Matthew / Safferson.

PROVENANCE
Matthew Safferson; ❦ East Coast institution (acquired, circa 1935, deaccessioned, circa 1990); ❦ Berman Daferner Sculpture & Paintings, New York, New York.

EXHIBITIONS
Muncie, Ball State University Museum of Art. *Objects of Desire: A Vision for the Future*. October 11-November 8, 1992, no catalogue.

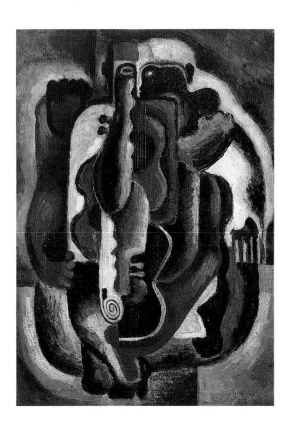

Esphyr Slobodkina

American, born Russia (1908-)
born Chelyabinsk, Siberia, Russia, September 22, 1908

Winter, 1943

paint (oil) on panel (masonite)
30.3 × 40.6 cm; 12 × 16 inches

Museum of Art Alliance Fund purchase with assistance from the Friends Fund
92.038.14

Simple, overlapping shapes dominate Esphyr Slobodkina's *Winter*. Precise outlines and pale colors—dominated by greens, blues, and violets so subtle they border on grays—suggest the

starkness and icy cold of a winter landscape. Although Slobodkina's works appear to be jumbles of meaningless forms, her paintings are abstractions—simplifications and rearrangements—of scenes or objects. In discussing her 1938 painting entitled *Irish Elegy*, Slobodkina alluded to this process in her work:

> [A friend] used to sing the sweet, cloying Irish ballad "Danny Boy"—that sad song about hanging… So [*Irish Elegy*] is an abstraction of the gallows and a primitive lyre with a wooden body. At least that's how I imagined it (1991).

Comparing *Winter* with more traditional images of the theme in the museum's collection, such as Willard Leroy Metcalf's *A Gray Thaw* (also called *Late Winter, Vermont*—see entry), demonstrates Slobodkina's success in conveying the crisp atmosphere and nearly colorless sky of a winter day. Jutting, pointed shapes amid rectangular areas of pale violet and pale blue suggest barren trees seen through a window. In 1943, when this was painted, Slobodkina lived in Manhattan; the compression and overlapping of her painted forms suggest the slender trees that grow cramped in narrow urban courtyards or alleys. Like her fellow members in the progressive American Abstract Artists group (formed in 1937 for the promotion of abstract art in America), Slobodkina sought to create paintings that would convey content without the intervention of realistic and narrative images.

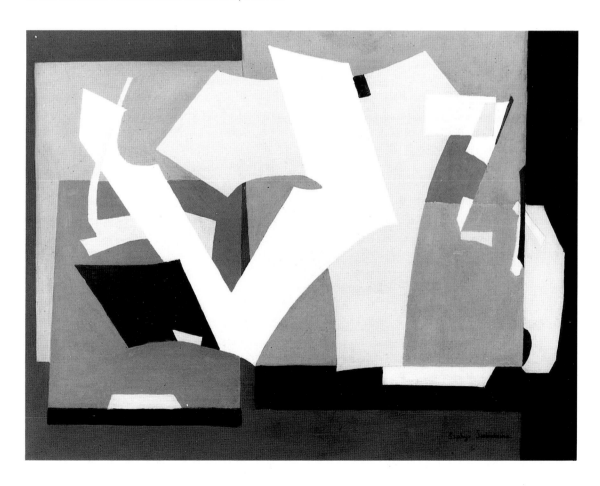

Slobodkina achieves a precision in her abstract paintings through a meticulous technique that she had perfected by the late thirties and which she continues to employ today. Early in her career she had experimented successfully with collage—cutting shapes out of paper and gluing them to composition board or cardboard. Seeking a painting method that would replicate the crispness and smoothness of collaged images, Slobodkina began working on surfaces coated in gesso—a plaster-based mixture that painters apply over canvases or boards before painting them. Slobodkina found that masonite boards coated with gesso provided the smooth surface she preferred to canvas. Working from drawings, she incises the main outlines of the composition into the relatively soft gesso. These incised lines create precise boundaries for the shapes she then colors with oil paint mixed with varnish, oil, and turpentine. By mixing varnish with the paint, Slobodkina discovered that she could produce a thick colorant that did not bleed or ooze on her glassy surfaces.

In addition to creating precise abstract compositions such as *Winter*, Slobodkina works in a variety of media and styles. Sculptures constructed of discarded mechanical components, paintings of interiors, still lifes, and landscapes in a traditional Impressionistic style that stems from her early training (but that she rarely exhibits), and children's books compose her vast body of work.

In the late thirties Slobodkina began illustrating children's books and by the end of the decade had begun writing them as well. In 1940 Slobodkina published the first edition of *Caps for Sale*, the charming tale of an itinerant cap vendor whose wares, stacked atop his head, are stolen by monkeys. Several editions later, with subsequent translations into many languages and media, *Caps for Sale* remains a children's classic.

Slobodkina spent her own childhood in Siberia and Manchuria. Born in 1908 to a prosperous oil field manager and a fine dressmaker, Esphyr demonstrated artistic leanings as a child. Upon entering a junior high school where mathematics and art were emphasized, Slobodkina was influenced to consider an artistic career and began taking painting lessons with a Russian artist who worked in an Impressionistic manner. In 1928 when she graduated from high school, still intent on becoming an artist, Slobodkina acquired a student visa and in January of the next year left for New York, joining a brother who had preceded her there in 1923.

In New York she took classes in English and enrolled in the National Academy of Design. Although for the most part she disliked the academy's emphasis on drawing from casts of ancient sculpture and from life, she engaged with other students in discussions about modern art. First her mother, then a sister, then her father emigrated to New York, and the women of the family earned a living as dressmakers and milliners. In 1933 Slobodkina married the painter Ilya Bolotowsky, thereby becoming an American citizen. During the Great Depression, she and Bolotowsky worked for the Federal Art Project in the Works Progress Administration, gaining some financial relief while pursuing their artistic careers. When the two divorced in 1938, Esphyr was preparing for her first one-person exhibition and had started illustrating children's books.

By 1943 when Slobodkina painted *Winter*, she had already been noticed by the art press. A group and solo exhibition the previous year had brought glowing reviews by important critics including the influential Clement Greenberg. Over the past several decades Esphyr Slobodkina has enjoyed a varied career as an artist and a writer and illustrator of children's books. Now in her eighties, Esphyr Slobodkina continues to exhibit her work across the country.

SOURCES

Lane, John R., and Susan C. Larson. *Abstract Painting and Sculpture in America 1927-1944*. Pittsburgh: Museum of Art, Carnegie Institute, 1983, and New York: Abrams, 1983. ❦ Mecklenburg, Virginia M. *The Patricia and Phillip Frost Collection: American Abstraction 1930-1945*. Washington D.C.: National Museum of American Art, Smithsonian Institution Press, 1989. ❦ Slobodkina, Esphyr. Interview by Gail Stavitsky and Elizabeth Wylie, pages 22-26 March, 1991. Transcript by Gail Stavitsky. Quoted in Stavitsky, page 20. ❦ Stavitsky, Gail. "The Artful Life of Esphyr Slobodkina." In *The Life and Art of Esphyr Slobodkina*. Medford, Massachusetts: Tufts University Art Gallery, pages 5-39, 1992.

INSCRIPTIONS

Recto: signed in black oil paint, lower right corner: Esphyr Slobodkina.

Verso: inscribed by the artist, in brown ink (now faded), panel, center: E. Slobodkina / 112 W. 27th St. / $125; ❦ and in brown paint, panel, upper right: A-613; ❦ and in black ink, panel, upper right: A-613/ES8.

Labels, etc.: bears oblong white paper label, typed (now in object file): (title, date, size) / 23; ❦ and rectangular white paper Sid Deutsch Gallery label, typed (now in object file): ES8 and A-36 (A-36 in red pen); ❦ and white paper Snyder Fine Art label, typed: (artist, title, date, medium, and dimensions).

PROVENANCE

Esphyr Slobodkina; ❦ Snyder Fine Art, New York, New York.

EXHIBITIONS

New York, Sid Deutsch Gallery, circa 1980. ❦ Muncie, Ball State University Museum of Art. *Objects of Desire: A Vision for the Future*. October 11-November 8, 1992, no catalogue.

REFERENCES

Snyder Fine Art inventory number 1SLOB10.

Henry Moore

English (1898-1986)
born Castleford, Yorkshire, England, June 30, 1898

died Much Hadham, Hertfordshire, England, August 31, 1986

Family Group, 1944 (model); 1944-1946 (cast)

metal (bronze)
$14.9 \times 13.3 \times 7.6$ cm; $5\frac{7}{8} \times 5\frac{1}{4} \times 3$ inches

Museum purchase
51.003

Intimate in scale and subject, Henry Moore's *Family Group* has the appearance of having been slightly eroded or weathered. Figures of a man, a woman, and two children seem to grow from the small mass of bronze. Although the two adult figures sit on separate benches, they and the children are connected through intertwining limbs and wrapped draperies. Moore had been fascinated by draped and intertwined figures since 1941, when he had sketched the huddled, blanketed Londoners who adopted the city's subway tunnels as bomb shelters during WWII. Over the next few years in Moore's sculptures exploring themes of mother and child or families, the image of wrapped and intertwined figures appeared again and again.

Moore created this particular image of familial unity and protection for the British educator Henry Morris, pioneer of the rural "village college" concept. "The Family Group in all its differing forms," Moore said of the project, "sprang from my absorbing [Morris's] idea of the village college—that it should be an institution that could provide for the family unit at all its stages (1964)." In Morris's plan, the village college would educate the entire family by housing primary, secondary, and adult education in one building.

Although the educator and artist had been discussing a sculpture project for about a decade,

it was not until 1944 that Morris asked Moore to begin work on a sculpture for the grounds of the village college at Impington in Cambridgeshire (built in 1939). In preparation for the project, Moore made a series of drawings and small clay models or maquettes of families with either one or two children. Meanwhile, Henry Morris had been unable to persuade local officials actually to order the full-scale sculpture. (A few years later, the county of Hertfordshire officially commissioned the work.)

Not willing to lose the time already put into the project, Moore had ten of the clay models cast in bronze in editions of seven. The museum's *Family Group* is one of these casts. (The full-sized bronze version, completed in 1948-1949 and now at a school in the New Town of Stevenage in Hertfordshire, was based on a different model with only one child being held between the couple.)

SOURCES
Berthoud, Roger. *The Life of Henry Moore*. New York: E.P. Dutton, 1987. ❦ Moore, Henry. *Sculpture and Drawings 1949-1954*, volume 2. With an introduction by

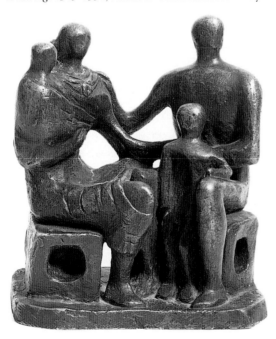

Herbert Read, fourth edition, 1957; reprint New York: George Wittenborn, Inc., 1968. ❦ Moore, Henry. Foreword to *Digswell: A Matter Done*, by Dorothy Bimrose. Welwyn Garden City: Digswell Arts Trust, 1964. Quoted in Berthoud, page 191, 1987. ❦ Moore, Henry. *Henry Moore: A Shelter Sketchbook*. Munich: Prestal Verlag, 1988.

INSCRIPTIONS
Labels, etc.: bears white linen tape label, underside, center, with typed inscription: FAMILY GROUP / Henry Moore / Buchholz Galleries.

CONDITION and TECHNIQUE
The piece is patinated a dark brown and apparently is cast solid with only a slight hollow under the base and into the stools.

PROVENANCE
Bucholz Gallery, Inc., New York, New York.

REFERENCES
(Former accession number: AC-51-2.) ❦ Sylvester, David, editor. *Henry Moore: Complete Sculpture*. London: Lord Humphries, 1988, volume I, *Sculpture 1921-48*, page 14, catalogue number 229, terra cotta version illustrated page 15.

RELATED WORKS
Henry Moore. *Family Group*, 1944, terra cotta, 14.9-cm-high, Henry Moore collection to 1986. (Sylvester, 1988, catalogue number 229.) The 1944 terra cotta is one of a group of fourteen studies executed in 1944 and 1945 of the family group theme. Ten of the studies were cast in bronze between 1944 and 1946.

Henry Moore. *Family Group*, 1944, pen, chalk, and watercolor, 55.9 × 38.1 cm, private collection.

Henry Moore. *Family Group*, 1944, pen, chalk, and watercolor, 18.4 × 17.2 cm, former collection of Mrs. Irena Moore.

Henry Moore. *Family Groups in Settings*, 1944, pen, chalk, and watercolor, 61 × 43.2 cm, private collection.

Henry Moore. *Seated Figures*, 1942, pen, chalk, and watercolor, 61 × 46 cm, The Museum of Modern Art, New York, New York.

For additional drawings related to the family group bronzes see Clark, Kenneth. *Henry Moore Drawings*. London: Thames and Hudson, 1974, pages 249-255, and plates 217 through 232.

Thomas Gaetano Lo Medico

American (1904-1985)
born New York, New York, July 11, 1904
died New York, 1985

Screeching Eagle, circa 1947

metal (brass), stone (slate)
74.0 × 28.0 × 20.5 cm; 29⅛ × 11 × 8⅛ inches

Gift of the George and Frances Ball Foundation
92.038.17a

CONDITION and TECHNIQUE
The piece is cast solid.

PROVENANCE
Thomas Gaetano Lo Medico; ❦ Thomas Gaetano Lo Medico
estate, 1985; ❦ Berman Daferner Painting and Sculpture,
New York, New York.

EXHIBITIONS
Philadelphia, Philadelphia Art Alliance. *Sculpture of the
American Scene*. 1987. ❦ Hampstead, Long Island, Hofstra
University. *The Coming of Age of American Sculpture:
The First Decades of the Sculptors Guild, 1930s-1950s*.
February 3-March 18, 1990, page 45, illustrated page 34. ❦
Muncie, Ball State University Museum of Art. *Objects of
Desire: A Vision for the Future*. October 11-November 8,
1992, no catalogue.

REFERENCES
Lo Medico, Thomas. *Thomas G. Lo Medico: Sculpture-
Design*. New York: privately published in collaboration
with Rogers and Butler, Architects, New York, n.d. (circa
1947).

REMARKS
The *Screeching Eagle* was Lo Medico's entry model for the
1948 Jefferson Memorial Expansion Monument
Competition, St. Louis, Missouri. The 1947 pamphlet
written by Lo Medico in collaboration with Rogers and
Butler includes statements by the artist and renderings of
what his proposal for the Jefferson Memorial Expansion
Monument was to look like when completed.

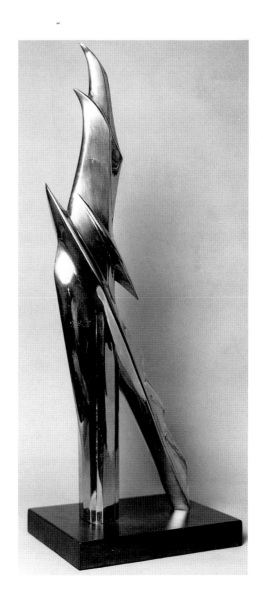

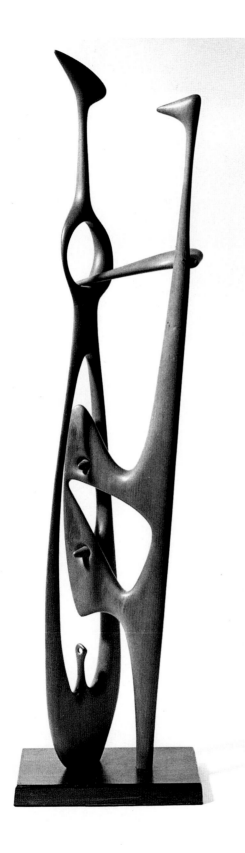

Leo Amino

American, born Japan (1911–1989)
born Formosa (Taiwan), June 26, 1911
died New York, New York, December 1, 1989

Keepers of the Moon, March 28, 1949

wood (cherry), metal on wood (mahogany), paint
(oil)
84.3 × 16.5 × 10.1 cm; 33¼ × 6½ × 4 inches

Museum purchase
50.001

INSCRIPTIONS
Signed with incised letters, highlighted with yellow oil
paint, base, front: LEO AMINO 49; ❦ inscribed by the
artist, base, underside, front, center: LEO AMINO / 3-28-49.

Labels, etc: bears white paper label, base, underside,
inscribed in blue pen (now in object file): 92. Amino /
Keepers of the / Moon.

PROVENANCE
Leo Amino; ❦ Sculpture Center, New York, New York.

EXHIBITIONS
Muncie, Ball State Teachers College Art Gallery. *Leo Amino*.
April–?, 1950, no catalogue.

REFERENCES
(Former accession numbers AC-53-41 and 48.001.)

Alexander Calder

American (1898–1976)
born Philadelphia, Pennsylvania, July 22, 1898
died New York, New York, November 11, 1976

Three Worms and A New Moon, circa 1949

metal (steel, aluminum), paint (oil)
76.2 × 127.0 cm; 30 × 50 inches

Friends Fund purchase
50.196

Michael Goldberg

American (1924-)
born New York, New York, December 24, 1924

Untitled, 1955

paint (oil) on canvas (linen)
146.2 × 154.2 cm; 57½ × 60½ inches

Friends Fund purchase
85.010

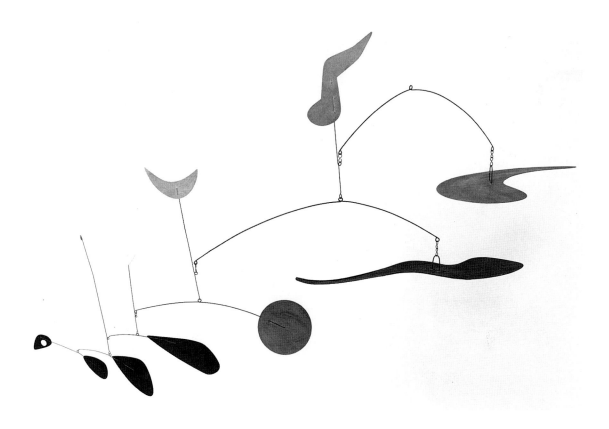

INSCRIPTIONS
Verso: signed in black felt pen, canvas, upper right: goldberg 55.

Labels, etc.: bears white paper Vanderwoode, Tananbaum Gallery labels, stretcher, vertical cross member, top and horizontal cross member, right.

CONDITION and TECHNIQUE
The painting was nap-lined to repair two small tears. Conserved, 1986, Intermuseum Conservation Association, Oberlin, Ohio.

PROVENANCE
Vanderwoode, Tananbaum Gallery, New York, New York; G.W. Einstein Company, Inc., New York, New York, 1985.

REFERENCES
Browne, Donna. "Gallery Acquires Major Abstract Work." *Arts Insight*, September, 1985, page 19.

Alfred Leslie

American (1927-)
born New York, New York, October 29, 1927

Pythoness, 1959

paint (oil, acrylic) on canvas
173.0 × 220.0 cm; 68⅛ × 86⅝ inches

Lent by David T. Owsley
L92.016

INSCRIPTIONS
Verso: signed by the artist: ALFRED LESLIE 1959 / 68 × 86
#75.

Label, etc.: bears white paper John Berggruen Gallery label, stretcher, upper member, right (now in object file); ❦ and white paper Atthowe Fine Arts Transportion label, stretcher, upper right member (now in object file); ❦ and white paper La Jolla Museum of Contemporary Art label, stretcher, inscribed with title, date, and owner (Max Zurier) (now in object file).

PROVENANCE
John Berggruen Gallery, San Francisco, California; ❦ Max Zurier, California?; ❦ David T. Owsley, New York, New York, 1992.

EXHIBITIONS
Apparently La Jolla, La Jolla Museum of Contemporary Art.

REFERENCES
New York, Christie's. *Contemporary Art, Part II.* May 6, 1992, lot number 284, illustrated in color.

Grace Hartigan

American (1922-)
born Newark, New Jersey, March 28, 1922

The Choir Is on Fire, 1960-1963

paint (oil) on canvas
132.4 × 121.3 cm; 52⅛ × 47¾ inches

Friends Fund purchase
86.035.1

INSCRIPTIONS
Recto: signed in blue oil paint, bottom right: Hartigan.

Verso: inscribed in black felt pen, stretcher, upper
member: "THE CHOIR IS ON FIRE" HARTIGAN '60-63 51
1/2" × 48"; ❦ and in black felt pen, stretcher, horizontal
cross member: #3 #3; ❦ and in black felt pen, stretcher,
vertical cross member: 7673; ❦ and in pencil, stretcher,
bottom member: DeNay.

Labels, etc.: bears white paper University Art Museum, The
University of Texas, Austin, Texas, Exhibition Program label,
stretcher, upper member, left; ❦ and white paper Norfolk
Museum label, stretcher, cross member, center; ❦ and
orange paper Martha Jackson Gallery label (now in object
file); ❦ and six unidentified white paper labels (now in
object file).

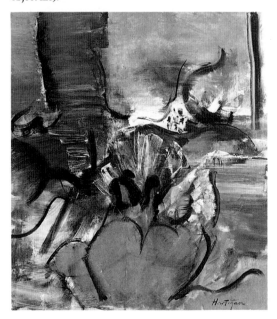

PROVENANCE
Grace Hartigan; ❦ Martha Jackson Gallery, Inc., New York,
New York; ❦ David Anderson Gallery, New York, New
York.

EXHIBITIONS
Narberth, Pennsylvania, Corinthian Gallery. *Premier
Exhibition of Paintings, Graphics, Sculpture*. December 1,
1963-January 1, 1964, no catalogue. ❦ New York, Martha
Jackson Gallery. *Group Exhibition*. January 7-February 1,
1964, catalogue number 6. ❦ Detroit, Franklin Siden
Gallery. *Grace Hartigan Exhibition*. March 16-April 11,
1964, catalogue number 2. ❦ Norfolk, Norfolk Museum of
Arts and Sciences. *Contemporary Art, U.S.A*. March
18-April 10, 1966, catalogue number 21. ❦ New York,
Martha Jackson Gallery. *Martha Jackson Gallery Presents
Six Painters*. May 20-June 22, 1986 (also Forth Worth, Fort
Worth Art Center, May 6-June 2, 1967; New Orleans, Bryant
Galleries, September 8-?, 1967; Nashville, Vanderbilt
Gallery, Birmingham Southern College and Gallery 31, Inc.,
December 3-15, 1967; Washington, D.C., Catholic
University, April 15-April 30, 1968). ❦ Washington, D.C.
Art in the Embassies Program. United States Embassy, San
Jose, Costa Rica, 1972-1974; Bogotá, Colombia, 1975-1976;
Tel Aviv, Israel, 1977-1981. ❦ New York, Ronald Feldman
Fine Arts. *Socialites and Satellites*. April 7-May 12, 1984.

REFERENCES
David Anderson Gallery reference number 7673.

Lee Krasner

American (1911-1984)
born Brooklyn, New York, October 27, 1908
died New York, New York, June 19, 1984

Right Bird Left, 1965

paint (oil) on canvas
177.8 × 345.5 cm; 70 × 136 inches

Lent by David T. Owsley
L92.001

In the expansive painting *Right Bird Left*,
exuberant petal or leaf-like shapes abut one
another. A narrow buffer of off-white paint

(almost the same color as the canvas) cushions one curving form from those around it. Although individual shapes go every which way, the general movement slants toward the left. Pink, orange, olive and pure green, purple, and crimson make an energetic dance across the canvas toward the left edge, where ocher yellows surprisingly emerge (perhaps prompting part of the title).

Although Lee Krasner shied away from explicating symbolic meaning or content in her work, in a 1973 interview she noted certain recurring shapes and motifs and conceded the potency of her titles. Always named after their completion, Krasner's canvases nevertheless invite an almost literal reading based on the few words imprinted on the label next to them. When asked by an interviewer if birds carried an important significance for her, since the word appears in a number of her paintings' titles (*Night Birds* [1962], *Bird Talk* [1955], and *Right Bird Left*), Krasner responded:

Most of it occurs a great deal without my consciously knowing it. In other words, it is there and I see it and recognize it. So all right, I get a bird image, I get a floral image, but I don't go around consciously thinking these images up. But they come through. So in that sense it's archetypal (April, 1973, 48).

In painting her canvases, Krasner worked from right to left, a direction derived from the lessons in Hebrew writing she took as a child. But rather than existing in a small, page-size scale, this painted "action" takes place in a vast arena: the canvas is more than eleven feet long, filling our field of vision as we stand before it.

Large-scale canvases became a big issue for American painters in the mid-1940s as they sought to expand their area of action. Throughout the 1950s the ubiquitous large canvas overshadowed the easel painting and signalled the twilight of the traditional, realistic picture as the artistic standard. For Krasner, large paintings were more then a matter of "blowing

up" a smaller work. By 1965, when *Right Bird Left* was painted, she had worked through a period of smaller paintings in which her recurrent elliptical motif had gradually expanded until it required a larger span of canvas. There it could be re-colored and repeated in an endless variety.

Since the early 1940s Krasner had been committed to "all-over" painting, in which the canvas is filled with strokes, shapes, and colors that demand equal attention throughout: no single area provides a focal point, nor does a dominant recognizable form emerge. Struggling toward a personal means of expression, around the same time Krasner sought to eradicate all references to the visual world in her work until, she noted, "There was no image at all."

This was a particular challenge for Krasner, who from 1937 to 1940 had studied under the German painter Hans Hofmann (as did a host of American painters, including Michael Goldberg—see entry) at his school in New York. Although Hofmann's own paintings as well as those of his students were abstract, he emphasized the importance of a model or nature as a starting point. Krasner, however, endeavored to make paintings that would arise solely from within herself and therefore be a more personal expression. In 1942 she participated in an exhibition that included the painter Jackson Pollock (whom she later married). In his works Krasner responded to what she later described as, "A force, a living force, the same sort of thing I responded to in Matisse, in Picasso, in Mondrian," that prompted her to reexamine her own work.

In sensibility almost the polar opposite of the meticulous Esphyr Slobodkina (see entry), Krasner described her working method as spontaneous and mysterious, evolving without pre-planning:

I make the first gesture, then other gestures occur, then observation. Something in the abstract movement suggests a form. I'm often astonished at what I'm confronted with when the major part comes through. Then I just go along with it; it's either organic in content, or quite abstract, but there's no forced decision. I want to get myself something via the act of painting... I sustain my interest in it through spontaneity (July, 1973).

Krasner was not alone in approaching painting in this almost automatic, subconscious way. Many of her colleagues in the 1940s and 1950s worked in a similar, spontaneous manner. In this way Krasner and other artists, known today as "Abstract Expressionists," believed they were replicating not the appearance of nature—as in traditional painting—but the processes of the natural world: organic, growing, filled with life, inevitable. Said Krasner:

Painting, for me, when it really "happens" is as miraculous as any natural phenomenon—as, say, a lettuce leaf. By "happens," I mean the painting in which the inner aspect of man and his outer aspects interlock... But the painting I have in mind, painting in which inner and outer are inseparable, transcends techniques, transcends subject and moves into the realm of the inevitable—then you have the lettuce leaf (1983).

SOURCES
Krasner, Lee. Interview by Maria Tucker, July, 1973. Quoted in Tucker, page 11. ❧ Krasner, Lee. "A Conversation with Lee Krasner." Interview by Cindy Nesmer, n.d., *Arts Magazine*, volume 47, number 6, April, 1973, pages 43-48. ❧ Krasner, Lee. In Rose, 1983, page 134. ❧ Nesmer, Cindy. "A Conversation with Lee Krasner." *Arts Magazine*, April, 1973, pages 43-48. ❧ Robert Miller

Gallery, 1991. ❦ Tucker, Marcia, 1973.

INSCRIPTIONS
Recto: signed in white oil paint, lower right: Lee Krasner '65.

PROVENANCE
Lee Krasner; ❦ Marlborough-Gerson Gallery, New York, New York; ❦ Maxxam Group, Inc., New York, New York; ❦ David T. Owsley, New York, New York, 1987.

EXHIBITIONS
London, Whitechapel Art Gallery. *Lee Krasner: Paintings, Drawings, and Collages.* September-October, 1965, page 24, catalogue number 62. ❦ New York, Marlborough-Gerson Gallery. *Lee Krasner: Large Paintings, 1973-1974.* Catalogue number 13. ❦New York, Whitney Museum of American Art. *Lee Krasner: Large Paintings.* November 13, 1973-January 6, 1974, page 36, catalogue number 13, illustrated page 30. ❦ New York, The Museum of Modern Art. *Lee Krasner: A Retrospective.* December 20, 1984-February 12, 1985 (also Houston, The Museum of Fine Arts, Houston, October 28, 1983-January 8, 1984), page 134, illustrated figure 130, page 133.

REFERENCES
Tucker, Marcia. *Lee Krasner: Large Paintings.* New York: Whitney Museum of American Art, 1973, page 36, catalogue number 13, illustrated page 30. ❦ Rose, Barbara. *Lee Krasner: A Retrospective.* New York: The Museum of Modern Art, 1983, page 134, illustrated figure 130, page 133. ❦ New York, Sotheby's, May 4, 1987, sale number 5570, lot number 49, illustrated in color. ❦ Robert Miller Gallery. *Lee Krasner: Paintings from 1965 to 1970.* New York: Robert Miller Gallery, 1991, unpaginated, illustrated, not in exhibition.

RELATED WORKS
Lee Krasner. *Untitled*, 1965, gouache on paper, 63.5 × 96.5 cm, Robert Miller Gallery, New York, New York.

Lee Krasner. *Gaea*, 1966, oil on canvas, 175.5 × 319.3 cm, The Museum of Modern Art, New York, New York.

Leo Sewell

American (1945-)
born Annapolis, Maryland, September 7, 1945

Man, circa 1970-1971

plastic, metal, wood (toys, auto parts, etc.)
125.7 × 55.9 × 69.8 cm; 49½ × 22 × 27½ inches

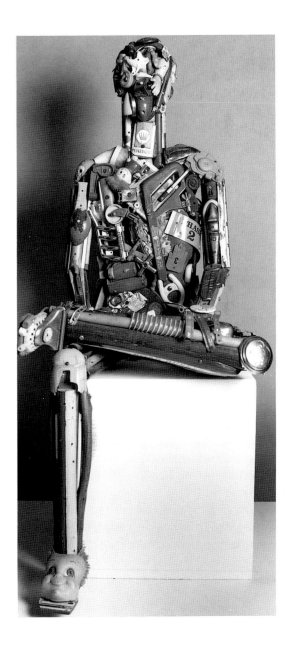

Gift of David T. Owsley
91.068.239

> As for my aesthetic, it is "horror vacui,"
> Latin for "fear of nothing[ness]." In
> other words, the worse [*sic*] thing the
> eye can see is plainness, so I fill my
> works with as much varied matter as I
> can for the eye to feast on."
>
> — Leo Sewell (1991)

Constructed of an intricate array of castaway toys and other discarded plastic and metal objects, Leo Sewell's *Man* presents a modern-day version of a traditional sculptural subject. Although the artist has composed his seated figure of what we might consider junk, he carefully selected objects that replicated parts of the human body's skeletal and muscular systems: a toilet brush on the back of one leg describes the calf muscle; the bowl of a spoon serves as a biceps; a piece of protective football gear conforms to the shape of the pelvis.

Artists use the term *found objects* to describe the discarded objects that they incorporate into their work. Dating to the turn of the century, the notion of using found objects in sculpture has a long history. Some artists of the early 1900s made collages or assembled sculptures from cast-off materials. In the 1960s, artists of the Pop movement (like Andy Warhol) borrowed imagery from the mass media and re-presented it in a realistic but often out-of-scale style. Around the same time, "junk sculptors" assembled abstract compositions from the discarded materials (especially metallic auto parts) of their urban, consumer culture. In *Man*, an assemblage of found objects, Sewell combines the idea of junk sculpture with the realism of Pop art. The artist described this work as "reclaimed objects assembled by bolts, screws, and nails, the finished sculpture being an essay of found objects."

SOURCES
Sewell, Leo. *Artist's statement*. Object file, Ball State University Museum of Art, n.d. (1991).

INSCRIPTIONS
Apparently unsigned and not inscribed beyond the printed information on the manufactured parts that compose the piece.

PROVENANCE
Unidentified cabinet shop, Suffern, New York; ❦ American Folk Art Gallery, New York, New York; ❦ David T. Owsley, New York, New York, 1981.

REFERENCES
(Former accession number: L88.007.02.)

Anthony Caro

English (1924-)
born New Malden, England, March 8, 1924

Fish: Table Piece CCLV, 1975

metal (steel), varnish
58.2 × 156.1 × 55.8 cm, 23 × 61½ × 22 inches

Friends Fund purchase
84.017

PROVENANCE
G.W. Einstein Company, Inc., New York, New York, 1984.

REFERENCES
Blume, Dieter. *The Sculpture of Anthony Caro, 1942-1980: A Catalogue Raisonné*, volume 1, *Table and Related Sculpture 1966-1978*. Cologne: Verlag Galerie, Wentzel, 1981, catalogue number 254, illustrated. ❦ Douglass, Joanne. "Caro Sculpture Acquired for BSU Gallery." *Arts Insight*, October, 1984, page 13, illustrated.

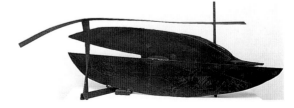

Clement L. Meadmore

American, born Australia (1929-)
born Melbourne, Australia, February 9, 1929

Untitled, circa 1975

metal (steel), paint (oil)
85.0 × 124.3 × 104.1 cm; 33½ × 49 × 41 inches

Gift of the Alconda-Owsley Foundation with
assistance from the Friends Fund in celebration of
Alain Joyaux's first decade as director
93.003

PROVENANCE
Clement L. Meadmore; ❦ Amstar Corporation, Stanford,
Connecticut.

REFERENCES
New York, Christie's East. *Modern and Contemporary
Paintings, Drawings, and Sculpture.* February 22, 1993,
lot number 176, illustrated.

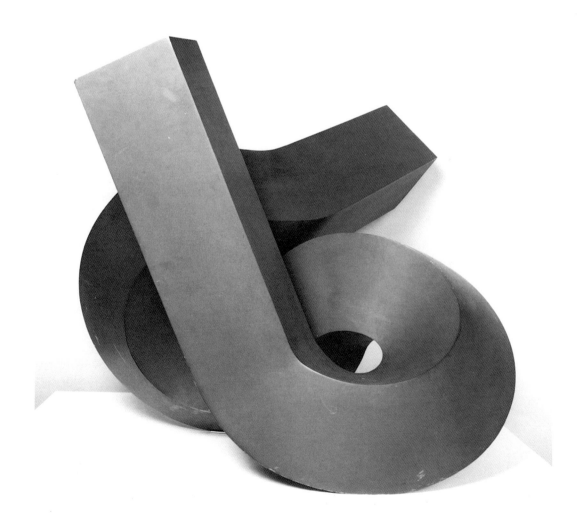

Herman Cherry

American (1909-1992)
born Atlantic City, New Jersey, April 10, 1909
died New York, New York, April 10, 1992

Shadow Series II, 1980

paint (oil) on canvas
167.6 × 152.4 cm; 66 × 60 inches

Gift of The American Academy and Institute of Arts and Letters, Hassam and Speicher Purchase Fund
88.026

INSCRIPTIONS
Verso: signed in black paint, upper left: Cherry / 1980; ❦ inscribed in black paint, below signature: 66x60; ❦ and in green marker, below signature: Shadow Series II.

Labels, etc: bears white paper American Academy and Institute of Arts and Letters label, stretcher, upper member, center (now in object file); ❦ and old unidentified exhibition label, stretcher, upper member, right.

PROVENANCE
Herman Cherry; ❦ American Academy and Institute of Arts and Letters, New York, New York 1988.

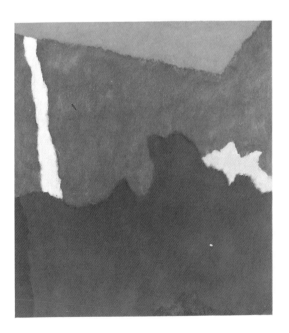

EXHIBITIONS
Southhampton, Illnois, Punto Blu Gallery. *Herman Cherry*. April, 1984, no catalogue. ❦ New York, American Academy and Institute of Arts and Letters. *40th Annual Purchase Exhibition, Hassam and Speicher Fund*. November 14-December 11, 1988, catalogue number 9. ❦ Muncie, Ball State University Art Gallery. *Herman Cherry: A Retrospective*. December 10, 1989-February 11, 1990, catalogue number 52, illustrated page 40.

REFERENCES
Ball State University Art Gallery. *Herman Cherry: A Retrospective*. Introduction by Judd Tully. Muncie: Ball State University Art Gallery, catalogue number 52, illustrated page 40.

Mimmo Paladino

Italian (1948-)
born Paduli, near Benevento, Italy, December 18, 1948

Canto Guerriero (diptych), 1981

paint (oil, gouache), pastel, wax on paper (adhered to canvas)
272.0 × 304.0 cm; 107 × 119½ inches (overall)

Friends Fund purchase with assistance from the Alconda-Owsley Foundation
87.009

From a surface congested with color and encrusted with wax and pastel emerge fragments of vaguely human forms. Images of a ghostlike figure and a swirling white mask or skull hover side by side on two immense panels of red and blue respectively. With their vibrantly contrasting colors the two panels that compose the painting suggest a dichotomy—perhaps of good and evil or life and death. At the top of the red panel of *Canto Guerriero* Paladino presents an amorphous head and shoulders that, even as it struggles to come into focus, is obliterated by a

massive brown smear. From below this mass bursts a tumble of mysterious shapes, variously bony, mask-like, or fish shaped. The adjacent blue panel seems almost a catharsis or antithesis, as a glowing white head is born of or consumed by a whirlpool.

Drama and mystery are Paladino's stock-in-trade. In interviews from the early 1980s the artist spoke of the mystery, drama, and intensity inherent in his work. Critics too speak of the symbolic and spiritual content of his imagery. The figure that appears in this work as a vaguely human spectre recurs more firmly formed in many of the artist's paintings and sculptures. Recurrent too is the egg-shaped head or mask that on the right spins into or out of the void.

Paladino entitled this painting *Canto Guerriero*, "war-like song" or "warrior song" a title which, although it does not exactly describe the painting, hints at a sense of discrepancy or discord. "The titles come to me much later . . . way after the completion of the paintings," said the artist in a 1982 interview, "The titles really don't serve to identify the paintings or to accompany the pictures or to help in the reading, but rather to create other poetic dimensions."

Born in 1948 near Naples, Italy, Paladino attended an art-oriented high school. By 1977 he had his first one-man show, followed by numerous exhibitions. After spending several years in Milan, Paladino now lives and works in his native town of Paduli, just a few miles from Benevento. Since the late 1970s, Paladino has been a prominent figure in the international art world, gaining attention along with a group of young Italian painters critics termed the "Transavanguardia."

Despite the geographical allegiance to his homeland (Paladino has never lived in New York, mecca for many artists), he denies personal or even national references in his work. Paladino has remarked that he deliberately seeks to communicate to a broad audience by avoiding specifics:

> It is unthinkable to attempt to base one's art on such a personal thing as background or family. Work should be universal—which doesn't mean that it has to be divorced from its cultural matrix. But it must attempt to be legible to an international audience. The idea of an Italian art or American art doesn't occur to me (1982).

In the wake of the completely nonrepresentational paintings that held sway for most of the twentieth century, artists working in the past few decades have invested their canvases with symbols and clues that provoke interpretations, though not necessarily literal readings. "In my paintings there is a head, and there is a landscape," said Paladino in a 1992 interview, "They meet up on the surface of the canvas. It's not a narrative, and I'm no visionary. I've merely had a thought and projected it pictorially." Critics referred to this new work as "Neo-expressionism," suggesting its link to turn-of-the-century art movements that distorted or exaggerated colors, objects, scenes, and figures for expressive purposes (see Lhote entry).

SOURCES

Berger, Danny. "Mimmo Paladino: An Interview." *The Print Collector's Newsletter*, number 2, May-June, 1983, pages 48-53. ❦ Faust, Wolfgang Max. "Searching for . . . an Interview with Mimmo Paladino." *Domus*, number 611, November, 1980, page 49. ❦ Kuspit, Donald. "Mimmo Paladino at Sperone Westwater." *Art in America*, February, 1984, page 146. ❦ Paladino, Mimmo. "Mimmo Paladino: An Interview." Interview by Danny Berger (New York, December 10, 1982). *The Print Collector's Newsletter*, number 2, May-June, 1983, page 49. ❦ Stevens, Mark. "Paladino's Paradiso." *Vanity Fair*, March, 1991, pages 180-185 and 208-209. ❦ Turner, Jonathan. "Mimmo Paladino: 30 Horses, a Watch, and a White Mountain." *Artnews*, March, 1992, pages 108-113.

PROVENANCE
Galerie Bischofberger, Zürich, Switzerland.

REFERENCES
New York, Sotheby's. *Contemporary Art, Part II*. May 5, 1987, lot number 272, illustrated in color. ❦ Mannheimer, Steve. "Indiana's Greatest Art Treasures." *The Indianapolis Star*, June 11, 1989, section E, page 1, illustrated in color.

see color plate VIII

Joan Snyder

American (1940-)
born Highland Park, New Jersey, April 16, 1940

Lady Labyrinth, November, 1989

paint (oil, acrylic), papier mâché, plastic, textile (mixed media) on canvas (linen)
152.4 × 152.4 cm; 60 × 60 inches

Museum purchase with assistance from Museum of Art Alliance and the National Endowment for the Arts
91.004

INSCRIPTIONS
Verso: signed in black ink, left tacking edge: Joan Snyder Nov 1989; ❦ and in black ink, upper left: J Snyder.

Labels, etc.: bears white paper Hirschl & Adler Modern label, stretcher, upper member, right.

PROVENANCE
Joan Snyder; ❦ Hirschl and Adler Modern, New York, New York.

EXHIBITIONS
New York, Hirschl and Adler Modern. *Joan Snyder*. February 3-28, 1990.

REFERENCES
Hirschl and Adler Modern inventory number: SJM05214D. ❦ Jones, Bill. "Joan Snyder." *Arts Magazine*, Summer 1990, page 26, illustrated.

Hubertus Giebe

German (1953-)
born Dohna, Germany, 1953

Massaker II, 1990

paint (oil) on panel (masonite)
164.5 × 124.5 cm; 64¾ × 49 inches

Gift of the Alconda-Owsley Foundation
90.011

INSCRIPTIONS
Verso: signed in black oil paint, upper center: GIEBE.

PROVENANCE
Hubertus Giebe; ❦ Raab Galerie, Berlin, Germany; ❦ Alconda-Owsley Foundation, New York, New York.

EXHIBITIONS
Chicago. *Chicago International Art Exposition, Raab Gallerie*. May, 1990.

RELATED WORKS
Hubertus Giebe. *Massaker I*, 1990, oil on panel, present location unknown, exhibited, Venice, *44th Biennale di Venezia*, 1990, Germany, *Hubertus Giebe*

Index of Artists

Adams, J. Ottis, 150

Amino, Leo, 176

Asch, Pieter Janszoon van, 70

Balestra, Antonio, 81

Bartolomeo di Giovanni (see Benedetto da Maiano, Studio of)

Bellini, Giovanni, and Studio, 51

Benedetto da Maiano, Studio of, 54

Benvenuto di Giovanni, 53

Blakelock, Ralph Albert, 134

Bonington, Richard Parkes, 112

Boudin, Eugène-Louis, 137

Calder, Alexander, 176

Caro, Anthony, 184

Carrier-Belleuse, Albert-Ernst, 129

Chardin, Jean-Baptiste-Siméon, 91

Chase, William Merritt, 152

Cherry, Herman, 186

Clodion (see Michel, Claude)

Cole, Thomas, 110

Constable, John, 109

Corot, Camille-Jean-Baptiste, 122

Dallin, Cyrus Edwin, 156

Degas, Hilaire-Germain-Edgar, 142

Diaz de la Peña, Narcisse Virgile, 123

Doughty, Thomas, 115

Drouais, François-Hubert, 96

Eakins, Thomas, 135

Faes, Pieter van der (see Lely, Sir Peter)

Fragonard, Jean-Honoré, 99

French, Daniel Chester, 140

Gechter, Jean-François-Théodore, 116

Gérôme, Jean-Léon, 153

Giebe, Hubertus, 189

Gifford, Sanford Robinson, 127

Girolamo di Benvenuto (see Benvenuto di Giovanni)

Goldberg, Michael, 177

Guardi, Francesco, 94

Guiliano da Maiano (see Benedetto da Maiano, Studio of)

Hartigan, Grace, 180

Hassam, Childe, 139, 151, 159

Holbein, Hans, the Younger and Studio, 59

Homer, Winslow, 130

Hunt, William Morris, 132

Inness, George, 146

Lely, Sir Peter, 74

Leslie, Alfred, 179

Lhote, André, 155

Lo Medico, Thomas Gaetano, 175

Lorenzo di Credi, School of, 55

Luini, Bernardino, School of, 56

Krasner, Lee, 180

Manship, Paul Howard, 167

Marilhat, Prosper-Georges-Antonine, 114

Marin, Joseph-Charles, 107

Martin, Homer Dodge, 132

Master of the Bracciolini Chapel, 48

Maurer, Alfred Henry, 165

Mazzouli, Giuseppe, Attributed to, 78

Meadmore, Clement L., 185

Metcalf, Willard Leroy, 166

Michel, Claude, called Clodion, 102, 103

Millet, Jean-François, 119

Molinari, Antonio, 79

Monnoyer, Jean-Baptiste, 72

Montauti, Antonio, Attributed to, 89

Monticelli, Adolph-Joseph Thomas, 129

Moore, Henry, 173

Nason, Pieter, 79

Paladino, Mimmo, 186

Powers, Hiram, 117

Raeburn, Sir Henry, 106

Redon, Odilon, 160

Rootius, Jan Albertz, 72

Ruisdael, Salomon van, 77

Safferson, Matthew, 170

Saint-Gaudens, Augustus, 148

Sewell, Leo, 183

Slobodkina, Esphyr, 170

Smillie, George Henry, 128

Snyder, Joan, 188

Stanzione, Massimo, 64

Stomer, Matthias, 67

Stuart, Gilbert (Charles), 105

Susterman, Justus, 66

Tommaso (see Lorenzo di Credi, School of)

Troy, François de (see Watteau, Antoine or Jean-Antoine)

Troy, Jean-François de, 87

Unidentified Maker, 13th century, French, 44

Unidentified Maker, 13th century, Spanish, 45

Unidentified Maker, 14th century, French, 47

Unidentified Maker, 15th century, French, 49

Unidentified Maker, 15th–16th century, Austrian, circle of Anton Pilgrim, 50

Unidentified Maker, 16th century, Italian, 62

Unidentified Maker, 16th–17th century, Italian, 63

Vannini, Ottavio, 68

Vigée-Lebrun, Marie Elizabeth-Louise, 101

Watteau, Antoine or Jean-Antoine, after François de Troy, 83

Weinmann, Adolph Alexander, 163

Wyant, Alexander H., 126